What Makes a Masterpiece

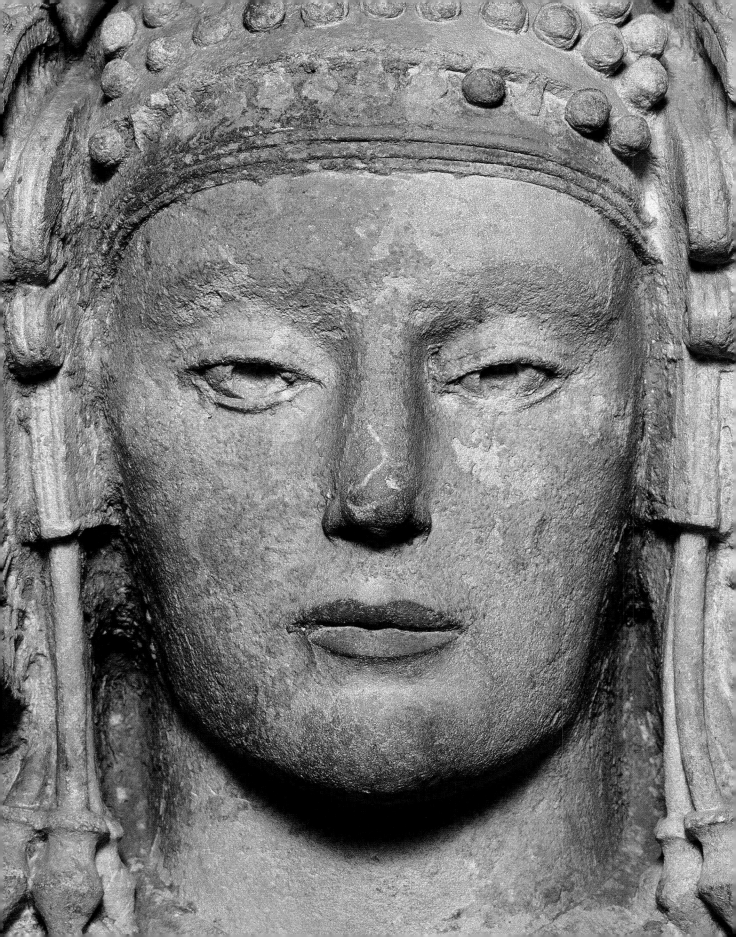

What Makes a Masterpiece

Artists, Writers and Curators on the
World's Greatest Works of Art

Edited by Christopher Dell

285 illustrations, 265 in color

CONTENTS

First published in 2010 in hardcover in the
United States of America by
Thames & Hudson Inc., 500 Fifth Avenue,
New York, New York 10110

thamesandhudsonusa.com

Library of Congress Catalog Card Number
2010923353

ISBN 978-0-500-23879-0

Printed and bound in China by Toppan Printing

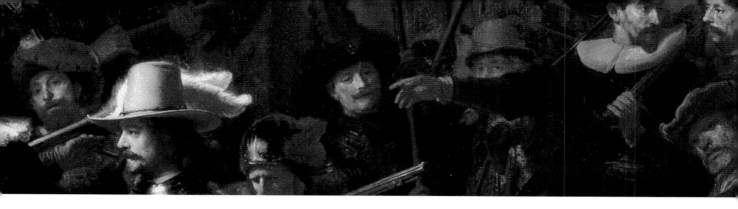

Unless otherwise indicated, all dimensions
are given in the order height × width.

half-title
The Lady of Elche, Artist unknown

page 4
The Villa of the Mysteries, Pompeii,
Artist unknown

page 5
The Court of Gayumars from Shah
Tahmasp's *Shahnama* ('Book of Kings'),
Sultan Muhammad

page 6
The Night Watch, Rembrandt van Rijn

page 7
Sunflowers, Vincent Van Gogh

The part-title pages show details from the
following works:

pages 14–15
Ashurbanipal's Lion Hunt, Artist unknown

pages 32–33
The Villa of the Mysteries, Pompeii, Artist
unknown

pages 66–67
The Reclining Buddha of Polonnaruwa,
Artist unknown

pages 96–97
The Birth of Venus, Alessandro Botticelli

pages 146–47
The Court of Gayumars from Shah
Tahmasp's *Shahnama* ('Book of Kings'),
Sultan Muhammad

pages 200–01
The Night Watch, Rembrandt van Rijn

pages 246–47
Sunflowers, Vincent Van Gogh

INTRODUCTION: MAKING MASTERPIECES

CHRISTOPHER DELL

Above
Leonardo da Vinci, *Portrait of Lisa del Giocondo, formerly Lisa Gherardini (Mona Lisa), c.* 1503–06 (detail).

The term 'masterpiece' originated in Europe in the late Middle Ages to refer to a virtuoso work produced by a craftsman to win entry into a guild. Often produced early in his career, such a work was calculated to show off his skills to best advantage. Today, however, the word has spread to many other arenas: films, music, recordings and books are all frequently referred to as masterpieces. The word has come to describe the pinnacles of a creative career, the works that define an oeuvre. Museums hope to collect masterpieces, not 'minor' works, and the jewels of their collections are highlighted and specially signposted. For many the Louvre is immediately associated with the *Mona Lisa*, the Prado with *Las Meninas*, the Rijksmuseum with *The Night Watch* and the Uffizi with *The Birth of Venus*; and many other collections are defined, in the popular imagination at least, by a small number of outstanding works.

This raises an interesting question: how do museums and scholars decide which works to highlight? What makes an artwork a masterpiece? The words employed to describe these pieces can be frustratingly nebulous: 'timeless', 'profound', 'work of genius', 'visionary', 'perfect'. But what do these terms mean? Sometimes it can feel as though critics are substituting one riddle for another. And yet great art does stray into a mysterious, even magical, world. This book opens with the remarkable cave paintings at Chauvet, made 30,000 years ago; their fluid, sinuous lines are charged with enormous power. And in the long ages since then, artists and sculptors have executed works of such supreme skill and accomplishment that, regardless of their medium, purpose or form, they are generally acknowledged to be masterpieces. All artists are conjurors, bringing to life before our eyes the real and the imaginary, the commonplace and the arcane, imbuing earthly materials – marble, bronze, clay, oil paint – with a sense of the numinous.

Without doubt the concept of the masterpiece is beguiling, and many great minds have wrestled with what gives these select works their status. Kenneth Clark, the connoisseur's connoisseur, in his book *What is a Masterpiece?* (1979), identified two key characteristics as: 'a confluence of memories and emotions forming a single idea' and 'a power of recreating traditional forms so that they become expressive of the artist's own epoch and yet keep a relationship with the past'. The preface states his hope that his book will drive the 'final nail into the coffin of subjectivity'. In the attempt to identify the objective greatness of great works, Clark highlights technical virtuosity, groundbreaking skill and originality of approach. Certainly many of the masterpieces of art were pioneering in their time – the monumental bronzes at Angkor and the equestrian bronze of Marcus Aurelius both pushed materials to new limits; the kouroi of ancient Greece dared to become human and led to Classical naturalism; and Masaccio's expression of perspective

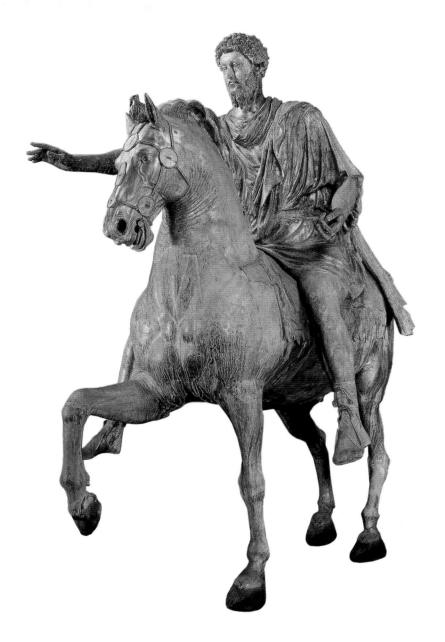

set the course of the Renaissance. Just as important is the artist's unerring ability to know when a work is finished – when to stop: 'In sculpture did ever anybody call the Apollo a fancy piece? Or say of the Laocoön how it might be made different?', asked Ralph Waldo Emerson in his essay on art in the collection *Society and Solitude* (1870). 'A masterpiece of art has in the mind a fixed place in the chain of being, as much as a plant or a crystal.'

Others have taken a more subjective and emotional view – namely, that masterpieces are the works that make the greatest emotional impact on us. Surely most people will feel touched by Van der Weyden's fragile depiction of a mother's loss in his quietly devastating *Descent from the Cross*. And surely it is Van der Weyden's articulation of the figures in their airless space, his careful arrangement of the composition, his exquisitely delicate and detailed painting that distinguishes this deposition from many an inferior, less moving version. And surely most people can be entranced by the peacefulness of the

Bodhisattva Avalokiteshvara, who holds with a calm and compassionate gaze the attention of a reverent child, caught up in this awesome encounter.

Now let us consider the definition of a masterpiece from a different angle. How universal is the concept of the masterpiece? Do all cultures make value judgments about their art? In the case of ancient Egypt, whose artefacts are remarkably well preserved, it is certainly true that the works we today consider to be masterpieces are found in the most important tombs. For the ancient Egyptians, the quality of the work was at least partly determined by the quality of the materials and the amount of time taken to produce it. In the intertwined traditions of Japan, Korea and China there is a broadly agreed canon of master artists, whose works are, by definition, masterpieces. Qiu Ying was regarded as one of the Four Great Masters of Ming painting, while Zhang Zeduan's remarkable *Qingming Shanghe tu* inspired a poem by a later Yuan emperor, making it famous throughout China. The canons were largely agreed on, even within the artists' lifetimes, and today this veneration is enshrined in a system of classified 'cultural goods' or national treasures.

While both the Far East and the West may think in terms of canonical schools of art, the focus of this book is on individual works rather than artists or movements. This is critical for two reasons. First, not all the works presented here have known creators. To concentrate on attributable pieces would cut out a number of anonymous geniuses. Good examples are the strikingly naturalistic Moche terracotta heads, or the powerful Ife bronzes. Secondly, even lesser-known artists are capable of breaking the mould on occasion to create a transcendental work: Hammershøi's *Sunbeams* is a good example of a work that enjoys more fame than its maker.

If we appeal only to the canon for our benchmark of the masterpiece, we are brought up sharp against the incontrovertible truth that though many masterpieces are instantly recognized as great works, some emerge as such only after the artist's lifetime: while he lived, Van Gogh's brother, Theo, was

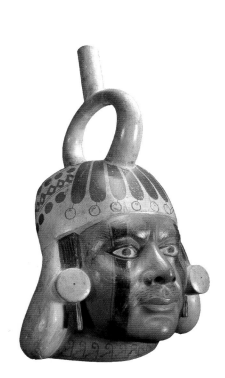

Top

Rogier van der Weyden, *Descent from the Cross*, c. 1435.

Above

Moche portrait vessel, c. 550.

his only loyal patron, but now his *Sunflowers* are among the most immediately recognizable works in all art. Other artists have enjoyed huge success in their lifetimes, only to be forgotten by successive generations. Although Alessandro Botticelli enjoyed enormous popularity in Florence while he was working for the Medici family, by the end of the 16th century his work was already eclipsed and overlooked, and it was not until the 19th century that collectors and then museums began to take a serious interest in him again. Just as we can see only from far away which of a range of mountains is the tallest, sometimes it is only with the distance of time that we can discern and appreciate the pinnacles of art.

Where masterpieces have gained their status only long after they were executed, their extended afterlife has often been the result of mechanical reproduction – in books, prints and even greetings cards. I recently visited the Rijksmuseum in Amsterdam, where I made the obligatory pilgrimage to Rembrandt's *The Night Watch*. The painting is a widely recognized masterpiece, held in such high esteem that since 1885 it has had its own dedicated room in the gallery. As I looked at the work, I began to dissect it, attempting to identify the details that make it distinctive. It struck me that certain elements border on the iconic: for example, the movement of the captain's hand as he turns to address his lieutenant. Can masterpieces be identified by particular constituents? Michelangelo's nearly touching fingers are world famous, as are Mona Lisa's smile and Venus's gathered golden hair. In the modern period most of these elements have been reproduced millions of times, and (as publishers, museums and galleries surely intend) we recognize them removed from their context, in almost the same way as, subconsciously, we understand branding in other situations. While a masterpiece is more than a collection of memorable gestures, it is perhaps the artist's genius at devising such speaking details that accounts for the fame of some works. Or does celebrity result from massive exposure? The two, of course, feed off each other.

At all events it is mechanical reproduction that allows us to make the sorts of groupings found in this book. As little as a hundred years ago, such comparisons could have been made only by the very few who had travelled, and even they had to rely on memory or their own jottings and sketches to set one work beside another. Today, however, we can assemble and compare works from around the world and across the ages; and, without underrating this privilege, we can perhaps let our imaginations wander inventively across the extraordinary variety of content, style and meaning of this collection by turning things on their heads. Would Leonardo have recognized the pared-down genius of a cave painting? What would the cave painter have made of a 16th-century Persian miniature? And what would the miniaturist in Tabriz have said to Delacroix's *Liberty Leading the People*? While Monet could discern the compositional genius of the work of, say, Utamaro, would a Maya sculptor have recognized the regimented Classical beauty of Poussin, for all its compositional rigour and use of 'timeless' proportions? This lighthearted game underlines the simple truth that a masterpiece is often determined by context – the context of the maker, the viewer, and what each knows of the other. An understanding of the culture that has given birth to a work of art remains critical in forming a value judgment of it.

* * *

Above
Utamaro, 'Lovers', from *Erotic Book: The Poem of the Pillow*, 1788 (detail).

The images in this book were made for a number of different reasons: to inform, to entertain, to commemorate, to educate, to reinforce beliefs, to encourage reflection or devotion. As a result, their forms, materials and subject matter differ widely: a manuscript designed for private devotion is radically different from a programme of biblical exegesis in stained glass or a statue of a warrior designed for public display. What they have in common, however, is that they are all concerned with the fundamental issues of composition, technical handling and the clear transmission of a message. It is this that makes them art.

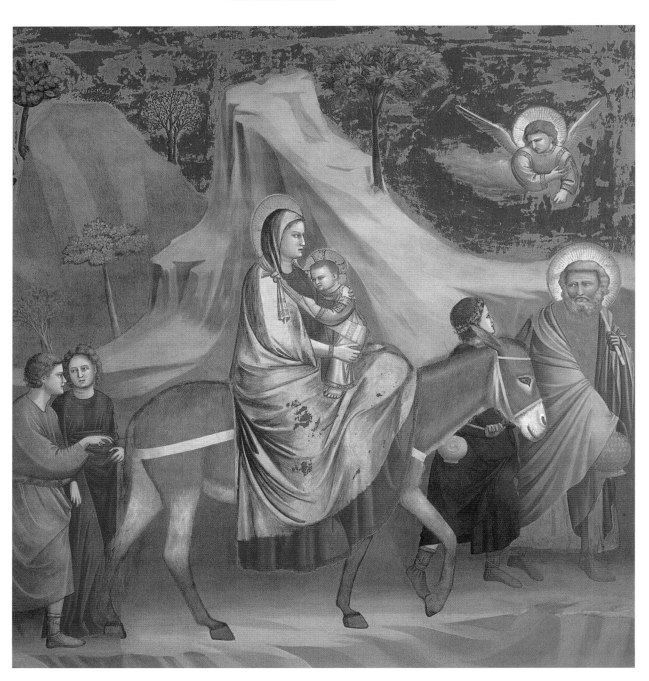

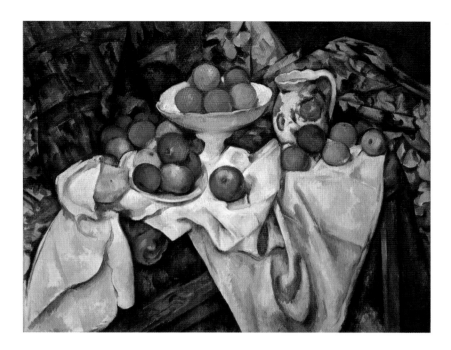

Our selection ends in 1900 – the cusp of modernity in Western art, but in fact a date of worldwide significance. Since that date humankind has found itself in an increasingly globalized world, where local cultural identities are eroded, and where international artistic currents increasingly mingle. It is also true that the 20th century saw the final overthrow of technical virtuosity as a prerequisite of a masterpiece: increasingly, it is ideas that count.

The works included in this book, regardless of when or where they were made, are all undeniably great. As to what makes them so, the authors give us seventy different answers. Some have decided to dismantle the composition of the work they have chosen, others to explain the story behind it or its unique significance, and others still to relate more personal accounts. Contemporary artists such as Tom Phillips, Grayson Perry, Avigdor Arikha, Anthony Caro and Antony Gormley offer penetrating insights into the art of the past, while scholars such as Pierre Rosenberg and Roderick Whitfield draw on a lifetime's experience of looking. Germaine Greer explores the impact of the artist's life on her work, while Jaś Elsner's poetic essays on a kouros and the sublime Sinai icon revive the Greco-Byzantine ekphrasis style. Philip Pullman makes an intriguing comparison between the groundbreaking *Bar at the Folies Bergères* and a contemporary work, while Martin Kemp is himself groundbreaking in his interpretation of *Mona Lisa*.

Claude Lantier, antihero of Zola's 1886 novel *L'Œuvre* (translated into English as *His Masterpiece*), is driven mad by his quest to create a masterpiece, believing that a triumph at the Salon will establish his career. Cézanne had a hunch that he was the model for the Lantier character, which led to an argument between the two men that ended by destroying a childhood friendship. It is understandable that Cézanne, hungry for recognition (and often just hungry), would have made an attractive subject for a novelist. But we cannot help feeling that Zola was unkind to mock the artist for doing what all artists naturally try to do: to surpass themselves, to produce something that is greater than the sum of its parts, and that will live on after they are gone.

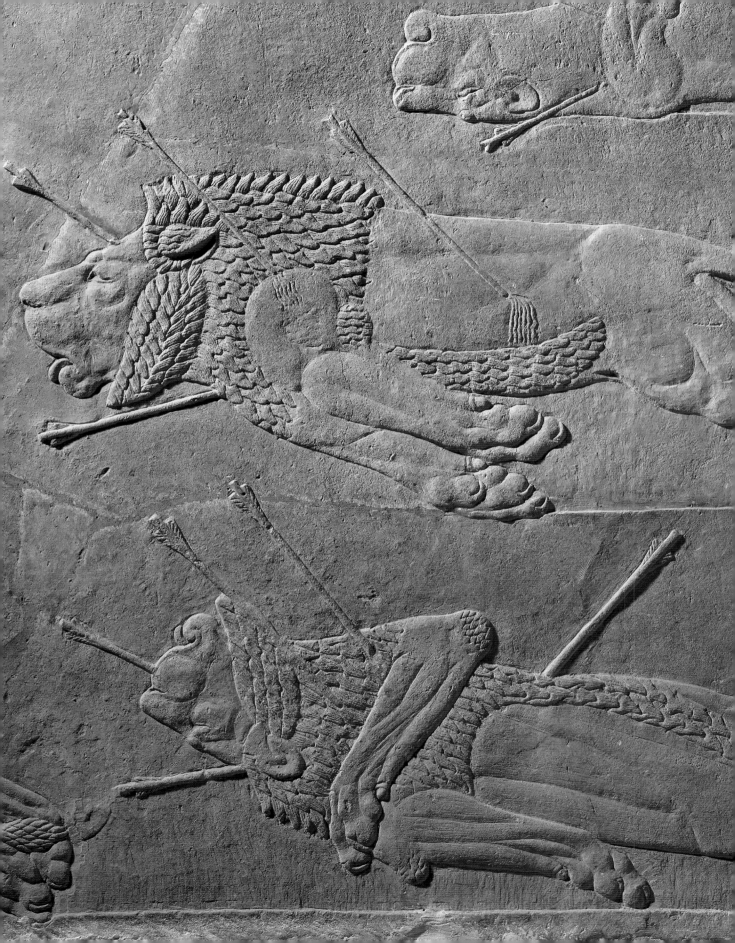

1

The Birth of Art

UP TO 500 BC

The Origins of Art

The Chauvet Cave, Artist unknown

JEAN CLOTTES

" *The discovery of Chauvet Cave has changed our conception of the evolution of art.*

Above
A red hand stencil in the first chamber of the Chauvet Cave, and above it the sketchy outline of a black mammoth.

Opposite
In the End Chamber, the panel to the left of the central recess shows a closely packed group of rhinoceroses, seven of which (top) are depicted in spatial perspective as if they were standing side by side; to their left are several lions, superimposed with a reindeer.

30,000–25,000 BC
Ardèche, France

When, on **29 December 1994,** I reached the floor of what would become known as the Chauvet Cave – having painfully crawled through a twisting narrow passage and descended a shaft down a wavy ladder – little did I suspect that the chambers discovered by the three cavers guiding me would be home to one of the greatest artistic masterpieces of all time.

Our torches picked a number of images out of the darkness. Any one of the panels that we saw would have been enough to make the cave famous. In the first chambers were three superb cave bears, a panther, a hyena-type animal, big dots and mysterious images reminiscent of insects. There was also an extensive panel with lions, rhinos and mammoths, handprints and hand stencils – all painted in red.

After crossing another chamber, devoid of designs, we came to a huge hall. Here the walls were covered with masterly engravings of horses, mammoths, aurochs, rhinos and an owl. From here on, most of the animals would be either engraved or black, with few of the red figures seen earlier.

Next we came upon a cave bear skull spectacularly deposited on a rock in the middle of the chamber. The most important panels in this chamber were on either side of a recess. An eight-legged bison appeared in front of a large lion courting a female; these, in turn, appeared among beautiful horses. Two rhinos seemed to be fighting and, above them, the wall was crowded with four horses' heads and a number of aurochs and rhinos. At right angles to the recess was another panel with deer and reindeer, bison, horses and ibex. The variety of animal species represented (fourteen in all in the Chauvet Cave) was striking and unusual.

We then followed a narrower passage, where cave bears had left scratches on the walls. We found more black drawings, of megaloceros deer, horses, rhinos and ibex. Large pieces of burnt wood littered the ground: fires had been made here, probably to obtain the charcoal with which to draw.

Finally, we reached what we would call the End Chamber. In this vast hall, the artists had thought very carefully, deliberately, about where to paint. At the very end, three big bison occupied an entire wall, while the walls next to the entrance bore lions, mammoths and bison, as well as strange W-shaped geometric symbols.

But what struck us most strongly was a remarkable accumulation of animals, once again carefully arranged on either side of a recess. The left-hand panel showed two distinct groups: four black lions' heads and an engraved reindeer superimposed upon five fainter red lions; and a congregation of seventeen rhinos, unique in Palaeolithic art. The central recess was a complex composition in itself, with a horse in its centre. The artist had initially scraped the wall into the form of a horse's body, but then had drawn the

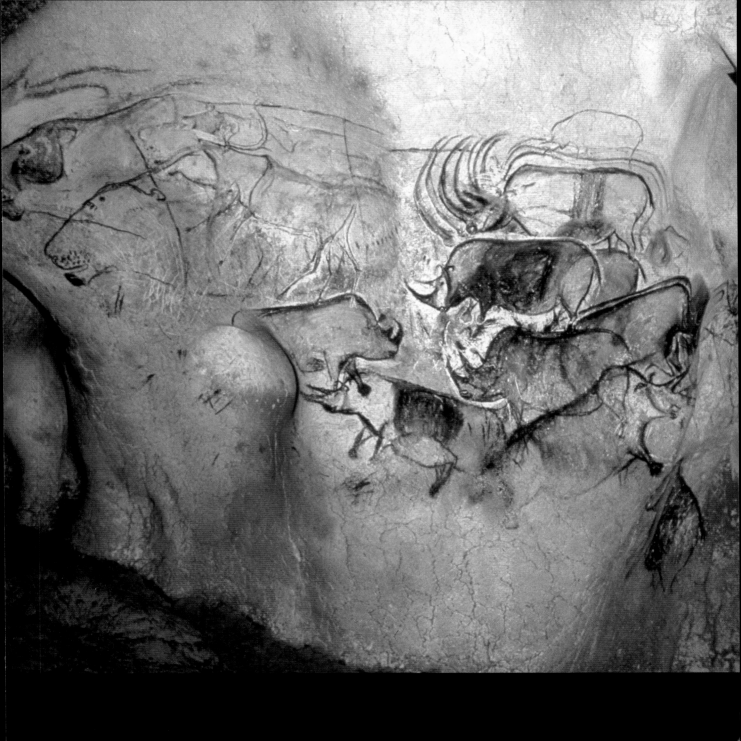

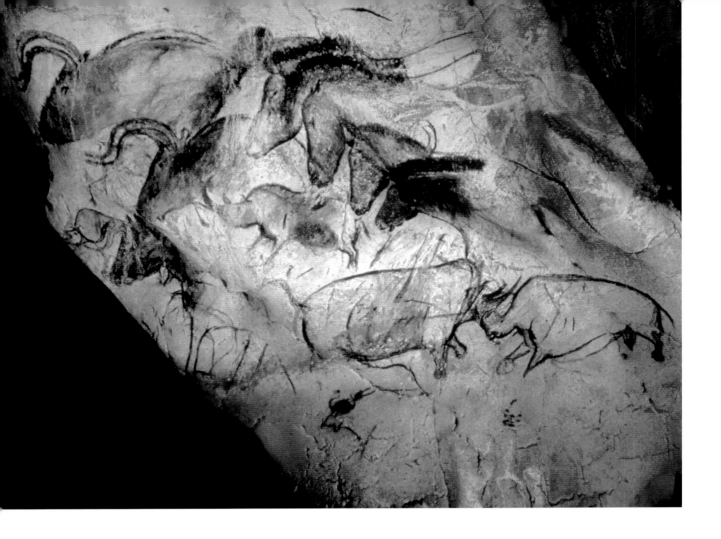

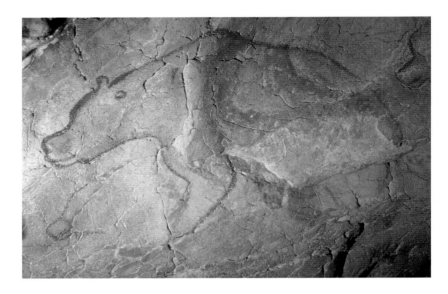

Above

The so-called Panel of the Horses shows
four exceptional horses' heads, with several
aurochs and rhinos, and a bison below them;
two of the rhinos are locked in combat.

Right

In a deep recess in the first chamber of the
cave three cave bears are outlined in red: the
artist captures their stance with startling
naturalism and a sure hand.

animal to the right, as though it were issuing from the wall. A large rhino on the left and a bison above and to the right gave the same impression of animals emerging from the depths. Two other rhinos and a mammoth topped the recess, completed on its right by three more mammoths, the head of a bison, a small rhino and a strange-looking animal.

The right-hand panel, the most spectacular in the entire cave, began with four bison heads on its edge, facing us. The artist took advantage of two slight concavities in the wall to draw two lions and five bison facing left. One engraved rhino tops the panel and another stands below it. To the right, the other, wider, concavity includes a very sketchy engraved mammoth at the top and another bison. However, most striking of all are the fourteen lions and an animal with an elongated body that could be a lion or a mustelid.

Today, we know more about this panel, as well as about the cave and its art. Sophistication and expertise are the words that most readily spring to mind to describe it. To the right is a pride of eager, tense male and female lions hunting bison (when after big game, males join the females in the hunt). For whatever reason – myths, perhaps, or special rites – the panels were carefully thought out so that the recess was their focal point. The constant recurrence of details and motifs (for example, the ears of the rhinos or the eyes of the lions) suggests that most of the art was the work of a single person – or at least a group working under one great artist.

The techniques used were simple but effective: charcoal for the blacks, haematite for the reds, plus occasional engravings. The shading inside the heads or bodies was done by spreading the pigment by hand or with a piece of hide.

Two of the animals most commonly found in this cave – lions and rhinos – are found only rarely elsewhere. Why this should be became clearer once we got radiocarbon dates from some of the drawings and from the charcoal on the ground: the cave contains work from two distinct periods, one around 26,000–27,000 years ago (Gravettian) and the other around 31,000–32,000 years ago (Aurignacian). Most of the works seem to belong to the earlier period, a period when animals such as lions, rhinos, mammoths and bears played a particularly important role in beliefs and ritual practices.

The discovery of Chauvet Cave has changed our conception of the evolution of art. For most of the 20th century, specialists believed that art originated in the Aurignacian period with crude figures and slowly improved until it reached the apogee of Lascaux, less than 20,000 years ago. Yet now we know that, at least as early as the Aurignacian, great artists were at work and had mastered most of the techniques and artistic concepts that would make Palaeolithic cave art famous.

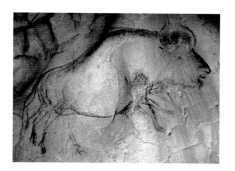

Above
A bison in the Recess of the Horses, its bulky proportions and characteristic gait perfectly captured.

A Giant Leap for Art

The Mycerinus Triad, Artist unknown

TOM PHILLIPS

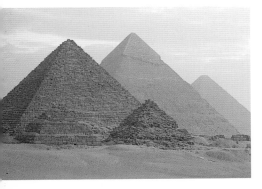

Above
The giant pyramids at Giza, seen from the
south. From left to right: Mycerinus (with
two of its three Queens' Pyramids), Chephren
and Cheops.

c. 2532–2504 BC
Greywacke
63 cm × 47 cm / 2 ft 1 in. × 1 ft 6½ in.
From the pyramid of Mycerinus, Giza, Egypt,
now in the Egyptian Museum, Cairo

Even if you have never seen in actuality the endlessly pictured pyramids of Giza you will know they come in different sizes. Most people can identify the largest, that of Cheops, and some that of Chephren: few, however, could put a name to the third and smallest. The pyramid of Mycerinus is dwarfed by those of his predecessors, yet it was in its complex that, just a hundred years ago, a group of triadic sculptures was unearthed. They mark for me a vital instant in the history of art, when virtuality and virtuosity achieved union in new-minted perfection.

Of the four intact examples, three are in the great Egyptian Museum of Cairo, whose arrangement, as I saw it a few years ago, recapitulated somehow the experience of exploration. Its sparse labelling, and absence of hectoring panels to preempt or condition personal reactions, left the visitor to make his or her own discoveries. And this was mine. In the dusty daylight of the huge display, reminiscent in atmosphere of a sculptor's studio, I found myself face to face with this particular triad, the most intense of the set. In an epiphanic moment I imagined its commandingly energetic figures, as if impatient of the artist's slow and arduous craft, bursting from the stone of their own accord, eager to show themselves to the world they ruled.

Mycerinus, God on Earth, leads the way with the goddess Hathor on his right and the demi-goddess of the Cynophilite *nome,* the region of the jackal, on his left. Even without the crown of Upper Egypt, Mycerinus would be the tallest with Hathor next in height; the minor goddess is appreciably shorter than either. The rules of size are strict, which does not pose a great problem for the sculptor but prevents perspective being of any use to the Egyptian painter who has to develop an alternative code for his version of reality. (People still assume that such artists did not understand perspective, could not 'do' it – as if they simply had not noticed that a figure far away appears smaller than one close by.) The only limitation this puts upon the sculptor is to urge him to keep to frontal images, thereby ensuring certainty as to who the most important is in any group, and also guaranteeing that no god turns his back on us. An artist of genius, like the Mycerinus sculptor, will turn this constraint to his advantage by investing frontality with the frisson of confrontation.

Status is indicated literally from top to toe since the feet also conform to and confirm the relative station of each. The king moves confidently towards us, his left leg forward in the pose that was to become fixed for many centuries as the convention for the upright male figure. Hathor also advances, though her front foot is slightly behind the back foot of Mycerinus. The minor deity knows her place and keeps her feet together in the passive stance customarily used for depicting female figures. All is therefore exactly as it should be, and yet the artist has brilliantly managed to convey an advancing thrust of the group as a whole.

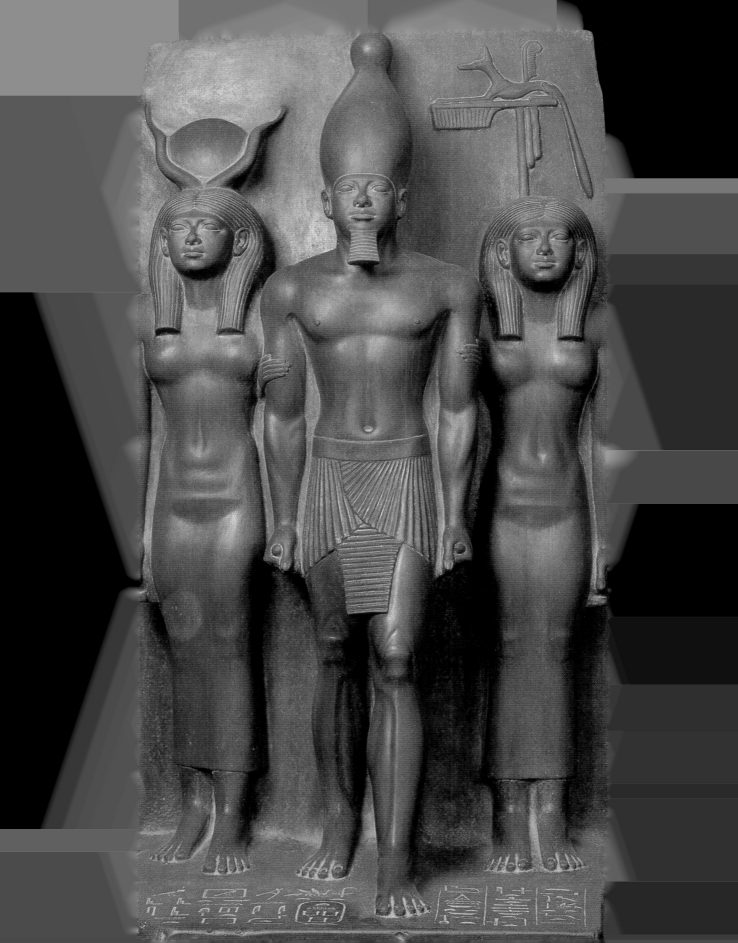

The command of human anatomy is especially impressive when one realizes how sparing the artist has been with detail in order to convey the idea of a supremely athletic young man: much animation is achieved by subtle shifts of plane and much power conveyed without a catalogue of bulges. The female figures are dressed in identical and improbably figure-hugging linen shifts. This allows for yet further simplification, concentrating on the all-important attributes of fertile readiness in the high ripe breasts and deep pubic triangle.

Portraiture plays little part in the sacred sculpture of the Old Kingdom. Enough characterization is given to distinguish one pharaoh from another by selecting one or two features that, so to speak, depart from the standard model. Here Mycerinus is identified by a roundness of face and an atypical snub nose. The attendant deities take their physiognomical cue from the God on Earth, with only mildly feminized versions of the face that for his reign would stand as the iconic ideal. In all likelihood it was the maker of this carving who devised the definitive image of Mycerinus for others to imitate.

After my initial shock of admiration for this work, a second amazement was to realize its age and to think how much of the business of art, of material facture, iconographic coherence, mathematical structure, anatomical sophistication and sheer elegance had been so soon summated in a single work. It almost calls for capital letters to state that it was made 4,500 years ago.

Even in the context of the huge time span of ancient Egyptian art it is an early work dating from only the fourth dynasty. It is therefore one of those vanguard artefacts that at key moments in the history of art asks the question, 'Having proved that we can do everything, what is there now to do?' The question is tied to that most elusive of concepts, realism. For its original audience it may have seemed on the verge of magical, a proto-Pygmalion phenomenon where one more inch of reality would threaten to make the whole thing (like the statue of Hermione in Shakespeare's *The Winter's Tale*) come alive.

In the great museums of the world Egyptian sculpture occupies as substantial a place as that of ancient Greece, yet, whereas Greek sculpture has always been revered as art and has been devoutly copied and drawn by generations of students, work of Egyptian sculptors tends to be regarded as of more historical than aesthetic interest. It is held to be exotic and, with its outlandish gods, alien. The iconography of the gods of Greece and Rome is well known as an antidote to the drabber Judaeo-Christian pantheon. Their names (Venus, Mars, Dionysus, etc.) are still usefully invoked. Greek artists are often identified by name even if, like the work of Zeuxis and Apelles, nothing from their hand survives.

The maker of this triad remains anonymous and as in almost all Egyptian art left no signature or identifying mark. It is a silly myth that, as I was brought up to think, in ancient Egypt even the leading sculptors were regarded as mere artisans. As well as being part of a necessary intellectual elite they were important to the state as chief creators of prestige, and artificers of what we now call public relations. No doubt there were officials to mediate between palace and studio. One imagines some high clerk of works

discussing with the sculptor what was needed. Could his workshop elicit from a single piece of stone an amalgam of benign nobility and warlike energy? Could he achieve an expression both stern and smiling, and could he, while of course featuring all the necessary attributes, add a sense of the erotic? And furthermore could he do all this in a new and forceful style? Luckily the official would be talking to the only person who, with a glance at his assistants, could cheerfully nod in assent.

… I imagined its commandingly energetic figures, as if impatient of the artist's slow and arduous craft, bursting from the stone of their own accord …

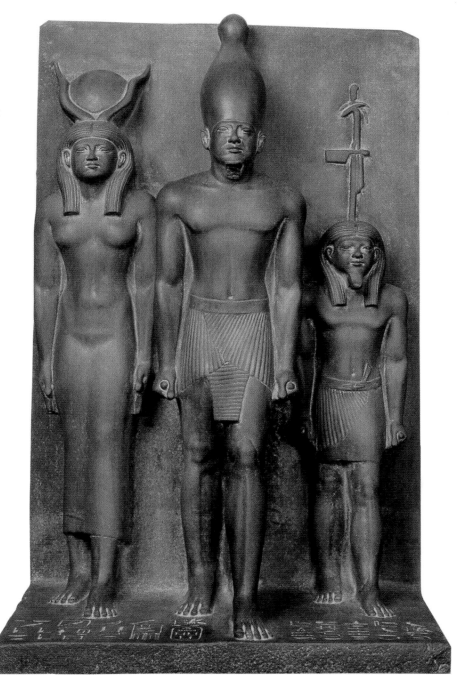

Right
In this triad, Mycerinus and Hathor are accompanied by a figure representing a *nome* (district of Egypt), identified by the symbol above its head.

The Immortal King

Olmec Colossal Head 8 (Monument 61), Artist unknown

MICHAEL D. COE

> *The frown at the top of the nose, the carefully delineated eyes, the flaring nostrils ... impart a sense of authority tempered with dignity and even serenity.*

1500–1200 BC
Basalt
H 220 cm × W 160 cm × D 165 cm /
7 ft 2½ in. × 5 ft 3 in. × 5 ft 5 in.
From San Lorenzo, Veracruz, Mexico,
now in the Museo de Antropología,
Xalapa, Veracruz, Mexico

The Olmec culture of south-eastern Mexico, dating to about 1500–400 BC, is the oldest complex culture of Mesoamerica, and is widely admired for its gigantic stone portrait heads, of which seventeen are known. Ten of these were found at the site of San Lorenzo, a massive, partly artificial plateau rising some 50 metres above the surrounding swamps and farmland. On this mesa was constructed Mesoamerica's first urban complex, not of stone, but of earth and clay.

Monument 61 was excavated from San Lorenzo in 1970. Almost all Colossal Heads, whether here or at other Olmec sites, have been discovered out of their original context: moved by post-Olmec peoples, or else eroded out of their original positions into ravines. In the case of Monument 61, it was deliberately buried before about 1200 BC – fortunately, since almost all recorded San Lorenzo monuments (stone thrones, sculptures of gods and man) were savagely mutilated or broken in about 900 BC, when the site fell into ruin. In contrast, Monument 61 is pristine.

Though not the largest of the Colossal Heads, Monument 61 is enormous. Probably weighing almost ten tons, it was carved from a basalt boulder that had been found on the slopes of the Cerro Cintepec, a volcanic mountain some 50 kilometres (30 miles) north-west of San Lorenzo. It would have been brought to the base of the plateau by river and seacoast on a huge raft of balsa logs, then hauled up to the top of the mesa by ropes and log rollers. This was a people without the wheel or draught animals, and completely bereft of metals. The precision and beauty of its carving is astonishing, considering that basalt has the hardness of jade, and all work had to be carried out by stone-on-stone hammering, pecking and grinding.

Like all others of its kind, this Colossal Head is the portrait of a king. On his head he wears what surely was a protective helmet. A strap at its base has a repeated low relief of either a claw, or (more likely) the beak of a raptorial bird like an eagle, perhaps representing this unknown man's personal name. His facial features, sculpted with utmost sensitivity and with a full understanding of muscular anatomy, convey an overwhelming impression of pure power. The frown at the top of the nose, the carefully delineated eyes, the flaring nostrils, the slightly open mouth and full lips, impart a sense of authority tempered with dignity and even serenity. There can be no doubt that this was a renowned Olmec potentate at the very dawn of Mesoamerican civilization.

It remains a mystery as to why this magnificent portrait was 'decommissioned' by being deeply buried shortly after the inception of San Lorenzo as the capital of a powerful state. The lack of mutilation suggests that this act marked not a dynastic overthrow, but a more peaceful passing of power. Regardless of what occurred almost three and a half millennia ago, one of the great masterpieces of antiquity has been preserved for us in all its glory.

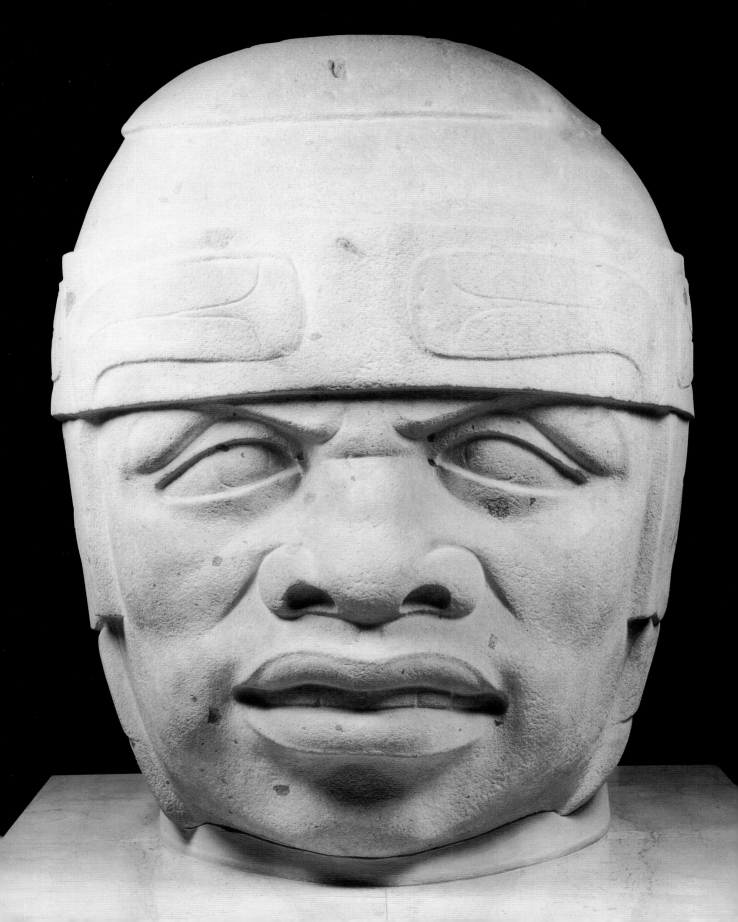

An Unfair Battle

Ashurbanipal's Lion Hunt, Artist unknown

JULIAN READE

... this is not a real hunt ... but a ritual in which the lions symbolize the forces of evil against which the king is pledged to protect his people.

I n 646 BC **Ashurbanipal,** king of Assyria, commissioned a new palace for his great capital city of Nineveh. The existing royal palaces, built by his grandfather Sennacherib, were beginning to show their age, but Ashurbanipal had at least one additional motive: he wished to commemorate his own achievements, as he had just completed two successful wars. One had brought Babylon back under Assyrian control. The other had culminated in the sack of Susa, a long-time rival in southern Iran.

In many ways Ashurbanipal's new palace was a traditional structure. Most of the walls were made of sun-dried brick, protected at the base with alabaster panels. The panels in the main rooms were carved in low relief and then, probably, brightly painted. Many carvings celebrated Ashurbanipal's triumphs as a military leader. One group of rooms, however, illustrated another facet of the king's personality – his role as a Mighty Hunter before the Lord, killing lions.

The theme of the Royal Lion Hunt was well established in the ancient Middle East, going back to before 3000 BC. The Assyrian royal seal itself represented the king in single combat with a lion. Most of these scenes were relatively simple, showing just one dramatic moment in the struggle between man and beast. In Ashurbanipal's palace, however, the subject occupies long stretches of wall, and the designer responsible for the work was one of the most imaginative ever to work at the Assyrian court. The drama of Ashurbanipal's Lion Hunt unfolds, like a film moving through time and space, along a wide corridor that connected the domestic quarters with a private gateway.

In a first episode the king's chariot is in a screened enclosure. Armourers attend to the royal weapons, busily checking the condition of bows and arrows. Grooms fasten the chariot horses in position. One horse stands wide-eyed but motionless as the groom tightens its harness; another shies away snorting, well aware of the dangers to come. There is a contrast between the anxious bustle of the attendants and the dignity of Ashurbanipal himself, who stands upright in his chariot, wearing an enormous hat. The king reaches out one arm to receive his weapons. This contrast – between the dispassionate attitude of the king as supreme hero and the mundane chaos surrounding him – grows wider and more prominent as the story proceeds.

While the king prepares for battle, the lions are brought in cages to an arena ringed by soldiers. For this is not a real hunt in which the king has to

Above
This small version of the royal seal shows the king gripping a lion's mane and stabbing it through the heart. Probably lions killed in this way had already been disabled. (8th–7th century BC, 2.5 cm high, British Museum)

Opposite
Ashurbanipal, magnificently bearded and wearing the royal uniform of tall hat and embroidered clothes, calmly draws his bow as he is driven in a chariot round the arena. The man beside him, represented as shorter and therefore less important, is his driver.

645 BC
Alabaster
c. 160 cm × *c.* 2,700 cm / *c.* 5 ft 3 in. × *c.* 90 ft
From Nineveh, now in the British Museum, London

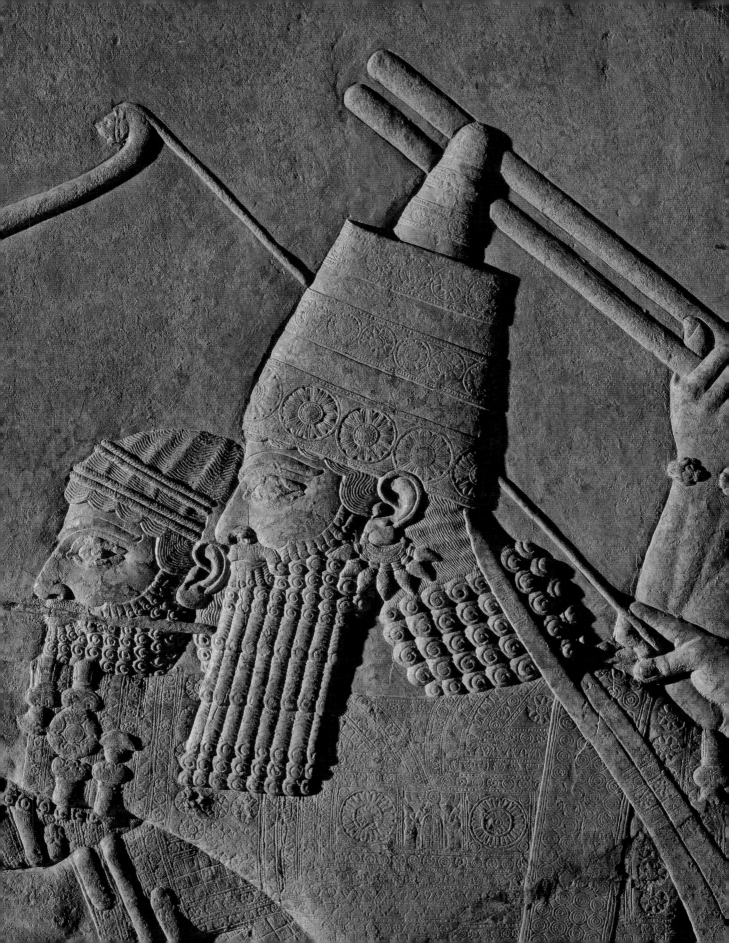

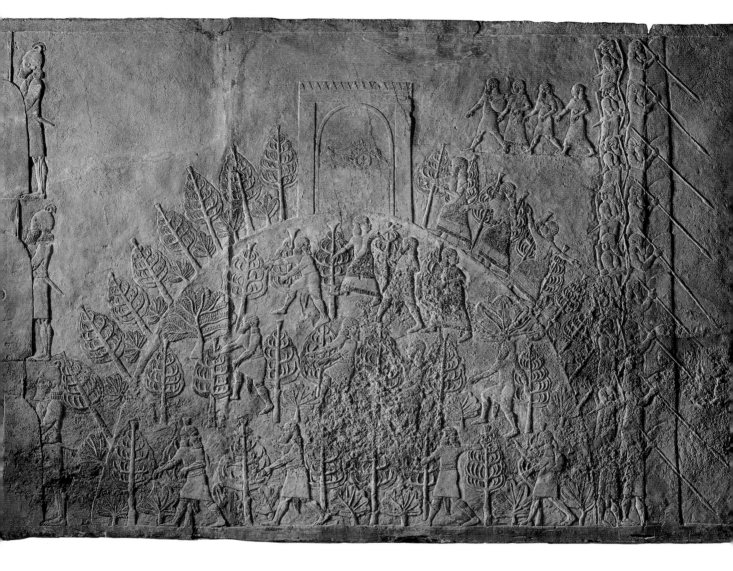

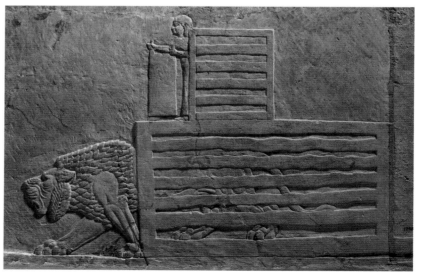

Above

As the king rides to and fro, soldiers stationed
around the arena prevent the lions from
escaping, but spectators are still frightened.
Here a panicky crowd is running into a wood
and climbing a low hill, which is itself crowned
with a monument showing a royal hunt.

Right

A lion is brought to the arena in a cage.
A child releases the animal by raising a
trapdoor, and can take refuge in his own
smaller cage on top if the lion turns on
him instead of attacking the king.

search for lions, but a ritual in which the lions symbolize the forces of evil against which the king is pledged to protect his people. Then he rides out in his chariot, accompanied in the cab by a driver and two guards holding spears; horsemen gallop around to assist. The lions are uncaged one by one. Crowds of spectators rush up a hill for a good view, or panic in case a lion escapes.

There are three separate episodes of the king performing. In one of them he is holding the bow, imperturbably shooting the lions down. We see his arrows loose in the air. The lions collapse as they are struck again and again. A wounded lion identifies its adversary and springs at the back of the cab, but the guards repel it. Then another lion throws itself at the chariot, and grabs a wheel; the king hands his bow to one of the guards, takes a spear instead, and drives it into the lion's head. A third lion succeeds in grabbing the back of the cab, but the king and his guards turn to dispatch it.

So the king triumphs, as usual. Good has defeated evil, the universe is as it should be. The sculptors have created a set of images that conform entirely to Assyrian requirements, showing the king supremely calm and the lions comically contorted in their death throes. That is how the Assyrians would have viewed these scenes, and they would have continued to do so until enemy forces overran Nineveh in 612 BC and left the place in ruins. Gradually the alabaster panels were buried under the crumbling brick walls, and the paint, if there ever was any, faded completely away. Ashurbanipal's palace was forgotten until 1853, when the Lion Hunt panels were discovered by the archaeologist Hormuzd Rassam, who promptly sent them to the British Museum in London.

Then something strange happened. The panels arrived in a city where pompous Oriental monarchs were regarded with some contempt, but where animal paintings with anthropomorphic connotations were all the fashion (1851 had been the year in which Sir Edwin Landseer completed his *Monarch of the Glen*). This sentimental attitude to wild animals is still common today. So, in the eyes of many modern viewers, Ashurbanipal the lion hunter is not a hero but a brutal stereotype. The dying lions, instead of being the evil enemy, are tragic persecuted victims. It has even been suggested that the designer and sculptors responsible for Ashurbanipal's Lion Hunt were foreigners or prisoners, who despised their Assyrian masters and deliberately made the lions into sympathetic figures.

There was no scope in ancient Assyria for interpretations of this kind, but the artists can legitimately be praised as masters of dramatic tension, as close observers of nature and as brilliant exponents of representational art. At the same time the grand sweep of the composition is balanced by close attention to detail and exquisite workmanship. So the sheer quality of Ashurbanipal's Lion Hunt means that it can be appreciated, like a painting of animals in Chauvet Cave, regardless of its exact original significance. The viewer, constantly discovering new felicities, can enjoy this masterpiece for its own sake.

Staring into the Future

The 'New York Kouros', Artist unknown

JAŠ ELSNER

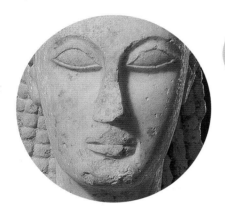

' *… with half-smile and a stare at once intense and far away, he gazes …. Where are you looking, marble man?*

Feet firmly planted between movement and rootedness, he simultaneously stands and walks. Crisp-cut, almond eyes, such beautifully bobbled hair patterned against the skin-smooth stone of flesh. Naked, but for that headband so deliciously tied and the choker with its knot before his neck. Muscles marked, precise, not natural but the sign of what it is to be a man. Not sexualized but archetypally male, hands resting by his side or almost tensed for action, with half-smile and a stare at once intense and far away, he gazes out of archaic eternity.

Where are you looking, marble man? Do you catch the glance of the passers-by who admired your manhood once, in ancient times, and mourned the lost youth above whose Attic tomb you stood or walked in the early years of Greece? Or do you look at those who now observe your marble finish as they saunter through the stone galleries that hug the east side of the park? What do you see, stone aristocrat of Greece? The dying world of heroes, kings and mythic monsters, whence you came? The democratic future when stone would be smoothed to look like flesh and statues really seemed to walk, when kings were overthrown and myths made subject to philosophy? Or the chaos of New York where you have come – another immigrant to the melting pot, to be the Ancient Greek amidst the teaming millions?

Brave youth caught in the morning of the world, poised naked at the cusp of adulthood, your standing walk seems, motionless, to span the whole expanse of what is past, and passing, and to come.

Above
The taut skin of the face betrays not a single mark of age. Is this eternal youth a funerary monument to a young aristocrat?

c. 600–575 BC
Marble
H 184 cm / 6 ft 0½ in.
From Attica, Greece, now in the
Metropolitan Museum of Art, New York

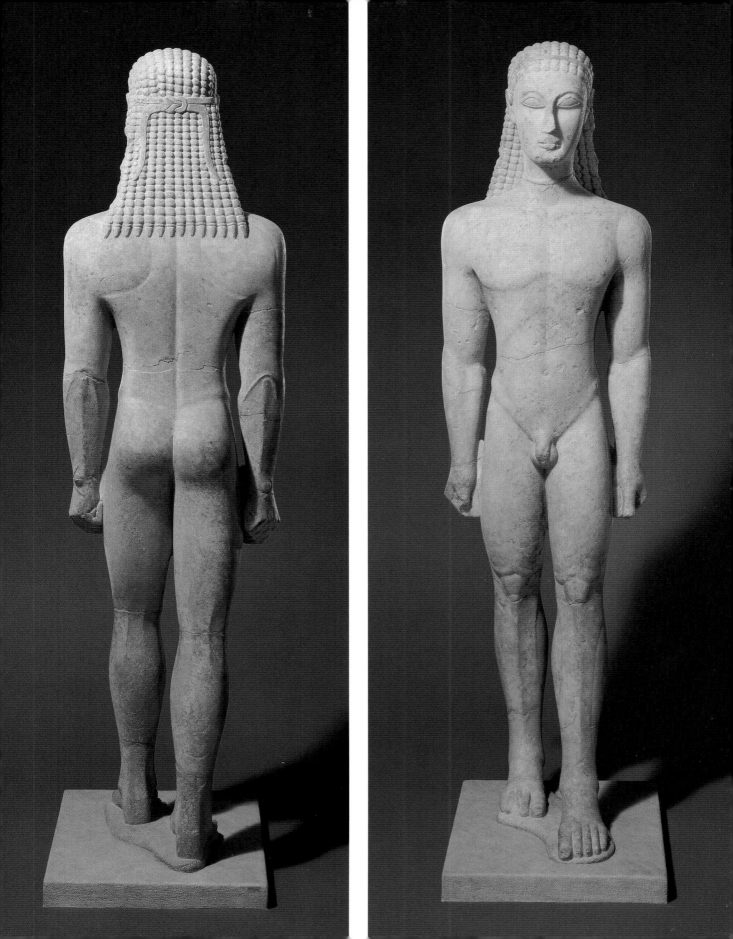

The Art of Power

500 BC–AD 1000

The Greek Diaspora

The 'Seven Against Thebes' Relief (Tydeus and Capaneus at the Siege of Thebes), Unknown Etruscan artist

GIOVANNI COLONNA

The 'Seven Against Thebes' saga relates the tale … of a siege of the city of Thebes by an army led by seven men.

Above
Partial reconstruction of the original polychromy (elaboration by Barbara Belelli Marchesini), using different shades of the four main colours (red, black, white and yellow); in addition, light blue was originally used for decorative motifs and details, such as the volute pattern on Tydeus' greaves.

Opposite
Tydeus' and Capaneus' deeds in the siege of Thebes: above, Zeus (left) confronts Capaneus, and below, Tydeus (behind) struggles with Melanippus.

470–460 BC
Terracotta
132 cm × 137.5 cm / 4 ft 6 in. × 4 ft 4 in.
From Temple A, Pyrgi, now in the Museo Nazionale Etrusco di Villa Giulia, Rome

Among the many masterpieces exhibited in the Museo Nazionale Etrusco in Rome, the high-relief terracotta plaque from Pyrgi showing two episodes from the 'Seven Against Thebes' saga stands out not only for its historical and cultural significance, but also for its technical perfection. Depicting a scene set in the remote world of gods and heroes from a cycle popular throughout Greece and philhellenic Etruria, it has been described by O. J. Brendel as 'one of the most spectacular discoveries of Etruscan art in recent time' and by Bianchi Bandinelli as 'the most important example of Etruscan art corresponding to the Greek "Severe Style"'.

The relief was discovered in fragments (partly due to ploughing) between 1956 and the early 1960s near Santa Severa, in a field next to the ancient harbour of Caere, some 50 kilometres (30 miles) from Rome along the Aurelia road. The excavations brought to light a huge sanctuary, almost certainly the one Greek authors described as being dedicated to the goddess Leucothea. This sanctuary was so wealthy that in 384 BC it was plundered by Dionysius the Elder, tyrant of Syracuse. The plaque belonged to the most monumental building at Pyrgi (today known as Temple A), and was originally placed at the top of its rear pediment, which overlooked the main entrance to the sacred area. Both the plaque and the temple can be dated to 470–460 BC.

After being modelled in terracotta, the plaque was cut into two pieces in order to make transportation to the kiln and the firing process easier. It was then fixed to the end of the ridge-pole (*columen*) of the temple with twelve bronze nails. The two lateral beams (*mutuli*) also bore terracotta plaques showing other episodes from the 'Seven Against Thebes' cycle; however, the small number of surviving fragments makes reconstruction of these impossible. The temple stood until the foundation of the Roman colony of Pyrgi around 270–260 BC, when it was dismantled and the three terracotta plaques were hauled down and were carefully buried together with the many terracotta revetments that had protected and decorated the roof of the building.

The plaque is about the same size as a metope from a great Greek temple such as the Parthenon, where each metope usually includes two or three figures. Here, however, there are six figures, represented at three-quarter size. The master-sculptor has taken full advantage of the technical qualities of clay, grading the depth of the figures from the almost flattened details at the lower level to the full relief of the heads. He also has carefully arranged the whole composition by placing the two foreground figures lying on the floor while the others stand in different poses in the background. This creates the illusion of two different superimposed registers. However, all figures rest on the bottom frame of the plaque, unifying the scene in a single time and space. The high relief is without precedent, and has been modelled entirely by

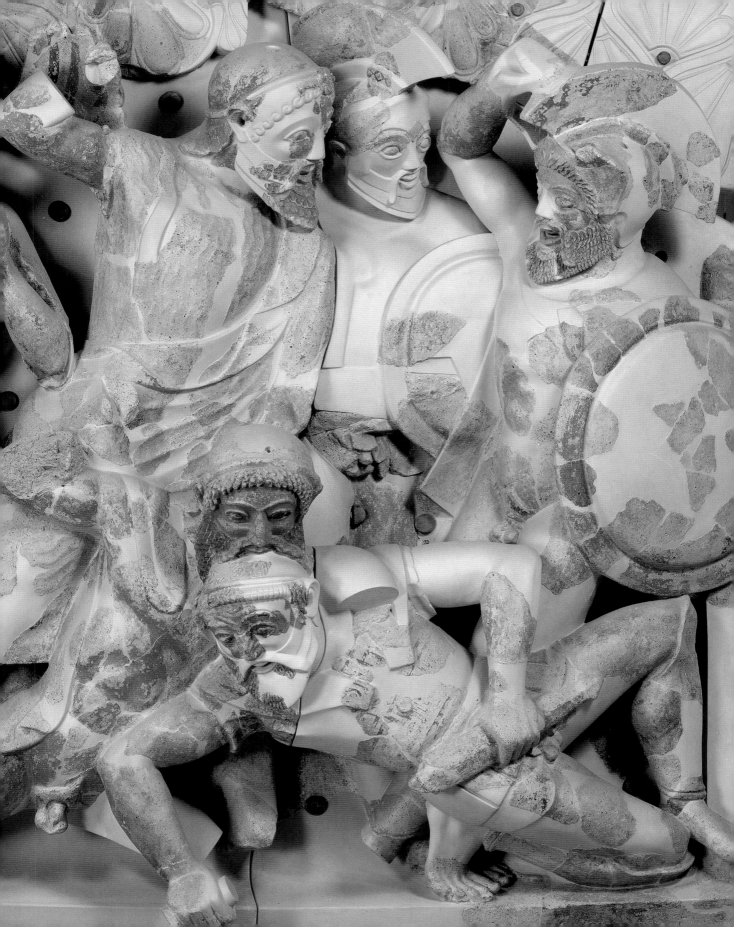

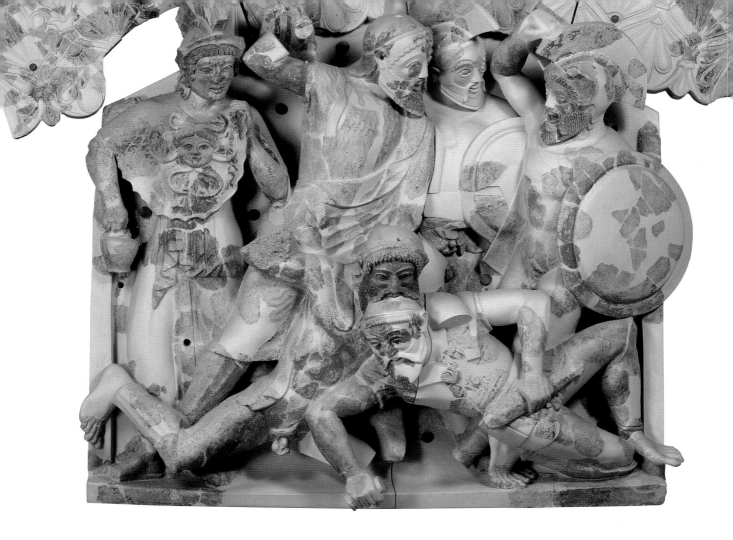

Opposite

Front view and two sections of the same relief (drawings by Barbara Belelli Marchesini). The relief was brought to light in the excavations of Pyrgi by the Sapienza University of Rome, under the supervision of Massimo Pallottino and Giovanni Colonna.

hand, following a preliminary sketch on the surface of the plaque. No one had ever been able to superimpose high-relief terracotta figures so that they could overhang by almost a quarter of their height – a decision that would have involved great difficulties and risks during the firing process.

The 'Seven Against Thebes' saga relates the tale (popularized by a play produced by Aeschylus in 467 BC) of a siege of the city of Thebes by an army led by seven men. The saga culminates in a battle that pits two brothers, Eteocles and Polynices, against each other. Apart from the final fratricide, the Pyrgi relief scenes feature the most defiant and feared chiefs of the assailants, Tydeus and Capaneus. Tydeus is shown in the lower register, locked in a fight to the death with his Theban opponent Melanippus. They have both been mortally wounded by javelins and lie stretched across the entire width of the plaque; their bodies are interlaced, forming a wavy line. Tydeus drags himself beyond Melanippus and seizes his neck; at the same time he hauls up his right arm holding a sword (which has not survived). Melanippus tries to draw his weapon out of the sheath, but to no avail. The intention of Tydeus is not to bite but to break his enemy's skull in order to eat the brain. Greek morality had rejected the practice of cannibalism of defeated enemies centuries before. In the corner of the plaque we see the goddess Athena, who bears

a jug of *athanasia* – the potion that could make her beloved Tydeus immortal. However, because of his act of cruelty, Athena leaves the scene disgusted and Tydeus will die.

The middle and the right side of the upper register depict the deeds of another of the Seven, Capaneus. The protagonists are Capaneus, who has just claimed that not even Zeus could prevent him from scaling the walls of Thebes, and Zeus himself. Man and god face each other – with a Theban warrior (probably Polyphon, who according to Aeschylus fought Capaneus) cowering between them – and Zeus raises an arm to throw a bolt of lightning (now lost) and punish Capaneus for his hubris. The head of Zeus and the juxtaposed heads of Capaneus and Polyphon mark the vertical axis of the scene; Capaneus opens his mouth in an expression of pain; his hair raised, he begins to fall back, hauling up his sword in vain.

In terms of iconography, the work is highly original from both a Greek and an Etruscan perspective. The representation of the dying Tydeus and Melanippus is unique, whereas the denial of immortality to Tydeus and the electrocution of Capaneus do appear elsewhere in later works. As regards the selected episodes, the commissioning authority and the master-sculptor took inspiration from ancient literary sources other than Aeschylus' play: for instance, the lost epic poems of the Theban cycle. The crime of Tydeus may be derived from a lost epic-lyrical poem by Stesychorus, while the denial of immortality to him was possibly suggested by poetry in praise of Athena by Bacchylides (also lost). The main theme at Pyrgi Temple A, however, was strictly linked to the political situation of the time: Caere had just got rid of the tyrant Thefarie Velianas, the friend of the Carthaginians who worshipped the goddess Astartes. Soon after the unsuccessful Etruscan attack on Cumae, the polis was under constant threat of attack by the Syracusans until Pyrgi was sacked by Dionysius the Elder, as told above. The same theme is represented in Aeschylus' play: the censure of hubris (the tyrants being the personification of wantonness and insolence), and the hope of recovering good morals and respect for the divinities.

The modelling of naked bodies and the rendering of expressions, such as the perplexity of Athena and the fighting enemies grinding their teeth, invite comparisons with the early Greek Severe Style (most obviously with the painting of Polygnotus), in spite of the archaic rendering of drapery, eyes, hair and beards. However, it is the moral inspiration permeating the whole work that lifts it above archaism and makes the relief a unique monument in Etruscan art.

Beauty from the Sea

The Ludovisi 'Throne', Artist unknown

ROBIN OSBORNE

A woman rises up, her lower body concealed behind a thick cloth held by two flanking female attendants. They steady her movements with hands gently placed behind her shoulders. She turns her head sharply to her right, displaying a fine profile, a keen gaze, and modestly closed lips. Her hair, prepared for this special occasion, is tied with a headband that pulls it back to reveal the top of her ear. The delicate fabric of her clothing (a chiton) clings sufficiently to her body to reveal the contour of her breasts, the structure of her ribcage, and a slim belly.

Damage to the gable of the relief has left the flanking figures headless, but their bodies tell both of their gender and of their intent concern for the woman they attend. Closely parallel in their stance, these two women are nevertheless distinct. Both wear garments whose overfold removes their upper bodies from prying gaze: the figure on the left wears a side-fastened woollen peplos, that on the right a linen chiton pinned along the arms and at the shoulders. These garments fall quite differently from one another over legs whose lines are revealed by the disturbance to the fall of the folds. Bare feet upon pebbles hint that it is from a pool or the sea that the central figure rises, and provoke curiosity about the body concealed by the cloth screen the attendants hold up.

But these three are not the only female figures on this object, for at either end is a woman seated on the ground. One, wearing sandals, sits on a stiff cushion, heavily cocooned in a cloak (*himation*) pulled up to veil her head. From a box in one hand she feeds fragrant grains into an incense burner that stands before her. The softness of the cushion on which the other woman sits corresponds to the softness of her young and naked flesh; legs crossed, hair bound up in a scarf, she plays the double pipes. The contrasts between the two ends of this 'throne' are marked – clothed against unclothed, music against perfume, pleasure against duty. Framed by these figures, the figures in the main scene invite the viewer to grasp their sensuous distinction: we desire to touch these bodies, hear these voices, smell the sea and the scent.

What are we to make of this array of women? In Greek myth various female figures disappear into or emerge from earth or sea. Their stories are ones of sexual desire: Pandora, the first woman, fashioned from earth to attract male attention; Persephone, taken off to the underworld by Hades to be his wife and released for a season every spring; Aphrodite, born from the sea foam. Yet these are three females of quite different character: Pandora, wily and source of troubles, Persephone, an innocent young daughter close to nature, Aphrodite, smiling charmingly and bent on seduction. Whichever figure we take to be central here – and this is another competition in which it is hard not to vote for Aphrodite – the exploration in the five figures of what

... we desire to touch these bodies, hear these voices, smell the sea and the scent.

Opposite
The central figure, rising from the sea, probably represents Aphrodite. The unusual treatment of her clothing not only reveals the contours of her body but emphasizes the effort as she stretches up her arms.

470–450 BC
Marble
Original H 108 cm / 3 ft 6½ in.
Now in the Palazzo Altemps, Rome

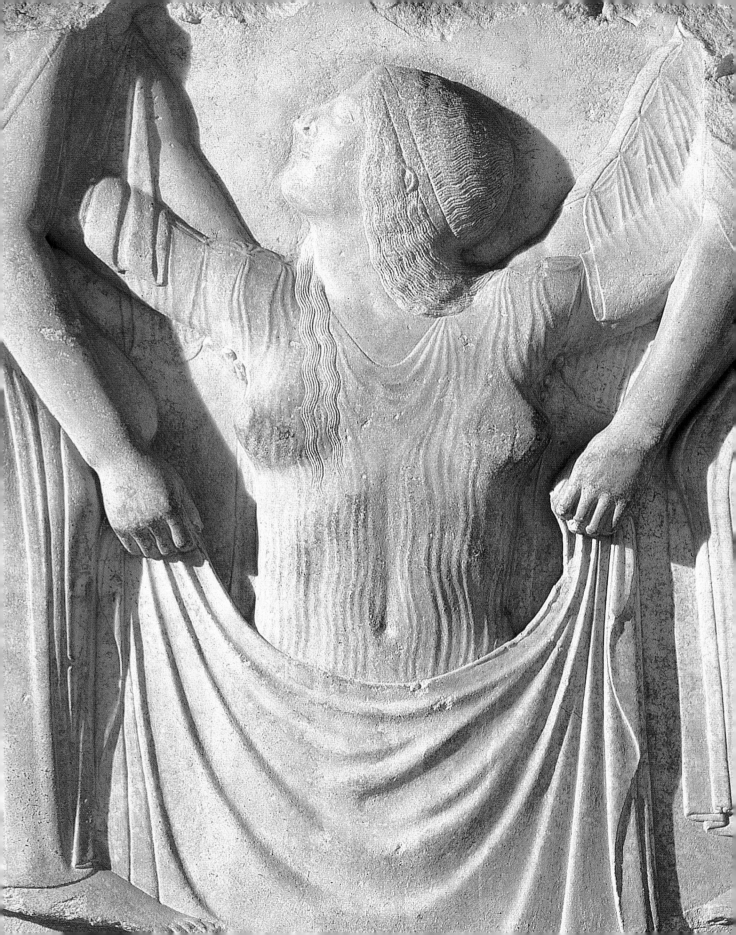

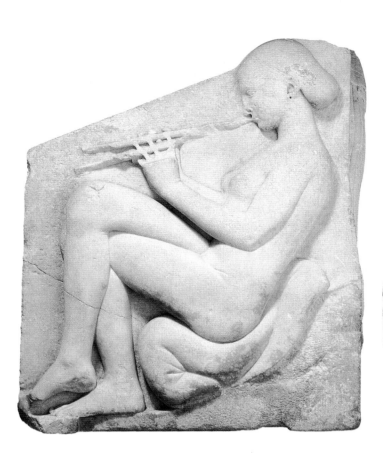

> *The attractions of the Ludovisi 'Throne' derive not merely from its beauty and indisputable eroticism but also from the enigma that surrounds it.*

it is to be female runs the whole gamut of these choices. The sculptor offers us the full range of ways in which women present themselves, with nudity and veiled modesty only the extremes.

The attractions of the Ludovisi 'Throne' derive not merely from its beauty and indisputable eroticism but also from the enigma that surrounds it. Although known to have been excavated in 1887 in Rome, in the grounds of the Ludovisi Palace and most probably in the area that in antiquity was the Gardens of Sallust, the precise site at which it was found is variously recorded. When it was first published, no other object of this form was known and the piece was identified as a throne for a cult statue. But without seat or legs it seems more likely to be a fender of some sort – but what sort, and from where? For this cannot have been an object made in Rome: its style identifies it as Greek and from the 5th century BC.

The most plausible original provenance is Locri Epizephyrii in southern Italy, a Greek city well known archaeologically for its cult buildings and associated reliefs of sacred scenes of a date and style closely akin to the style of the 'throne'. Locri's rich cultic engagement with women, known both from

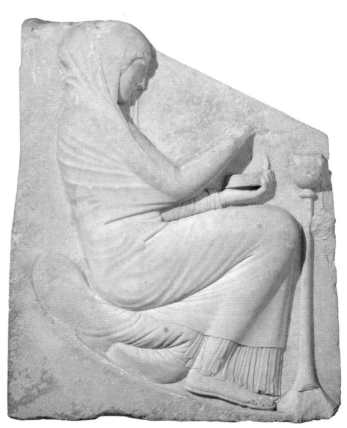

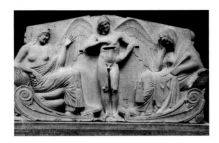

archaeology and from ancient texts, offers a space in which the associations
of the imagery are most resonant. A possible site at which the 'throne' could
have been used as a balustrade around a sacred pit has even been identified.

Just two years after the first scholarly publication of the Ludovisi
'Throne' in 1892 another 'throne' came to light and was quickly bought by
an American collector and given to the Boston Museum of Fine Arts. Made
from the same Greek island marble, and with similarly contrasting characters
(a heavily draped old woman and a naked younger figure) on the two ends,
this appeared to be the twin of the Ludovisi 'Throne'. Its main scene showed
the weighing of souls to determine their fate, and between them the two
'thrones' appeared to cover life and death, female and male. But the carving
and iconography of the Boston 'Throne' are dubious: is it a modern forgery?
A work of the 5th century BC originating from the same place as the Ludovisi
'Throne'? Or a Roman copy of a genuine 5th-century work? The confidence
with which we can embrace, or dismiss, complex theological interpretations
of the Ludovisi 'Throne' depends upon these, currently unanswerable, ques-
tions. But the beauty of this enigmatic object does not.

Men of Mystery

The Riace Bronzes, Artist unknown

ROBIN OSBORNE

> *The urge to bring these statues to life is irresistible.*

Above
The fine observation of the human body is manifested in the way these figures stand, as well as in details (the veins of the hand) and skin textures.

Opposite
The slightly downcast gaze of Warrior B combines with a body less fit than it once was to give an impression of reflective melancholy.

Mid-5th century BC
Bronze
Warrior A: H 198 cm / 6 ft 6 in.
Warrior B: H 197 cm / 6 ft 5½ in.
Found off Riace Marina, Reggio Calabria, Italy, now in the Museo Nazionale della Magna Grecia, Reggio Calabria

They stand with left leg advanced, and swing their torsos to place their weight on the straight right leg. On their left arms they carry what is now sadly just the strap-handle of the heavy hoplite shield. The fingers of the right hand curl round a missing spear. Something has caught the attention of each, as a turn of the head signifies. Described like this, these are brothers.

But even the most superficial glance shows these warriors to have few common genes. The straitjacket of a common pose is only the basis for an exploration of how different men can be. Warrior A is quivering with taut life. His skin pulls tight over firm flesh. Look at his buttocks. Prominent and firmly rounded, these point to a mature man whose life is dominated by hard training. Age has certainly thickened him up from the days when he was a wiry youth, but there is not an ounce of this body weight that cannot be put to work, whether in the games or in the field of war. He is proud of his condition – as proud to show it off in his springing curls and luxuriant beard as he is in his firm martial stance. Something catches his attention and he springs to life to confront it: no one can doubt that he is looking at them.

Life impinges more slowly on Warrior B. He is somewhat listless, not sure that what is going on in the world is worthy of his attention. He hasn't been sure for some time, nor that going to the gymnasium is worth his while either. He has put on some weight and doesn't feel as lively as he once did. In an idle moment he notices how many veins now trace their progress across his torso, his hands, his feet. He realizes that he has lost the firmness he once had; the flesh lies thin and slack. Rather like his beard and hair. It is still a beard to boast about, but it doesn't have the same spring it once had, and the sweat on the brow too easily plasters down the curls upon the forehead.

The urge to bring these statues to life is irresistible. When they are viewed side by side the temptation to compare and contrast quickly turns into a need to explain difference. The impression that these two have been caught at a particular moment stimulates our desire to tell the story of past moments, to construct a life history. Ever since their chance discovery by a scuba-diving holidaymaker from Rome in the sea off Riace Marina in Calabria on 16 August 1972, these statues have been attracting stories. In one reincarnation they have taken the place of the saints Cosmas and Damian as the patrons of Riace; in another, Warrior A has acquired an active heterosexual life in the world of the Italian pornographic comic. A survey by sociologists found that Warrior A appealed to heterosexual visitors to the museum in Reggio, while homosexual visitors responded to B.

But what was their ancient story? The chances are that they spent many centuries under the sea after the ship carrying them from a sanctuary in Greece to adorn the public spaces of a Roman town or the private spaces

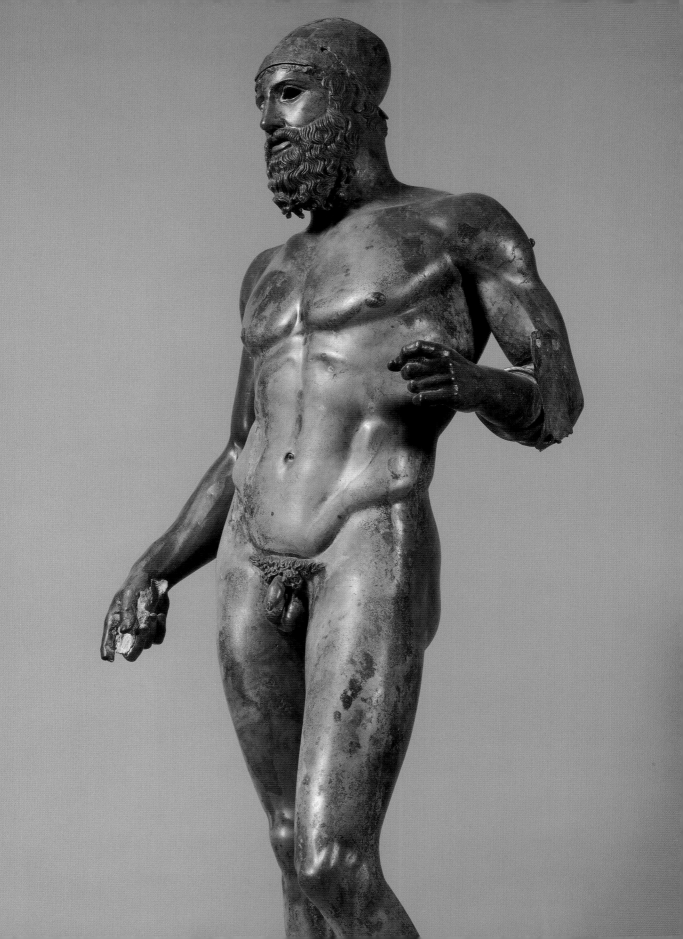

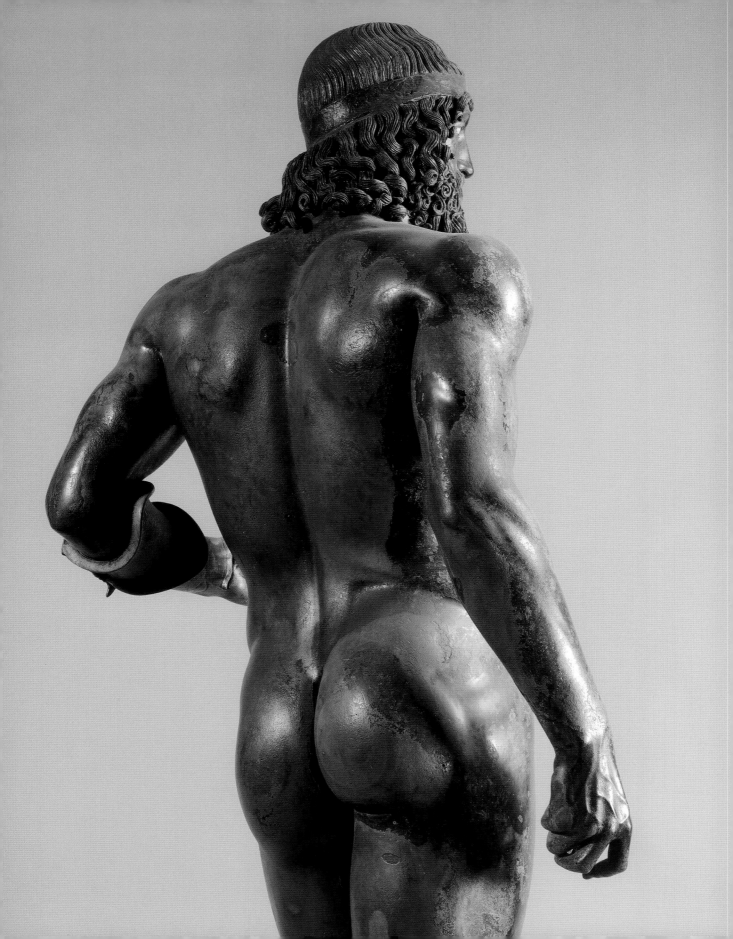

of a Roman villa sank in stormy weather. But which sanctuary? And when and why were they commissioned? Divorced from their original context, all assessments of the date of these statues depend upon the internal evidence of their technique and style. Although some scholars have demurred, the case for their coming from a single monument and from the workshop of a single sculptor is extremely strong – as is the temptation to identify that sculptor with one of the great names known from ancient texts. Could these be works of Phidias?

Whoever he was, he was certainly at work in the generation immediately after the Persian War (480–479 BC). These statues stand in the tradition of the Kritian Boy and the Athenian images of Harmodios and Aristogeiton, celebrated in the agora of that city as the men who 'slew the tyrant'. They are determined to evoke in the viewer not just the presence of mature men, but the presence of mature men of a particular lifestyle. In contrast to classical sculptures produced in the second half of the 5th century BC, whose generalized bodies avoided such particularizing and drew attention instead to what men share, these bronze bodies impel the viewer to create a particular narrative to justify their very particular appearance.

It is the emphasis on the particular self-contained body here that makes these warriors so richly satisfying. No one viewing them conceives them to be only a fragment of a larger whole, for they seem to need nothing more than each other. Yet it is likely that they come from a bigger monument, that these were only two of a number of variations on the warrior theme. Whether the warriors belonged to the realm of history – a monument, for instance, celebrating the part played by individual generals in Greek success against Persia – or of mythology – could they be two of the seven heroes who attacked the city of Thebes, or is one of them Achilles? – we cannot know. But we are so distracted by the details of their bodies that we do not feel the need to know. Such lack of concern is perhaps one reason why no subsequent classical sculptures look quite like these.

'... *Warrior A has acquired an active heterosexual life in the world of the Italian pornographic comic.*

Opposite
Some of the most powerful effects of these sculptures derive from features – the massive furrow that marks the spine – not given by nature.

Right
Our ignorance of the original arrangement of these sculptures is tantalizing: were they side by side? Or did they eye each other up?

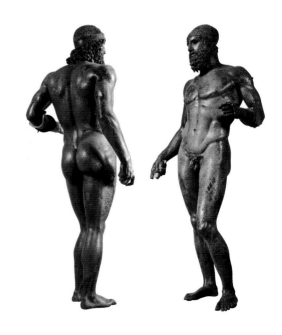

Leading Lady

The Lady of Elche, Artist unknown

RUBÍ SANZ GAMO

'... the Lady of Elche is the product and reflection of an urbane aristocratic class.

The Lady of Elche has fascinated all who have seen her since she was found in 1897. From the moment of her discovery she was associated with the Iberian people, of whom at that time little was known – just a few references in classical texts and some curious inscriptions. The most beautiful image of the period yet discovered, she propelled the study of the ancient peoples of the Iberian Peninsula.

The sculpture combines idealized facial features with realistic jewelry and stylized clothes. She wears a cloak and a tunic with rigid, schematic folds. Her face and chest show an excess of jewelry: a pointy tiara covers her hair, while on top of her veil we see a diadem covered in three rows of pearls; a small clasp or brooch (known as an annular fibula) fastens the tunic around her neck; on her chest are three thick necklaces from which amphorae and wide tabs hang like amulets; her ears are hidden by plates decorated with volutes – from these, hanging jewels spread out over her shoulders. Finally, two large pearl-covered radiating roundels on either side of her face are held in place with ribbons that cross the top of her head. In 2005, the findings of institutes in Spain and France allowed us to recreate her original colouring, with pink skin, red lips, Egyptian blue tunic, cinnabar red cloak and tiara. Some of her jewelry would have been covered with a layer of gold.

The tiny gold particles that have been found in the pores of the stone underline her royal or cultish character. Perhaps her gaze is that of a goddess, to be admired and adored. Or maybe she represented a being that emerges from the earth; she may even be a copy in stone of an original wooden sculpture, dressed and wearing real jewelry. Others have proposed that she was designed to contain the ashes of a dead person, as the hollow space in her back suggests. In any case, the Lady of Elche is the product and reflection of an urbane aristocratic class.

Certain questions remain, of course. Pierre Paris first pointed out the Greek heritage of the Lady of Elche in 1903, and today this is widely accepted, though there may have been additional sources of inspiration. Some have argued that she is a bust, others that she is the remaining piece of a full-body statue. Goddess or mortal, she is unquestionably striking, an adaptation of Mediterranean classicism to Iberian taste.

When the sculpture was found, the inhabitants of Elche (in Alicante, south-eastern Spain) called her 'the Moorish queen', while the local scholar Pedro Ibarra compared her to Apollo. G. Rochegrosse used her as inspiration in his illustrations to Flaubert's *Salammbô*, and in 1899 the city of Marseille helped spread her fame through a commemorative poster. She became a symbol of the 19th-century regeneration in Spain and was seen as capturing the essence of Spanish women. Since then she has remained integral to Spanish culture, appearing in façades, sculptures, banknotes and textbooks.

Above
This side view of the Lady of Elche shows the astonishing pearl-covered radiating roundels that flank her head.

5th–4th century BC
Stone, with traces of polychrome and gold
H 56 cm × W 45 cm × D 37 cm /
1 ft 10 in. × 1 ft 6 in. × 1 ft 2½ in.
Museo Arqueológico Nacional de España, Madrid

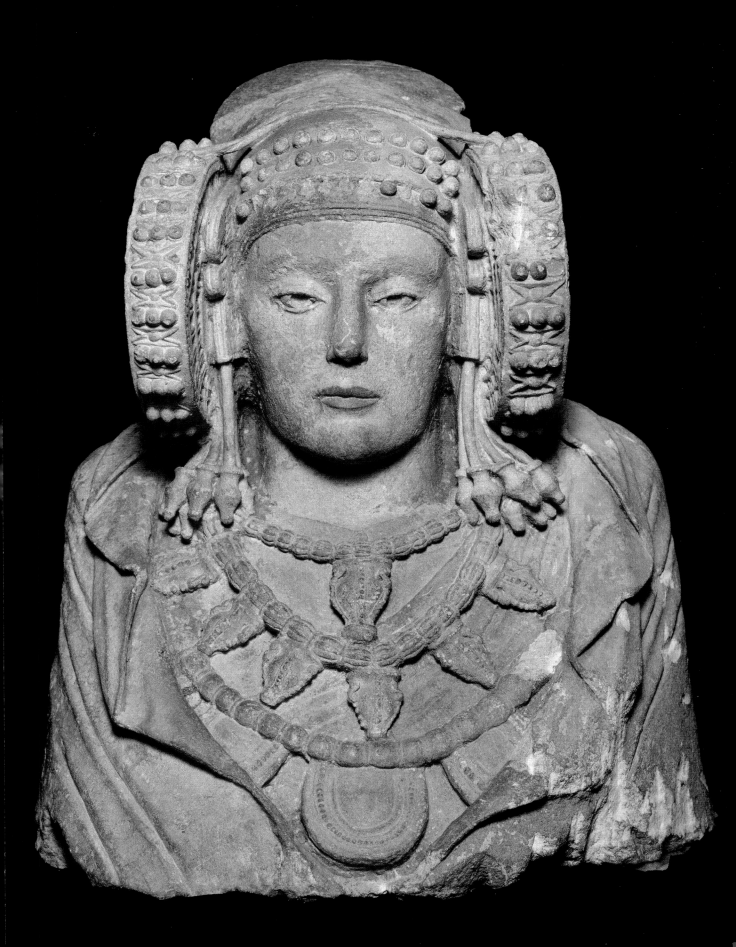

Forgotten Rites

The Villa of the Mysteries, Pompeii, Artist unknown

MARY BEARD

‘ *... part of the pleasure of the frieze is the way that it repeatedly plays with our ability to decode it.*

Opposite
A young woman buries her head in the lap of her companion, exposing her bare back for the lash of a whip.

Before AD 79
Fresco
Pompeii, near Naples, Italy

The most famous painting discovered in the buried city of Pompeii – indeed the most famous surviving anywhere in the Roman world – is the curious frieze that covers the walls of a large room in the 'Villa of the Mysteries', a substantial property just outside the boundary of the ancient city. Painted in the mid-1st century BC, its series of almost life-size figures, set against a luscious red background, has become the modern icon of Pompeii, copied onto thousands of posters and postcards, ashtrays and fridge magnets.

Unearthed in 1909 in one of the last 'private' excavations at Pompeii (conducted by a local hotel-keeper eager for spectacular finds to boost his trade) it was an immediate sensation. The frieze from the 'Villa Item' (as it was then called, after its amateur excavator) was enthusiastically hailed in press reports across Europe, and its intriguing subject matter was soon dissected in scholarly articles. What was this strange collection of almost thirty gods and mortals – from a winged 'demon' to a naked child – wrapped around these walls? Was some ritual going on? If so, what?

But it was the lavishly illustrated publication of the paintings in 1931 by Amadeo Maiuri (the Superintendent of Pompeii for almost forty years in the mid-20th century) that secured their reputation as Roman masterpieces of the first rank. By now, the Villa had taken its modern name, from the theme of the frieze itself: not merely 'mysterious' (though it is certainly that) but depicting, as one interpretation suggests, the religious 'Mysteries' or initiation rites of the god Dionysus.

At one end of the room, opposite the main door, the first thing you would have seen as you walked in was Dionysus, sprawling semi-naked in the lap of his mother, Semele – or maybe his wife, Ariadne (the female figure only partly survives). This divine couple is clearly the centrepiece of the whole composition, with its exotic cast of characters. Leading up to the pair along the left-hand wall is a relatively stately procession: the naked child reads out words from a scroll; a woman carries a loaded tray, while looking out to catch the viewer's eye; a group of women cluster around some kind of container, as one pours out water or wine from a jug.

Yet, as the figures get nearer to Dionysus, things become decidedly stranger. Next to the figure of young Pan playing his pipes, his female partner (a 'Panisca') appears to suckle a goat; a satyr, one of Dionysus' mythical followers, holds up a cup into which his friends gaze intently (we cannot see what they are looking at, but one of them holds up a theatrical mask over the satyr's head); at the corner of the room a woman seems to start back in horror – but at what?

The answer to that question is probably to be found on the other side of the divine couple. For here a woman kneels as she begins to reveal something

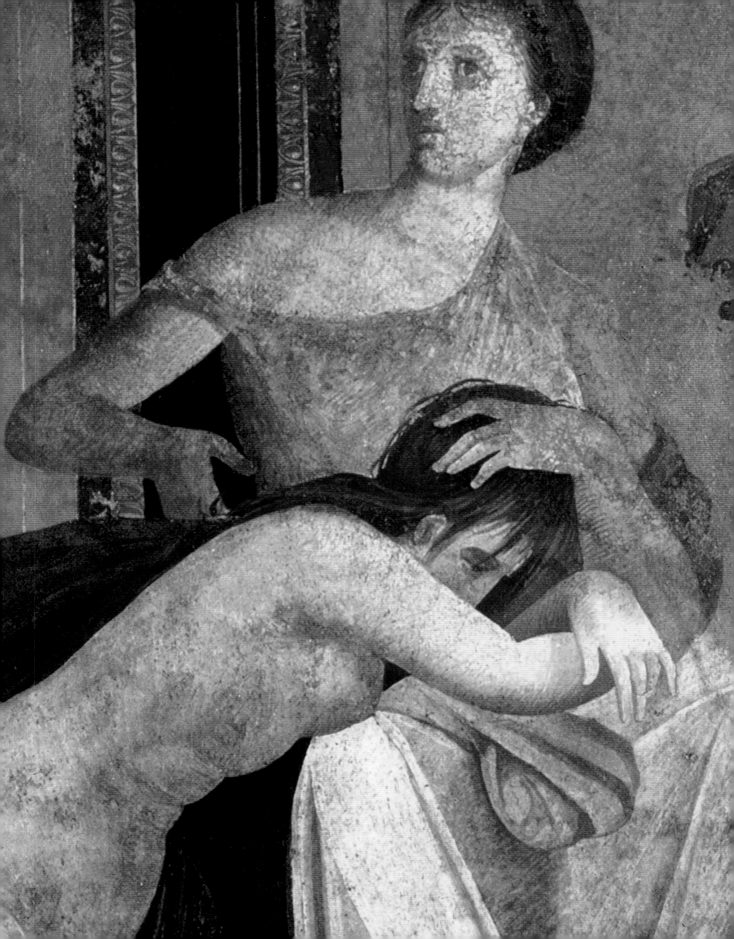

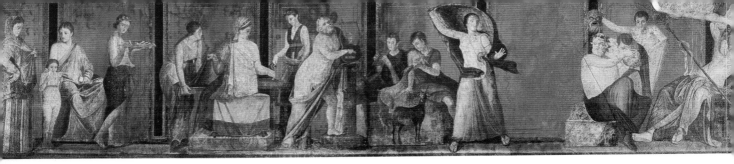

> *What was this strange collection of almost thirty gods and mortals – from a winged 'demon' to a naked child – wrapped around these walls?*

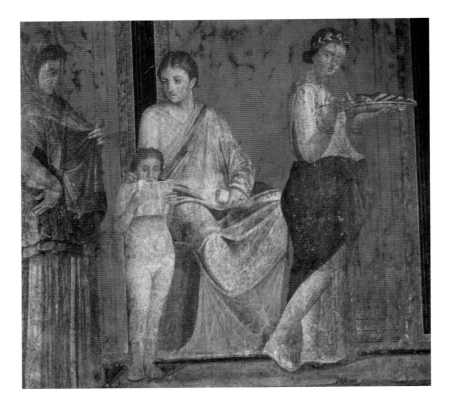

Top
The frieze extends around the four walls of the room – here 'unfurled'. Is it a linear narrative or a series of tableaux?

Above
A child reads from a script. In this and several other scenes the characters are engrossed in something we viewers cannot see – here perhaps a sacred text.

that has been concealed beneath a dark cloth (a phallus, it is usually imagined), while the winged demon whips the bare back of a girl who buries her face in her companion's lap. Just next to her a naked woman dances and plays the castanets.

What on earth is going on? And what kind of room was it that these images decorated? Perhaps, as the Villa's modern title has it, the frieze is meant to depict an initiation into the cult of Dionysus: hence the revelation of the phallus, and the flagellation. But the room itself is hardly the hidden sanctuary of some esoteric cult. It is in fact one of the showrooms of this large house, opening onto a portico with a panoramic sea view. So this would be a scene of initiation intended not as the decoration of a shrine, but instead as an elegant backdrop to dining and entertainment. Others have preferred to see the painting as an allegory of marriage and the preparation for a wedding. The bride has been identified as a young woman shown seated to the right of the main door and the central couple. On this interpretation, Dionysus and his wife, Ariadne, would symbolize the divine nature of marriage.

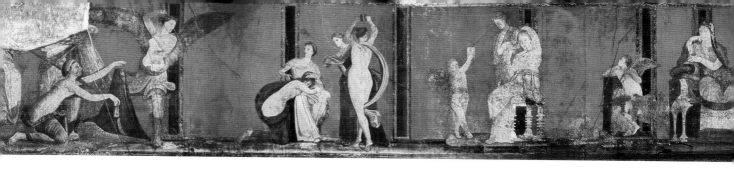

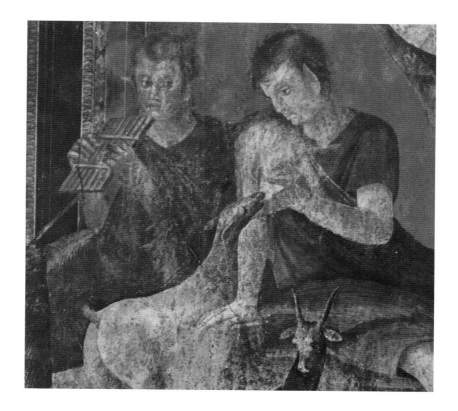

The truth is that we do not know exactly what is depicted here. Indeed part of the pleasure of the frieze is the way that it repeatedly plays with our ability to decode it. What is the naked boy reading? We cannot see. What is being revealed from under the cloth? We can only guess. What are the satyr and his friends studying so intently in the cup? They do not show us.

But there is a surprising sting in the tail. One reason for the impact of this frieze is the way that it envelops anyone who steps into the room. We become part of the strange world inhabited by these figures. Another is the sheer lustre of the deep red background, against which the figures are set: 'Pompeian red' at its loveliest. This colour, however, cannot entirely be attributed to the original artist. When the paintings were first uncovered they were so badly affected by damp that unsightly salts leeched through the paintwork. In order to remove the salts and to prevent further seepage, petroleum wax was carefully and repeatedly rubbed into the painted surface. That memorable sheen is, in other words, a 20th-century creation.

The Reluctant Hero

The Equestrian Statue of Marcus Aurelius, Artist unknown

NANCY H. RAMAGE

> *Remarkable details abound ... the leather shoes that cling to the feet, revealing the shape of the toes inside; or the open mouth of the horse, champing at the bit, while his ears twitch in opposite directions.*

This over life-size horse and rider, the only bronze equestrian statue of an emperor to have survived from antiquity, has been witness to almost 2,000 years of Rome's history. Its survival is little short of miraculous. Bronze statues were normally cut up and melted down for a secondary purpose, whether for cannonballs, doors, locks or other useful items. This practice had started already in late antiquity, when bronze was needed especially for coins. Though four ancient bronze horses from a chariot group in Constantinople survived, and were later brought during the Crusades to San Marco in Venice, where they remain today. How did this horse and rider escape the furnace? In the Middle Ages it was popularly thought that the man on horseback was Constantine (r. AD 306–37), the first Christian emperor – and therefore untouchable. However, the figure actually represents the emperor Marcus Aurelius (r. AD 161–80), as proven by comparison with coin portraits and marble statues and reliefs.

It is not known where it originally stood, but by the 10th century the statue had been placed in front of one of the great basilicas in Rome, St John Lateran. A painting in the church of Santa Maria sopra Minerva by the Renaissance artist Filippino Lippi, and a drawing by Martin van Heemskerck, both show the statue in that location. But in 1538 Michelangelo was commissioned by Pope Paul III to design a new square on top of the Capitoline Hill in Rome, in anticipation of the impending visit of the Holy Roman Emperor Charles V. Although Michelangelo wanted to leave the statue where it was, he reluctantly used it as the centrepiece of his new trapezoidal piazza. This square has buildings on three sides, and is open to a marvellous view of papal Rome on the fourth. Here the statue stood on the pedestal designed by Michelangelo for almost 450 years. But by 1981 the bronze was corroding so badly from acid rain and air pollution that it was decided to remove the statue from its pedestal and to clean and restore its surfaces. Only at that time was it discovered that some of the original gilding, obscured over the centuries, was still adhering to the bronze. Today, the cleaned and conserved statue is installed within the Capitoline Museums in a huge space that allows the viewer to experience the greatness of this sculpture from all angles. A replica replaces it outdoors on Michelangelo's piazza.

Later 2nd century AD
Bronze, with some gilt
H 350 cm / 11 ft 6 in.
Capitoline Museums, Rome

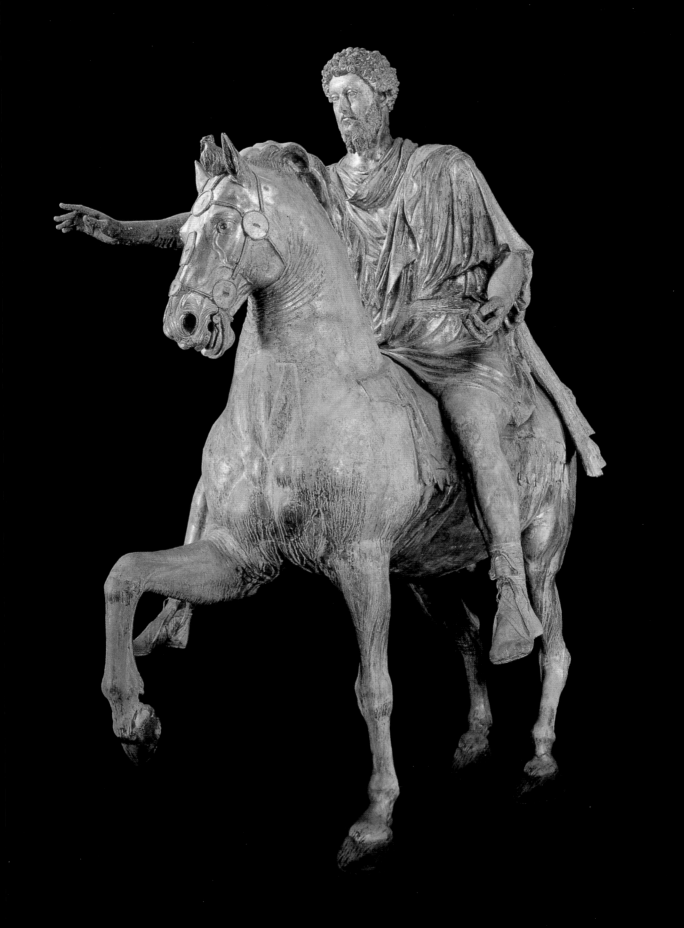

Above

The Piazza del Campidoglio, Rome (engraving by Etienne Dupérac, 1568). The piazza on top of the Capitoline Hill, with the statue of Marcus Aurelius in the centre, was designed by Michelangelo.

Right

Coin portrait of Marcus Aurelius. The emperor's features (straight nose, heavy eyelids, long thin face, curly hair and beard) confirm the identification of the rider in the equestrian statue as Marcus Aurelius.

A man on horseback seems like such a standard subject that we might assume any example would look much like any other. This is not the case. In this masterpiece, the unknown sculptor addresses the power of the rider in a number of different ways. Marcus Aurelius was a sensitive man and a thinker whose *Meditations*, written in Greek, summarize his stoic philosophy. The emperor's long, thin, thoughtful face, with heavy eyelids and curly hair and beard, is accurately reflected in this bronze portrait. Although he fought wars against the Marcomanni in Germany, the Pannonians in Hungary, and others, he was haunted by the violence and destruction caused by warfare. His 33-metre (100-ft) high commemorative column that still stands in Rome is full of scenes sympathizing with the enemy, and shows images of women, children and old men being abused, tortured and killed by the Romans – scenes reflective of his philosophy.

Wearing a tunic and cloak (*paludamentum*), the emperor stretches out his hand toward the crowd of soldiers he is addressing in a gesture known as *adlocutio*. The great and noble horse is barrel-bellied, strong and powerful. Its remarkably thick neck, with protruding veins and skin wrinkled into folds, is pulled back by the reins, now missing, in Marcus Aurelius' left hand. The emperor sitting astride the horse, with feet hanging loosely, is in complete control of the animal. His relaxed position and generous, peaceful gesture add to the imposing appeal. Striking details abound, such as the leather shoes that cling to the feet, revealing the shape of the toes inside; or the open mouth of the horse, champing at the bit, while his ears twitch in opposite directions.

The sculpture is not symmetrical, suggesting that it was intended to be seen from the rider's right side. The left side of both man and horse are larger than the right, taking into account that the farther side would appear to be smaller if it were not in fact enlarged to compensate for this optical effect. Other features too indicate an optimal view from the rider's right: the man and horse both turn slightly in that direction. It may be that this group was originally paired with a second equestrian statue, probably representing Marcus Aurelius' son and co-ruler, Commodus. Such a statue would have been similarly asymmetrical, but in the opposite direction. A figure of a submissive barbarian captive may have been placed under the raised front leg of the horse, according to the somewhat unreliable 12th-century *Mirabilia urbis Romae* (Wonders of the City of Rome).

It would be difficult to exaggerate the influence that this bronze has had on later equestrian statues. Among them, in the Renaissance, are Donatello's bronze statue known as the Gattamelata in Padua and Verrocchio's Colleoni in Venice; but well into the 19th century, many commemorations of soldiers and rulers throughout the Western world were modelled on the equestrian statue of Marcus Aurelius.

> *Wearing a tunic and cloak ... the emperor stretches out his hand toward the crowd of soldiers he is addressing ...*

Above
Detail of the right hand of Marcus Aurelius, making the gesture of address known as *adlocutio*.

Unearthly Beauty

The Buddha Preaching the First Sermon, Artist unknown

JOHN GUY

> *The image is unrivalled in the history of Indian Buddhist art. It is the embodiment of the Buddha message and of the Buddhist aesthetic.*

Representations of the Buddha account for some of the most sublime images in the history of art. This sculpture of the historical Buddha Sakyamuni, expounding his newly defined path to enlightenment, is not only among the most refined images of the Buddha to have survived in India, but has also proved to be an iconic form that has had a lasting impact and legacy in the lands beyond India where Buddhism flourished.

The sculpture shows a supremely calm and reflective Buddha, seated in an advanced yogic posture. His hands are raised in a specific gesture, representing the 'turning of the wheel' of Buddhist law, *dharma*, so invoking the moment when the Buddha shared the supreme wisdom he had attained after his recent Enlightenment at Bodhgaya. This event, often referred to as the Buddha's First Sermon, took place in the forest retreat at Sarnath, north of the ancient city of Varanasi, and was witnessed both by his immediate disciples and by the forest animals. The devotees, together with two recumbent deer, are represented in the frieze below the throne-seat, seated left and right of the *dharmacakra* ('law-wheel'). The *dharmacakra* is a spoked wheel, which emerged early in Indian iconography, variously associated with Hinduism (as Vishnu's weapon) and adopted into Buddhism to denote the Buddha's teachings. The worshippers raise their clasped hands in veneration (*anjali*) of the *dharma*. The Buddha's hands by contrast, are complexly configured in a double teaching gesture, which conjoins by one finger, so evoking the 'turning of the wheel'.

This image is the culmination of a lineage of representations of the Buddha that has its beginnings around the 1st century AD at and in the area of Mathura. The earliest works are of a more robust nature, showing powerful, martial figure-types, associated with the cult of the hero (*vira*) in early Indian religions. The monumental standing Buddha-*vira*, which was commissioned according to its Brahmi inscription by the *bhiksu* ('monk') Bala, around the year AD 130, epitomizes this style. Although this sculpture was discovered within the monastic complex at Sarnath, it is carved in a sikri red sandstone characteristic of Mathura, some kilometres to the west, suggesting that even large-scale images were on occasions transported to distant locations. Numerous seated Buddha sculptures survive from the centuries preceding the Sarnath Preaching Buddha, and they almost universally display a raised hand in *abhaya-mudra*, a gesture of protection to followers of the Buddha's teaching. In the early period, the 'turning of the wheel' gesture occurs most frequently in the Buddhist art of the Gandharan region of north-western India (modern Pakistan), and it would appear that this iconography is a specific revival by the Sarnath school in the Gupta period.

The Sarnath Preaching Buddha carries within it these multiple lineages, and may be characterized as representing the distillation and apogee of

Gupta period, c. 475
Chunar sandstone
161 cm × 79 cm / 5 ft 3½ in. × 2 ft 7 in.
From Sarnath, Uttar Pradesh, India
Now in the Archaeological Museum, Sarnath

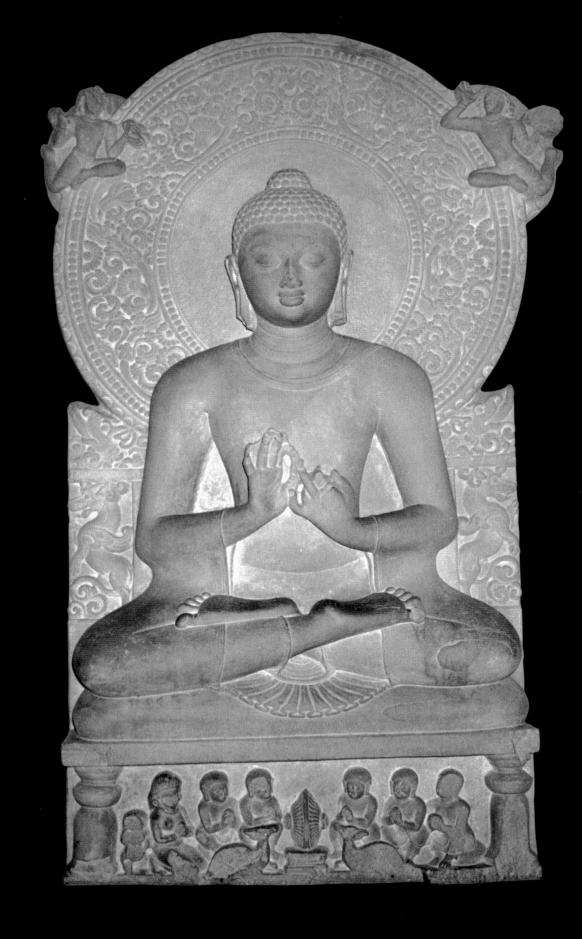

Its stylistic legacy, in the form of a new internationalism in Buddhist Asia, was without precedent in the history of Asian art.

these traditions. For example, while the Mathuran and Gandharan versions presented the Buddha flanked by two attending bodhisattvas, the Sarnath Buddha is depicted alone, serving as a single focus of devotional attention. Rearing winged leogryphs in foliage replace the bodhisattvas, and the nimbus, typically a plain disc or one with a radiant-sun border, has evolved into a riot of foliate meanders, embedded with lotus buds, ringed by registers of pearls and encircled by a flame border. Celestial fly-whisk bearers adore the image from above.

The resulting image is unrivalled in the history of Indian Buddhist art. It is the embodiment of the Buddha message and of the Buddhist aesthetic. The genius of the artist lay in capturing the inner meditative quietude of the Buddha, achieved by the absolute symmetry of the figure in a yogic meditation posture (*padmasana*), and in conveying a sense of his other-worldliness through a non-naturalistic approach to form. Both are handled masterfully. The robust musculature of preceding styles has surrendered to a softness of form in which mass is conveyed by supple rounded contours. The result is a highly stylized image of beauty, codified according to the rules of *citra* ('image-making'), as given sublime form in the murals at Ajanta, and, in the secular realm, in the verses of the poet Kalidasa.

No longer does the artist seek to represent the Buddha with verisimilitude, as a spiritual ruler on earth; rather, he attempts to convey a sense of the otherness of the Buddha-nature. This in part reflects a devotional realignment in which the Buddha had been redefined as belonging to the realm of the gods, no longer that of the Perfected Mortal. In theological terms, we are witnessing a shift in emphasis from the Buddha as spiritual protector to the Buddha as the embodiment of supreme knowledge (*anuttara-jnana-vapti*).

This sculpture is undated but can be assigned, by comparison to inscribed examples, to the close of the 5th century. It would have served as one of a number of Buddha icons for veneration and meditation by members of the *sangha*, along with gilt-copper alloy images, some monumental, of which the most spectacular survivor is the Sultanganj Buddha. The majority of inscribed Sarnath-school images indicate monastic patronage and it is reasonable to assume that this sublime Buddha was commissioned by senior members of the *sangha* for installation within the principal monastery at Sarnath.

The Sarnath style of Buddha-image went on to have an impact on Buddhist art unforeseen in its day. It became both progenitor and prototype for a Pan-Asian Buddha style, which extended north to Nepal and into Sui and Tang China, and east to mainland Southeast Asia, as vividly witnessed in the Buddhist art of the Dvaravati kingdoms of Thailand. Its stylistic legacy, in the form of a new internationalism in Buddhist Asia, was without precedent in the history of Asian art.

Above
Standing Buddha, commissioned by the senior monk Bala, dated to the third year of the reign of Kanishka, equivalent to AD 130. The inscription describes the patron as a master of the Tripitaka, the 'three baskets' (collections) of Buddhist canonical texts. This monumental standing Buddha embodies the memory of *yaksha* images belonging to early Indian nature cults, united with the Vedic notion of the Bhagavata, the worshipped hero. (Mathuran school, sandstone, height 289.5 cm / 9ft 6 in. From Sarnath, Uttar Pradesh, India, now in the Archaeological Museum, Sarnath)

Above

Buddha attended by bodhisattvas, from
the Kushan period, late 2nd century AD.
This image embodies the finest attributes
of Kushan Buddhist art, notably a robust
musculature and an alert, engaging Buddha,
communing directly with his devotee. It
pays homage to the ancient Indian ascetic
preoccupation with yogic practices, seen
in the cross-legged posture of the Buddha,
and to the celebratory aspects of Buddha's
veneration by attending bodhisattvas and
celestial adorers. (Mathuran school, sikri
sandstone, height 72 cm / 2 ft 4½ in. From
the Katra mound site, now in the Government
Museum, Mathura, Uttar Pradesh, India)

Right

Sultanganj Buddha. This copper alloy image,
cast in sections, is a rare reminder of the lost
tradition of monumental metal casting in
Buddhist India, the prevalence of which was
confirmed only by recent discoveries of large-
scale metal images at Buddhist monastic sites
in Bangladesh. (6th–8th century AD, copper
alloy, height 230 cm / 7 ft 6½ in. Excavated
at Sultanganj, Bihar, India, now in the
Birmingham Art Gallery and Museum, UK)

A Heavenly Hierarchy

The Virgin and Child with Angels and Two Saints, Artist unknown

JAŠ ELSNER

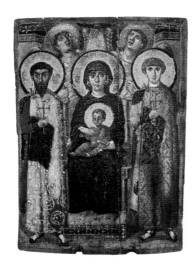

‘ *... lady, why do you look away? Am I not worthy to catch your gaze, nor that of your anointed son ...?*

Above
The Virgin enthroned between angels and two saints of uncertain identity, both of whom carry crosses.

Opposite
The wax impasto technique gives a tactile quality to the cloaks of the Virgin and Jesus, but at the same time highlights the sketchiness of the brushstrokes in the two angels.

Probably 6th century
Wax encaustic pigments on wood
68.5 cm × 49.7 cm / 2 ft 3 in. × 1 ft 7½ in.
Possibly from Constantinople, now in the Monastery of St Catherine, Mount Sinai

Lady, why do you look away? The stern saints at your side look straight at me, holding my gaze in theirs. The ethereal angels at your back look up towards another world, whence peeps the hand of God that blesses you on high. But you, it seems, choose to look away. And likewise, the Son of God, your son, gold-robed and golden-haloed, with golden hair, right hand raised in blessing and left clutching childlike at a scroll, he too looks aside and not at me.

Made of pigments cased in the encaustic medium of set wax, applied impasto-thick and hot upon the wooden board, the icon is a window to a heavenly world. Full-colour, fresh and lifelike are the seated lady and the saints in courtly dress, their shadows claiming presence on the ground; more monochrome, translucent, not of this world, the angelic company. And all – angels, lady, saints, the curving niche wherein they stand – pierced by a ground of holy gold which penetrates the wax at the haloes, the throne and the robe of the Incarnate Lord, seated with his head before her heart. Do we notice first the figures, flat but built of wax, or the glistening gold that cuts through the painted forms? The colourless wax medium contains pigments of crushed mineral and stone – as once the Virgin lady held inside herself the child now seated on the blue-robed lap. This painterly matter where pigment rests in wax, figures too the double nature of the boy the lady bears, who sits – an infant Word – before the saintly womb. Some called her Mother of God, some Mother of Christ – naming thus, but with brutally contested emphases, the way He is both man and God. Others call her Queen of Heaven, the blessed Virgin, the pointer of the Way. All these she is, in this majestic vision of a heavenly court, ministered by angels and attended by saints, a golden star upon her covered head.

Lady, you sit enthroned at the onset of iconic art – the earliest point from which Christian icons survive. Your throne is guarded by warrior saints who carry martyr crosses that testify to the life each once laid down in witness to the Godhead of your son. Your back is guarded by angels bearing staffs. God's blessing falls as a beam of gold-flecked light from above, and that star upon your forehead flickers back as in response. So, lady, why do you look away? Am I not worthy to catch your gaze, nor that of your anointed son who also looks away? Is access to your sanctity offered only through the retinue of saints, by facing one of your protectors, gaze for gaze? Or do you look away from the sorrows and imperfections of the world, where few know fully how to venerate your son? Does that glance aside disdain the history of candle-offerings, bows to the ground and kisses that have marked your worship in this very icon for nearly fifteen hundred years? Surely, lady, you would not prefer the anodyne regulation of humidity and air in a museum to the rising incense and the candle's smoke, whose burning wax melts in homage to your wax-made potency?

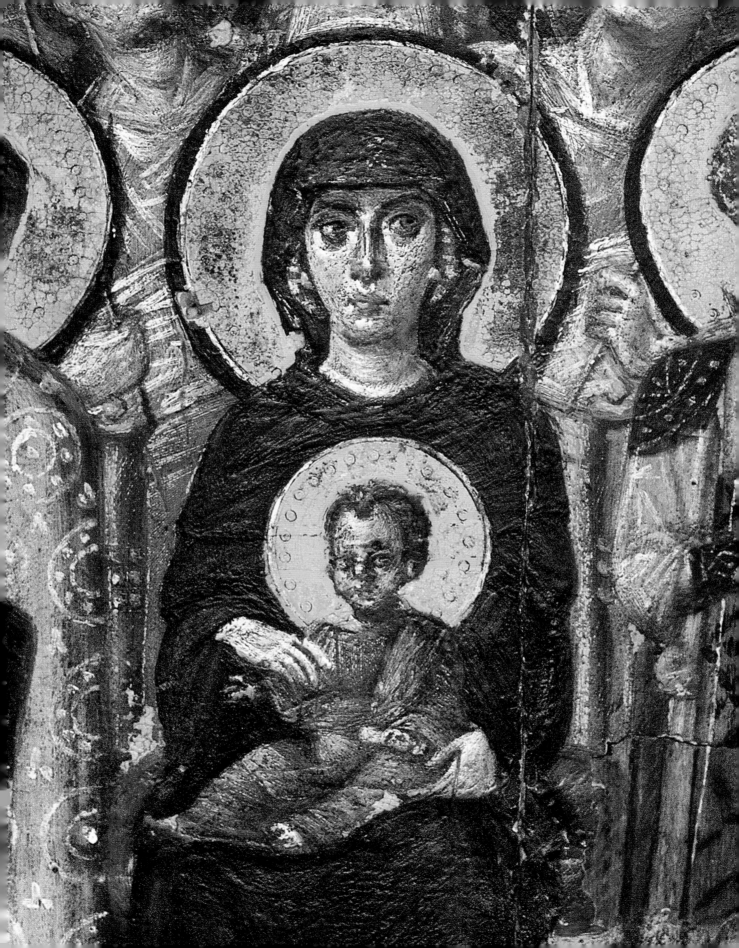

Ancient Portrait from Peru

Moche Portrait Vessel, Artist unknown

CHRISTOPHER B. DONNAN

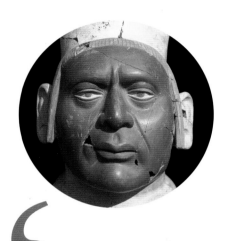

‘ *Moche portraits ... allow us not only to meet ... people who lived more than 1,500 years ago, but even to sense the nuances of their ... personalities.*

Opposite and above
The two vessels show the same individual, (opposite) earlier and (above) later in life. In the mature portrait, his ear ornaments and headdress have been removed, indicating that he was captured in ceremonial combat and was to be sacrificed.

c. 550
Ceramic
H 28 cm / 11 in.
Museo Rafael Larco Herrera, Lima, Peru

The Moche civilization flourished on the north coast of Peru between AD 100 and 800. Although the Moche had no writing system, they left a vivid artistic record of their beliefs and activities in beautifully modelled and painted ceramic vessels. Among the greatest achievements of Moche potters was the ability to create true portraits of individuals – showing the anatomical features of a person with such accuracy that the individual could be recognized without relying on accompanying symbols or texts.

Moche portraits were made as portable ceramic vessels that could contain liquid. The faces are usually somewhat smaller than life-size. They include an astonishing range of facial types and expressions, and allow us not only to meet Moche people who lived more than 1,500 years ago, but even to sense the nuances of their individual personalities.

Although nearly all Moche portraits have been found in graves, they were not made for funerary purposes. They were made to be used by the Moche, and most show signs of wear – abrasion, chipping or mended breaks – that occurred before they were put into graves. There is no evidence that a portrait vessel was ever buried with the individual it depicted. Nearly all are portraits of adult males, yet they are sometimes found in female burials. Moreover, portraits of some individuals have been found in the graves of various people.

This splendid portrait vessel has a stirrup spout, a term derived from its shape. The individual is shown with most of his hair enveloped in a plain cotton cloth, wrapped around his head. A tapestry weave band was then added, along with tassels that terminate in small metal discs. He wears tubular ear ornaments, and has vertical black stripes painted on his cheeks.

The geometric pattern painted on this individual's neck is characteristic of adult Moche males who engage in ceremonial combat, in which pairs of warriors, elegantly dressed in elaborate clothing and ornaments, engage in hand-to-hand combat. The objective was to capture rather than kill the opponent. Once a warrior was captured, his weapons, clothing, headdress and ornaments were removed, and a rope was put around his neck. He was then paraded to a ceremonial precinct, where he was sacrificed – his blood consumed by ritually dressed priests and priestesses.

The distinctive facial features of this individual make it possible to recognize four other portraits of him that are in various museum collections. All four show him somewhat older than he appears in this portrait. Three show him with his headdress and ear ornaments removed, and one of those even depicts a rope around his neck. These imply that later in life he was captured in ceremonial combat and sacrificed. He leaves us with a fascinating portrait, the artistic and technical quality of which ranks it among the most remarkable of the ancient world.

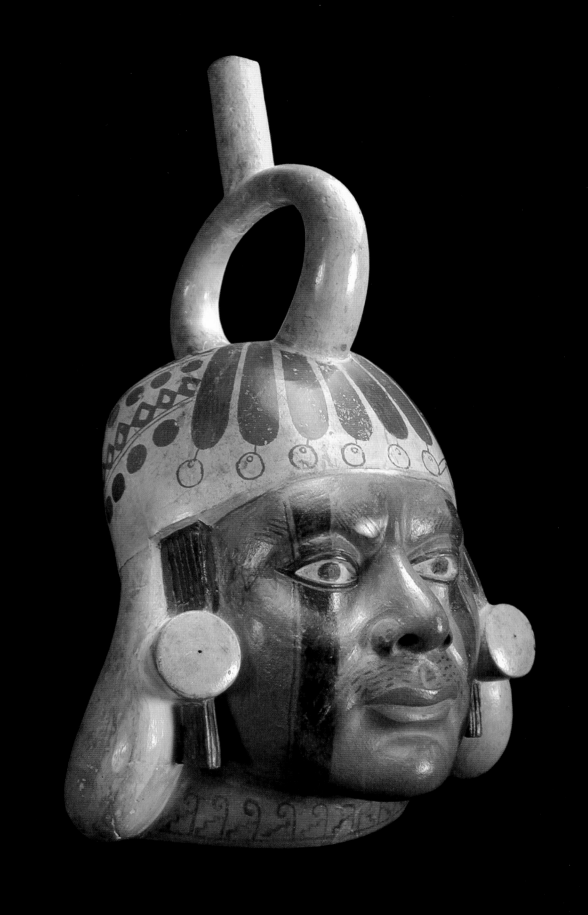

The Dancing King

The Relief of Ahkal Mo' Nahb III, Ruler of Palenque, Artist unknown

MICHAEL D. COE

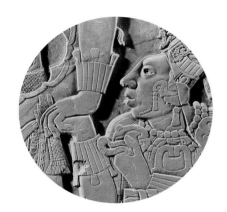

'*This is probably the most magnificent relief ever carved by a Maya artist, and an outstanding work of portraiture.*

Above
The figure to the right of the ruler is the king's *ajk'uhuun* (an office that we do not fully understand, but which probably entailed overseeing tribute offerings, taking care of hieroglyphic manuscripts and perhaps supervising rituals and other court affairs).

c. 730
Limestone relief panel
H 340 cm / 11 ft 2 in.
From Temple XIX, Palenque, Chiapas, Mexico, now in the regional museum, Palenque

Many archaeologists and art historians consider Palenque the most beautiful of the Classic Maya cities. Situated in the forested hills above the Gulf Coast plain of south-eastern Mexico and watered by a network of streams, its architecture and carved stucco reliefs are unforgettable. The Maya of a millennium and a half ago may have thought so, too, for they gave it the name Lakamha', 'Great Water'.

Apart from the aesthetic value of its art and architecture, Palenque was also the densely urbanized capital of a powerful city-state. In 712, a new king was inaugurated, Ahkal Mo' Nahb. Though a warlike ruler, he was also a keen patron of Palenque's artists and architects, commissioning several temples in the south-eastern part of the city, all apparently dedicated to his distinguished ancestors, including his grandfather Pakal and the progenitor deities.

Among these buildings was Palenque's Temple XIX, dedicated on 14 June AD 734, in a strange (to us) ceremony commemorated by this enormous relief panel, which had been the facing of an interior pier supporting the structure's corbelled roof. Carved from lithographic-quality limestone, it represents a standing and bejewelled Ahkal Mo' Nahb being garbed with a towering back rack apparently representing an enormous, red-feathered bird. Presumably the king would then have danced in public, with this improbable apparatus and its waving macaw tail-feathers behind and above him.

This is probably the most magnificent relief ever carved by a Maya artist, and an outstanding work of portraiture. Take the profile of the king: Ahkal Mo' Nahb gazes to the left with startling immediacy. His eye fools us into thinking that we may be looking at a real personage, but this is due to a sculptor's trick: he has excavated the white of the eye, leaving a cup-shaped protuberance to represent the iris, and a sharp depression within that cup to stand for the pupil. Such bold invention to invoke the gaze of a real person in cold stone would not be seen again until the last decades of the 18th century, in the portrait heads of the Neoclassical sculptor Jean-Antoine Houdon.

How was the Temple XIX relief meant to be seen? Its position on an interior supporting pier meant that what light reached it would have been flattened and diffuse. By torchlight, however, the carving would have appeared more three-dimensional. Traces of pigment surviving on some surfaces show that at least some areas were painted: the glyphic texts and some of the loincloth ornamentation in 'Maya Blue', and red ochre for the background of glyphic texts, the ruler's macaw headdress, the feathers of the back rack and the simulated water lily flowers used as pompoms on the royal sandals.

While the panel as we see it today has clearly suffered the vicissitudes of history, not all of Temple XIX has yet been excavated. Surely the missing third of the panel will be found one day, and this great work of art will be seen in its complete majesty.

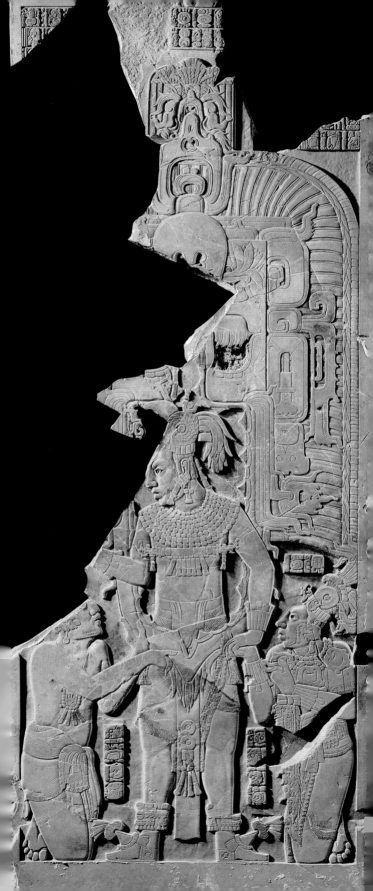

3

The Blending of Cultures

1000–1300

Travelling in Space and Time

Spring Festival on the River, Zhang Zeduan
RODERICK WHITFIELD

> The scene is both dramatic and detailed ...

Above
Scenes on the bridge: a porter with laden baskets, a wheelbarrow with side panniers, a gentleman on a dappled horse, and a trader touting for custom at his hardware stall.

Northern Song Dynasty, 11th century
Handscroll, ink and colour on silk
25 cm × 525 cm / 10 in. × 17 ft 3 in.
Palace Museum, Beijing

Hidden for many centuries until its rediscovery in Shenyang in 1945, today this Song Dynasty handscroll painting enjoys legendary fame, being as familiar in China as the *Mona Lisa* is in the West. Not only do long queues form and wait for hours to view it, but details, such as the one shown here, appear in a host of books on Chinese history and culture, while longer sections adorn the shop fronts and interiors of thousands of restaurants, and countless copies in every kind of material – carpets, porcelain, boxwood and wallpaper – are on sale everywhere. An unbroken series of colophons appended to it between the 12th and 18th centuries documents much of its collecting history, but little is known of its author, and the exact date of its production is still debated.

Even the title allows for differing interpretations: the original Chinese, *Qingming Shanghe tu*, is generally interpreted as *Spring Festival on the River*, Qingming being the occasion on the one hundred and fourth day after the winter solstice (around 4 April) when visits were made to ancestral graves. The fresh green of the willows and the sprigs of willow and plum on sale in the street confirm the season. A more political interpretation relates Qingming (literally 'Clear and Bright') to the reforms in government instituted by the second emperor of the Later Zhou Dynasty (r. 954–59), which laid the foundation for the peaceful and prosperous period of the Northern Song dynasty (960–1126). Both dynasties had their capital at Bianjing, a city of unparalleled splendour, on the Bian river. This river was actually a canal that provided transport of grain from the lower Yangzi region for the needs of the court and the civil and military administration. Drawing its water from the Yellow River, this canal ran through the capital, and is the setting for over a third of the composition in the central part of the scroll.

The painting, on finely woven silk, is over 5 metres (17 ft 3 in.) in length, and only 25 centimetres (10 in.) high. It was intended to be unrolled from right to left and viewed by no more than two or three persons at one time. Only as much as was comfortable to hold between the hands would be visible at any moment. This (to Western eyes) extreme format allows the artist to portray events occurring over time – in this case from early morning in the deserted countryside outside the city, to a crowded evening within the city walls – in an unbroken sequence. The first surviving commentary on the painting, written in 1186, sixty years after the fall of the capital, and citing a lost Northern Song text, tells us that the painter Zhang Zeduan was a native of Shandong province, a scholar who had gone on to study painting in the capital, specializing in street scenes, boats and carts, and the like.

The mid-point of the scroll is marked by a massive wooden bridge arching over the fast-flowing Bian. According to the *Song History*, the earliest bridge of similar rainbow construction was built in 1032. The scene

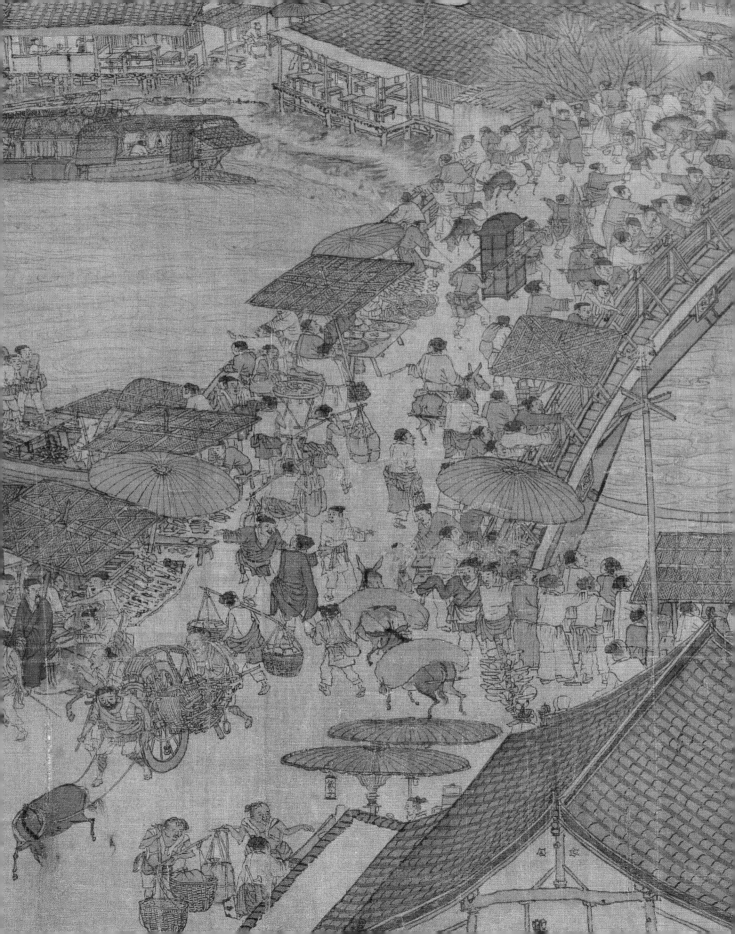

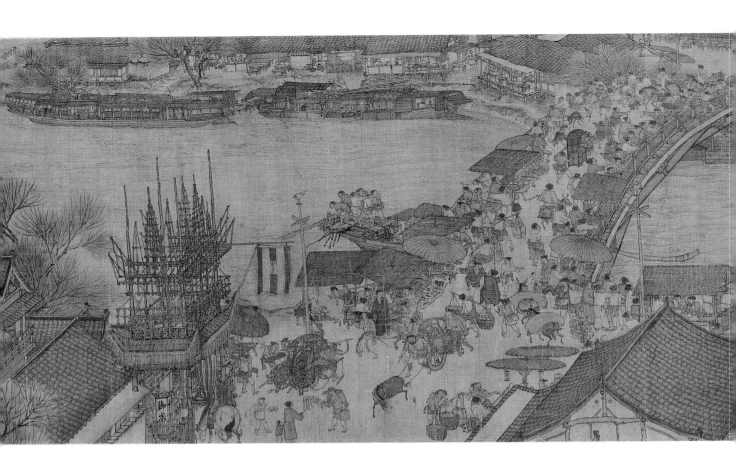

Above

Scenes above and below deck: the captain's
wife and infant child watch as the crew
struggle to lower the mast and fight the
swift current.

is both dramatic and detailed: in order for a vessel to pass upstream it was
necessary for the tracking mast to be lowered to the deck, so the crew battle
with poles against the swift current that threatens to carry the craft back
downstream. At the same time, another vessel, barely glimpsed beneath the
bridge, is preparing to lift anchor and run with the flow, guided by a massive
sweep at either end. A collision seems almost inevitable. Both the specta-
tors on the bridge and those on board are in thrall to this manoeuvre, which
represents the climax of a narrative that begins earlier, when two vessels on
a collision course first catch sight of one another, and that will conclude with
another pair of barges that have safely passed and are calmly continuing on
their respective journeys. The shifting perspective allows the person unroll-
ing the painting to see from a high viewpoint over the buildings on the near
bank as far as the towpath; then right underneath the bridge on the opposite
side, before moving a little farther to the left when the approach to the bridge
and the bustling scenes taking place on and around it fill almost the whole
height of the scroll. The elaborate construction at the left, a feature of com-
mercial establishments throughout the city, carries a banner and characters
identifying it as a wine-shop, second class, and customers can be glimpsed on
the upper floor. There were thousands of such establishments in the capital.

Although this painting was hidden from public sight for many centuries
(it entered the imperial collections no later than the first year of the Qianlong
Emperor's reign, 1736), it was copied widely, the copyists drawing on the
detailed descriptions of the painting provided either in the colophons or by

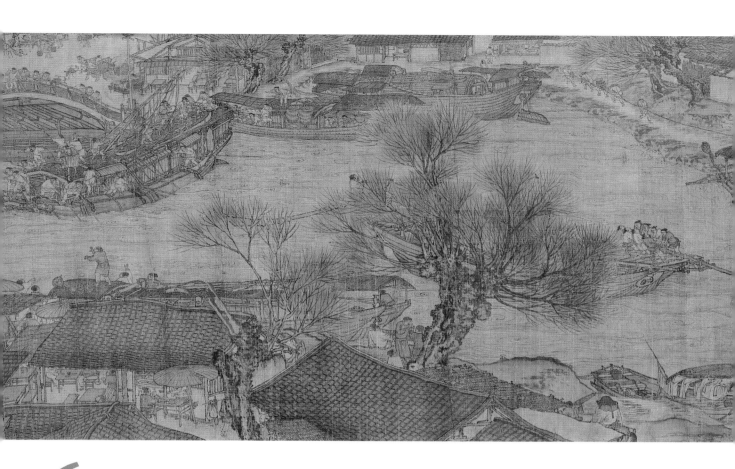

'*… this Song dynasty handscroll painting enjoys legendary fame, being as familiar in China as the* Mona Lisa *is in the West.*

those who had been lucky enough to view it. Yet none of them could have seen the original, since without exception all the copies depict the rainbow bridge as being made of stone, not wood, and show barges with sails instead of tracking teams on the towpath: there is accordingly no drama of boats bound upstream and downstream, encountering one another as they pass.

The Northern Song dynasty is best known in the West for subtly glazed porcelain and monumental landscape paintings. The setting for this painting, in the middle of the Central Plains, allows for no grandiose mountain views (though the hapless authors of later versions never failed to include a range of mountains in the opening section). Instead, the artist displays the thriving urban economy that afforded the means for the creation of such unmatched ceramics. Only one other painting, *Carts at the Mill* in the Shanghai Museum, depicts similar scenes: heavily laden ox-carts delivering grain to an impressive state watermill. *Carts at the Mill* is generally held to be a 10th-century painting; the *Qingming* scroll is closely related: its vivid portrayal of life in the capital in its heyday testifies to the personal experience of its author.

A Fresh Start

Vishnu Reclining on the Serpent Anantha, Unknown artist

JOHN GUY

> *Vishnu ... the great creator ... awakens from his cosmic sleep on the coils of the giant serpent ... Anantha, 'the infinite'.*

Above

Vishnu Ananthashayana, depicted in a 7th-century rock-cut shrine at Mamallapuram, in the coastal state of Tamil Nadu. This relief sculpture is among the earliest indications of the importance of the Vishnu creation myth in the art of southern India, from where it was probably transmitted to Cambodia. The heroic nature of the subject combines with the startling level of naturalism to create one of the most inspired renderings of this subject in Indian art.

c. 1060
Copper alloy, with traces of inlay, now missing
120 cm × 222 cm / 3 ft 11¾ in. × 7 ft 3 in. (estimated original length c. 6 metres / 19 ft 8 in.)
From Western Mebon, Angkor, Siem Reap, Cambodia, now in the National Museum of Cambodia, Phnom Penh

This spectacular icon of Vishnu represents the moment when the great creator of the Hindu universe awakens from his cosmic sleep on the coils of the giant serpent Sesha (also known as Anantha, 'the infinite'). Hindu cosmology is premised on a cyclical vision of time, whereby in successive epochs the universe is consumed by a great flood, becoming a formless ocean. Between each epoch, Vishnu enters a cosmic sleep, floating on the back of Sesha on the formless ocean, awaiting the appropriate moment to intervene in worldly matters. Vishnu thus serves as both the creative force and the restorer of order from chaos.

Depictions of this creation myth can be found as early as the 5th century in Indian temple art – the earliest example is the monumental rock-cut relief at Udayagiri, Madhya Pradesh, in central India, while a famous example exists in the 6th-century Gupta temple at Deogarh. Perhaps the most powerful representation, and the one closest to the tradition that emerged in Cambodia, is the 7th-century rock-cut shrine dedicated to Vishnu Ananthashayana at Mamallapuram. In Cambodia itself we find a near-contemporary version of this subject in a lintel from a Pre-Angkorian temple in a style associated with Prei Khmeng, located near the Western Mebon, Angkor region. The fully elaborated subject depicts the four-armed Vishnu reclining in a deep cosmic sleep on the coils of the serpent with a lotus stem growing from his navel, upon which presides Brahma, here serving as Vishnu's agent for change. In some representations, Vishnu's consort Lakshmi massages his feet.

The worship of Vishnu was imported early into Southeast Asia alongside other Indic cults. That this representation of the god should be chosen for a monumental cult image in a temple created by King Udayadityavarman II (r. 1050–66) is testimony to the power of the Vishnu creation myth and its intimate associations with the life-giving powers of water. The siting of this cult image on an artificial island in the heart of one of the two greatest reservoirs built in Angkorian history underscores the water symbolism – something that also chimed with existing Khmer beliefs in the power of water and *nagas* (snake-guardians of the subterranean realms). We may imagine this icon worshipped in a manner not dissimilar to that still performed today at the Vishnu pool-shrine at Budhanilakantha in the Kathmandu valley, Nepal, with lustration *pujas* performed according to the temple calendar.

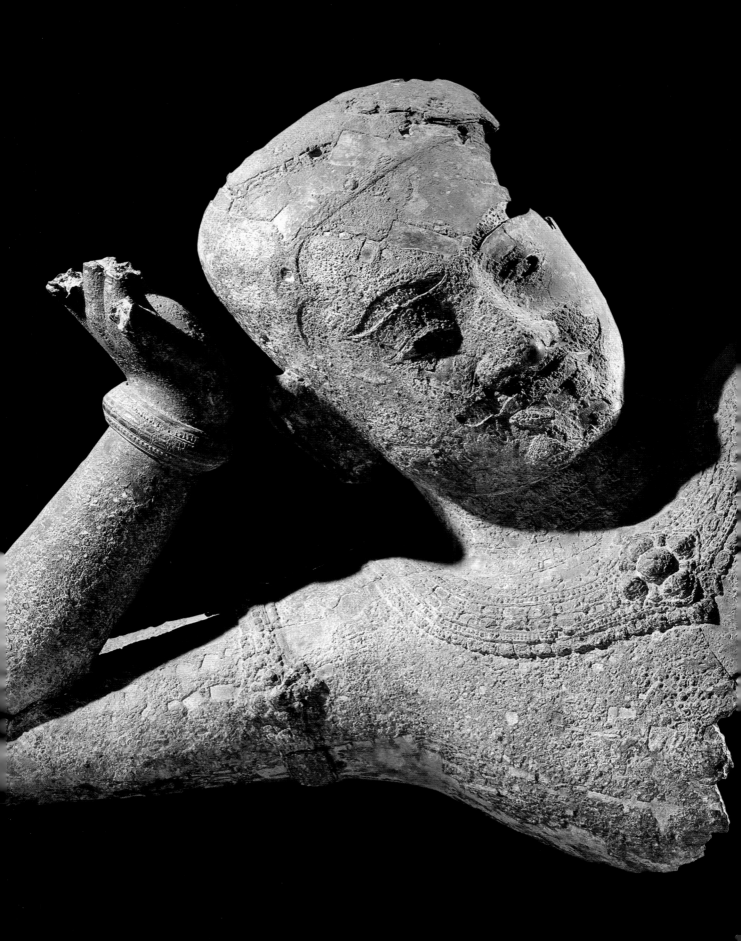

This sculpture was rediscovered in 1936 by the French archaeologist Maurice Glaize in the ruins of the Western Mebon temple on a man-made island in the great reservoir (*baray*) west of the royal city of Angkor Thom. In addition to the intact section seen here, consisting of head, upper torso and the two right arms, further fragments were recovered. The complete figure would have exceeded 6 metres (19 ft 8 in.) in length. It is clear from the joining seams and the use of rivets that it was cast in sections; traces of such fixing are still visible where the crown (probably a conical fixture of gold or gilt copper sheet) was once secured. The other beautifying jewelry, such as the elaborate torque, armbands and bracelets, are cast into the fabric of the image, where instead there might have been spaces reserved for detachable jewelry. In all likelihood the entire figure was gilded, and was further enhanced with inlays of contrasting precious metals in the eyebrows, eyes and moustache – most probably silver with the addition of rock crystal for the pupils.

This is the largest bronze image ever recorded from Cambodia, and without rival in this period in all of Southeast Asia. Its importance however transcends its scale. Aesthetically it is unmatched in the corpus of Angkorian bronzes. The sculptor has created in the inclination of the head, the poise of the two arms – which do not actually support the head but rather rest in space – an image of sublime ease. This is a god emerging from slumber – his eyes are open, his face alert.

‘ *This is the largest bronze image ever recorded from Cambodia, and without rival in this period in all of Southeast Asia.*

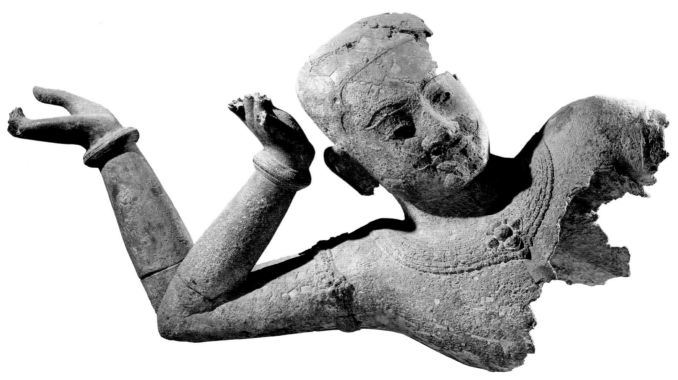

The full radiant beauty, gravitas and majesty of this figure, installed in its tank of flowing water, would have been inspiring for all who saw it. Its placement on a small temple-island in the Western Mebon would have ensured, however, that this was only a select few – perhaps just the king, his entourage and an elite corps of Brahman priests. Zhou Da-guan, member of a Chinese delegation who resided at Yasodharaura (Angkor) in 1296–97, described a shrine in a great lake that had a 'bronze reclining Buddha with water constantly flowing from its navel'. Could it be that Zhou Da-guan was describing from hearsay the great Vishnu reclining on Sesha that had been placed under worship some 230 years earlier? Certainly he referred to great numbers of golden and bronze images at several major shines in and around the Angkor Thom area. In 1983 a life-sized silver-copper alloy bull was discovered in Tuol Kuthea in southern Cambodia, evidence of the widespread making of monumental metal images in early Cambodia.

This shrine and its life-sustaining icon were undoubtedly conceived as essential to ensuring the fertility and prosperity of a kingdom whose wealth and power was built in large measure on the management of water. That this bronze was an image of sublime beauty and majesty capable of attracting the god's pleasure would have assured the image's efficacy.

Above

Vishnu Ananthashayana (7th century), in a temple tank, in situ at Budhanilakantha, Kathmandu, Nepal. This is perhaps the most perfect realization of the myth of Vishnu's cosmic sleep, in which the three key elements, the god, the serpent and the cosmic ocean, are in absolute harmony. In its pool setting, this version comes closer than any other South Asian rendering to the 11th-century image from the Western Mebon in Cambodia. However, it differs profoundly in that Vishnu is deep in his cosmic sleep and not, as in the Angkorian bronze, alert and engaging.

Opposite top

The Western Mebon Vishnu, during excavation in 1936. The sculpture was found fragmented into numerous pieces, perhaps broken up intentionally for scrap; substantial portions of the figure have never been located.

All Around the World

The Vézelay Tympanum, Artist unknown

JEAN-RENÉ GABORIT

> *In the centre, within a slightly concave almond-shaped mandorla, Christ sits enthroned with his arms open wide.*

Above
The apostles gather around a huge Christ. From Christ's fingertips emanate rays of flame.

c. 1130
Stone
W 600 cm / 19 ft 8 in.
Abbey Church of La Madeleine, Vézelay, France

The 12th century in France saw a remarkable campaign of cathedral and abbey building in the style today known as the Romanesque. Most of these buildings included high-quality and inventive sculpture, the most important element of which sat about the main doorway – the tympanum. Typically, tympana show didactic scenes, such as the Last Judgment. The example in the narthex (porch) at Vézelay is altogether more puzzling.

In the centre, within a slightly concave almond-shaped mandorla, Christ sits enthroned with his arms open wide. From the tips of his fingers (although one hand has been damaged), rays of flame shoot out and touch the heads of the apostles, barefoot and holding books, who are seated around him. The eight strictly compartmentalized reliefs that frame the central scene have given rise to various interpretations. The two seated figures on the left have been identified as authors of antiquity or early Christianity (Aristotle? Pliny? Isidore of Seville?) though their bare feet suggest instead that they are the evangelists Saint Luke and Saint Mark, who are not included among the group of apostles. The next compartments show the many peoples of the world: the Jews, personified by their king Jeroboam, with his 'dried up' right hand; the Cappadocians, who according to a Byzantine legend were born from Siamese twins; and in the compartment next to Christ's head, Arabs (in the form of a doctor tending to a crippled man) and the peoples of India (including two with the heads of dogs). On the right, the lowest compartment may represent Armenians, recognizable by their dress and their shoes with pattens; above them is a Greek, armed with the fearsome 'Greek fire', confronting a barbarian; in the next compartment, the remains of an inscription have allowed the old man leaning on a crutch to be identified as King Priam, admonishing the people of Troy; and in the topmost compartment, closest to the head of Christ, two of the figures have flattened noses and may be Ethiopians.

The 'ethnological' interpretation of these eight reliefs (although there have also been attempts to identify them with episodes from Homeric tales, particularly the story of Circe in the fourth compartment on the left) seems to be confirmed by the figures on the lintel running under the central scene. On the left-hand side we see a scene of pagan sacrifice (recalling, perhaps, the Romans); behind the bearers of offerings, a group of archers may represent one of the barbarian peoples of the East (aside from the Parthian horsemen). On the right-hand side we see (from left to right) a warlike crowd of peoples from Europe, the Pygmies (using a ladder to mount a horse), the giant Macrobii of India, and the Panotii with their huge ears.

This exceptionally detailed representation of 'all nations' or 'all people' (Psalm 72: 17; Luke 2: 31) moving in procession towards Christ the Redeemer

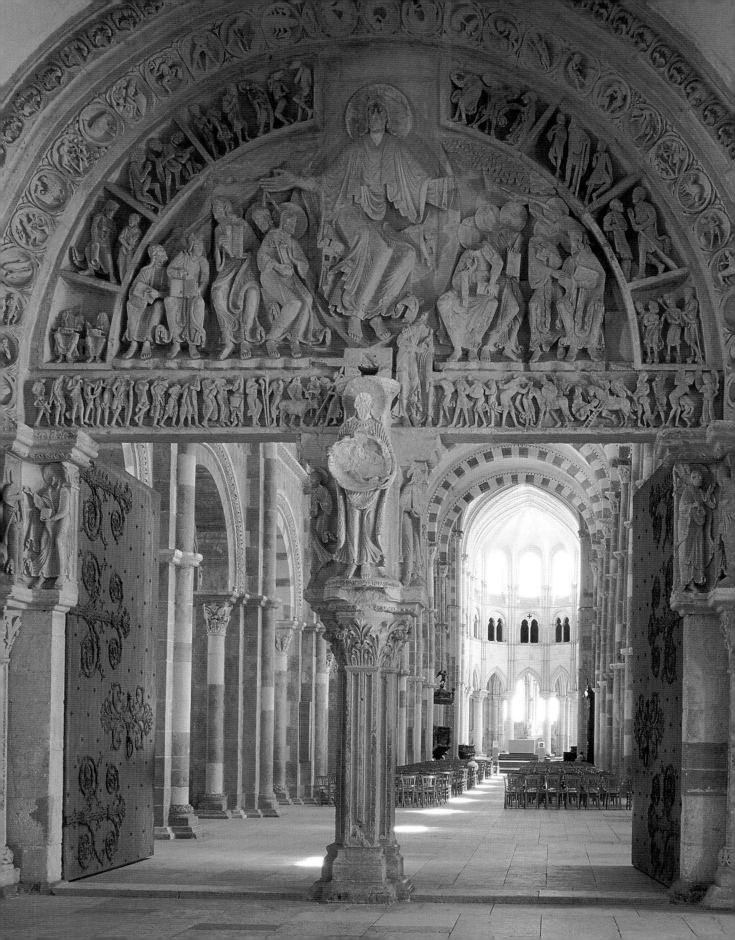

... the sculptor gave the programme form with such skill that the power of the imagery is undeniable, even to those who cannot decipher its multiple meanings.

provides the key to the iconography of the Vézelay tympanum, which is neither a Last Judgment nor a Second Coming of Christ. It affirms the cosmic power of the Son, whose shoulders are framed with the waters (or perhaps clouds) and the plants of the Earth. The signs of the Zodiac and the Labours of the Months in the roundels that make up the first archivolt portray his mastery over passing time. Despite the rays that shine out to touch the heads of the apostles, the tympanum is not a representation of the events of the Pentecost (Acts 2: 1–4), nor of the 'Mission of the Apostles' (John 20: 21–23; Luke 24: 45–49); instead, it is a masterly interpretation of the conclusion of the gospel of Saint Mark: 'And they went forth, and preached everywhere.'

Who was the creator of this exceptional programme, which testifies to both deep theological understanding and a remarkable knowledge of secular texts? Renaud de Semur, Abbot of Vézelay from 1106 to 1128, is the most probable candidate, although the name of Peter the Venerable, future Abbot of Cluny and Prior of Vézelay until 1120, has also been suggested.

When construction of the present-day nave and its façade was begun, following a fire that ravaged the abbey in 1120, the plans probably included only a broad and slightly raised portal, beneath a simple porch. However, the former element was quickly replaced by the much more ambitious narthex, with a central vault slightly higher than that of the church. The piers that had already been built for the porch were surmounted by short fluted columns and figures in very high relief (including an impressive group of the saints Peter and Paul). To create a link between the two levels, the central pillar features a monumental figure of John the Baptist in front of a fluted column,

a possible holdover from the earlier plans. The desire to create a more fitting setting for the grandiose iconography, which was developed after building work had begun, may account for this radical modification.

But the originality of the iconography alone is not enough to explain the exceptional quality of the Vézelay tympanum: the sculptor gave the programme form with such skill that the power of the imagery is undeniable, even to those who cannot decipher its multiple meanings. In the massive figure of Christ, whose asymmetric pose is majestic without being static, it is not so much his face (which is almost drowned in shadow and set outside the semi-circular field of the tympanum) but his huge right hand that attracts our gaze. The broad and flowing drapery of his long robe creates a dynamic that animates the whole composition; the apparent indifference to proportions, as well as the strongly expressive poses and the non-realistic but deliberate stylization of the main figures, show that the Romanesque artist was not seeking to transpose natural forms into stone but to give material form to the truths of the faith in the eyes of worshippers.

The principal master would certainly have required the aid of collaborators to sculpt the six large blocks that form the tympanum itself; the group of apostles on the left do seem to be of slightly lesser quality than their counterparts on the right. Nonetheless, the whole bears witness to a great conceptual unity. This master, who perhaps trained in the workshops of Cluny, remains anonymous; the monastery chronicle from the time of the abbot Hugues de Poitiers (1161–65) makes mention of a sculptor by the name of Lambert, but at this date the portal had already been complete for some thirty years.

Opposite
The 'monstrous races' who lived in far-flung countries were a popular subject in medieval art. Here a Pygmy mounts a horse with the help of a ladder.

Above
The many peoples of the world, all of whom come under the sway of Christ, include the giant Macrobii of India, and, to the right, the Panotii, with their enormous ears. Most of the information on these exotic races came from Classical Greek and Roman authors, such as Pliny.

The Light of The World

The Cefalù Mosaics, Artist unknown

JOHN JULIUS NORWICH

" … let your eyes adjust … to the cathedral twilight and follow the march of antique Roman columns … towards the sanctuary … past the high altar and the saints, the angels and … archangels … until at last, high in the conch of the great eastern apse, they are met by those of Christ.

Sailing from Naples to Palermo in the summer of 1131, King Roger II of Sicily was suddenly overtaken by a violent tempest. After two days, during which it seemed that all on board must perish, he made a vow: if they were spared, then at whatever point they should be brought safely to shore he would build a cathedral to Christ the Saviour. The next day – it was the feast of the Transfiguration – the wind dropped, and the vessel glided to a quiet anchorage in the bay of Cefalù. At one time it had been a prosperous little town, the seat of a Greek bishop in Byzantine days; but the king's father, Roger I, had sacked it during his conquest in 1063. Now it was for his son to make amends. Stepping ashore, he called for measuring-rods and set to work at once. So, at least, runs the legend. All we can know for certain is that on 14 September 1131 Cefalù was once again given a bishop of its own – a Latin one this time – and that already, by that date, the building had begun.

But the cathedral was only the beginning. Roger was the true creator of the Sicilian kingdom, grafting as he did a relatively small Norman element onto a population previously split between Greek and Arab; and in doing so he became the only man ever to have almost single-handedly fused the cultures of three of the great races of the Mediterranean into a single, harmonious, trilingual state. True, there is little of the Arab in evidence here; to see the influences of all three in happy coexistence you must go to Roger's exquisite Palatine Chapel in Palermo, with its Latin plan, its Greek mosaics and its purely Islamic stalactite roof; this too is a miracle of beauty, but it possesses none of the sheer power of Cefalù.

Approach, if you can, from the west, along the old coast road from Palermo. A gently curving beach fringed with pine and prickly pear leads the eye along to a confusion of roofs, clustered at the far corner of a wide bay. Above and behind, but still very much part of the town, rises the Cathedral, dominating the houses below as effortlessly as its sisters at Lincoln or Durham. Once arrived in the little central piazza, we are struck by the perfection of the Cathedral's placing. The slope of the rock sets it, a little obliquely,

There is nothing soft or syrupy about him, yet the sorrow in his eyes, the openness of his embrace, even the two stray locks of hair blown gently across his forehead, speak of mercy, tenderness and compassion.

on a higher level than that of the square; it must be approached, like the Parthenon, at a slight angle and from below. And so the realization grows that here is one of the loveliest small cathedrals in the world. The façade with its twin towers – fraternal rather than identical – dates from a century after Roger's time but is none the worse for that: a sunny, southern Romanesque, uncluttered but never austere.

But the miracle is yet to come. Pass now through the municipal palm trees, up the surprisingly steep staircase, between two rather endearing Baroque bishops in stone, and across the upper courtyard. Once inside the building, let your eyes adjust themselves to the cathedral twilight and follow the march of antique Roman columns and their slender arches towards the sanctuary. From there they are led up, past the high altar and the saints, the angels and the archangels ranged above it; until at last, high in the conch of the great eastern apse, they are met by those of Christ.

He is the Pantocrator, the Ruler of All. His right hand is raised in blessing; in his left is a book, on which is written 'I am the Light of the World' in both Latin and Greek – and rightly so, for this mosaic, the glory of a Roman church, is of purest Byzantine style and workmanship. Of the master who wrought it we know nothing, except that he was almost certainly summoned by Roger himself from Constantinople and that he was unquestionably a genius. And at Cefalù he produced the most sublime representation of Jesus Christ in all Christian art. Only one other Pantocrator, at Daphni just outside Athens, can be said even to rival it; near contemporaries though they are however, the contrast between the two could hardly be greater. The Christ of Daphni is dark, and heavy with menace; the Christ of Cefalù, for all his strength and majesty, has not forgotten that his mission is to redeem. There is nothing soft or syrupy about him, yet the sorrow in his eyes, the openness of his embrace, even the two stray locks of hair blown gently across his forehead, speak of mercy, tenderness and compassion. Byzantine theologians used to insist that religious artists, when representing the Redeemer, should seek to reflect the image of God. It was no small demand, but here – perhaps like nowhere else – the task has been triumphantly accomplished.

Beneath him, his Mother stands in prayer. Such is the splendour of her son, the proximity of the four archangels flanking her and the glare from the window below, that she can easily pass unnoticed: a pity, since if she were standing in isolation amid the gold – as she does, for example, in the apse at Torcello – she too would be hailed as a masterpiece. (The archangels are dressed like Byzantine emperors, even to the point of carrying the orb and *labarum* of the imperial office.) Further down still are the twelve apostles, less frontal and formalized than they often appear in Eastern iconography, turning a little towards each other as if in conversation. Finally, on each side

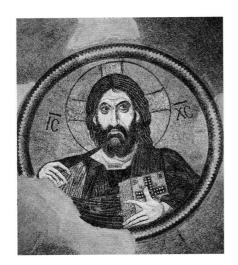

Above
A mosaic of Christ Pantocrator in the central cupola of the Church of Daphni, near Athens, is almost exactly contemporary with the mosaic at Cefalù.

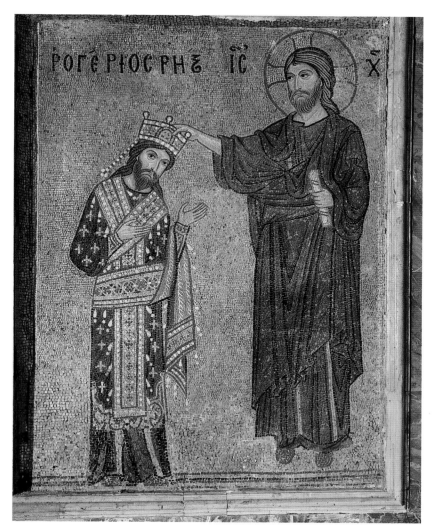

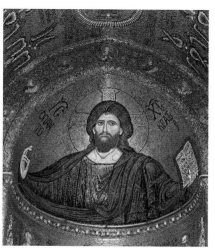

of the choir, stand two thrones of white marble, studded with Cosmatesque inlays, red and green and gold. One is the bishop's; the other was that of the king.

Here King Roger must have sat during his last years, gazing up at the magnificence that he had called into being; an inscription beneath the window records that all these apse mosaics were completed by 1148, six years before his death. He always conceived of this cathedral as his own personal offering, and had even built himself a palace in the town – traces of which still remain – from which to superintend the building operations. And so it can have come as no surprise to his subjects when, in April 1145, he designated it as his burial-place, endowing it at the same time with two porphyry sarcophagi – one for his own remains and the other, as he put it, 'for the august memory of my name and the glory of the Church itself'. Alas, his wishes were disregarded – he now lies amid the vacuous pomposities of Palermo Cathedral – and it is hard to leave Cefalù without putting up a quick, silent prayer that the greatest of the Sicilian kings may one day return to rest in the church which he loved, and where he belongs.

The Edge of Nothingness

The Reclining Buddha of Polonnaruwa, Artist unknown

ANTONY GORMLEY

Parinirvana: the moment the Buddha passes from earthly existence into the state of conscious non-being. This concept, strange to Western, monotheistic minds and transcendent expectations, is not about the eternal soul but rather about the final realization of the relation of being and non-being, matter and void.

This astonishing sculpture of the Buddha was carved in the mid-12th century at the great city of Polonnaruwa in central Sri Lanka during the reign of King Par kramab hu I. Some fourteen metres long, the head alone measures almost two metres in diameter. Traditionally, the West has been resistant to the hyperbolic image, associating it with inflated egos and totalitarian monuments. However, colossal Buddhist iconography, from the great Buddhas of Bamyan in Afghanistan and those of Luoyang in China to the more recent example – some 416 metres long – being carved in Jiangxi Province, has always embraced scale to reinforce the public and collective nature of this philosophy of life.

The scale of the Polonnaruwa Buddha is monumental but conveys a quiet joy and a sense of engagement and peace that has nothing to do with being dominated but everything to do with a precious sense of sharing space and place. This feeling is the result of an acceptance of the earthly in an image that is in and of the ground and is gently (and so differently from the greatest Western treatment of this subject, the four *pietàs* by Michelangelo) returning to it.

The Buddha is carved from grey granite striated with white quartz lines. This striation suggests two quite different things: the 'dream' of life that like a river passes through names and forms (*Namarupa*), but also its very opposite: the reinforcement of material reality, palpable, perceivable and bounded by time and space.

The coexistence of image and landscape would be a brilliant conceptual proposition by itself, but to have realized it with such grace and formal purity is a miracle: literally an apparition in the real. Here is the abstract body of Buddhism that has taught me so much – the body itself seen as a site, to *be with* more than to *show*. It succeeds by the acute tension between precept and a feeling for form inherent in this Indian-influenced approach to sculpture.

This approach manifests itself in four key ways. First, there is the sense of full volume shared by the works of the Gupta, Pala and Chola Indian empires: a convex, taut surface that, like the skin of an apple, conveys a sense of the fullness of life below it. Second, the forms of the body are based on proportional rules that are almost like preset algorithms: 'long and slender fingers and toes all the same length, feet with level treads', in the words of the *Digha Nikaya*, a collection of Buddhist dialogues. This has nothing to do with Greek, Classically idealized or anatomically accurate models of

> *... colossal Buddhist iconography ... has always embraced scale to reinforce the public and collective nature of this philosophy of life.*

Opposite
An unknown sculptor carved a subtle depression in the pillow supporting the Buddha's head. This optical illusion contrives to make the vast stone head appear practically weightless.

Mid-12th century
Granite
L *c.* 14 metres; H *c.* 4 metres /
c. 46 ft; *c.* 4 ft 3 in.
Polonnaruwa, Sri Lanka

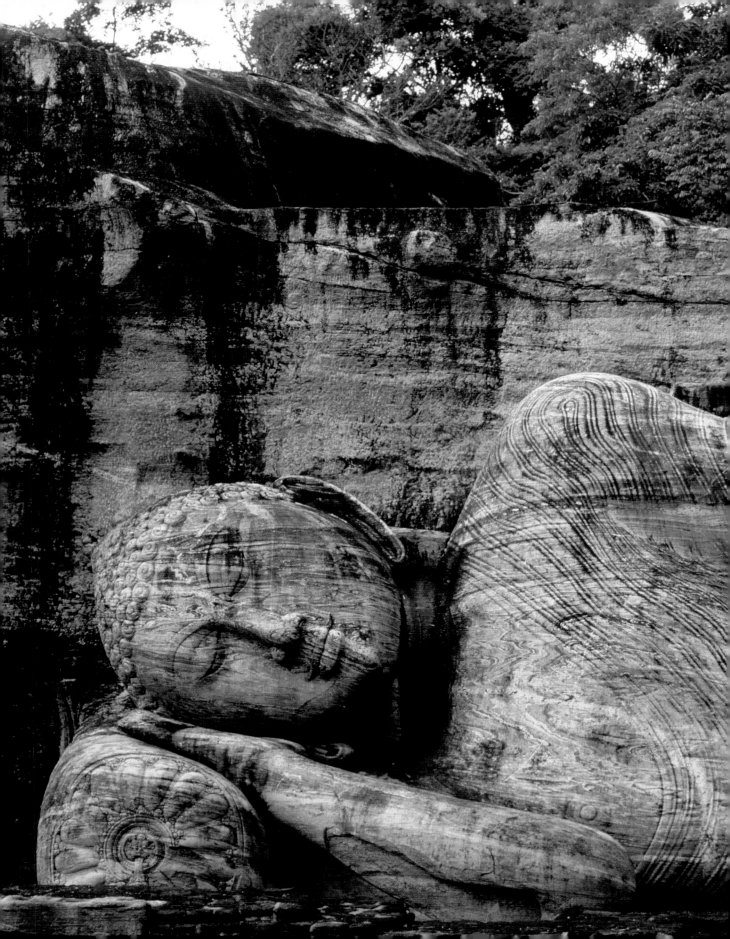

Here is the abstract body of Buddhism that has taught me so much – the body itself seen as a site, to be with more than to show.

representation. Third, the tracing of surface lines allude to the curls of hair, the folds of skin or cloth but are less about representation than a play or animation of surface. Finally, the reclining Buddha exhibits a notable grasp of the underlying body, seen very powerfully in the subtle indentations of the diaphragm and the solar plexus: the source of *prana* or breath.

It is this treatment of vitality in mass that is this work's most remarkable feature. The feeling of mass at rest is clear. The shape and size of a beached blue whale, there is a sense of a quiescent force in this object/place. Look at the extraordinary curvature of the left arm that lies like a sleeping snake on the upper thigh ('arms long enough to touch and rub the knees without bending over', stipulates the *Digha Nikaya*) exuding, like the whole sculpture, a sense of vital peace hard to reconcile with its size.

And what about the head and the expression it carries? The bird-winged eyebrows that echo the hovering smile and typically down-turned eyes that in this vertical orientation do not simply express *samadhi* – concentrated meditation – but the transition of consciousness in the final release of Nirvana. The Buddha's head is round like a globe, the eyes half-closed, the lips half-smiling.

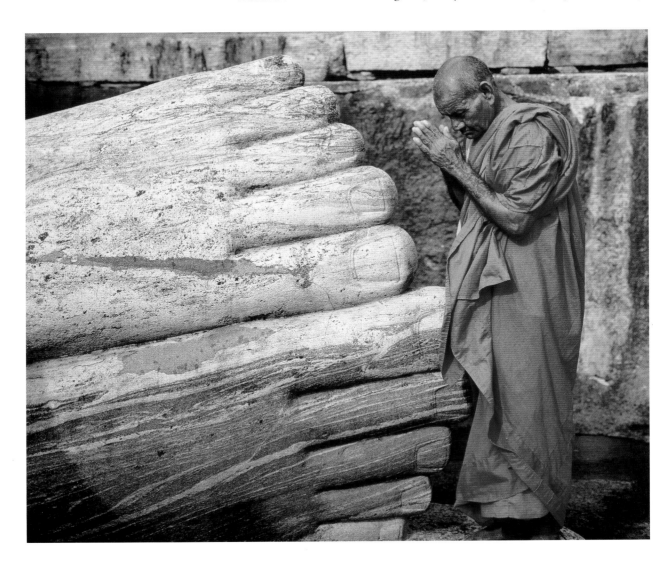

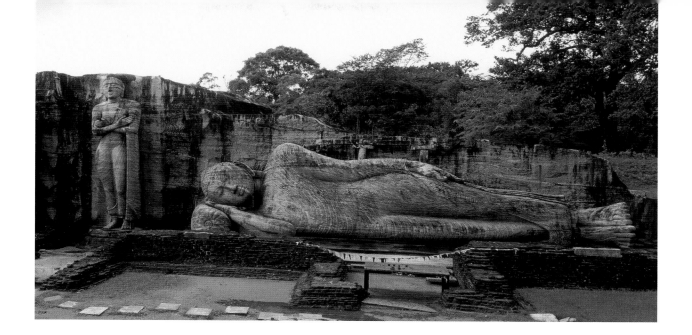

> *Look at the extraordinary curvature of the left arm that lies like a sleeping snake on the upper thigh … exuding, like the whole sculpture, a sense of vital peace hard to reconcile with its size.*

What does the total image actually convey? The body is conscious but at rest, the formal relation between a carved horizontal plane and the multiplicity of curves, inscribed and volumetric. It conveys an acceptance of being over doing, acceptance of dependency but also the celebration of being itself.

We in the Western world, lost in a tangle of obligation, work and duty, are tied to *doing* – perhaps doing good, but achievement nevertheless. The notion of discovering our nature in nature and our dependency on a geological and telluric earth comes to us rarely. Perhaps sculpture is the only art form – at least when fully integrated to site and exposed to the elements – that can convey this dimension of the human condition. In rare moments of non-action we might glimpse it; submerged half-awake in a warm bath with consciousness at the horizon of its perception we might feel what this work conveys: a closeness to the hard duration of things and our ability to escape it.

Opposite
A saffron-robed monk stands only as high as the toes of the Buddha.

Above
The great statue would originally have been displayed in a wooden image-house. Though now exposed to both the elements and the tourists, the Buddha seems monumentally unperturbed.

Revolutionary Realism

Muchaku and Seshin, Unkei

DONALD F. McCALLUM

'*The figures of Muchaku and Seshin … must rank among the greatest portraits produced in any country or period.*

Opposite
Muchaku (right) is shown in deep concentration. He holds in his hands a bag thought to contain a Buddhist ritual object. Both priests wear robes of the kind worn by contemporary prelates in Japan. The drapery folds show an extraordinary naturalism.

c. 1208–12
Wood and polychromy
Muchaku: H 194.7 cm / 6 ft 4¾ in.
Seshin: H 191.6 cm / 6 ft 3½ in.
Kōfukuji, Hokuendō, Nara City, Japan

Within the corpus of Japanese Buddhist sculpture, no category is more interesting than that of priest portraits, even though representations of deities are generally better known. While sculpted portraits are found in the Nara (710–94) and Heian (794–1185) periods, the highpoint of this genre is undoubtedly the Kamakura period (1185–1336), an era characterized by an intense concern with realism. The figures of Muchaku and Seshin are perhaps the best examples of this tendency, and must rank among the greatest portraits produced in any country or period.

Definition is essential here – the two statues are putative depictions of the ancient Indian theologians Asaṅga (known in Japan as Muchaku) and Vasubandhu (Seshin), but they cannot be considered literal portraits of the historical individuals because the sculptor who produced them, Unkei (*c.* 1150–*c.* 1220), could have had no direct knowledge of their actual appearances. Rather, Unkei has rendered the two sages as East Asians, not as Indians, and yet the superb realism, especially in their faces, conveys a sense of a living presence. In that regard, they should be seen as idealized portraits, presumably based on people that Unkei either knew or had seen in Nara.

Kōfukuji, where the statues have been housed since their creation, is one of the most important of all Japanese temples; it belongs to the Hossō school, and the brothers Muchaku and Seshin were the authors of that school's foundational texts. Consequently, although they are not worshipped they receive the highest respect and veneration. Kōfukuji, like many other important temples in the city of Nara, had sustained major damage during the civil war of 1180, and had to be rebuilt – giving Unkei and his studio the opportunity to work on a commission of the highest importance.

Kamakura sculpture was strongly influenced by that of the earlier Nara period, a time when realism also dominated, and certainly the two statues look back to the 8th century rather than reflecting the more elegant styles of the immediately preceding Late Heian period of the 11th and 12th centuries. Of course, the strong sense of animation seen in the sculptures reflects the genius of Unkei, as he combined the earlier Nara style with his own vigorous, expressive mode. Efforts have been made to associate the realism and vitality of the two statues with the spirit of the newly powerful warrior class but it is important to keep in mind that Kōfukuji was a traditional temple, connected with the aristocratic Fujiwara clan – meaning that, on balance, it is likely that the representations of Muchaku and Seshin have more to do with sculptures of the Nara period than they do with warrior culture. Either way, there is little disagreement among scholars that Unkei is the greatest sculptor of the Japanese Buddhist tradition and that these two statues are the culmination of his career.

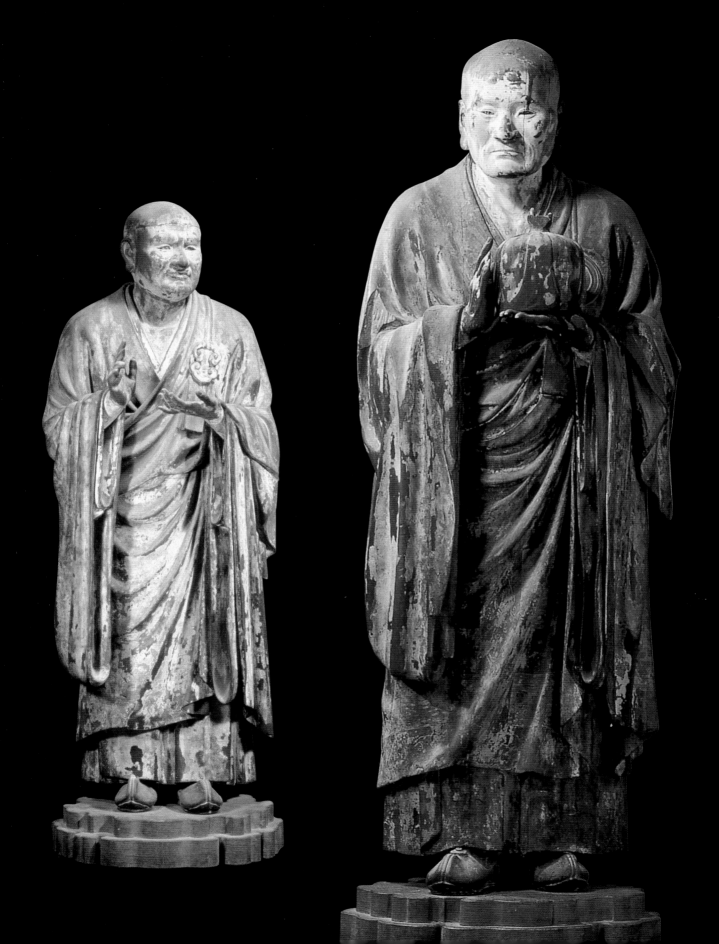

The Kingdom of Heaven

The Stained Glass of Chartres Cathedral, Artists unknown

PAINTON COWEN

'*Miracles abound in these scenes – reassuring, ... for 13th-century pilgrims, who had come to Chartres in search of their own miracles.*

Opposite
The south rose window, *c.* 1225. Christ of the Apocalypse, surrounded by angels and the symbols of the Evangelists, and (in the outer circle) the Twenty-Four Elders. Below, the Evangelists appear on the shoulders of the four major prophets: (left to right) Luke on Jeremiah, Matthew on Isaiah, John on Ezekiel and Mark on Daniel; in the centre is the Virgin Mary carrying the Christ Child (detail above). At the bottom of the lancets are the donors of the window, the Count of Dreux, Pierre Mauclerc, and members of his family.

c. 1200–30
Stained glass
Chartres Cathedral, France

The stained glass of the cathedral of Chartres is unique in many ways. Nowhere else has so much medieval glass survived the wars, storms, religious bigotry and neglect of the centuries. Of 173 original windows, 143 are still largely intact – in total there are nearly 1,500 panels with scenes and figures that together comprise a practically unrivalled library of images of medieval life and belief. But apart from that, seen as a whole it constitutes an artistic programme of a quality and ambition rarely found elsewhere – indeed, in iconographic complexity and ambition it is comparable with Michelangelo's Sistine Chapel Ceiling or Giotto's Scrovegni Chapel.

The cathedral that we see today dates largely from after the fire of 1194, which destroyed all but the west end of the old Romanesque building. The chance to build a bigger, better cathedral in the latest Gothic style must have been seized upon by the clergy, and those responsible for the rebuilding – almost certainly a combination of artists and priests – conceived of a programme that would unite stained glass, architecture and sculpture into a ringing statement of the Church's authority and dogma. One of the great innovations of Gothic architecture was the flying buttress, which channelled the load of the roof vaults away from the walls, which meant, in turn, that the windows could be larger. The increased area available for glass allowed for an expanded iconography and even for a whole new vocabulary and means of expression through stained glass. This resulted in an explosion of creativity during the second half of the 12th century that reached its peak in the High Gothic cathedrals of the 13th century – at Bourges, Reims, Amiens, Paris and above all at Chartres.

The installation of the glass at Chartres took place over thirty or so years, beginning in about 1205. The impact on those making their first visit to the cathedral is often profound: many are surprised by how dark the interior is, even on a sunny day. The deeply coloured glass – mostly red, blue, yellow and green, with lesser amounts of purple, brown and pink – creates a magical atmosphere. This was, at least in part, intentional; after all, the Gothic cathedrals were in one sense an evocation of the Heavenly Jerusalem described in the Revelation to Saint John, and the windows were seen as the jewels of the celestial city.

The highlights are the three huge rose windows, placed at the north, south and west cardinal points of the building. These astonishing displays of light, colour and geometry celebrate the lives of Jesus Christ and the Virgin Mary (while also incorporating the arms of secular rulers – Blanche of Castile and a local duke), and set the tone for the rest of the glass. The high east window in the choir again underlines what was important, for it shows the Virgin Mary holding the Christ Child. The prominence of the Virgin in the

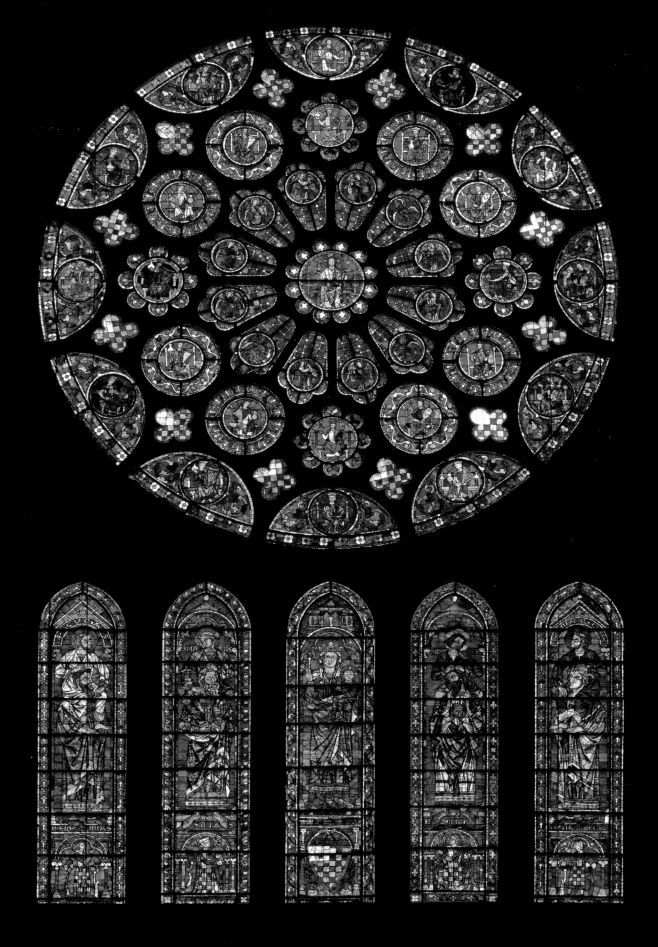

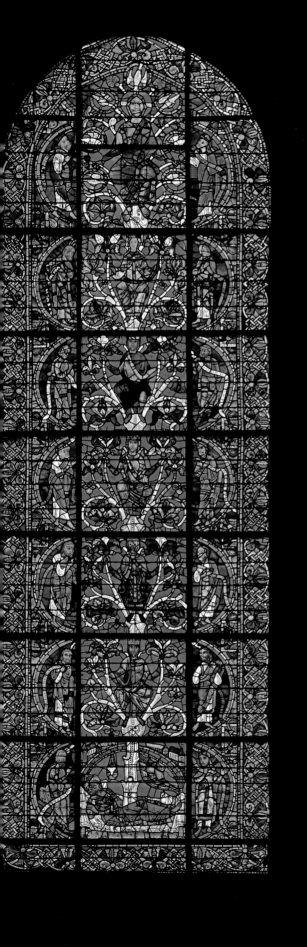
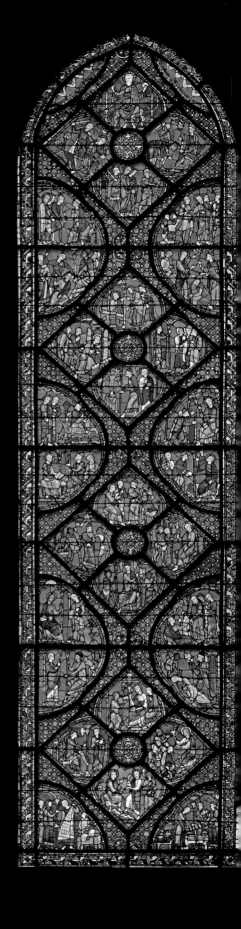

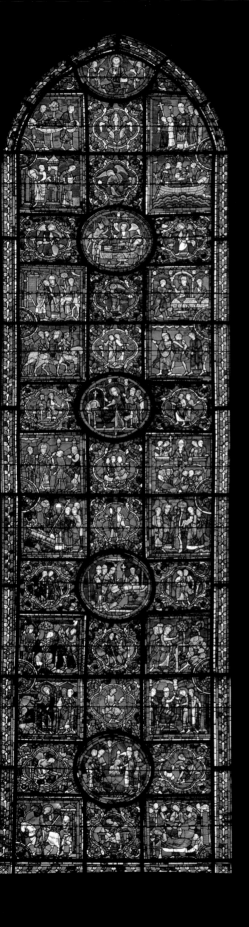
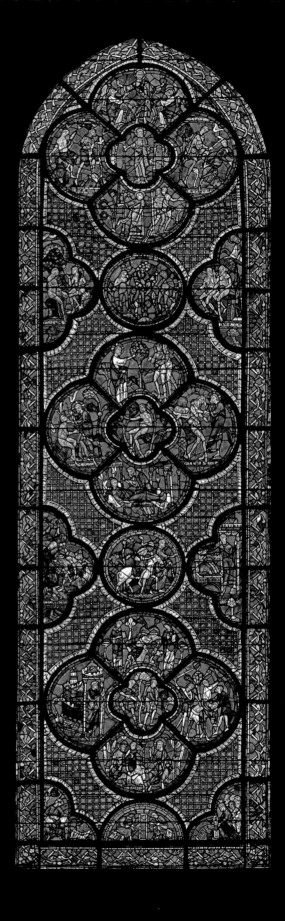

> *… nearly 1,500 panels with scenes and figures … together comprise a practically unrivalled library of images of medieval life and belief.*

pp. 92–93

Four of the fifty-one lancet windows at the lower level of the cathedral. The stories they tell generally unfold in sequence, running from bottom to top and left to right. The lowest row often portrays the window's donors. (Left to right): **Tree of Jesse**, *c.* 1150. One of the Romanesque windows that survived the fire of 1194, it shows Christ's lineage as prophesied in Isaiah: above Jesse, the father of King David, appear four kings of Judah, with the Virgin Mary and Christ at the summit, surrounded by seven doves symbolizing the gifts of the Spirit and the embodiment of Wisdom; along the sides are the prophets who foretold Christ's mission. **The Story of Saint James**, *c.* 1220. Given by the furriers, this window tells the story of the saint's life, focusing on the conversion of the magician Almogenes and his demons. The top nine scenes recount James's death at the hand of Herod. **The Story of Saint Martin**, *c.* 1220. Martin was a popular saint in France and he appears in a number of windows. In this one, given by the shoemakers, the story of his life and miracles are recounted in thirty-eight scenes: his birth is in the lowest central circle and his death in the highest circle, with Christ receiving his soul at the summit. **The Good Samaritan**, *c.*1210. The story of the Good Samaritan occupies the lower half of the window and the Fall of Adam and Eve the upper part. Through the Good Samaritan's actions the Fall is redeemed. This window was also given by the shoemakers, who appear at the bottom.

Right

Detail from the Prodigal Son window, *c.* 1210. Here he gambles away his inheritance at a game with dice and a chequerboard. He has been playing all night – the sun is rising – and he has lost his shirt, which can be seen on top of a pile of garments behind his adversary.

iconography at Chartres is not only due to the fact that the cathedral is dedicated to her but also because its most precious relic was her tunic – the *sancta camisa* – which had miraculously survived the fire of 1194, as had the famous window known as 'Notre-Dame de la Belle Verrière'. This particular devotion coincided with a broader 12th-century interest in the Virgin.

The east window in the ambulatory beyond the high altar reflects the concerns of the cathedral chapter. This important position was traditionally occupied by either the Tree of Jesse (showing the ancestors of Christ) or the Passion, but here at Chartres it is filled with the Lives of the Apostles. The choice of this subject reveals the main change of emphasis that took place in the Western Church at the beginning of the 13th century, away from great mystical themes and towards illustrations of the Christian life in action.

Answering to the same trend, almost all the windows running round the cathedral at ground level – the most visible windows to the lay congregation – are filled with the lives and stories of saints and the parables. They are masterpieces of narrative, organizing the stories in such a way as to draw theological parallels. Miracles abound in these scenes – reassuring, no doubt, to 13th-century pilgrims, who had come to Chartres in search of their own miracles. The high-up clearstory windows continue this theme, displaying mostly giant and stately figures of saints.

These accounts of the lives of the saints also tell us much about daily medieval life: royalty, knights, peasants, boats, carts and transport, build-

Above
Detail of the bakers, donors of the Apostles window, *c*. 1220. In the dough they are working can be seen the face of Christ – an allusion to his presence in the bread of the Eucharist (that fragment of glass is a 14th-century replacement). This and the detail opposite show how the window is made up: coloured glass is painted on the inner surfaces with the faces, folds of cloth and other decorative and textural details. The pieces of glass are held together by thin strips of lead (the black lines) and these assemblages are held in position by an iron armature.

... astonishing displays of light, colour and geometry ...

ings, animals, birds and nature, mealtimes, clothing, ceremonies – all these and more can be seen. Each panel expresses its scene with the utmost economy so that what is going on can be discerned at a glance and the participants instantly recognized; thus saints have haloes, while trees, towns and buildings are illustrated in a rudimentary fashion, and the attitudes and 'body language' of people are depicted, so that their thoughts, words and actions can be rapidly deciphered. And yet there is also a kind of 'hidden language' at work as well, the full meaning of which may be lost to our age. This is particularly noticeable in the gestures that certain figures make in their conversation or activities. The frequent appearance of devils, angels and the hand of God demonstrate the activity and involvement of supernatural forces or divine intervention.

An important social and cultural question about the stained glass at Chartres relates to who commissioned and paid for it. In most of the windows, both high and low, can be seen the donors, who were members of the clergy or the nobility, or associations of workers. The last category provides rare illustrations of many trades, including bakers, water-carriers, masons, furriers, cobblers, moneychangers, drapers, armourers, metalworkers, butchers and barrel-makers – the last of whom, with some sense of humour, chose for their window the drunkenness of Noah.

4

A New Beginning

1300—1500

Gods in the Family

Ife Copper Mask, Artist unknown

SUZANNE PRESTON BLIER

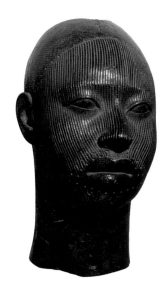

fe's remarkable corpus of copper and copper-alloy heads are among Africa's most technically accomplished and visually striking works of art. These heads appear to have been commissioned by King Obalufon II (the man credited with inventing casting in the region) to commemorate a truce he brokered between feuding indigenous and new dynastic families. All but one of the heads was unearthed at the Wunmonije royal compound, about 150 metres from the palace rear wall – a site identified as Obalufon II's burial place. Most likely the heads were originally housed in a shrine dedicated to the king and were used both in ceremonies honouring the ancestors of local chief priests and in enthronement rites of family leaders.

Descriptions of cast brass heads found in 20th-century Yoruba Obalufon shrines seem to support this interpretation. In interviews that I conducted with an Obalufon priest in the Ife area, he identified the bronze heads housed in his temple – works presumably modelled on the ancient Ife heads – as representing 'powerful human beings' (*imole, erunmole* earth spirits). The same priest was able to identify some of the deities and deified humans represented in the metal Obalufon heads in his temple: Obalufon II, Oramfe (the early god of thunder), Obatala (god of the autochthonous residents), Oluorogbo (the ancient Ife messenger deity), Obameri (an early warrior), Ore (an early hunter) and Oranmiyan (a famed military conqueror) – all key Ife historical, religious and political figures. These references reinforce current views that the heads served not only as portraits of leaders but also as symbols of office. Conceivably the works were linked to the Ogboni political group sponsored by King Obalufon II to promote the rights of indigenous chiefs and landowners.

The visual differences between the sculptures give us further clues as to their identity and meaning. Some have vertical line face markings, while others (including the Obalufon mask, shown opposite) have no marks: the former probably represent autochthonous chiefs, the latter new dynasty elites. Most of the plain-faced works feature holes around the male facial hairline, though this is less frequent in heads with face marks; it may be an indication of age seniority. Many of the heads with vertical face marks are cast from nearly pure copper (as is the Obalufon mask); all heads without marks are cast from a copper alloy, making a colour distinction (copper works being more reddish). This, along with their greater technical complexity, suggests that the autochthonous elites had greater sacral authority. The likely combination of life cast and free-hand sculpture techniques in the making of these heads adds to their iconic power. Rowland Abiodun has pointed out that in the Owo Yoruba area moist clay was applied to the faces of deceased elites to create a posthumous sacral reference (called *ako*); in Ife this practice was used for Ogboni elites. Similar *ako* clay models may have figured in the casting process, though heavily reworked to convey Ife stylizations and aesthetics.

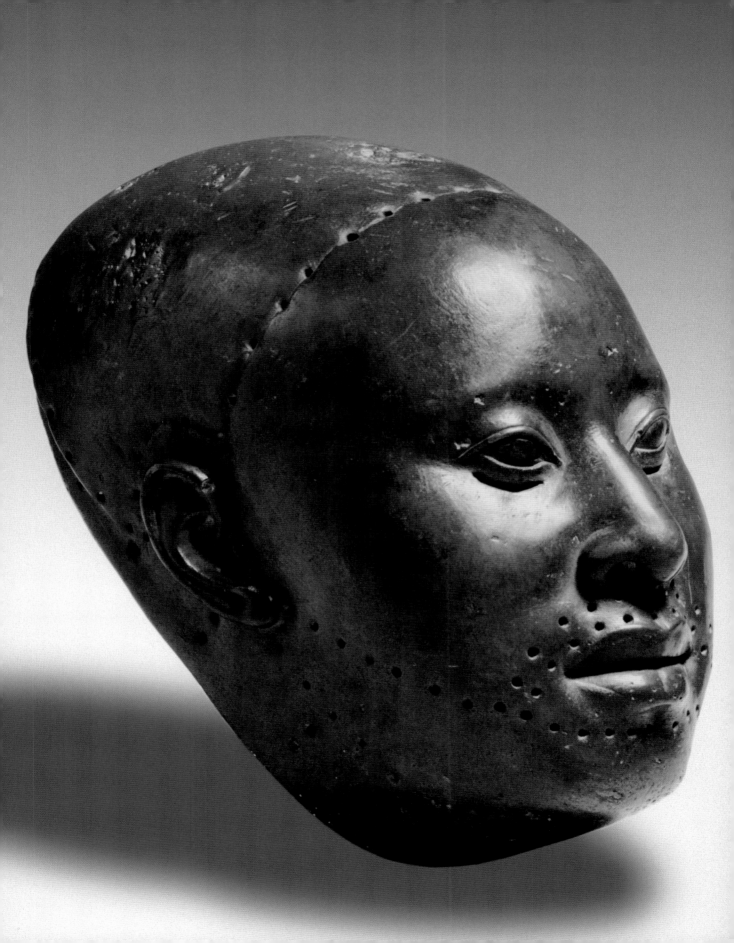

A Bid for Glory

The Scrovegni Chapel Frescoes, Giotto

GIUSEPPE BASILE

'*The broad message of this masterpiece is that if we meditate on and imitate the example of Christ, who died on the cross to redeem humanity's sins, we can avoid the horrors of Hell.*

Above
Detail of the *Last Judgment*, representing one of the damned, tormented by the devils of Hell.

Opposite
The pictorial decoration of the Scrovegni Chapel after its restoration, seen from one side of the apse.

1303–05
Fresco
Scrovegni Chapel, Padua, Italy

The decoration of the **Scrovegni Chapel** (also known as the Arena Chapel) in Padua, northern Italy, is without doubt one of the most important large-scale cycles in Western art. The painted surface occupies an area of over 900 square metres (1,100 square yards), covering the vault, the two side walls, the arch just in front of the apse and the inner façade. In total, more than one hundred subjects are represented, including many busts of prophets and saints, and, in the lower part of the side walls, *trompe l'œil* statues representing the Virtues and Vices that lead, respectively, to Heaven and Hell. However, the most important part of the cycle are the forty scenes depicting episodes from the lives of the Virgin Mary and Jesus (including his death and resurrection), while the culmination of the entire programme, a depiction of the Last Judgment, can be found on the wall by the entrance.

The broad message of this masterpiece is that if we meditate on and imitate the example of Christ, who died on the cross to redeem humanity's sins, we can avoid the horrors of Hell. Enrico Scrovegni, the man who commissioned the work, has apparently already achieved this, since he has had himself depicted on the side of the redeemed in the *Last Judgment*. (Elsewhere, the patron appears offering the chapel to the Virgin.) However, these frescoes also had a more concrete and earthly significance, constituting a sort of political manifesto: by commissioning the cycle from the most celebrated Italian painter of that time, Giotto di Bondone (1267–1337), who painted it between 1303 and 1305, Enrico, the richest man in Padua (indeed, one of the richest men of his age), was underlining his intention to become the lord of the city. Things did not work out quite as planned (in the end Francesco da Carrara became lord of Padua, and Enrico was forced into exile in Venice), but the decoration of this chapel was, and still is, considered one of the masterpieces that laid the foundations for Western post-medieval art.

In the Scrovegni Chapel cycle the theme of salvation – a relatively common subject at this time – is given a theological and philosophical base so complex and beautifully articulated that we may well detect the input of a particularly knowledgeable theological 'adviser'. Some have suggested that this adviser was the priest responsible for the chapel, though this is not

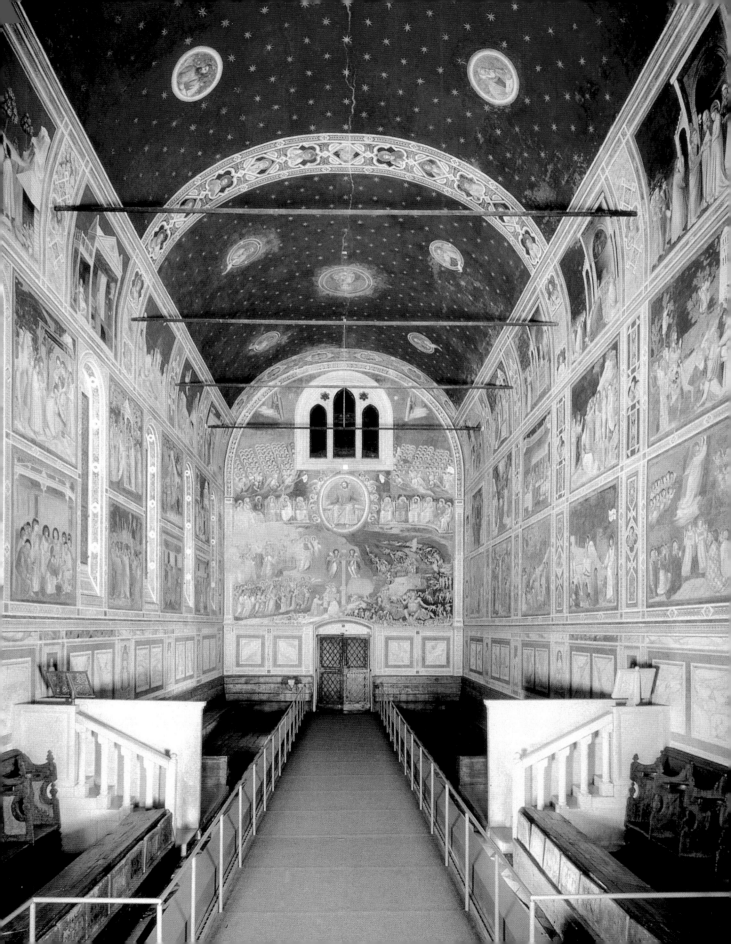

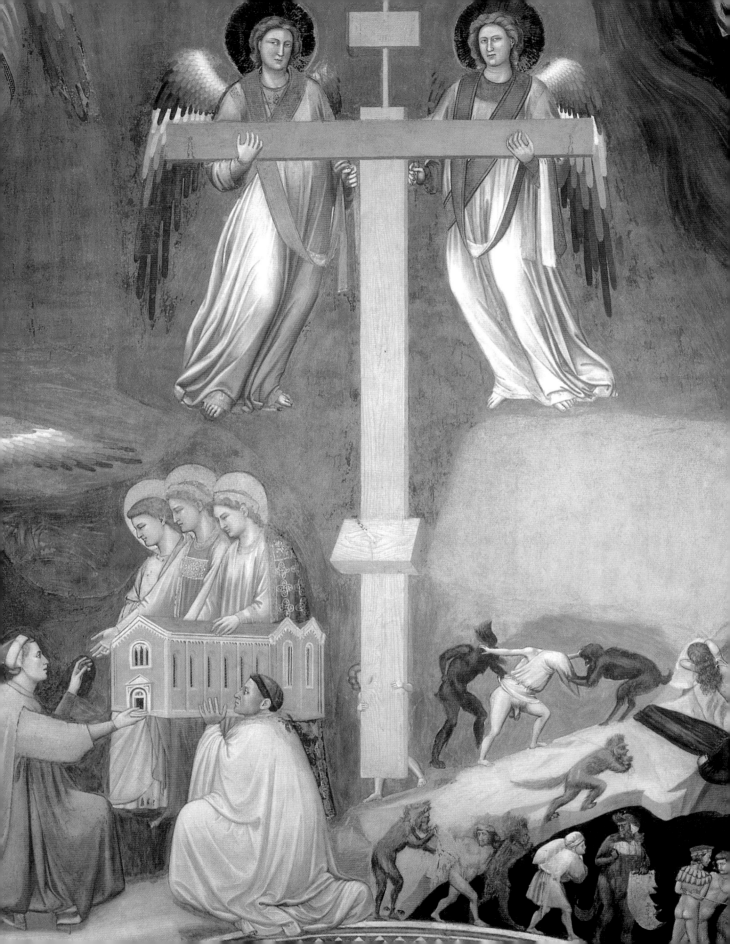

Above

Two *tondi* from the vault, depicting (left) an unidentified prophet, who has announced the future Incarnation of Christ, and (right) Saint John the Baptist.

Opposite

Detail of the *Last Judgment* (end wall), showing the donation of the chapel on the part of Enrico Scrovegni, the mouth of Hell, and Christ's cross, carried by Simon of Cyrene and supported by two angels.

The novelty of Giotto's work was instantly recognized by the most important writers of the time, beginning with Dante Alighieri.

completely certain. However, that Giotto was given some direction in the cycle's planning is the only explanation for several unusual scenes – for example, God the Father ordering the Archangel Gabriel to go and announce to Mary her impending pregnancy, or the angels that fill the skies at the end of the day of the Last Judgment. Another sign of a great coordinating mind at work is the fact that every year on 25 March – the feast of the Annunciation and the anniversary of the consecration of the building – the scene of the donation of the chapel is struck by light from a particular window.

Nevertheless, it was Giotto alone who broke away from the dominant Byzantine art tradition to create completely new forms and paint in a naturalistic way. And it was Giotto who revived the expressive forms of antique Roman art, as well as a more scientific and rational approach towards the depiction of reality. In this way, the artist achieved a profound remodelling of traditional figurative themes, and to all intents and purposes anticipated, with great intuition, the most important formal innovation of 15th-century European art: geometrical perspective. These conceptual or theoretical breakthroughs found an essential counterpart in the astonishing technical knowledge that Giotto had accumulated, which we can see in the wide range of techniques used in the chapel's decoration. These include the use of oils (a particularly rare technique in Italy at that time) and the antique *stucco romano* fresco technique.

The Scrovegni Chapel is the most important project in the Florentine master's vast body of work, which also includes the frescoes depicting the life of Saint Francis in the Upper Basilica of San Francesco in Assisi (though the extent of his involvement there is questioned), as well as later decoration of the Peruzzi and Bardi chapels in Santa Croce, Florence. The novelty of Giotto's work was instantly recognized by the most important writers of the time, beginning with Dante Alighieri. Since then his genius has been acknowledged throughout the centuries, while his paintings remained a source of inspiration for many of the great Italian painters: Masaccio, Piero della Francesca,

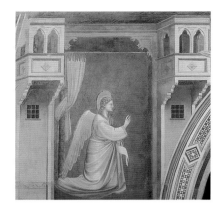

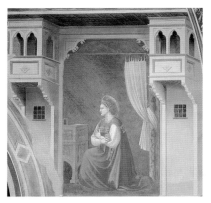

> *... the decoration of this chapel was, and still is, considered one of the masterpieces that laid the foundations for Western post-medieval art.*

Mantegna, Raphael, Michelangelo. Indeed, Giotto's influence can even be felt in the 20th century in the works of some of the Mexican muralists.

Unfortunately the frescoes have suffered serious damage over the centuries, especially due to the lack of care by the last private owners, the Foscari Gradenigo family, who in 1824 decided to demolish the adjoining palace (built on the remains of a Roman arena), thus depriving the chapel of structural support and protection. In 1881 the chapel was acquired by the Paduan local government, and the first, rather radical, restoration was undertaken at the end of the 19th century by Guglielmo Botti and Antonio Bertolli.

Top
The *Annunciation* by the Archangel Gabriel to the Virgin Mary (details of the decoration of the triumphal arch).

Above
The *Adoration of the Magi* (scene from the life of Christ, on the right wall).

A second restoration was undertaken at the beginning of the 1960s by Leonetto Tintori, and then finally, in 2001–02, another restoration by the Istituto Centrale del Restauro brought this masterpiece as close as possible to its original, magnificent condition.

Above
The *Flight into Egypt* (scene from the life of Christ, on the right wall).

Distant Shores

Water-Moon Avalokiteshvara, Kim U-mun and other artists

YOUNGSOOK PAK

> *Avalokiteshvara, meaning 'He who hears all sounds', is the embodiment of compassion. He promises to delay his Buddhahood until he has rescued all sentient beings from suffering, calamity and illness …*

The magnificent Bodhisattva Avalokiteshvara, the Bodhisattva of Great Compassion who can rescue living beings from all manner of calamities, attired in sumptuous garments and jewelry, appears in the shimmering rocky environment of a mysterious seashore. The saint, seated in a relaxed and graceful posture, looks down to a boy in the lower right-hand corner, who appears before him in a reverent attitude with folded hands. Though the painting is damaged, we can still easily appreciate the noble features of the Bodhisattva, and the attentive gaze of the boy. The image is articulated in fluid brush-strokes, with radiant mineral colours in gold, red, white, green and lapis lazuli, and delicate textures of silk brocade and embroidery. The body of the saint is gold, while that of the boy is flesh pink; the halo and aureole of the Bodhisattva, as well as the sturdy bamboo stems behind him, have partly survived.

Within the halo and next to the Bodhisattva's left hand, a gold-inlaid bronze *kundika* (pure water bottle, used in purification ceremonies) holding a willow branch – an attribute of the Bodhisattva – is just visible. Similar *kundika*s with designs inlaid in silver on bronze are found among Buddhist ceremonial vessels of the Koryŏ period. The ornaments and patterns that embellish the Bodhisattva's garments from head to foot are subtle yet exquisitely rendered: phoenixes flank the seated Amitabha Buddha (Buddha of the Western Paradise, where all beings wished to be reborn) in the centre of the crown; large, bejewelled lotuses fall from the chignon, golden floral scrolls adorn the green and blue sashes and the hem, and honeycomb patterns superimposed with oval lotuses decorate the red skirt. The white silk lining covering the right thigh is decorated with large gold medallions, while small florets fill the intervening spaces. Phoenixes and clouds on the transparent white veil are beautifully depicted in gold. On closer inspection, we can see that the soft armrest and seat that protect the Bodhisattva from the rugged rocks are formed from individual blades of grass, while the blue lotus petals of the Bodhisattva's footrest are finely delineated in gold. Gold dust and jewels are scattered along the shore beneath the Bodhisattva, where bright red and pink corals spring out of the water. Rocks and waves are painted in ink, in the

Opposite
The head of the Bodhisattva Avalokiteshvara. The face is painted in gold and the saint wears a high chignon, a transparent veil and a crown with two phoenixes, one on either side of the seated Buddha Amitabha.

1310
Pigment and gold on silk
419.5 cm × 254 cm / 13 ft 9 in. × 8 ft 4 in.
Kagami Jinja, Karatsu City, Saga Prefecture, Kyushu, Japan

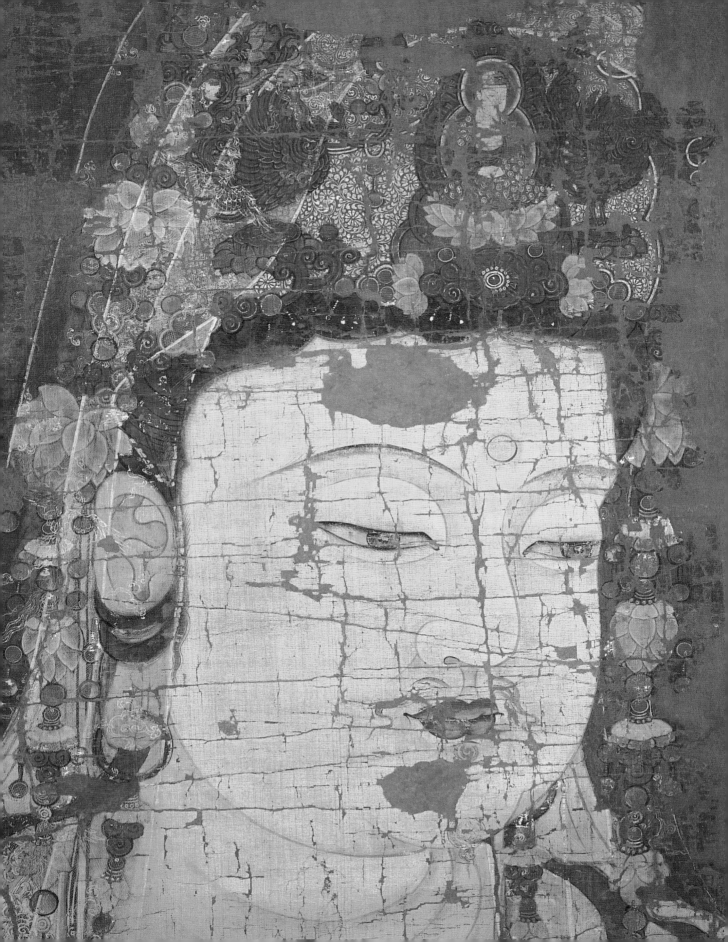

> *Considering the enormous size of the painting ... the composition, imposing presence of the Bodhisattva, fine details and refinement of colouring are astounding.*

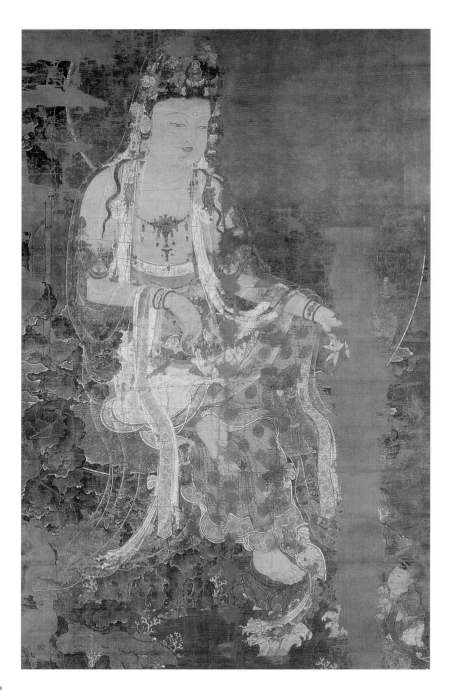

traditional manner. This profusion of rich detail enhances our impression of a visionary world. Considering the enormous size of the painting – the largest surviving silk painting in East Asia – the composition, imposing presence of the Bodhisattva, fine details and refinement of colouring are astounding.

The subject matter is Sudhana's encounter with Avalokiteshvara in his legendary abode of Mount Potalaka, on an island supposedly located in south India. Avalokiteshvara, meaning 'He who hears all sounds', is the embodiment of compassion. He promises to delay his Buddhahood until he has rescued all sentient beings from suffering, calamity and illness, brought

Above
The gossamer robes of the Bodhisattva, falling over his rocky seat; the fabric is decorated with a motif of a phoenix in flight, painted in gold.

Right
The Water-Moon Avalokiteshvara, more than 4 metres (13 ft) in height, is the largest surviving Koryŏ painting.

happiness and comfort, and rescued people from danger (as described in the seventh volume of the *Lotus Sutra*). The willow branch is the symbol of fulfilling the wishes of devotees, and is also a symbol of healing. As a result, he became the most popular Buddhist deity of all time. In the *Avatamsaka* or *Garland Sutra*, a boy named Sudhana, following the instructions of Manjushri (the Bodhisattva of Wisdom), embarked on a journey in search of enlightenment by visiting fifty-three saints. He encountered Avalokiteshvara, the twenty-eighth saint, in the grotto of Potalaka. The Bodhisattva's appearance is compared with the full moon, shining and complete. From this description the name of the Bodhisattva Suwŏl Kwanŭm or 'Water-Moon Avalokiteshvara' is derived. Suwŏl Kwanŭm was venerated by the Korean aristocracy during the Koryŏ period, since it was believed that Potalaka was actually Naksan (the Korean rendition of Potalaka) on the east coast of the Korean peninsula. It is said Avalokiteshvara manifested himself in this place and settled there facing the East Sea. Naksan became one of the most holy Buddhist sites in Korea, frequented by royal devotees and the nobility.

The complete painting must have been even grander and more splendid than it is today. It originally bore an inscription, undoubtedly written in gold, by a royal patron in the large square space on the upper right corner, but this must have been cut away at a later period. According to an 1812 Japanese copy of this inscription, recently discovered by the Japanese scholar Hirata Yutaka, the painting was commissioned by Queen Sukbi in the fifth month of the second year of King Ch'ungson's reign (1310), and was the work of several court painters. The founder of the Koryŏ dynasty established Buddhism as the state religion in Korea, and the *Koryŏ sa* (History of the Koryŏ dynasty) and various *munjip* (collections of writings by literati) record numerous state and private Buddhist ceremonies that were held for the protection of the nation in the face of foreign invasions by the Liao, Jin and Mongols, to quell natural disasters, to remedy all human conditions by prolonging lifespan, or to promote recovery from illness. Such ceremonies needed both sculptures and paintings, which were displayed in temples and in prayer halls in the palace and noble households. Around 140 Buddhist paintings from the second half of the Koryŏ dynasty (13th–14th centuries) have survived, mostly in Japanese and a few in Western collections. This monumental painting of Avalokiteshvara is thus powerful testimony to the sophisticated court patronage of Buddhist culture in medieval Korea, as well as its highly refined artistic tradition. More specifically, it reflects the fact that from the second half of the 13th century Korea fell under Mongol rule, leading Queen Sukbi, an ardent Buddhist devotee, to attempt to ease the situation through particular devotion to the all-compassionate Bodhisattva depicted here.

The painting still carries a second inscription in ink by the Japanese monk Ryoken, faintly visible at the bottom in the space between the shore and the white stem supporting the lotus pedestal. This inscription, dated 1391, describes how this painting was brought from Korea and entered the Kagami Jinja, a Shinto shrine where it is still kept today.

Above
Detail of the boy Sudhana, adoring the Bodhisattva at the latter's abode on the island of Potalaka, believed to be located at Naksan on the east coast of Korea.

The Short-Sighted Prophet

The 'Well of Moses', Claus Sluter

SUSIE NASH

> ' *The drama and power of the highly individualized prophet figures, in particular, have led to the ['Well of Moses'] being celebrated as a harbinger of the Renaissance …*

Above
David is represented as an ancestor of the kings of France, with royal emblems on his robe and a fleur-de-lis design on his crown, (restored in the 19th century, but now recreated from fragments discovered at the bottom of the well below the monument).

Opposite
This view with Daniel (left) and Isaiah (right) would have marked the back of the cross, which rose directly above it. The prophets act as exemplars for the monks. Isaiah's attitude, as he attends to Daniel, suggests the monks' duty to listen silently to readings from scripture, as represented by the text on his scroll: 'as a sheep before her shearers is dumb, so he openeth not his mouth'.

1395–1404
Asnières stone, with traces of gilding and polychromy
H *c.* 3.5 metres / 11 ft 6 in., originally (with the monumental cross) *c.* 11 metres / 36 ft
Champmol, near Dijon, France

The 'Well of Moses', carved by Claus Sluter between 1395 and 1404, is among the most important works in Western sculpture. The drama and power of the highly individualized prophet figures, in particular, have led to the piece being celebrated as a harbinger of the Renaissance, and linked into a tradition that leads to Donatello, Michelangelo and Bernini. However, fully to understand and appreciate the importance of the piece we need to consider its original context, conception and construction, which are remarkably well documented.

Referred to in contemporary sources as 'La grand croix' (the 'Well of Moses' is a 19th-century name), the surviving hexagonal pillar surrounded by six life-sized prophets and six angels is only the base of what was originally a monumental cross, a work of brilliant engineering as well as artistic invention (see the reconstruction on page 113). It was designed for the centre of the large cloister of the Carthusian monastery at Champmol near Dijon, founded by the most powerful and wealthy ruler of the period, Philip the Bold, Duke of Burgundy (who died in 1404). The monastery was intended as Philip's burial place, but also as an aid to the salvation of his soul, since the Carthusian monks who lived here would spend their time praying for the duke and his family. The 'Well of Moses' was the central devotional element in the most private and enclosed space in the whole complex. As such, much thought went into its planning, much effort was spent on its construction, and no expense was spared for its lavish decoration with gold and ultramarine (still visible on its newly restored surface). The rest of the monastery was largely destroyed in the French Revolution and its artworks scattered – the 'Well of Moses' is almost all that remains on the site today.

The challenge for Sluter in planning and executing this work was to produce, in stone and on a difficult site (Champmol literally means 'marshy field'), a monumental crucifix with complex, additional figurative elements (the six prophets and angels) that would enrich its meaning and be legible and visually interesting from every viewpoint. The scheme Sluter devised was visually and structurally astounding, apparently defying the constraints of the available materials, standing around eleven metres (36 ft) high with a base sunk another four metres (13 ft 1 in.) into the earth, creating a well around it.

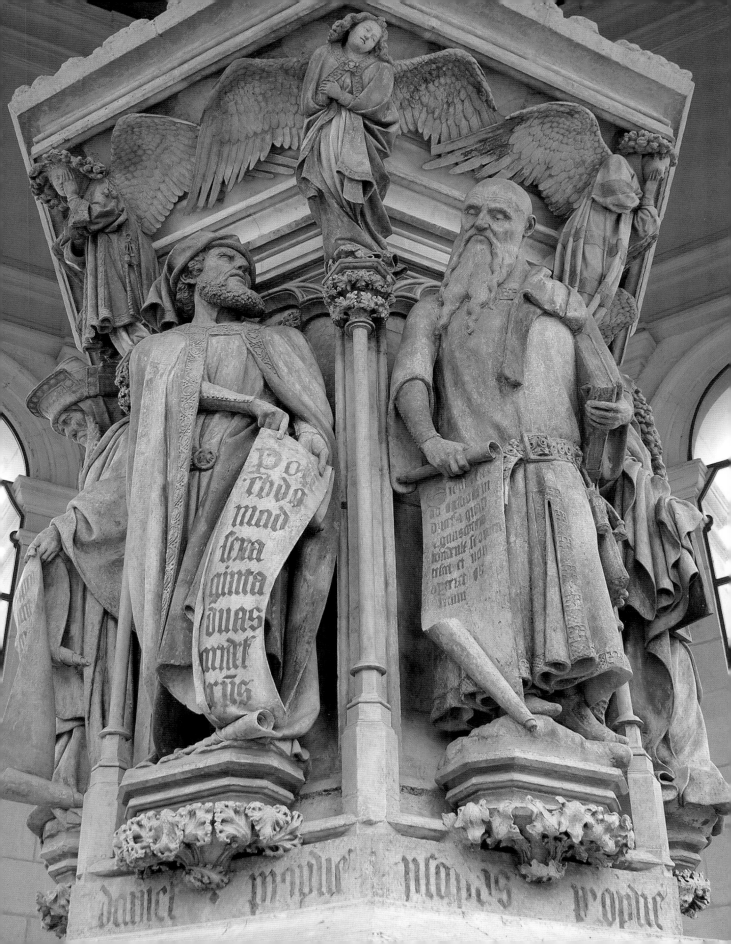

Potho maiseraginta duasanderris

Icum quod dest aliu duora quod gnoscere tomruit fedem tum et non oprat is fnim

daniel napur napas ropue

King David stood for Philip's nephew, the King of France, since the robe is decorated with the royal emblems of sunbursts and his crown with the fleur-de-lis.

Above

David (left) and Jeremiah (right) form a kind of diptych and present the main view of the monument; their inscriptions refer to the physical and mental suffering of Christ. David is shown with his harp, as composer of the Psalms, which the monks recited daily. The angel in (Carthusian) white makes a gesture that the monks themselves would have made in their devotion to the cross.

This has always been viewed as a fundamental iconographic feature, referring to the Waters of Life, but it may initially have been conceived as a sump: a technical solution to the problem of the wet ground.

The six monumental prophets (David, Jeremiah, Zachariah, Daniel, Isaiah and Moses) are set around the base, standing on small green mounds, holding scrolls with texts relating to Christ's Crucifixion. The architectural setting of the pillar is almost obliterated by their oversized forms – a relationship that enhances the immediacy of their presence, further emphasized by their heavy drapery falling in complex, often highly decorative, folds. In fact, when originally finished, the pillar was painted black, giving the figures even greater presence.

The prophets were conceived of in pairs, with the 'principal' pair – that is, those set directly under the face of the cross – being David and Jeremiah. This was the view that monks would have had as they entered the cloister from the church. But approaching the monument, the viewer was encouraged by the gestures of the angels and the prophets to move anticlockwise around it. These two prophets have particular significance for the Carthusians – David the composer of the Psalms, which the monks read constantly, and Jeremiah a model for their contemplative life. However, they also had contemporary significance. King David stood for Philip's nephew, the King of France, since the robe is decorated with the royal emblems of sunbursts and his crown with the fleur-de-lis. Jeremiah, meanwhile, stands for the Duke himself – an allusion made explicit by his being carved as a portrait of Philip, evident not only from the physical resemblance but also from the purple-red robes (a colour favoured by the Duke) and the presence of metal eyeglasses (now lost), similar to Philip's own (made by the ducal goldsmith). Jeremiah's unbearded face, and the open book from which he reads, both unusual for a prophet, further mark the figure out as 'contemporary'. Philip had intended to enter the Carthusian order (an ambition he did not achieve in life, though he was buried in the robes of a Carthusian), and by having himself represented on this monument he ensured that he was perpetually present at the heart of his foundation. His scroll quotes from Lamentations: 'all ye who pass by, behold, and see if there be any sorrow like unto my sorrow'. This is, in part, an allusion to the Duke's own sorrow: in 1396, just as this monument was being planned, disaster struck France, with the defeat at Nicopolis by the Turks, in which the Duke lost many of his dearest friends and advisers, and his son was held to ransom, plunging the nation into mourning.

Above and between the prophets, the angel dressed in (Carthusian) white, would also have had significance for the monastic viewer. Its crossed arms are a gesture well known at the time as one of prayer, used specifically when contemplating the cross. All six angels have wings carved to seem weightless from below, yet which (appear to) support the terrace and cross above: they direct their attention downwards, however, interacting with the viewer, each performing other gestures of prayer and grief for the monks to imitate. Some of the angels also have ducal allusions: they were used as an emblem by Philip and here they are dressed in the colours of the ducal arms – red, blue, white and gold, creating a type of heraldic framework around the figures of David and Jeremiah. The ducal ownership of this work was made explicit too: on the base of the monument, Philip's coats of arms were set below each prophet (traces of which are still visible); on the cornice above

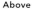

were painted his initials and those of his wife, Margaret of Flanders; and even on ends of the cross itself their arms were carved. The monks viewing this monument from whatever angle would have emphatic reminders of whom they were to pray for.

On the terrace above the monumental prophets, the Magdalene knelt alone at the foot of the cross, her lone presence an innovative and dramatic demonstration of the Carthusians' dedication to this saint. She was painted red, linking her to the blood of the crucified Christ above; indeed, the impact of the monument, its meaning and its effectiveness as a memorial and focus of devotion were significantly enhanced by its polychromed surface. The cross itself was richly gilded with 3,100 reinforced gold leaves, and coloured with the best-quality ultramarine and other pigments. These were applied by the Duke's painter, Jean Malouel, who must have collaborated closely with Sluter to achieve the desired finish. This surface treatment was not about lavish display, however, but about giving appropriate glory to God – a quality recognized in descriptions of the cross in 15th-century indulgences (guarantees of spiritual credit granted to those who prayed before it) as being 'glorious', 'of honorific construction', 'of beautiful and wonderful workmanship' and 'wonderfully adorned'. Indeed, it was so lavishly decorated that, just three years after it was completed, a tent had to be erected to protect the paint and gold from the wind and the rain. In thus protecting it, the monks irrevocably undermined its function as a constantly visible symbol and focus of veneration in the centre of the Carthusians' enclosed world.

Silent Worship

The Ghent Altarpiece, Hubert and Jan van Eyck

CHRISTOPHER DELL

> *... ultimately, it was the realism ... combined with the symbolism, that made* The Ghent Altarpiece *so radical, and so influential.*

Above
A detail of the group of Jewish and pagan writers from the central, *Adoration of the Mystic Lamb*, panel.

Opposite
The altarpiece in closed position: (bottom to top) the donors praying to statues of John the Baptist and John the Evangelist; the Annunciation to the Virgin Mary; and the prophets Zachariah and Micah, with two sibyls (prophetesses) between them.

Before 1426–1432
Oil on panel
375 cm × 520 cm / 12 ft 4 in. × 17 ft (open);
375 cm × 260 cm / 12 ft 4 in. × 8 ft 6 in. (shut)
Ghent, St Bavo Cathedral

Tucked away in a chapel in St Bavo Cathedral in the Belgian city of Ghent is perhaps the defining masterpiece of 15th-century Netherlandish art. A large multi-panelled structure, *The Ghent Altarpiece*, played a vital part in revolutionizing painting north of the Alps.

Today it is most often displayed open, but when it was originally made it would have been kept closed almost all the time. When the hinged panels are folded over the main image (as shown opposite), we see a depiction of the Annunciation (rather awkwardly flanking two empty central panels), two remarkable grisaille panels depicting illusionistic sculptures, and the two donors in the lower tier to left and right. Whenever they saw the altarpiece disposed like this, the passing congregation would have been reminded of the couple who had commissioned it – Joos Vijd and his wife, Elisabeth Borluut; their desire to figure so prominently is perhaps understandable, considering what the work would have cost them. The donors are depicted with a due sense of decorum: they do not enter the space of the holy figures – indeed, they pray to depictions of statues of the saints, not even depictions of the saints themselves.

An inscription on the frame confirms that the painting was begun by Hubert van Eyck, but completed by his brother Jan after Hubert's death in 1426. Jan van Eyck soon eclipsed his brother, but clearly this work owed a great deal to Hubert. The 16th-century Italian art historian Vasari attributed to Jan van Eyck the invention of oil paints; although this was almost certainly unjustified, Van Eyck was instrumental in popularizing them. And *The Ghent Altarpiece* was perhaps the work that did more than any other to convince artists of the possibilities the new medium offered. The glossy surface must have intrigued rival artists at the time.

The exterior was probably deliberately muted in order to heighten the effect of opening the wings. As they swing apart, we are confronted by a barrage of fierce colour and figures at varying scales: it is difficult to know where to look when encountering this work for the first time. As on the outside, there are essentially two tiers. In the upper tier, we see the naked Adam standing in a fictive niche; sumptuously dressed angels singing; the Virgin Mary; God the Father; Saint John the Baptist; angel musicians playing various instruments; and Eve, the counterpart to Adam. Adam and Eve are depicted after their expulsion from the Garden of Eden: they are aware of their nakedness and attempt to hide it. Eve is already carrying a child, the pain of whose birth is part of her punishment for encouraging Adam to eat the forbidden fruit. Thus, this peripheral pair represents Original Sin. Their isolation from God is emphasized by the shallow, claustrophobic space in which they are situated. Above Eve is one of the results of their sin – the murder by Cain of his brother Abel.

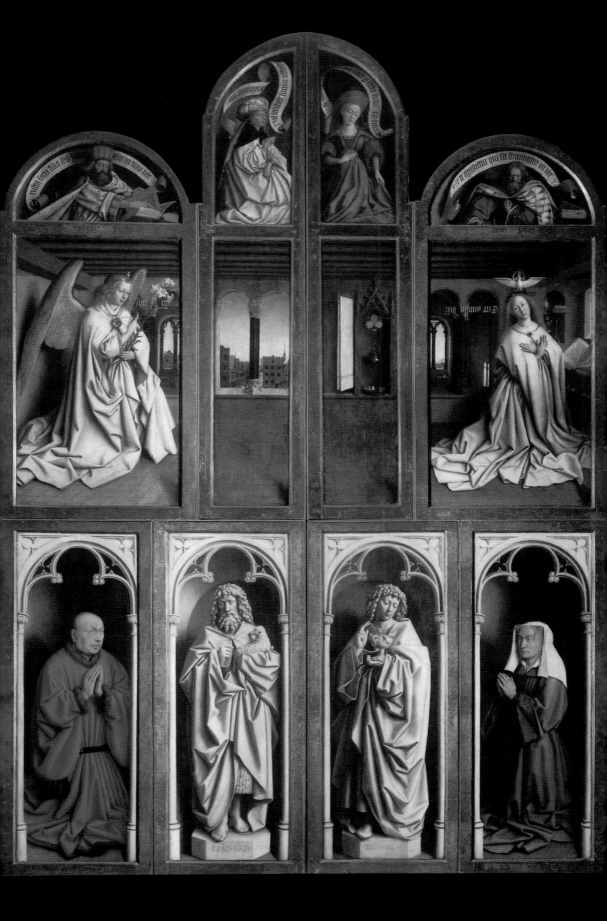

The central figure dominates, of course, being raised above the others on a magnificent throne. Discussion continues as to who, precisely, this represents: God the Father, or possibly Christ the King of Heaven? The three-tiered tiara suggests that we could also read the figure as a personification of the Holy Trinity. The inclusion of Saint John the Baptist is not a surprise, since the church (elevated to a cathedral in the 16th century) was originally dedicated to this saint. Yet the central figures, though grand (in the Byzantine, hieratic style) and beautifully executed, are too static to hold our attention. So instead our eyes drift down to the panel below, the most original in the altarpiece: the *Adoration of the Mystic Lamb* itself.

This extraordinary scene is set in an almost magical landscape, at once of this earth (as the distant towns indicate), yet also of another place. The impossibly verdant meadow is dotted with naturalistic flowers; some bushes conveniently divide up the space and form a clearing. The heightened colours border on the psychedelic.

Four groups approach the clearing, each identified by their costume and attributes. The high viewing point – there is something almost cinematic about the scene, as though we are observing it from a gantry – allows us clearly to make out each group. From the top left come holy bishops and cardinals. From the top right, female martyrs carry palm leaves, symbols of their martyrdom. At the bottom left is a group of Old Testament prophets and (perhaps surprisingly) some Classical, pagan authors, including Virgil. And at the bottom right is a group representing the Church, including the twelve apostles (dressed simply), followed by the massed ranks of the contemporary Church – bishops, popes, cardinals – in all their finery. Seen through modern eyes, the stark contrast between the early holy men and their modern-day equivalents seems almost subversive. Van Eyck, however, was concerned to give the hierarchy of the Church legitimacy by showing its origins.

It is hard to avoid the feeling that this is a clandestine meeting outside city walls. But the groups have stopped short of converging, for in the centre of the clearing is an altar. And upon that altar is a lamb, the object of their devotion. They dare not get closer, for something strange is happening. This surreal scene captures all the power of a hallucination: the heightened colours, the inverted rainbow of the Holy Spirit's dazzling light, the sharp rays that shoot out, the lamb standing on the altar, waiting patiently as four congregations file in. Bewilderingly, the lamb – the Lamb of God, symbol of the sacrificial lamb and emblem of Christ – has become real, just as the bread becomes the

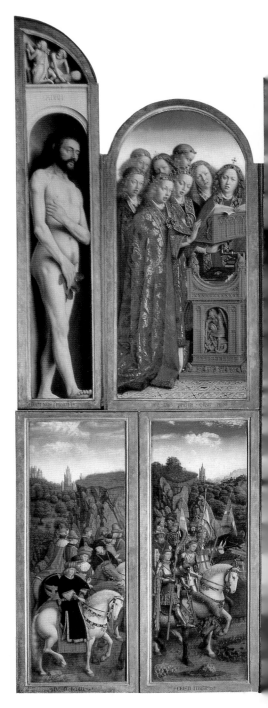

Top left
The female martyrs arrive. Each carries a palm leaf as a symbol of her martyrdom. Some also carry specific attributes that identify them.

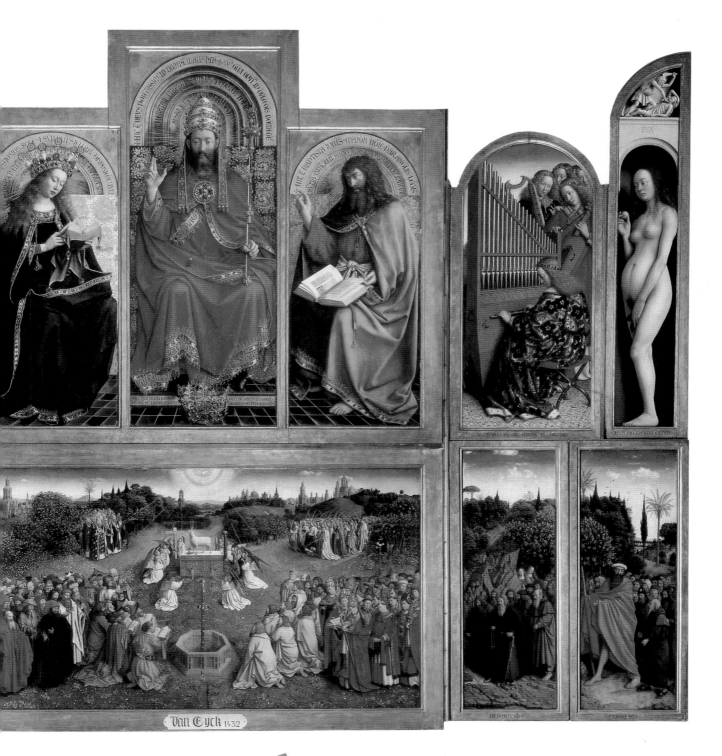

Above
With wings unfolded, the altarpiece measures
over 5 metres (17 ft) across. Although the
scenes across the bottom register are not
continuous, the horizon is: a curious effect.
The lower left-hand panel, known as 'The
Just Judges', was stolen in 1934, and replaced
by a copy finished in 1945 by J. Vanderveken.

*... there is something almost cinematic about the
scene, as though we are observing it from a gantry ...*

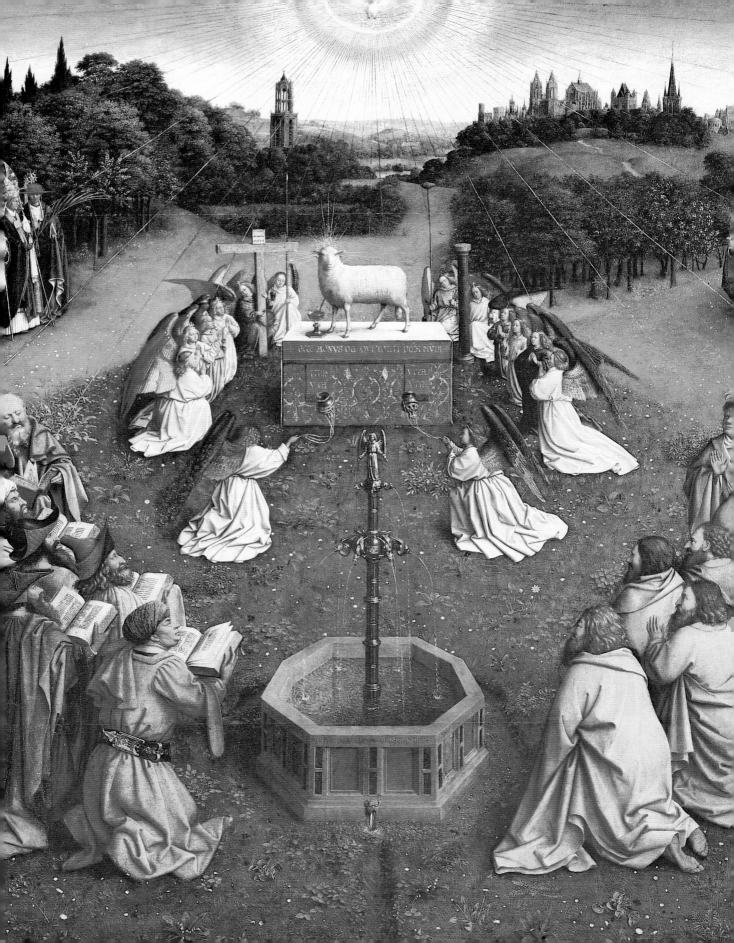

body of Christ in the Eucharist. The stillness of the scene is undermined only by the swinging censers, which hang in mid-air. Ranged around the altar like celestial bodyguards is a ring of angels. Some of these hold the instruments of the Passion – the column on which Christ was flagellated, the nails used to fix him to the cross, the lance with the sponge dipped in vinegar that quenched his final thirst. Blood pours from the lamb's breast into a chalice. This is the true meaning of the altarpiece – sacrifice, blood and the role of the priesthood in administering the holy sacraments. The scene is not only still, it is silent: all we might hear is the trickle of blood into the chalice, the sing-song splash of the fountain, perhaps the gently creaking chains of the censers.

In front of the altar is a fountain – the Fountain of Life. It first flowed in the Garden of Eden, which takes us back to Adam and Eve. The splashes of the thin trickles of water are masterful – miraculous, even. Unlike the chalice on the altar, which seems to continue to fill without ever overflowing, the water from the fountain escapes the basin at the bottom, falls into a channel and flows out of the painting in the direction of the viewer. The message running down the central axis of the picture is clear: it is the blood of Christ that gives us life. A Latin inscription on the altar front reads: 'Behold the Lamb of God who takes away the sins of the world.' In fact, the entire altarpiece is covered with inscriptions in Latin, which many scholars have taken as signs of Van Eyck's deep learning.

Although elements of the altarpiece had appeared elsewhere before – for example, the Fountain of Life was a well-known symbol – the originality of the work as a whole cannot be overstated. There is no one explanation for the choice of imagery, though there are strong references to the Book of Revelation. Yet ultimately, it was the realism – the careful studies of the animals, textures, plants, trees, landscape – combined with the symbolism, that made *The Ghent Altarpiece* so radical, and so influential. It was widely admired in its own time, and without doubt laid the foundations for much that was to follow. Both Gerard David and (later) Albrecht Dürer made careful studies of it.

Perhaps the greatest miracle surrounding this work is that we are able to see it today almost in its entirety, and (almost) in its original location. It is a work that has suffered more than most, and travelled extensively. The break-up began in the early 19th century, when the cash-strapped diocese of Ghent pawned some of the panels. Unable to pay off the loan, the diocese sold them to an English collector, who in turn sold them on to the King of Prussia. From the royal collection they migrated to the Gemäldegalerie in Berlin. There they were joined by other panels that had been taken by Germany during the First World War. However, all the pieces of the work were returned to Belgium under the terms of the Treaty of Versailles. This remained a source of resentment in Germany, and when the Second World War broke out, fearing another seizure, the Belgian authorities decided in 1940 to send the panels to the Vatican. When Italy's entry into the war was announced, they were diverted to Pau in the Pyrenees. There they were seized in 1942 on Hitler's orders, and sent to Bavaria, where they ended up in a salt mine for safekeeping. It was only with the Allied victory that the panels once more saw the light of day, and were returned to St Bavo.

'The message running down the central axis of the picture is clear: it is the blood of Christ that gives us life.

Opposite
Christ is represented as a sacrificial lamb. He is placed on the same axis as God the Father, the Holy Spirit and the Fountain of Life. Only the lamb directly addresses the viewer in this scene.

A Drama of Grief

The Brancacci Chapel Frescoes, Masaccio and Masolino

ORNELLA CASAZZA

‘ *... all the pain in the world is etched on [Eve's] face.*

The Brancacci Chapel is situated to the right of the transept in the Church of Santa Maria del Carmine in Florence. The chapel gets its name from the Brancacci family, who patronized it from the second half of the 14th century until 1780, when it was transferred to the Riccardi family. It was Felice di Michele Brancacci, a rich merchant and a key figure in Florence's elite, who started the works in the chapel, probably in 1424. Two artists were commissioned to execute the frescoes: Masolino and Masaccio. They worked together until 1427 or 1428, at which point Masolino travelled to Hungary, leaving Masaccio to continue work alone. After returning to Italy, Masolino stopped in Rome, where he was joined by Masaccio, leaving the chapel unfinished. The cycle was finally completed by Filippino Lippi in 1481–82.

The present-day appearance of the chapel is the result of a number of modifications, undertaken between about 1435 (when Felice Brancacci was exiled in disgrace) and the 19th century. Originally it had a simple crossed vault with lunettes (decorated by Masaccio), and light came in through a single circular window. Above the main altar there was originally the final scene from the legend of Saint Peter, showing his crucifixion. This was destroyed to make space for the venerated 13th-century 'Madonna del Popolo' altarpiece, and only a few fragments remain. In 1670, wooden frames were installed to divide up the two tiers of the frescoes, and shortly afterwards, in 1674, the chapel was clad in marble, and the pavement and balustrade were refitted. (Almost certainly it was at this time that leaves were added to hide the modesty of the figures of Adam and Eve in Masolino's *Temptation of Adam and Eve* and Masaccio's *Expulsion from the Garden of Eden*.) In 1746–48 the vault was raised, a process that destroying Masaccio's lunettes (the new ceiling was decorated with frescoes by Vincenzo Meucci). And then, during the night of 28–29 January 1771, fire devastated the church. Although the chapel was largely spared, the fire did destroy the golden cornices that divided the paintings of the first and second tiers, burning and altering the colours around those areas and also affecting the plaster bearing the depictions of the *Tribute Money* and the *Raising of Tabitha*.

With such an ill-fated history, by the end of the 20th century the chapel was in need of thorough restoration. This restoration, undertaken in the 1990s, removed various additions (including Adam and Eve's leaves), along with a 'patina' made with egg that had darkened and degraded (and which had probably been applied in around 1900 to 'varnish' and 'nourish' the frescoes). Sadly, the restoration revealed no trace of the original lunette decorations, but it did bring to light two preparatory drawings in sinopia dating back to the 15th century and relating to the panels of the legend of Saint Peter by Masaccio and Masolino. These were discovered underneath the frescoes,

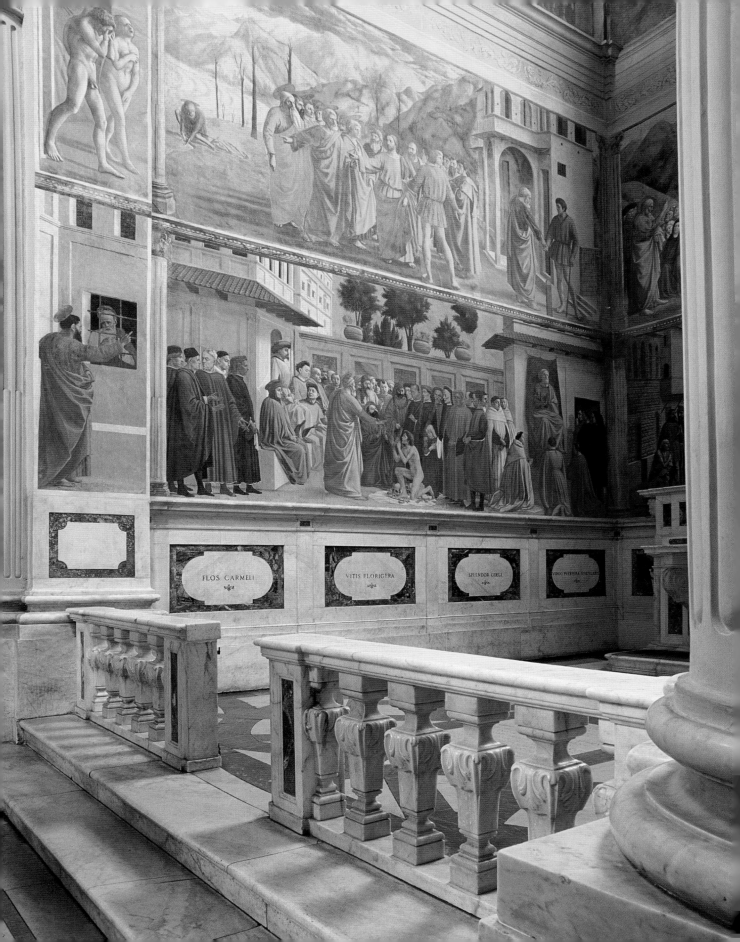

FLOS CARMELI VITIS FLORIGERA SPLENDOR COELI VIRGO PVERPERA INVIOLATA

> *' ... man, even though he is a sinner, has not lost his dignity ...*

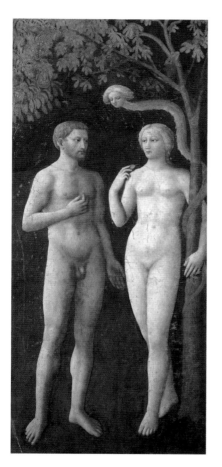

Above

Masolino's conception of the Temptation focuses on the perfection and innocence of Adam and Eve, whose sweet expressions give no hint of the suffering that awaits them in Masaccio's *Expulsion*.

Opposite

View of the Brancacci Chapel showing two scenes from the life of Saint Peter painted by Masaccio: (above) *The Tribute Money* and (below) *The Raising of the Son of Theophilus and Saint Peter Enthroned*. The Brancacci is sometimes called the 'Sistine Chapel of the early Renaissance'.

on the far wall next to the window. Thanks to the discovery of these preparatory drawings, in which we can clearly see the two distinct hands of the painters, it is safe to assume that Masaccio was fully involved from the outset of the project, and that each of the artists was given particular scenes at the very beginning, to avoid too much inconsistency.

Nevertheless, there remain clear differences between the two painters. For example, if we compare *The Temptation* with *The Expulsion from the Garden of Eden*, we can see that Masolino leans towards a more conventional, traditional iconography, his two figures showing in their gestures a gentle and courteous manner – quite the antithesis of the episode painted by Masaccio on the opposite wall. *The Expulsion* manifests, to a singular and extraordinary extent, a new cultural and formal approach, a spiritual 'harmony' and technical ownership. It is an excellent example of the Renaissance ability to dramatize real and complex emotions through the expressive depiction of the body.

In Masaccio's work, man, even though he is a sinner, has not lost his dignity – he is not derided or made to look ugly; indeed, leaving aside certain innovative expressions, his beauty takes us back to the archetypes of Classical, ideal beauty. In characterizing Eve, it is obvious that Masaccio had in mind the Greco-Roman 'Venus pudica', filtered through 14th-century models, such as the figure of Temperance by Giovanni Pisano on the pulpit of Pisa Cathedral. (Two of the figures of the damned on the Pisa pulpit, holding their heads in their hands, may well have influenced Adam's gesture.) Yet it is only in her gesture that Masaccio's Eve recalls a 'Venus pudica': her body is not idealized, and all the pain in the world is etched on her face. Masaccio's conception of Eve also suggests comparison with the relief of the Expulsion on the fountain at Perugia, by Niccolò and Giovanni Pisano, and the expression of her mouth, open in a cry of anguish, recalls that of Isaac, about to be sacrificed by his father, Abraham, in Brunelleschi's competition piece for the Baptistery doors in Florence.

Masaccio's Adam, too, seems to establish a relationship with the Classical world, from the Laocöon to Marsyas, but at the same time shows a contemporary approach to anatomy that perhaps owes something to Donatello's crucifix in Santa Croce in Florence. His reinterpretation of the antique, cross-fertilized by recent innovations in Italian art, led to a flowering of extraordinary originality in Masaccio's art, which must have astounded the first viewers. To appreciate the revolutionary nature of his work, one has only to consider the foreshortened angel, flying freely, and caught at the moment of landing in a cloud of fire as red as his robes.

Outside Paradise, the desolate landscape echoes the movement of the two figures and seems to reinforce their divinely ordered exile from the garden. On one side a steep, rocky slope follows the line of Adam's left leg, while a gentler incline cuts a shallow diagonal behind Eve's left leg. The couple's shadows – now, thanks to the restoration, much easier to discern – trail behind them like a symbol of the burdens that await them in the terrestrial world. The gravity of the event and the intensity of the drama influence every line and form: nothing is gratuitous, and the distillation of the image to the bare essentials seems to bespeak the irrevocable fulfilment of the will of God.

A Tuscan Passion

The Deposition, Fra Angelico (and Lorenzo Monaco)

MAGNOLIA SCUDIERI

> *Fra Angelico has arranged his composition around the shape of an X, the two diagonal lines intersecting at the body of Christ.*

Opposite
Christ's body is lowered from the cross by Joseph of Arimathea (top, with perspectival halo), Nicodemus (right) and St John the Evangelist (below, dressed in blue).

1430–32?
Tempera and gold on panel
176 cm × 185 cm / 5 ft 9¼ in. × 6 ft 1 in.
Museo di San Marco, Florence

The fascination of writers and art historians with Fra Angelico's *Deposition* – which can be found as early as Vasari – does not stem only from the fact that it is one of the artist's greatest masterpieces, but also from the mystery that surrounds its origins and history, and its links to one of the most important Florentine families of the time, the Strozzi. Although the painting is today displayed in the museum in the former convent of San Marco, it was originally installed in the sacristy of the church of Santa Trinita. The sacristy had been commissioned by Noferi Strozzi before 1417 as a funerary chapel for him and his son Niccolò, who had died young. After the death of Noferi, in 1418, another son, Palla, was intended to continue the construction; this was more or less complete by 1423, as may be inferred from surviving invoices and receipts. Sadly none of these documents relate to Fra Angelico's *Deposition*, though some of the donations that Palla gave to the convent of San Domenico in 1429 could be linked to this work, as may be a document from 1432 that mentions the layout of an altarpiece to go above the altar in the sacristy. These dates could be congruent with this panel, but they still do not explain the origins of the work.

In fact, although Fra Angelico executed the central panel with the Deposition and the pillarets showing saints and prophets, he was not the sole author of this work. The three scenes in the pointed gables of the painting – the Resurrection flanked by the 'Noli me tangere' and the Three Maries at the Sepulchre – were painted by the slightly older Lorenzo Monaco. Lorenzo also produced panels showing Saint Onophrius visited by the Abbot Pafnuzio, the Nativity, and Saint Nicholas saving some sailors, which were incorporated into the predella of the original altarpiece.

This raises many questions. When did Fra Angelico become involved in this project? And why? In what state did he find the painting? Did he finish it or modify it? Some have proposed that work could have begun as early as 1418, while others have recently suggested that it was started only shortly before Lorenzo's unexpected death in 1424. Either way, Palla Strozzi, a true humanist, decided later to bring the work up to date and entrusted its completion to Fra Angelico, the most 'modern' artist – in the humanistic, Renaissance sense – that Florence had to offer now that Masaccio had died and Gentile da Fabbriano and Masolino had departed.

Fra Angelico achieved the desired transformation. He turned the panel with its three pointed arches – possibly intended to be divided into three sections, in the Gothic tradition – into a work with a single, three-dimensional space, the main characters arranged in groups that reveal a familiarity with the work of Lorenzo Ghiberti, so as to give life to the sacred scene.

At the very centre of the composition we find the cross, from which Nicodemus, Joseph of Arimathea and others are lowering the lifeless body

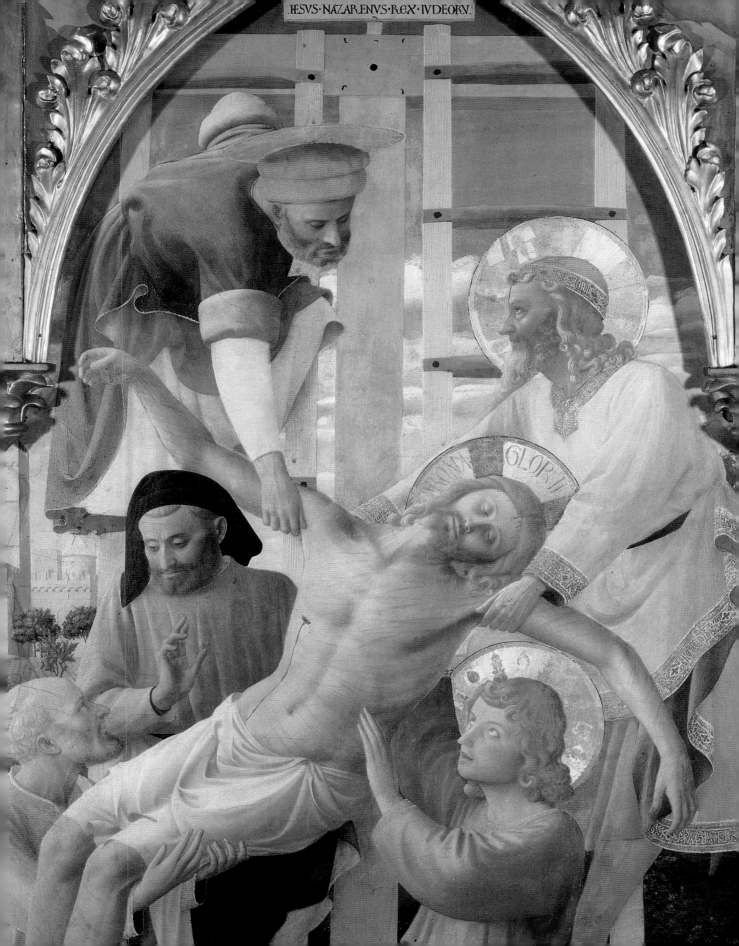

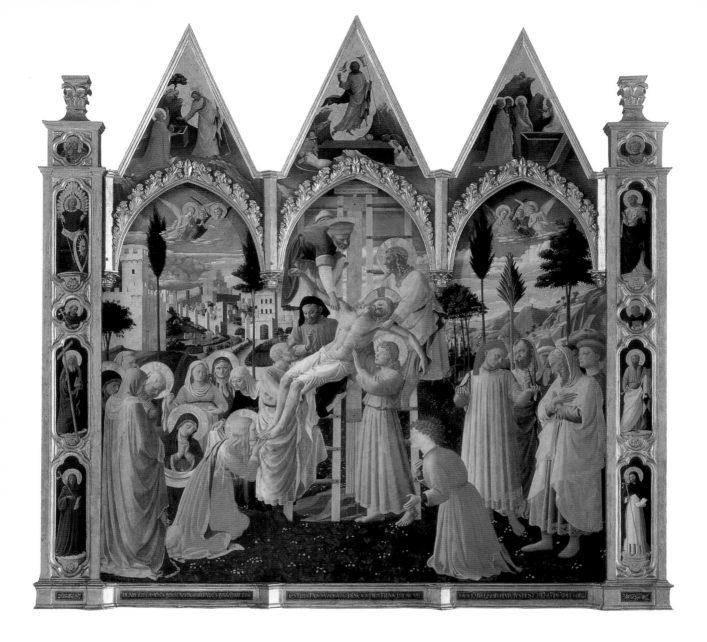

Above
Fra Angelico inherited the tripartite division of the main scene from Lorenzo Monaco. Monaco painted the three scenes in the gables.

of Jesus. Fra Angelico has arranged his composition around the shape of an X, the two diagonal lines intersecting at the body of Christ. Along these two lines are arranged the key figures and elements in this scene, their organization and proportions suggesting a new sensation of spatial depth, although not yet of true perspective. Along one line we see Mary Magdalene (kissing Christ's feet), the body of Christ, Nicodemus and the weeping angels in the top right-hand corner. Along the other line are a man kneeling on the ground (Alesso degli Strozzi?), Saint John, the man with the black headgear and the walls of the city in the background, with another group of angels flying above. Other figures are arranged on lines parallel to these, as are many of the elements in the distant landscape: the trees, the hills, the buildings.

This landscape is completely novel in the way in which it blends elements of reality, history and imagination. The rocky soil of Calvary is confined to a tiny space directly underneath the cross; all the rest of the foreground is

covered by a verdant, flower-filled meadow. This seems to allude to the Garden of Paradise reclaimed for humanity by Jesus' sacrifice; the naturalistic detail betrays the late Gothic taste. In the background, meanwhile, the evocation of the Holy Land is fused with a desire to capture the Tuscan landscape, with its tiny villages and castles – the aim being to bring this sacred scene closer to the world of the viewer.

Other elements in the painting reveal the same desire of the painter to translate the extreme events of the Passion to the 15th century. Most important of these are the possible inclusion of portraits and the contemporary styles of dress. Vasari believed that he could discern a portrait of Michelozzo – probably the man with the black headgear – while it has also been supposed, perhaps correctly, that underneath the cloak that Nicodemus wears (his name is inscribed on the edge), you could see the semblance of Palla Strozzi, as revealed by another inscription (now partially lost): 'magister P...L'. Others have identified Palla as the man who holds the crown of thorns and the nails, and Palla's son as the youth who kneels in the foreground; perhaps another son stands on the far right wearing the most wonderful red headgear.

> *Fra Angelico ... turned the panel with its three pointed arches ... into a work with a single, three-dimensional space ...*

Right
This young man, wearing a typical Florentine red hat, may be identifiable as one of the sons of the donor, Palla Strozzi.

A Mother's Grief

The Descent from the Cross, Rogier van der Weyden

GABRIELE FINALDI

' *The elegant curve of*

Christ's body is echoed

in that of the Virgin,

and their hands come

together just to the left

of centre ...

Above and opposite
The juxtaposition of the hands of Christ and the Virgin, and the matching contours of their bodies, constitute points of intense emotional expression in Van der Weyden's tragic pictorial elegy.

c. 1435
Oil on oak panel
220.5 cm × 259.5 cm / 7 ft 2¾ in. × 8 ft 6 in.
Museo del Prado, Madrid

One has the suspicion that when the Tournai master Rogier van der Weyden was commissioned to paint this altarpiece for the Great Crossbowmen's Guild of Louvain (Leuven, in modern-day Belgium) he already knew he was going to produce his first great masterpiece. He chose the best Baltic oak to make the wooden support and lavished the surface with gold and the finest lapis. He applied in concentrated form his genius for pictorial design, for the representation of human emotion and for capturing religious sentiment, to produce a painting that has always been held in the greatest esteem. Within just a few years of being placed on the principal altar of the guild's Church of Our Lady Without the Walls in Louvain, the *Descent from the Cross* had already been copied by an anonymous painter in the *Edelheer Altarpiece* (dated 1443); about a century later it was acquired by Mary of Hungary, Governor of the Netherlands and sister to the Emperor Charles V, for her palace at Binche (about 50 kilometres – 30 miles – south of Brussels), and in 1556 it was sent to Spain as a gift to her nephew, Philip II. He duly placed it in the gigantic monastery–palace he was building at El Escorial, near Madrid. Today it occupies a place of honour in the Prado Museum. The magnificent state of conservation of the work attests both to its inherent technical qualities and to the high regard in which it has been held ever since it was painted.

The panel shows the moment when Christ's lifeless body is removed from the cross to be taken for burial. Nine figures, nearly all of them weeping profusely, are arranged in a frieze of composed but fathomless grief, around the slim, pale corpse of the dead Saviour. Joseph of Arimathea, in red, who offered his own tomb for Christ's interment, and Nicodemus, the Pharisee who was a secret follower of the Messiah, support the body reverentially. The Virgin, meanwhile, has fallen to the ground in a deathly white swoon, though she is supported by the apostle Saint John and a green-clad woman (perhaps Mary Salome). The elegant curve of Christ's body is echoed in that of the Virgin, and their hands come together just to the left of centre to manifest the spiritual juxtaposition of Christ's *passio* (or suffering) and the Virgin's *compassio* (sharing of his suffering) – a notion central to the *devotio moderna*, the affective, emotion-drenched spirituality of the 15th-century Netherlands. Christ's pose has recently been likened to the shape of a crossbow, supposedly in allusion to the patrons – a more concrete reference to whom can be seen in the tiny crossbow pendants that hang in the Gothic corner traceries. On the right, Mary Magdalene's mannered, spiky stance reflects the particular heartache of her loss, evidenced also by the paired names inscribed on her girdle: 'IhESVS MARIA'. Three other figures play their part in this theatre of sorrow and devotion: the elegant youth on the ladder, perhaps an African,

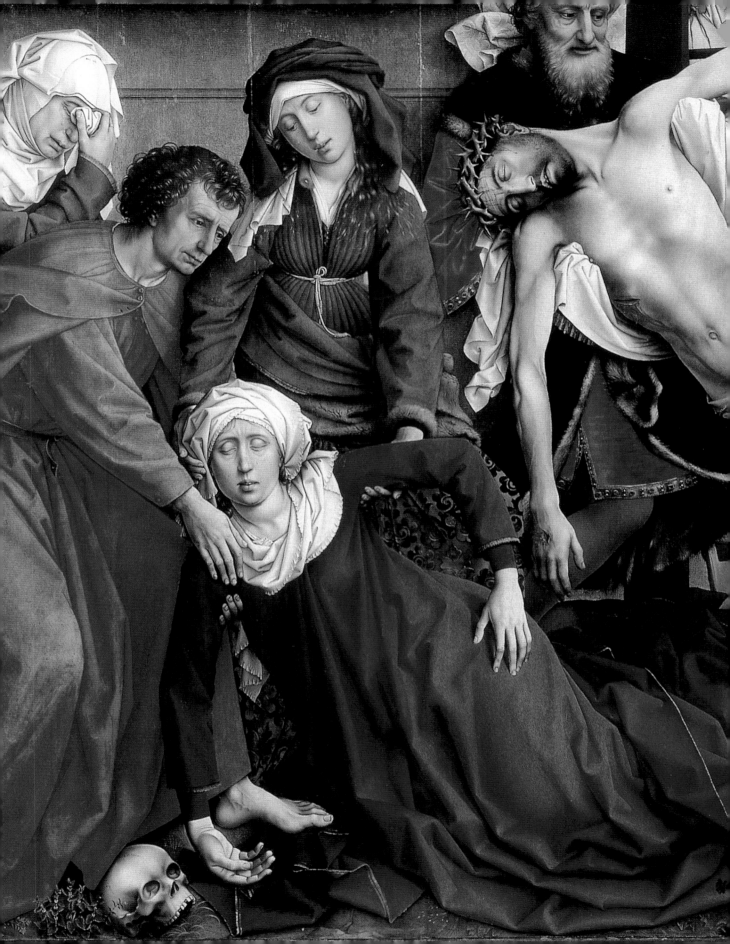

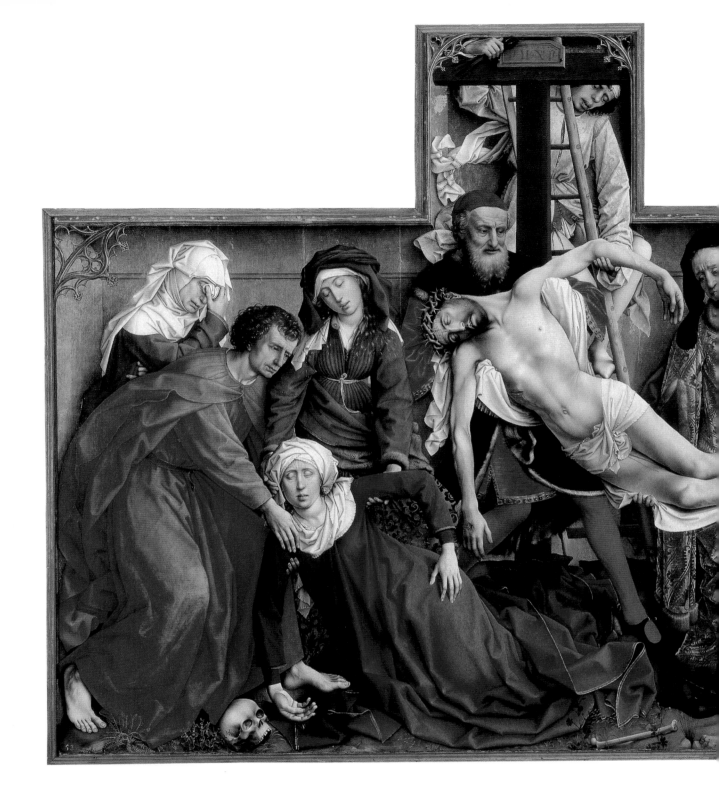

> *Nine figures, nearly all of them weeping profusely, are arranged in a frieze of composed but fathomless grief, around the slim, pale corpse of the dead Saviour.*

Above

Van der Weyden conceived the composition in terms of a subtle equilibrium of forms and colours, employing symmetry and asymmetry, abstraction and detailed realistic rendition, to achieve expressive ends.

who holds Christ's arm with one hand and the nails that fastened him to the cross in the other; the balding, bearded man who holds a jar of ointment – the Magi's myrrh for burial – and the weeping woman on the left, her headdress a cascade of sharp angular folds that seems to make of her an ancestor of Picasso's screwed up, howling women of the *Guernica* years. Erwin Panofsky noted in 1953 that 'Rogier's intention was not focused on action nor even on "drama" but on the fundamental problem of compressing a maximum of passion into a form as rigorously disciplined as a Shakespearean sonnet.'

Historians have wondered if Van der Weyden, who was still relatively young when he painted this work, was seeking to reproduce the appearance of a *tableau vivant* or of a sculpted altarpiece come to life. What is clear is that the sophisticated handling of natural appearances (from Nicodemus's stubble to the saxifrages that grow beside Adam's skull), combined with the non-natural setting of the shallow golden box, enable the artist to represent a scene that is both real and sacramental, historical and mystical. In its original setting above an altar, at the moment that the officiating priest elevated the host at the Consecration, sacrament and painting would have fallen into a related visual configuration – for the devout viewer, the Eucharistic body of Christ and the represented body of Christ would have met in an alignment of mutual illumination and exegesis. Thus the artist's goal in this work is not just aesthetic innovation, but also a visual theology. Yet he is also greatly concerned with the convincing representation of a huge variety of textures and objects: sable and silk, gold thread embroidery and linen, rope and leather, skin and hair, congealed blood, and the astounding, crumpled, inexhaustible folds of the Virgin's blue dress.

It is rare in Netherlandish painting of this date for a painted altar panel to be so large. The *Descent from the Cross* may originally have had wing panels, although since these are not mentioned in the early sources, it is more likely that it did not. Philip II commissioned wing panels from the mute painter Juan Fernández Navarrete, showing the four Evangelists and the Resurrection, but these are lost. An early 16th-century Netherlandish copy of the painting, probably made when the original was still in Louvain, is in the Prado's collection, as is another copy commissioned by Philip II from Michel Coxcie in 1567, so that the king could have the image in two of his palaces. It is curious to note that the former of these two copies probably arrived in Spain some decades before the original. The fame of Rogier's *Descent from the Cross* had preceded it.

The Tyrant Killer

David, Donatello

ULRICH PFISTERER

> ' *... the theme of David and Goliath bore a political significance in Renaissance Florence, which was under constant threat from powerful enemies.*

Above
The striking contrast between the adolescent's elegant leg and foot and the bearded giant's decapitated head, with its weighty helmet, emphasizes the miraculous victory of David.

c. 1440
Bronze
H 158 cm / 5 ft 2¼ in.
Museo Nazionale del Bargello, Florence

Donatello's statue of the shepherd David with the head of the defeated Goliath at his feet seems to have defied not only the expectations of his contemporaries but also any art-historical categorization. The first freestanding bronze figure of the Renaissance, the upright nude alludes to the honorary statues on top of columns in antiquity, while depicting a scene from the Old Testament. Yet more than this, it is a sensual and lifelike depiction of youth.

Criticism has dealt with this apparent paradox in different ways: Cristoforo Landino recognized Donatello's antique influence in 1481, and Vasari claimed that while Donatello belonged to the second wave of Renaissance artists, his work – and certainly this statue – was on a par with that of the later Michelangelo. And in 1895, André Gide fantasized about the 'amazing preference for the male body', and the 'ornamented nudity of his David; the flavour of the flesh', which gives this work a homoerotic charge that it has never lost. (It should be remembered that the Hebraic etymology of the name David is 'worth desiring'.)

Though no primary source concerning the statue has survived, its context can convincingly be reconstructed. The innovative pose and the wreath below it, for example, can be found in other contemporary works, and we know that the statue was originally erected in the (old) palace of Cosimo de' Medici. We know, too, that the plinth's original inscription, written by Gentile de' Becchi (the humanist tutor of the Medici), read: 'The Victor is he who guards the land of his fathers. God dashes to pieces the anger of the overpowering enemy. Surely, did not a youth subdue the tyrant. Prevail citizens!' From this it is clear that the theme of David and Goliath bore a political significance in Renaissance Florence, which was under constant threat from powerful enemies. Later examples in the same tradition include Verrocchio's bronze David (*c.* 1473–75) and Michelangelo's 1504 marble figure.

Yet there is more to this sensual nude than iconography. Indeed, the figure embodies the early Renaissance search for a true contrapposto, as well as the ways in which sculptures could be made more lifelike. In this, Donatello seems to have set himself against the great antique sculptor Polycleitus, who was said to have created the ideal male nude with his statue of Doryphoros. The only preserved standing nude attributed to Polycleitus in 15th-century Italy was the figure of Apollo displayed on a well-known gem. The jewel could have inspired the expansive hip of Donatello's *David*.

If Donatello created his *David* to rival or even surpass the art of antiquity, it would have been to the greater glory and benefit of Cosimo de' Medici, since the statue would have served to prove that benevolent government results in the prosperity of the arts. And so Cosimo erected the statue as a symbol of the divinely protected, prospering city of Florence – in the courtyard of his private palace.

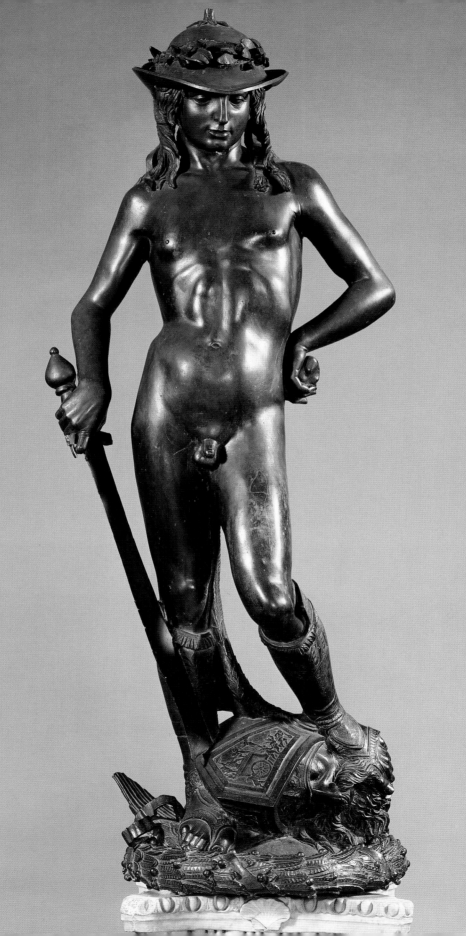

Guardians of the Sun

Aztec Eagle Knight, Artist unknown

SUSAN TOBY EVANS

The Eagle Knight sculpture is a masterwork of stylistic expression and technical skill.

Above

The encyclopaedic *General History of the Things of New Spain* (the Florentine Codex, *c.* 1569) includes this illustration of two Eagle Knights flanking a Jaguar Knight and brandishing shields and clubs, edged with razor-sharp obsidian blades.

Mid-15th century
Ceramic
H 170 cm / 5 ft 7 in.
Museo del Templo Mayor, Mexico City, Mexico

The Eagle Knight is a life-size ceramic sculpture, a naturalistic representation of a member of an Aztec elite warrior cadre, dressed in battle costume. Dating to 1440–69, it is one of two nearly identical figures that once flanked the entrance to the House of the Eagles, thought to have been a sanctuary for the Eagle Knights – warriors for whom the eagle, an avatar of the life-giving sun, served as a totemic patron. This building is located just north of the Great Temple (Templo Mayor) of Tenochtitlan, the very pivot point of the Aztec *axis mundi*, anchoring heaven and the underworld to the plane of the earth.

The Eagle Knight sculpture is a masterwork of stylistic expression and technical skill. The figure reflects the Aztec ideal of young manhood. It shows either the brave and noble warrior dedicated to securing war captives for sacrifice to the sun – or that warrior's immortal transformation after death into a companion of the sun god in his daily circuit. His earlobes are perforated, indicating the honours in insignia that would have been bestowed on the knight and would have adorned his effigy. The face emerges from the open beak of a dramatic eagle head mask. This headdress as worn by the actual Eagle Knights would have been constructed as a framework of wood or reeds over which fabric was stretched, and then feathers attached.

He stands 170 cm (5 ft 7 in.) tall, with erect posture, arms extended forwards. The hands have been shaped to accommodate a standard, or perhaps weapons. The Eagle Knight costume, worn in battle, was a fitted full-length suit appliquéd with feathers. On the ceramic figure, these feathers are indicated by thin flat ceramic ovals, secured to the figure during manufacture, and also by the volute shapes edging the wings extending back from the arms. The power of eagles is further conveyed by the claws at the figure's knees. The figure's sandals represent a singular honour in Aztec society, where such footwear was a privilege of rank under strict sumptuary rules.

Made up of five large components, the sculpture would have required considerable expertise to manufacture. It and the five other large anthropomorphic ceramic sculptures in this compound were probably the products of a specialist studio in Tenochtitlan. The figure was stuccoed and painted, but little remains of these surface embellishments because the House of the Eagles was destroyed by the Spaniards in their siege of Tenochtitlan in the summer of 1521. When Aztec warriors took refuge there, Spanish guns were levelled at the structure and all the courage of eagles could not save it or its guardian figures. The shattered sculptures became part of the fill underlying the capital of colonial New Spain; the weight of four-and-a-half centuries of burial and superimposed construction left them in fragments. It was only in the early 1980s that excavation retrieved the remains of this remarkable sculpture and its companion pieces.

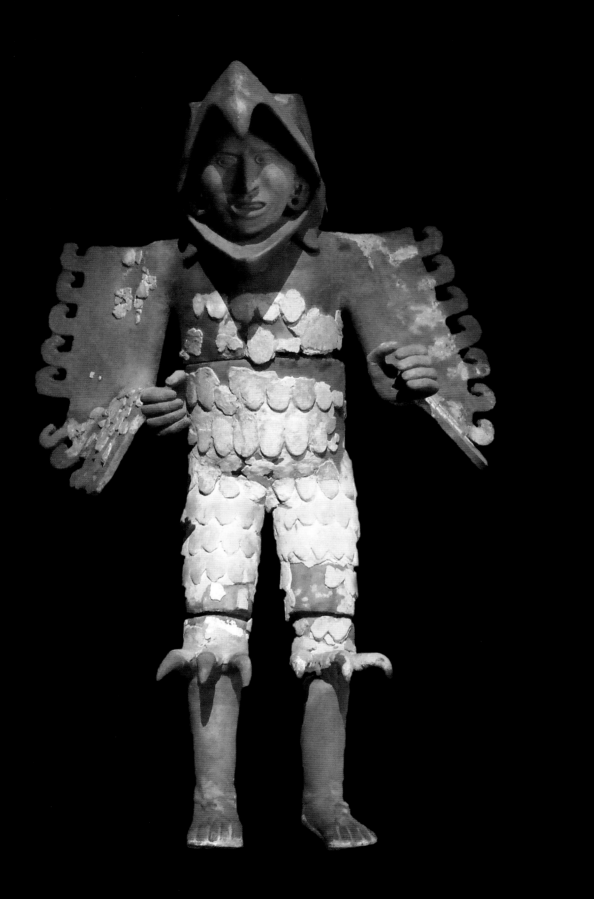

A Dream Come True

The Montefeltro Altarpiece, Piero della Francesca

MARILYN ARONBERG LAVIN

> ‘ *One night, many years ago, I had a dream. In this dream I saw Federico, Duke of Urbino …*

Above
Detail of Federico's breast and arm, clad in armour. The fitments include: a reinforcing plate bolted onto the bent-forward breast-plate; a hook to hold a lance; butterfly-shaped elbow guards; and a velvet-covered strap with external hinge at the wrist. On his hands are wedding and insignia rings and he wears the knotted belt of Saint Francis.

1472
Oil, mixed with some tempera, on panel
248 cm × 170 cm / 8 ft 1½ in. × 5 ft 7 in.
Pinacoteca di Brera, Milan

One night, many years ago, I had a dream. In this dream I saw Federico, Duke of Urbino, wearing a full suit of laminated steel, excluding his helmet and gauntlets, which lay on the ground before him. And then I heard a voice: ‘Federico da Montefeltro changed his armour.’ Perplexed, the next morning I sought out a book on Piero della Francesca and studied a reproduction of the *Virgin and Child with Saints* (commonly known as the *Montefeltro Altarpiece*) that had appeared to me in the night. There was Federico, kneeling in prayer before an august company of the Virgin Mary with her son lying asleep (dreaming?) on her lap, six male saints, and four smartly dressed angels. These twelve figures, physically overlapping in a tightly knit group, filled every millimetre of the width of the panel. At the same time, the empty upper part of the splendid building they were standing in occupied a good half of the panel's height. Within this vast architectural space, and seemingly above Mary's head, an egg dangled from a thin gold chain, suspended from the tip of a large shell filling the semi-dome of an apse at the end of a barrel vault. Federico was occupying the same space as the intercessors, but he did not address them. On the contrary, kneeling in strict profile, he was staring fixedly before him.

My dream had led me to look anew at this remarkable painting, and in describing it to myself, I realized what made the image unique. Aside from Piero's painterly brilliance, and the work's conceptual solemnity – a stark contrast with the fairly rigid early Renaissance *sacre conversazioni* – this is probably one of the most mysterious works of art of the 15th century.

Before I could ask how Federico had ‘changed his armour’, I had to ask what in the world was he doing in church in full battle regalia?

One of the first works Piero did primarily in oil, the *Montefeltro Altarpiece* abounds in stunning pictorial refinements: the gold palmettes embroidered on the edge of the Baptist's cloak; the pearls that decorate the neckline and hem of the Madonna's mantle; the transparent gown of the angel on her right; the fragile crystal cross proffered by Saint Francis; the reflection of the lighted window on Federico's breastplate; the gold flecks that brighten the rosettes in the coffered ceiling. Piero has represented a spiritual realm with Renaissance realism and naturalism. But simultaneously, he has provided a world of symbols that belie the realistic details. If the Virgin were to stand up, she would tower over her sacred cohorts. With this irrational leap of scale, he recalls the age-old metaphor of Mary as Ecclesia, the personification of the universal Church. If you look carefully, you will see that Piero has placed us in the nave of a huge basilica; the figures are in the transept and behind them there is a deep space leading to the apse where the egg hangs. With his stunning skill in the art of perspective, he has created a complete illusion. The saints

surrounding the Virgin like a theological guard of honour stand for the Church – in fact, the many churches of Urbino that bear their names. The presence of the gorgeously inscrutable angels sanctifies the figures and the building.

Mary prays over her divine infant, nude to verify his status as the 'word made flesh'. With sunken eyes and down-turned mouth, he sleeps in an uncomfortable position, setting up a major diagonal in the composition. As he stretches across his mother's ample lap, his somnolence itself is a symbol of his future sacrifice. Around his neck is a chain of coral beads from which hang two amulets, one a crystal ball, the other an uncut branch of coral. These semi-precious stones are meant, magically, to ward off evil. But the coral branch, resembling a miniature pulmonary tree, also symbolizes the lungs from which Christ will breathe his last but which yet hold the vital spirit that will live for all eternity. This allusion to death and resurrection, in turn, explains the egg – most probably an ostrich egg – often found in Italian churches suspended in just this fashion. It refers both to Mary's fertility and to Christ's regeneration. What is out of the ordinary is its geometric perfection, its purity of form. In a typical manner, Piero has used the lack of decoration to assist in reading the egg, as a volume both within the depth of space and on the surface of the painting, to relate to the mother and child, thereby reinforcing the optical illusion. As a result, in the vertical path from shell to egg, egg to the holy couple and back again, the full cycle of salvation is housed within the authority of Ecclesia.

In the foreground, the armoured Federico kneels to pray. He had ascended to the noble rank of count in 1444, and during his long and successful reign waged many battles while engaged as a *condottiere*, or paid general. In the early 1470s – precisely when this altarpiece was executed – he enjoyed his greatest victories and as a result was heaped with honours; one of his daughters was even engaged to a nephew of the pope. Although these honours carried visible signs in the form of seals, tags and jewelry, only two indicators of his new position are shown: a sword wrapped in red velvet, and the spurs of steel and gold – both gifts of the pope. This, then, was how he 'changed his armour'. As we begin to understand his pose (and his armour), the final clue is his air of emotional isolation. Federico has not come to pray in the usual manner as suppliant, begging for help from his heavenly mentors. He is not presented by a patron. Instead, he appears as a strong, self-sufficient agent, offering, not asking for, protection. He is a new kind of Christian knight boldly pledging to the Church, along with his piety, his entire physical force and military prowess. Piero changed the nature of the altarpiece and created for Federico a visual oath of fidelity in an image of harmonious balance between immediacy and timelessness – one that still calls out in the night, and insists we keep looking day by day.

Above
Detail of the coral amulet and the crystal ball suspended on a string of coral beads round Christ's neck.

Borne on Wind and Wave

The Birth of Venus, Alessandro Botticelli

PAUL JOANNIDES

'Bewitching in her combination of beauty and freshness, the goddess looks shyly outwards, not yet conscious of her power or in possession of her realm.

There is no record of the *Birth of Venus* before 1550, when it was described by Vasari; it was then in the Medici villa at Castello, just outside Florence. The painting was long believed to have been commissioned by Lorenzo the Magnificent in the 1480s as a wedding gift to his young cousin, Lorenzo di Pierfrancesco de' Medici. But it is absent from the latter's inventories and the picture's patron, early owners and planned location – the unusual dimensions indicate a site-specific project – remain conjectural. The Medici were active as collectors as well as patrons in the later 15th and early 16th centuries and the *Birth of Venus* could just as well have been a later acquisition as a contemporary commission. But if not for a Medici, it was probably painted for someone in their circle, and almost certainly to celebrate a marriage.

Earlier critics assumed the *Birth of Venus* to be a pendant to Botticelli's *Primavera*, which does appear in Lorenzo di Pierfrancesco's 1499 inventory, but in his house on the Via Larga, not at Castello. The two paintings are the earliest known – and certainly the earliest surviving – large-scale treatments of mythological divinities in Italian art (excluding examples of heroic virtue such as Hercules) and it is natural to associate them with each other. They are similar – but far from identical – in size, and although the *Primavera* is primarily an allegorical evocation of Spring, its protagonist is Venus and it might plausibly accompany a representation of her birth. However, several facts count against a pairing: the *Primavera* is usually dated *c.* 1478, the *Birth of Venus* up to a decade later; the *Primavera* is on wood, the *Birth* on canvas; and their principles of design and complement of forms and textures are very different. None of these facts is decisive, but taken together they strongly suggest that notwithstanding their continuities of cast – as well as Venus, Zephyr and Chloris appear in both – they were separate commissions. The *Primavera* is based on a text from Ovid's *Fasti*, with erudite additions, and a complex narrative of transformation and association unrolls in time and space from right to left. Its proliferation of spring flowers gives it the air of a transposed *mille-fleurs* tapestry, and its visual precedents are largely to be found in tapestries of the months. The *Birth of Venus*, in contrast, depicts a single moment and its story and meaning are instantly grasped.

The *Birth of Venus* was a subject frequent in antique and – very occasionally – medieval art. It is also found in Renaissance literature, notably by Agnolo Poliziano (a friend of Botticelli), who wrote verses on the subject in his *Stanze per la giostra*. But Botticelli's treatment is quite new and demonstrates a powerful visual intelligence. The painting's size demanded breadth and clarity and the flexible support a generous breadth of treatment. Botticelli extends to a private and secular commission the grand simplicity developed in his large-scale mural paintings in the Sistine Chapel in Rome in 1483.

Opposite
Venus' abundant hair responds to Zephyr's breath, but also takes on independent life caressing her shoulders and neck; her right eyelid, slightly heavier than the left, hints at sensuality.

1480s
Tempera on canvas
172.5 cm × 278.5 cm / 5 ft 8 in. × 9 ft 1¾ in.
Galleria degli Uffizi, Florence

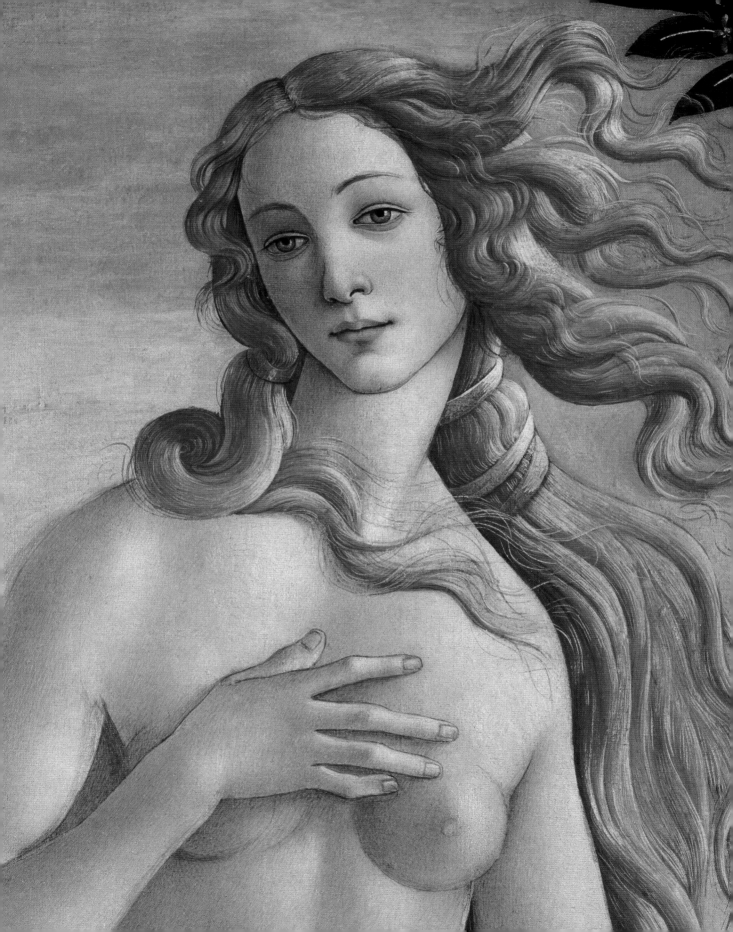

> *… the compositional structure is a transposed Baptism, with Venus – like Christ – in the centre …*

The light tonality and dry surface of the tempera medium are texturally similar to fresco and the precise, elaborate detail of the *Primavera* gives way to simplified and stylized forms – the repeated Vs of waves, the stage-flat vegetation and the highlights in gold. The patterning of the image, and its denial of perspective, from one of the most dynamic perspectivists of the period, evince a rigorous control of means. The narrative is shot frontally, as if through a long lens that compresses the space, tips the scallop shell, and arrests the action in iconic stasis – a technique plundered by legions of fashion photographers and film-makers. While the *Primavera* is a formal dance, the *Birth of Venus* is magical theatre: at the left Zephyr and Chloris' conjoined silhouette is that of a looped-up canopy and the receptive cloak on the right doubles as a curtain withdrawn to reveal Venus' beauty. Botticelli's display, inspired by the curtaining of altarpieces, may, in turn, have prompted Raphael's exploitation of the motif in the *Sistine Madonna*, with its majestic vision of the cloud-borne Virgin.

Paler against pale, Botticelli's Venus floats against a high sky that seems a condensation of ether rather than transparent. Her contours are slightly shadowed to make her stand out against the sky and the interior of her body lightened and unemphatically modelled to bring it forward. This was a principle absorbed by Michelangelo, who employed it in the central histories of the Sistine Chapel ceiling. It is a gamble saved from crudity only by draughtsmanly accomplishment: in Botticelli, as in Michelangelo, the intensity of the line, elastic and rhythmical, animates the figures and keeps the eye in

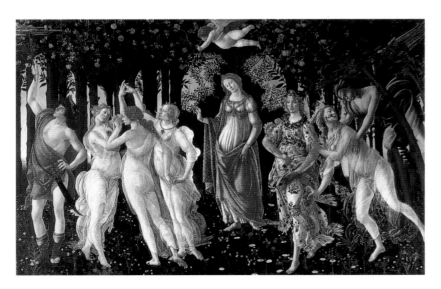

Left

The *Primavera* might have been intended as part of an unexecuted seasonal cycle – Botticelli certainly designed an Autumn. More formal than the *Birth of Venus*, its tapestry-like detail gives way in the later work to simplified, pared-down patterning.

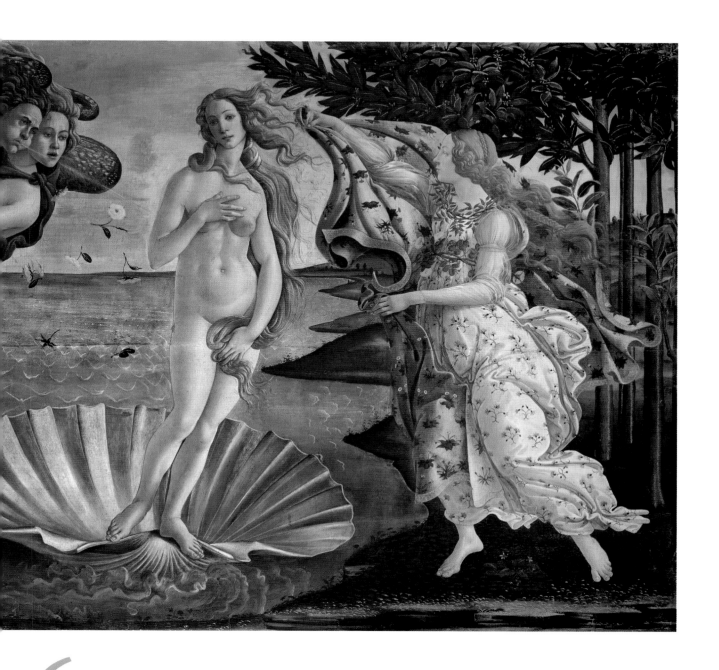

' *The narrative is shot frontally, as if through a long lens that compresses the space, tips the scallop shell, and arrests the action in iconic stasis ...*

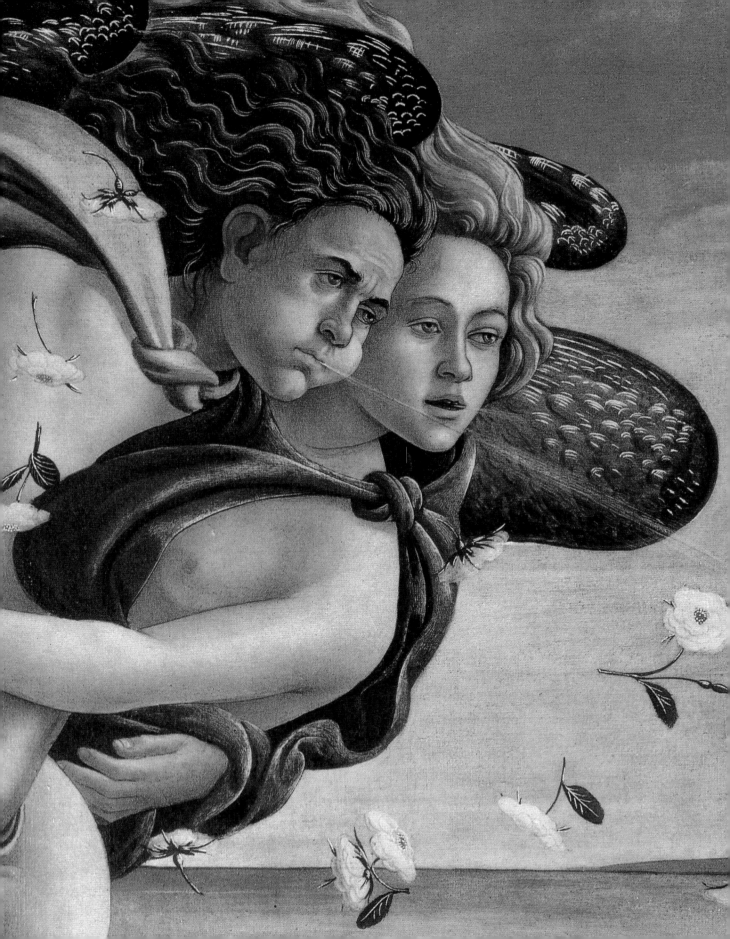

constant exercise around them. Botticelli's 'colour field' technique was also to affect Michelangelo: warm and cold colours are, as it were, cross-fertilized as the cool body of Venus is drawn towards the warmth of the cloak and the foliage.

Appropriately for a mythological scene, Botticelli drew on Classical sculpture: Zephyr and Chloris were inspired by flying figures in one of the il Magnifico's sardonyx cameos, while Venus is an elongated and willowy interpretation of the *Medici Venus*, undulating with the breeze that wafts her to shore amid roses. But these references function within a scheme – and theme – inspired by religious imagery. It is well-known that the compositional structure is a transposed Baptism, with Venus – like Christ – in the centre, the nymph who receives her occupying the place of the Baptist, and Zephyr and Chloris (whose first union is seen at the right of the *Primavera*) replacing angelic witnesses. But this scheme is much more than formal scaffolding; it subtly transfuses the meaning of baptism from the spiritual to the erotic: Venus is born from liquid as the soul is reborn in baptism. And since she sprang fully grown from the severed genitals of Saturn thrown into the Mediterranean, Venus' birth is divine. This explains another transposition, the equivalence of her face to those of Botticelli's immaculate Virgins and it may also have inspired the drift of roses, widely associated with the Virgin.

Bewitching in her combination of beauty and freshness, the goddess looks shyly outwards, not yet conscious of her power or in possession of her realm. The *Birth of Venus* is sometimes interpreted as an evocation of the celestial (as opposed to the terrestrial) Venus, embodying divine rather than earthly love, a common Neo-Platonic trope. But there is no reason to confine the painting to philosophy. Venus personifies and expresses physical beauty and modesty; but if at the moment innocence reigns, physical love is immanent – and perhaps imminent: the painting might be a bridegroom's vision on his wedding night. No painter was to achieve such equilibrium between eroticism and innocence until Burne-Jones, an artist obsessed with Botticelli's work.

Notwithstanding the uncertain origins of the *Birth of Venus*, the compelling force of Botticelli's vision was appreciated within his own lifetime: he and his studio repeated the Venus with slight modifications in paintings now in Berlin and Turin. There is no previous example of a single mythological figure being extracted from a larger composition and it foreshadows later practices: it is the full-length close-up that follows the long shot and it brings Venus into still more immediate relation to the viewer. She emerges modestly from a dark setting into the bedchamber – and the bridegroom's presence.

Above
Alessandro Botticelli (and studio), *Venus*, 1480s?, tempera on canvas, 157 cm × 68 cm (5 ft 1¾ in. × 2 ft 2¾ in.), Gemäldegalerie, Berlin. The main change to the single figure is the hair, which, no longer blown by the wind and also plaited into two strands, makes Venus more immediate and accessible.

Opposite
Zephyr and Chloris, as well as wafting Venus to the shores of Paphos, foreshadow in their conjunction what is to be Venus' primary activity.

Perfecting the Art

1500–1600

In God's Image

Self-Portrait, Albrecht Dürer

ULRICH PFISTERER

' *Dürer grasps the fur trim with his right hand, his index finger pointing to himself and emphasizing the 'divine hand' of the artist ...*

Above
The superbly executed detail of the fur is made all the more realistic and tactile by the artist's decision to present himself as touching it, as the viewer instinctively desires to do.

1500
Oil on panel
66.3 cm × 49 cm / 2 ft 2 in. × 1 ft 7¾ in.
Alte Pinakothek, Munich

For humanists north of the Alps such as Conrad Celtis the year 1500 represented a chance to celebrate the renewed 'Germanic' culture under the rule of Maximilian I. It is likely that this self-portrait by Albrecht Dürer, dated to the same year, was produced in this spirit, to demonstrate German rivalry of Italian painting. Sadly, no contemporary evidence can verify this: the earliest reference to this painting dates from the time of its sale to the Kurfürstliche Gemäldegalerie München in 1805. And though a poem by Celtis from the year 1500 mentions a Dürer self-portrait, it is far from certain that he is referring to the Munich panel.

However, the gilt inscriptions on the image itself offer a clue. Dürer's familiar 'AD' monogram and the date 1500 can be seen on the left, while on the right appears a four-line inscription in Latin that translates as: 'I, Albrecht Dürer from Nuremberg, have painted myself with my own paints at the age of 28.' Dürer turned 29 on 21 May, 1500, but whether he was actually 28 when he painted this remains debatable – after all, ever since Saint Isidore 28 had been perceived as the age of a man's utmost beauty and strength. What is particularly interesting, however, is that the inscription uses a humanistic chancery script not found in any other work by Dürer – pointing again to the circle around Celtis.

In this, his third independent self-portrait, Dürer presents himself almost life-size in a frontal pose, though his eyes avoid the gaze of the viewer. The beard is finely trimmed, the magnificent head of brown curls meticulously draped on the shoulders. Over a white shirt he wears a sumptuous coat – a symbol of prosperity and social status – trimmed with marten fur and with a fashionable vent in the sleeve. Dürer grasps the fur trim with his right hand, his index finger pointing to himself and emphasizing the 'divine hand' of the artist – very subtly, he seems to hint that he owes his social position to the marten hairs of his paintbrush.

The most striking feature of the portrait, however, is its close resemblance to depictions of Christ, in particular as they appear in the work of Jan van Eyck. Dürer's carefully parted auburn curls correspond to the description of Christ in the letter supposedly written by Pontius Pilate's predecessor, Lentulus. Furthermore, Dürer's head adheres to the ideal proportions dictated by the painter himself, underlining the perfection of God's creation. As early as 1600, painters would adopt this self-portrait as the image of Christ. However, Dürer's image should not be construed either as heretical hubris or as an affirmation of faith. Rather, the image is a statement of the artist's own ability to depict a human being created 'after the image of God'. The fact that Dürer restricted his palette to black, brown, red and white – the same four colours used by the ancient painter Apelles, whom Dürer sought to emulate – seems to support the reading of this painting as a virtuoso work.

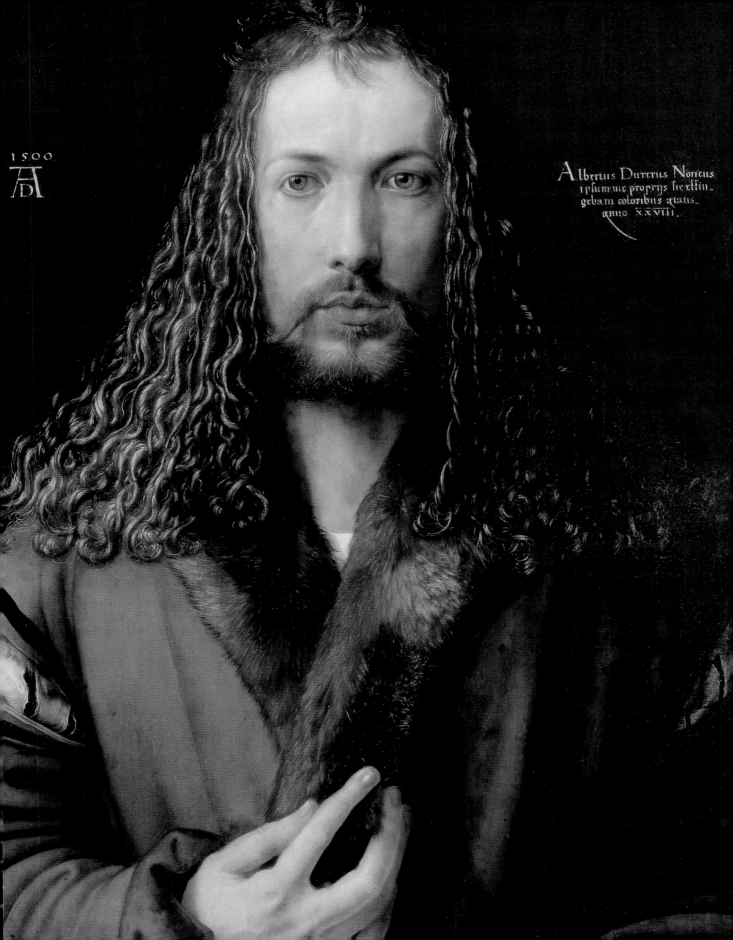

1500

Albertus Durerus Noricus
ipsum me proprijs sic effin
gebam coloribus aetatis
anno XXVIII.

The Human Landscape

Portrait of Lisa del Giocondo, formerly Lisa Gherardini (Mona Lisa), Leonardo da Vinci
MARTIN KEMP

> *Leonardo saw the eyes as the windows of the soul. Lisa's windows are glazed with smoked glass.*

The famed mystery of the *Mona Lisa* no longer involves the identity of the sitter. She was Lisa Gherardini, born in Florence on 15 June 1479 to an old Tuscan landowning family, no longer at the height of their prosperity. On 5 March 1494 she married a rising silk merchant, Francesco del Giocondo. Leonardo's father, the important notary Ser Piero da Vinci, knew Francesco and was probably responsible for his son agreeing to paint his friend's wife. Francesco's will, written in 1537, two years before his death, testifies to 'the affection and love of the testator towards Mona Lisa, his beloved wife.' Furthermore, 'in consideration of the fact that Lisa has always acted with a noble spirit and as a faithful wife,' Francesco decrees that, 'she shall have all she needs.'

Nor is there any mystery about the date at which Leonardo began her portrait. In 1503 Agostino Vespucci, cousin of the famous Amerigo and secretary to Niccolò Machiavelli, noted in the margins of his printed edition of Cicero's letters that a portrait of 'Lisa del Giocondo' was among the paintings on which Leonardo was engaged. It is likely that Lisa was pregnant with one of her five children. This does not mean that the painting was finished and ready to be handed over. Leonardo was a slow painter, and the portrait never left his possession.

After Leonardo's death in 1519 the painting passed into the hands of the master's rather disreputable pupil, Salai, who himself died five years later. It was among the late Salai's possessions when a list was drawn up for the division of his assets between his sisters. At some date it was acquired by the French king Francis I, for whom Leonardo had worked in the last three years of his life, and eventually passed to the Louvre.

The mystery is why this portrait of an apparently unremarkable Florentine bourgeois woman should have become the world's most famous picture. The answer is that the painting, having begun life as a standard commission, came to transcend its function as a portrait in a very radical way.

Even as a portrait, the *Mona Lisa* was very innovatory. The Florentine sitter is surprisingly shown sitting on a balcony high above a landscape. She looks at the spectator and reacts to our presence with an elusive smile. The smile may serve as an emblem of her name: 'La Gioconda' (the cheerful one). It was very daring for a woman to make eye contact in this way, and could even be regarded as bad manners. None of Leonardo's earlier portraits of women do this. It is likely that the very private nature of the commission gave Leonardo the licence to innovate in this way.

But its originality goes beyond these formal and emotional novelties. It translates the image of the 'beloved lady' that permeated Italian Renaissance poetry into a new visual form. Dante had written:

Opposite
Glazed subtleties and teasing ambiguities in the *Portrait of Lisa del Giocondo, formerly Lisa Gherardini* (known as the *Mona Lisa*).

c. 1503–06
Oil on canvas
77 cm × 53 cm / 2 ft 6¼ in. × 1 ft 9 in.
Musée du Louvre, Paris, France

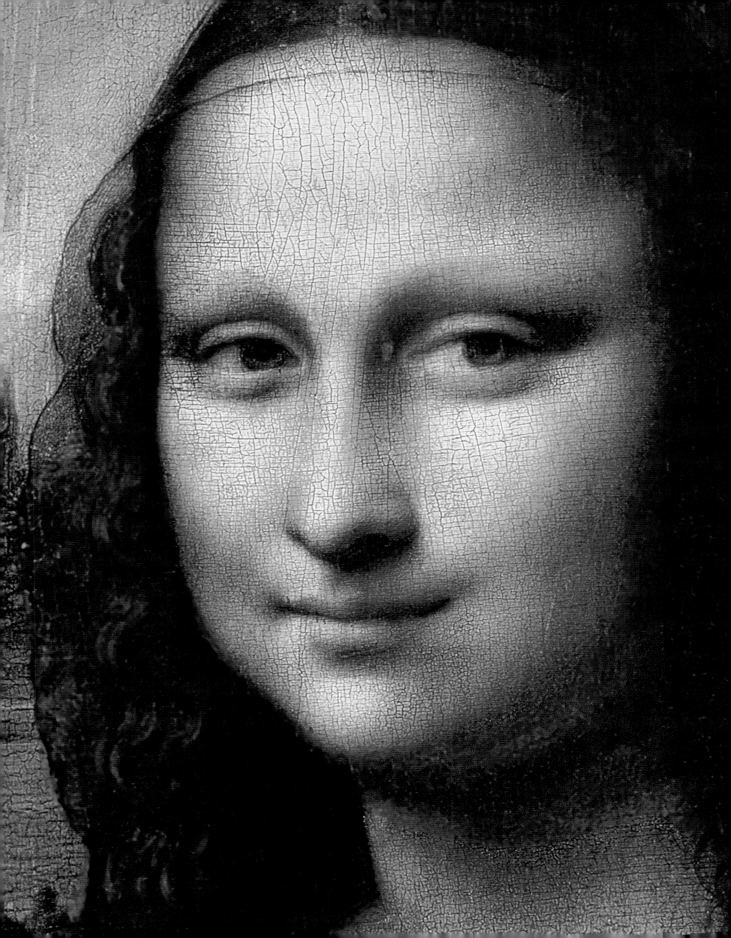

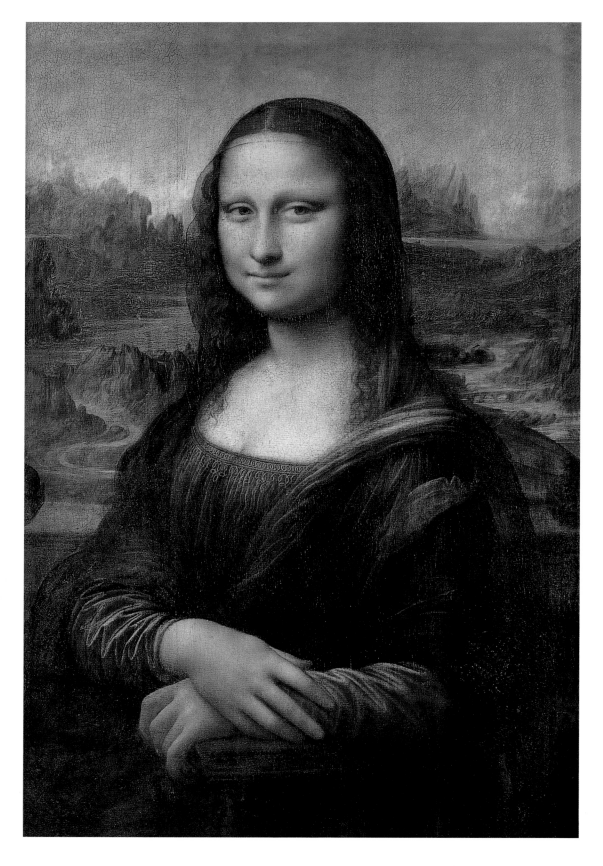

The soul operates very largely in two places, because in these two places all the three natures of the soul have jurisdiction, that is to say in the eyes and mouth. ... These two places, by a beautiful simile, may be called the balconies of the lady who dwells in the architecture of the body, that is to say the soul, because she often shows herself there as if under a veil.

A veiled portrait of the soul – this is precisely what Leonardo was proposing. His miraculously fine layers of pigment, applied in countless tinted glazes, leave the surfaces elusive. Our eye seeks the certainty of defined contours, but is drawn into an imaginative play with her expression. Leonardo saw the eyes as the windows of the soul. Lisa's windows are glazed with smoked glass.

The 'architecture of the body' for Leonardo profoundly mirrored the architecture of the body of the earth. The human body was a microcosm, or 'lesser world', reflecting the forms and functioning of the macrocosm of the world as a whole. As Leonardo wrote:

By the ancients man was termed a lesser world.... In that man is composed of water, earth, air and fire, his body is an analogue for the world: just as man has in himself bones, the supports and armature of his flesh, the world has the rocks; just as man has in himself the lake of the blood, in which the lungs increase and decrease during breathing, so the body of the earth has its oceanic seas which likewise increase and decrease every six hours with the breathing of the world; just as in that lake of blood the veins originate, which make ramifications throughout the human body, similarly the oceanic sea fills the body of the earth with infinite veins of water.

Lisa's hair and drapery flow in curving rivulets, echoing the watercourses in the valley below. Leonardo describes blood as 'vivifying' the human body just as the 'veins of water' nourish the earth. The landscape is permeated with motions of life in the terrestrial body. A high lake on the right feeds a lower lake to the left. This will change over time, just as the human body changes.

A portrait has become a philosophical mediation on human nature in the context of the life of the body of the world. Leonardo uses his subtle visual magic to entice us into his meditation, but he teases us. He does not tell us what to think. We, like earlier generations, are seduced into making of it what we will.

Lisa's hair and drapery flow in curving rivulets, echoing the watercourses in the valley below.

Above
A seemingly dry meander in an old water course. It will eventually receive water from the lake as the earth undergoes its vast transformations.

Trick of the Light

The San Zaccaria Altarpiece, Giovanni Bellini

PETER HUMFREY

‘ *... the painting ... offers the worshipper a glimpse into the majesty and serenity of heaven, where the saints eternally contemplate the glory of God to the sound of celestial music.*

Above
Bellini painted several so-called *sacra conversazione* altarpieces during the course of his long career. Typically, however, the holy figures do not converse with one another, or even meet one another's gazes, but are rapt in inner meditation, like Saint Peter.

1505
Oil on canvas, transferred from panel
402 cm × 273 cm / 13 ft 2¼ in. × 8 ft 11½ in.
San Zaccaria, Venice

Just inside the marble-clad church of San Zaccaria in Venice, in its original position above the second altar in the left aisle, is a richly glowing masterpiece by one of the great painters of the Italian Renaissance, Giovanni Bellini. The painting shows the Virgin Mary seated on a tall throne against the apse of what appears to be a small chapel. She lightly supports the Christ Child on her left knee, and presents him to the spectator for worship. At the foot of the throne sits an angel playing a *lira da braccio* (an instrument not dissimilar to a modern-day violin) and to his left, affixed to the red marble of the step, is an unfolded slip of paper bearing the artist's signature and the date 1505. Standing like sentinels on either side are four saints: Peter, with his Bible and keys; Catherine of Alexandria, with her palm of martyrdom and shattered wheel; Lucy, with her own palm and glass lamp; and Jerome, dressed in the robes of a cardinal and reading his Bible. Architecturally, the chapel-like structure, with its delicately carved foliate ornament on the faces of the supporting piers, is in the style of the early Renaissance; the mosaic decoration of the half-dome, meanwhile, harks back to Byzantine art and the state church of Venice, San Marco. It is clear from this combination that the architecture is not that of any real chapel; furthermore, it is open at the extreme left and right to glimpses of verdant landscape, with trees in a meadow leading to distant blue mountains and a luminous sky. For all its command of Renaissance realism, the painting does not depict any actual scene, but instead offers the worshipper a glimpse into the majesty and serenity of heaven, where the saints eternally contemplate the glory of God to the sound of celestial music.

Other details provide symbols of the divine nature and redemptive love of Christ and his mother: the carved head of Solomon at the top of the throne (referring to divine wisdom); the crystal lamp and ostrich egg hanging above it (referring respectively to purity and the virgin birth); the fig tree to the left (a well-established messianic symbol). But Bellini's evocation of divine immanence is achieved even more powerfully through pictorial means. In the first two decades of his long career he had mastered the essential innovations of early Renaissance Florence: the representation of rounded form in three-dimensional space, by means of geometric perspective, consistency of

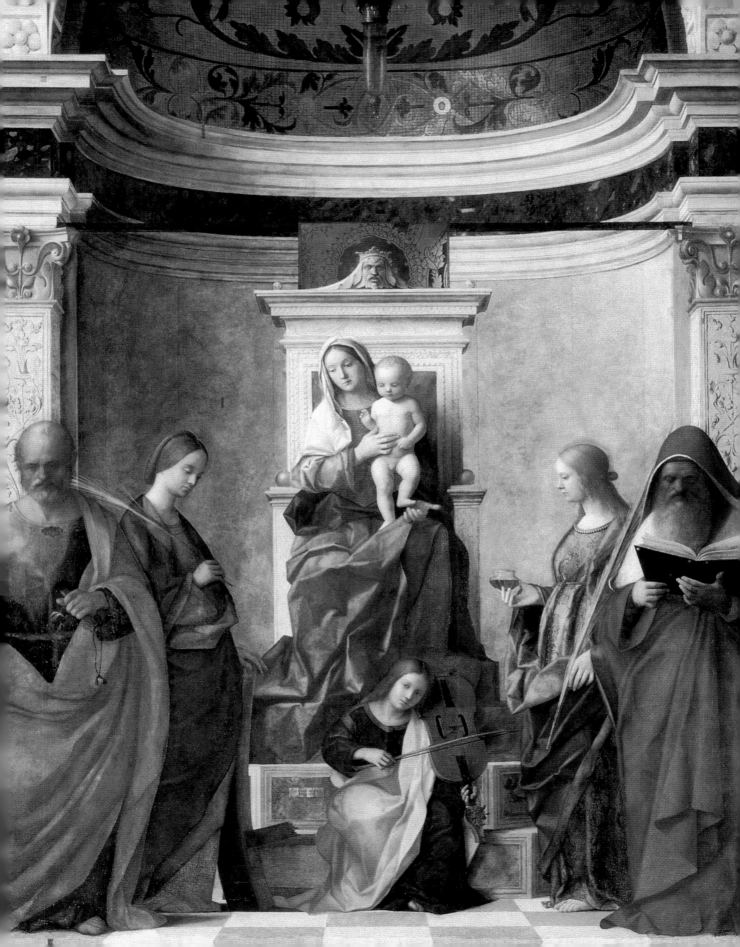

> *The voluminous draperies of the San Zaccaria altarpiece appear to glow as if from within, and set up a harmonious pattern of shapes and colours on the picture surface.*

Above

Bellini, *Madonna of the Pomegranate*, *c.* 1486–89 (oil on panel, 91 cm × 65 cm / 2 ft 11¾ in. × 2 ft 1½ in. National Gallery, London). One of Bellini's most characteristic types of production, apart from his majestic series of altarpieces, was the image of the Virgin and Child alone, seen in half length and on a scale more suitable for contemplation in private. Although it precedes the San Zaccaria altarpiece by some two decades, this example already shows a full mastery of the oil technique.

Opposite

Bellini's altarpiece in its original frame in the church of San Zaccaria. As well as enhancing the illusion that the near-life-size holy figures occupy a space just beyond an opening in the church wall, the frame reinforces the link with the altar below, where daily masses would have been said for the donor and his family.

lighting, and understanding of human anatomy. Until about 1475, Bellini combined these achievements with a metallic sharpness of outline, an enamelled hardness of surface, and a cool austerity of colour, all of which were the consequence of his continuing employment of the traditional technique of egg tempera. But his growing mastery from the 1480s of the Flemish technique of oil painting stimulated him to soften edges and tonal transitions, and to employ a new depth and richness of colour. The voluminous draperies of the San Zaccaria altarpiece appear to glow as if from within, and set up a harmonious pattern of shapes and colours on the picture surface. Bellini was never particularly interested in Florentine experiments with dramatic action, but whereas his earlier figures show some gesture and movement, here they are absolutely still, absorbed in inner meditation. This effect of stillness is emphasized by the deliberately archaic symmetry of the composition, with a strongly pronounced central axis running down through the lamp, the Virgin's throne and the tiled floor, and the saints posed in contrasting profile and strict frontality.

Bellini's painting is still enclosed in its original, monumental frame, in which smooth marble columns are paired with richly carved pilasters. The Classical forms of the frame closely match and link up with those of the painted architecture to create the illusion that the church wall has dissolved to reveal the holy figures in a sacred precinct immediately above and beyond the altar. This effect remains vivid, despite the fact that it has been compromised ever since the Napoleonic period. In 1797 the painting was carried off by French troops as war booty, and while it was in Paris areas of architecture above and floor below were vandalously amputated, so that on its return to Venice in 1816 it no longer filled its original frame.

It is not known who commissioned Bellini's painting and its magnificent (and certainly very expensive) frame, but it is a fair guess that the patron was a member of Venice's ruling patriciate. In this connection, it is worth remembering that the Benedictine nuns' church of San Zaccaria was the destination of an annual Easter procession by the doge and his retinue, and the site was one of exceptional prestige. The ducal associations with the church may also account for the evocation of San Marco in the apse mosaic.

The rapid pace of developments in Venetian painting meant that the art of Bellini quickly came to appear old-fashioned after his death in 1516, and the meditative stillness and spiritual depth of the San Zaccaria altarpiece were replaced by the extrovert rhetoric of Titian. Its removal to Paris by the French was a compliment of sorts, but the modern appreciation of Bellini really only began in the mid-19th century. Leading this revival was John Ruskin, who in a lecture at Oxford in 1871, called the San Zaccaria altarpiece one of 'the two best pictures in the world' – the other being Bellini's Frari triptych of 1488.

Unknown Pleasures

The Garden of Earthly Delights, Hieronymus Bosch

GRAYSON PERRY

> *Over the past century this dazzling enigma has been interpreted as being about the sin of luxury, the rebirth of the world after the Flood, alchemy, heresy, astrology and a 'paradisiac marriage' rite ...*

Opposite
It is impossible to take in all the minutiae of *The Garden of Earthly Delights*, let alone make sense of them. In this detail from the central panel we see bizarre acrobatics, cavorting couples and swimmers.

1505
Oil on wood
220 cm × 390 cm / 7 ft 2½ in. × 12 ft 9½ in.
Museo Nacional del Prado, Madrid

magine the scene: it is about 1517 and you are a guest of Hendrick III, Count of Nassau-Breda, at his elaborate palace in Brussels. It is a house of pleasure and visual wonders, natural and man-made: there is a bed large enough to hold fifty drunken revellers and a meteorite that once almost landed on your host. He takes you to see one of his famous treasures, a large painted altarpiece, most probably commissioned by him a decade or so previously. At first you are mystified by the scene on the exterior of the closed doors, a desolate monochrome landscape contained in a glass sphere. A tiny God, Bible in hand is depicted hovering above. He is on his third day of creation, and below him is the world before humankind arrived, overcast and empty. Then the huge doors are thrown open and you are overwhelmed by what is the most provocatively inventive fantasy in all Gothic and Renaissance painting. You are drawn into a complex maze of hallucinatory colour and incident – you are in Hieronymus Bosch's greatest work, *The Garden of Earthly Delights*.

The origins and meaning, even the true title of this work, are lost to history. Over the past century this dazzling enigma has been interpreted as being about the sin of luxury, the rebirth of the world after the Flood, alchemy, heresy, astrology and a 'paradisiac marriage' rite performed by a religious sect to which Bosch belonged. Some or all of these things may have influenced Bosch's vision. From his output it is clear that Bosch was a moralist as much as an individualist. The fact that it is in the traditional form of a winged altarpiece and can be read from the exterior then inside from left to right suggests that it is meant at least as a commentary on contemporary religion or maybe as a highly unusual devotional work.

The interior left-hand panel shows a relatively conventional vision of Paradise. In the foreground we see God (in the form of Jesus) introducing a waking Adam to Eve, having fashioned her from his rib while Adam was asleep. They are surrounded by flora and fauna, both real and imagined. The pink phallic crustacean form in the centre of the panel is the Fountain of Paradise that irrigates all the land. In a round aperture in the fountain's base sits an owl, a predator of the night, wise and yet brutal – a hint perhaps that nature is far from innocent and a sign of the Fall of man that is to come.

The central panel appears to depict a weird orgy. In 1517 you might perhaps have turned away, fearful that you had been exposed to a heretical image – after all, the Inquisition, with its detestation of all physical pleasures, was in progress. But your host could quell your fears with his interpretation. You are staring at an earthly Paradise that never was and never will be. On closer inspection it turns out to be a strangely innocent scene, one of harmony between humans and nature and between different races. Giant birds feed berries to men and women, couples of different races embrace in boats.

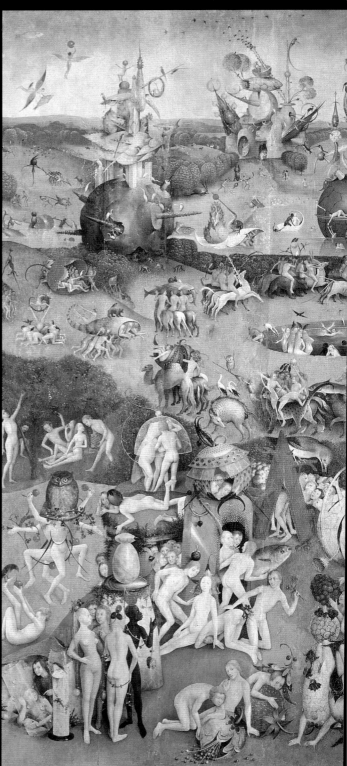

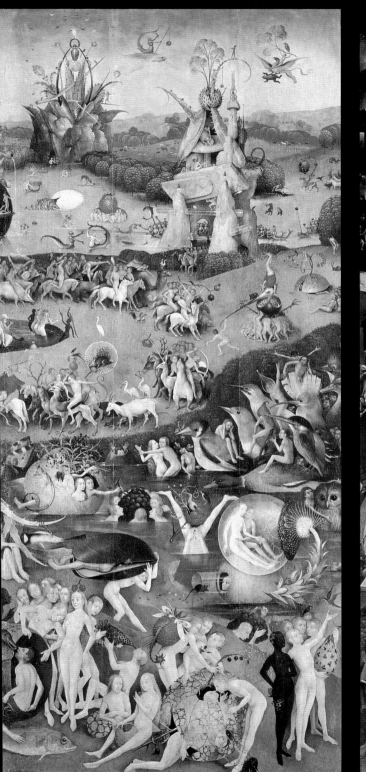
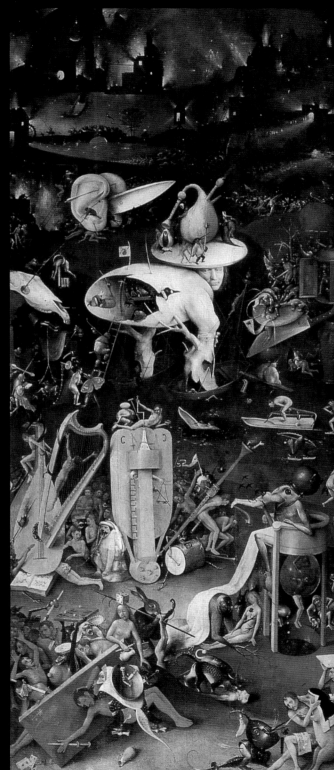

> *… an earthly paradise that never was and never will be … a strangely innocent scene, one of harmony between humans and nature …*

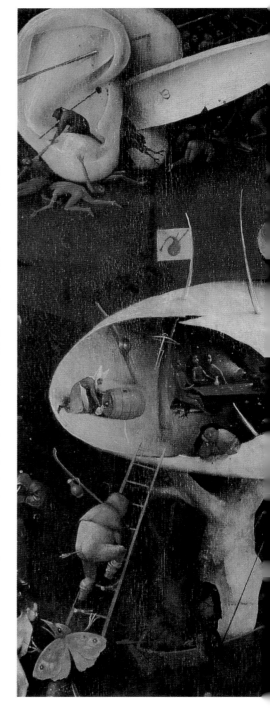

Everyone is naked. It is a celebration of natural fecundity full of unsettling juxtapositions and distortions of scale. Hieronymus Bosch's imagination is one of surreal darkness, so that even this scene of unfettered pleasure and carnival is suffused with an air of threat.

In the background four huge biomorphic structures represent the four regions of the world. Each one straddles a river, and the rivers come together in the centre, where a futuristic minaret of cosmic fertility rears up out of the lake surrounded by frolicking couples. Throughout the panel men and women enjoy each other's bodies – only in the middle ground, where a ceremonial courtship display seems to be taking place, are the sexes segregated. The men, riding animals, parade around the pool where women disport themselves; some hold fruits as if taking part in a ritualized mass version of the Original Sin.

The striking dreamlike imagery of Bosch seems to our eyes to be a completely original eruption of bizarre genius. Bosch was unusual, even unique, in the way he painted his own fictions. As well as his imaginative inventions, Bosch also brought into the biblical context the contemporary popular visual idioms of proverb and parable. The wry parodic style, if not the content, of these myriad scenes of erotic and bestial acts would have been familiar to a contemporary audience from the popular art of their day – especially from the tin, lead or pewter 'pilgrim badges' that were bought like modern-day T-shirts at festivals and feast days, and depicted satirical proverbs, erotic jokes and fantastic hybrid creatures, as well as more conventional religious imagery.

Here in the central panel Bosch has illustrated an ideal world that is not the celestial Christian Heaven but an earthly Paradise of his own invention. It is without death or children, populated by ageless unindividualized figures that seem childlike in their effortless enjoyment of bodily pleasures. Bosch the moralist shows us Heaven on Earth as a gorgeous nightmare. The concept of imaginary ideal societies must have been very much in the air, for this was the age of discovery. Columbus's first reports of the New World were filtering through, and the idea of Paradise as a real geographical place (as often depicted in medieval world maps) was in some ways made more real but also

pp. 160–61
In the left-hand panel we see paradise; in the central panel, a mass of figures, apparently showing harmony between humanity and nature; and in the right-hand panel, hell.

less likely to be found. The year of Bosch's death, 1516, saw the publication of a literary counterpoint to his vision, Thomas More's *Utopia*.

The right-hand panel shows Hell. There is no nature here: all the torments are man-made. Musical instruments made for pleasure have become instruments of torture. The contemporary audience might also have drawn a sharp intake of breath at the image in the bottom right-hand corner. A pig dressed as a nun is trying to get a man to sign away his fortune to the Church – too late, since he is in Hell anyway. What would have kept him out would have been a good moral life rather than faith in a corrupt Church. In the centre of this panel is perhaps one of Bosch's most famous images, a tree man with a tavern in his belly and his legs ending in boats. Many scholars think this striking figure looking askance at the viewer is a self-portrait.

The Garden of Earthly Delights was famous and much admired in Bosch's lifetime for probably the same reasons it is loved today. High-quality copies were made up to a generation after his death. Later facsimiles took the form of tapestries, some of which made their way into the royal collections of France and Spain. In the 20th century, echoes of this work can be seen in the art of Surrealists like Max Ernst, in psychedelic popular art of the late 1960s and in the tormented, orgiastic figures trapped in transparent boxes by Francis Bacon.

Perhaps what Bosch shows us in this wondrous painting is that Paradise is not found in the traditions of the Bible of the left-hand panel nor in the real, corrupt world of the right but only in the centre, the artist's own imagination.

Above left
The tree man is at the centre of Bosch's vision of hell, a phantasmagoric scene in which everyday objects become instruments of torture.

Above
Late 14th-century pilgrim badge from Canterbury. The badge depicts a peacock (a Christian symbol of immortality and resurrection) being ridden by Thomas Becket. Unfortunately the saint's head has been lost.

'Painting is Not my Art'

The Sistine Chapel Ceiling, Michelangelo

WILLIAM E. WALLACE

'*The astonishing energy of God contrasts strikingly with the passive Adam, who looks longingly towards his creator. In the few centimetres that separate their fingertips, Michelangelo has created the greatest suspension of time and narrative in the history of art.*

Above and opposite
God the Father creating Adam. Boldly, and in contravention of the second commandment, Michelangelo has imagined the face of God the Father.

1508–12
Fresco
c. 14 metres × *c.* 40.5 metres /
c. 46 ft × *c.* 133 ft
Sistine Chapel, Vatican Museums,
Vatican City

I n 1505, the newly elected Pope Julius II called Michelangelo Buonarroti to Rome. With unparalleled energy, Julius was re-establishing papal authority through bold military action and a sweeping programme of artistic patronage. As the 'warrior Pope' he led the papal army; as patron he employed the architects Giuliano da Sangallo and Donato Bramante to build a new Rome, Raphael Sanzio to decorate the Vatican apartments, and Michelangelo to carve his tomb – envisioned as the most grandiose funerary monument since Classical antiquity. After eight months quarrying marble for the tomb, Michelangelo returned to Rome only to discover that the Pope's attention had turned to war and the rebuilding of St Peter's. Incensed that papal interest and resources had been diverted from his project, Michelangelo departed for Florence. Not until 1508 was the artist lured back to Rome, not to renew work on the tomb, as he had hoped, but rather to undertake a task ill-suited to a marble sculptor: the painting of the Sistine Chapel ceiling. Michelangelo's objection that 'painting is not my art' proved ineffectual against the will of the imperious Pope. However, like other commissions that Michelangelo initially resisted, once reconciled to the task, he devoted enormous energy to creating a masterpiece.

For four years, between 1508 and 1512, Michelangelo struggled with the manifold difficulties of painting the ceiling. The commission presented formidable obstacles but it also unleashed the artist's imagination. He began with his usual concentrated fury, neglectful of health and sociability. Michelangelo's father worried: 'It seems to me you are doing too much, and it upsets me that you are not well, and are discontented.' Michelangelo compounded his father's concerns when he confessed that he had no money but was 'still obliged to live and pay rent'.

Despite a brief stint in Domenico Ghirlandaio's workshop, Michelangelo had no experience directing a large-scale campaign in the demanding medium of fresco. To assist him in the gigantic undertaking, he hired a number of Florentine compatriots, including long-time painter friends Francesco Granacci and Giuliano Bugiardini, as well as the talented young

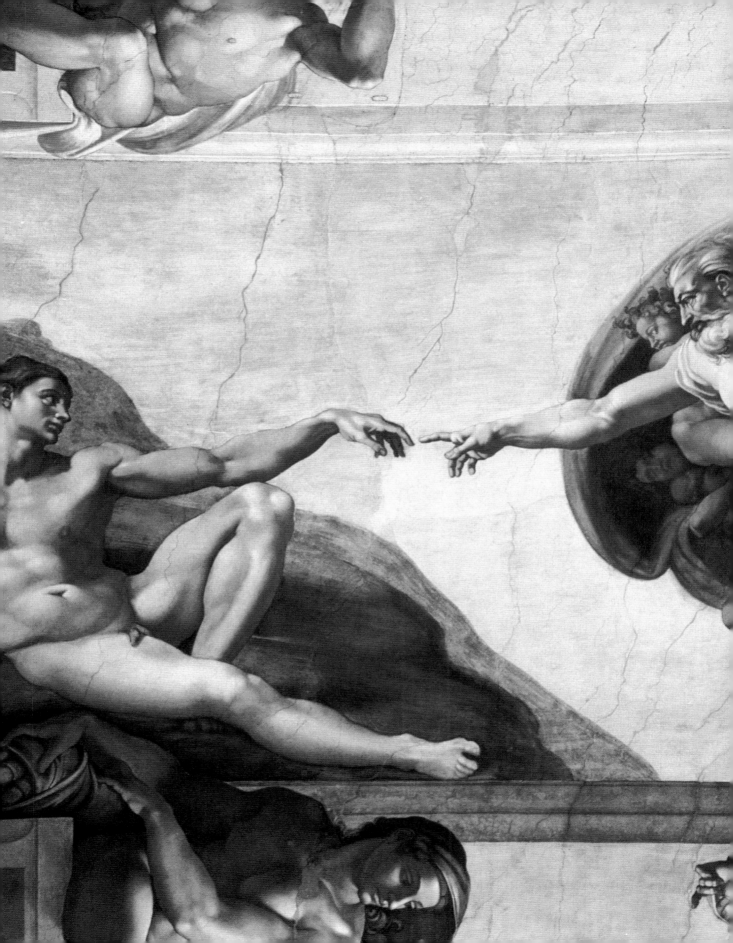

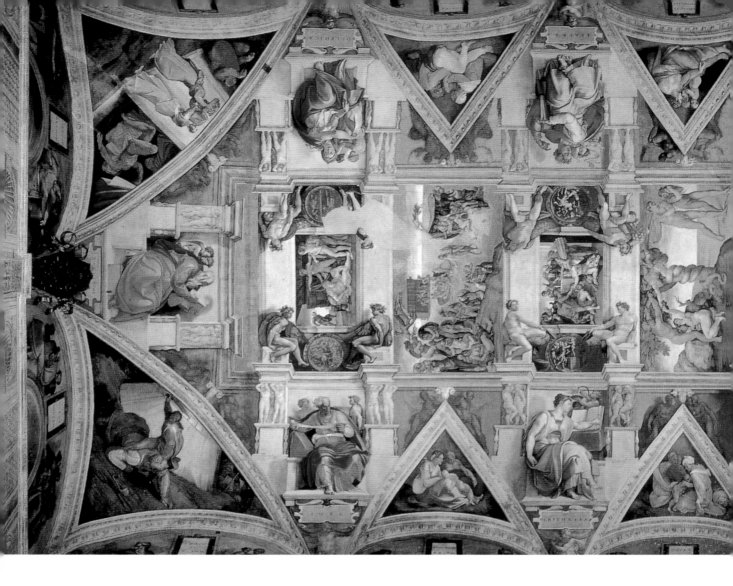

artist Aristotile da Sangallo. Others assisted with the technical problems of building the scaffold and preparing the highly irregular vault for painting. Altogether, at least a dozen people helped in carrying out the numerous tasks associated with fresco: hauling water, slaking lime for plaster, grinding and mixing pigments, pricking and transferring cartoons. Several worked alongside Michelangelo, painting minor figures and ornament, as well as acres of architectural decoration. Michelangelo, however, reserved the most important figures and narratives for himself. When his biographer Ascanio Condivi wrote that the artist finished the job in twenty months 'without any help whatever, not even someone to grind his colours for him', he was grossly exaggerating in an effort to praise what was already a superhuman achievement.

'In the beginning God created the heavens and the earth....' The stately words of Genesis come to mind as one looks at the ceiling – one of the greatest works of art ever created. Like a handful of timeless monuments the Sistine Chapel never fails to excite wonder. No one forgets the experience of stepping through the small doorway into the vast expanse of the Sistine Chapel and having one's eyes drawn inexorably to Heaven.

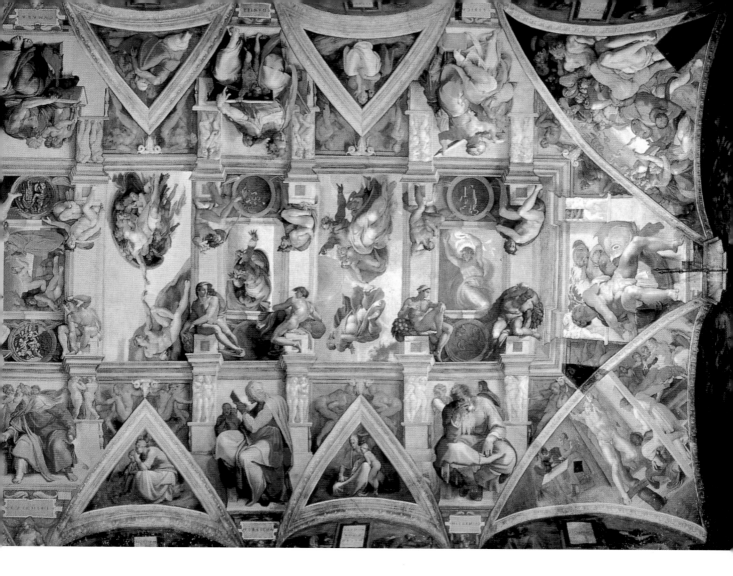

> *Michelangelo's objection that 'painting is not my art' proved ineffectual against the will of the imperious Pope.*

Although visitors generally enter the chapel under the *Last Judgment*, we properly should begin with the scene of the *Drunkenness of Noah* at the opposite end and proceed in reverse chronological order towards creation – and, by analogy, from our present sinful state to a renewal of faith at the altar. In a total of nine main scenes – four large and five smaller rectangular fields – Michelangelo imagined the beginning of time, and the face of divinity. This was not the first or only depiction of the subject, yet, like Leonardo's *Last Supper*, it has become the canonical representation; we visualize the first book of the Bible according to Michelangelo.

Visitors to the chapel find it difficult to focus on a linear narrative since many parts of the densely populated vault compete for their attention. Rather than viewing the ceiling in an orderly fashion, most visitors tend to look discursively, fastening upon large figures and familiar scenes. Towards the centre of the ceiling is the famous scene of God creating Adam. The astonishing energy of God contrasts strikingly with the passive Adam, who looks longingly towards his creator. In the few centimetres that separate their fingertips, Michelangelo has created the greatest suspension of time and narrative in the

> *Like Verdi's* Requiem *or Milton's* Paradise Lost, *the Sistine ceiling is a transcendent work of genius that will never be exhausted through looking or describing.*

history of art. That magnetic gesture is the focal point of the entire ceiling, perhaps the most universally recognized and one of the most frequently imitated images of all time. As God created Adam, so Michelangelo has forged the image of the deity for all of Western Christianity.

Flanking the nine Genesis scenes are seven Old Testament Prophets as well as five Sibyls, female seers of pagan antiquity who were thought to have foretold the coming of the Messiah. These alternating male and female figures are seated on broad marble thrones, and each is accompanied by two companions or *genii* who, like visible thoughts, assist the majestic Prophets and Sibyls in their scholarly labours of reading, writing and cogitating. Between the narrative scenes, and frequently overlapping them, are twenty nude youths or *ignudi*. They belong to a different realm – and perhaps an antecedent time. They are intermediaries between narrative and decoration, the pagan and Christian worlds, flesh and spirit. Like living sculptures, the *ignudi* are animated bodies without precise narrative justification or meaning. Arranged in every conceivable manner, they appear natural, even comfortable, even though most of their poses are physically impossible. As with his figures in marble, Michelangelo suggests languor from unlikely

bodily contortions. In these figures – twenty painted reconstructions of ancient marbles – Michelangelo invented a repertoire of poses that subsequent centuries repeatedly plundered.

In the lunettes (semi-circular fields linking the ceiling and chapel walls) Michelangelo represented the ancestors of Christ, thereby creating a visual genealogy that begins with Genesis and continues through the Prophets and Sibyls to the 15th-century frescoes below. Michelangelo painted each of the lunettes in two or three days and without the aid of cartoons, revealing his complete mastery of the fresco technique. And framing the entire ensemble, the four corner spandrels depict scenes of triumph over oppression, serving as Old Testament prefigurations of the triumph of Christ.

In many ways the ceiling is a compendium: of Michelangelo's art, of the Renaissance, and of Christian theology. Like Verdi's *Requiem* or Milton's *Paradise Lost*, the Sistine ceiling is a transcendent work of genius that will never be exhausted through looking or describing. In the words of Johann Goethe: 'Until you have seen the Sistine Chapel, you can have no adequate conception of what man is capable of accomplishing.' Michelangelo was just 37 years old when he completed the ceiling. Had he died in 1512, the carver of the *Bacchus*, *Pietà* and *David* would still have been judged a great artist. As it was, he still had 52 more years to live, the *Last Judgment* to paint, *Moses* to carve and St Peter's to build.

Opposite

(Clockwise from top left): *The Drunkenness of Noah*. Noah, seen in the background cultivating the soil, is found by his sons in a drunken stupor. **The Libyan Sibyl**, one of five female seers from pagan antiquity, who were said to have foretold the birth of Christ. An *ignudo*, one of twenty nude youths framing the Genesis. **Ancestors of Christ**, one of sixteen lunettes offering a visual genealogy of Christ: the lunette of Jacob and Joseph, the earthly father of Christ.

Above

God the Father creating Adam. One of the most recognizable images of Western art and Christianity, the first of four episodes from the story of Adam and Eve shows God reaching out to touch the newly created Adam.

A Well-Read Patron

The School of Athens, Raphael

INGRID D. ROWLAND

> *The paintings of the Stanza della Segnatura are all about books, and about their authors; it is as if the volumes of the Vatican Library have suddenly come to life …*

Above
Tommaso Inghirami as Epicurus (detail, left-hand side). Fat, flamboyant Tommaso Inghirami was the greatest actor in Renaissance Rome, as well as being the Vatican librarian, and is the probable collaborator with Raphael for the design of the *School of Athens*.

Opposite
Although not all the figures in Raphael's allegorical fresco can be named with certainty, the identification of the central figures is indisputable. Plato and Aristotle dominate the picture, each carrying one of his own works. The figure in the foreground on the left is generally accepted to be a portrait of Michelangelo.

1509–11
Fresco
500 cm × 770 cm / 16 ft 5 in. × 25 ft 3 in.
Apostolic Palace, Vatican, Vatican City

By every account we have of him, Pope Julius II (r. 1503–13) was a force of nature, a man of furious energy who obtained his high office through a combination of bribery and the sheer power of his implacable will. He craved the papacy because he had plans for the Church and its place in the modern world – visionary plans that began from his own view of Christianity as a universal religion, available now to the New World as well as the Old. Julius used every means at his disposal to spread his ideas: books, sermons, art, city planning, diplomacy, money and, when all else failed, his army (he was also the Pope who first hired a protective corps of Swiss guards). Fortunately, he also had exceptional taste, in people and in art. It was Julius who told Michelangelo to paint the ceiling of the Sistine Chapel, over Michelangelo's protests that he was only a sculptor, not a painter. And it was Julius who set a team of painters to work on the walls and ceilings of his private apartments in the Vatican, at least until a look at Raphael's *School of Athens* (painted between 1509 and 1511) inspired him to fire all the rest.

Raphael is the artist, then, that this extraordinary Pope chose to decorate the spaces where he lived, and in Raphael's *School of Athens* we therefore come as close as we can to the heart of Julius II, and to the heart of the city that he created: Renaissance Rome. The Sistine Chapel paints a large, cosmic picture of that Rome, but *The School of Athens* takes us into more intimate spaces, the working world of the Pope and the Church. Furthermore, Raphael proved to be a painter of almost uncanny technical skill; here he transforms the difficult medium of fresco into chill marble statues, warm, living faces, velvety cloth, transparent skies, wisps of beard. This complex, densely significant painting is a joy to look at no matter how little, or how much, we know about its subject matter.

The School of Athens occupies one of four walls in a room that has been called the Stanza della Segnatura (the 'Signature Room') since the 16th century. The central room in the papal suite, this is where later popes put signed mountains of bureaucratic documents drafted on parchment or paper and often sealed with 'bulls' of wax or lead. Either in this room or nearby, Julius kept a private library of 200-odd books; two floors below

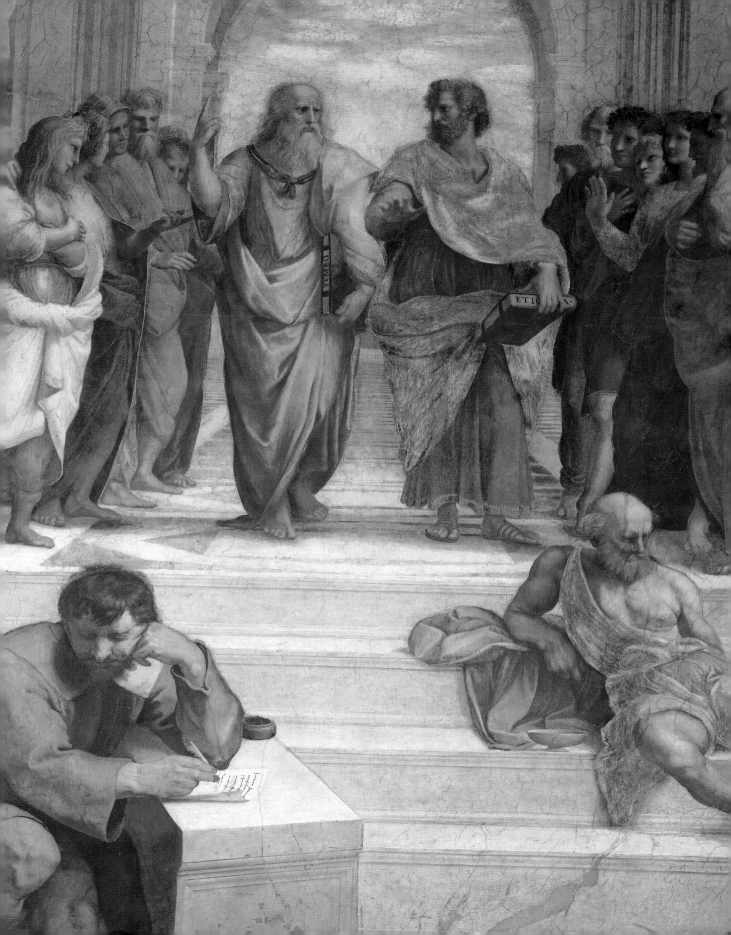

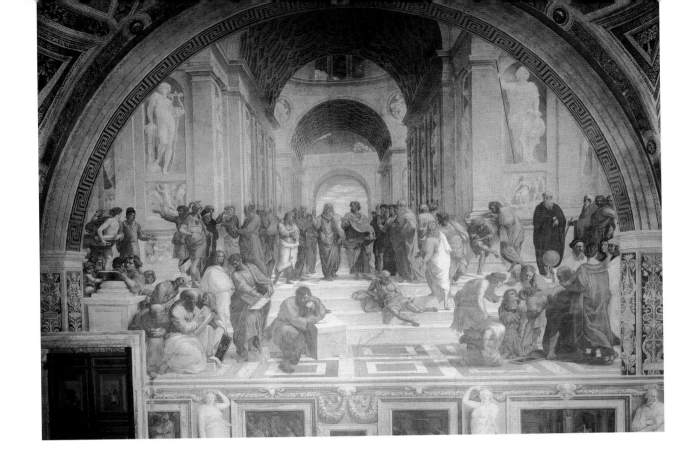

This complex, densely significant painting is a joy to look at no matter how little, or how much, we know about its subject matter.

Above
The School of Athens celebrates the wisdom of the ancient world as an essential foundation for the Christianity of Renaissance Rome.

were the 5,000 books of the Vatican Library, an institution with which the Pope had been connected since the mid-1470s. The paintings of the Stanza della Segnatura are all about books, and about their authors; it is as if the volumes of the Vatican Library have suddenly come to life, with characters from the Bible, ancient philosophers, legal scholars and contemporary poets all talking, reading, discussing, or lost in thought. Surprisingly for this hyperactive Pope, most surviving portraits of Julius II (including Raphael's own) show him thinking, his terrifying gaze directed slightly downward and his head cocked at a quizzical angle.

The thoughts behind *The School of Athens* have to do with the connection between ancient wisdom and modern Christianity, between Classical Greece and Renaissance Rome, and these connections played out against a dramatic political background: in 1453, Constantinople, the great capital city of the Byzantine Empire, had fallen in a brutal siege to the Islamic forces of the Ottoman Turks. Many of the Greek manuscripts in the Vatican Library had been brought to Rome by refugees from that conflict, and Julius, the militant Pope, was resolved to defend the whole written heritage of the West, classical, Hebrew and Christian – including Arab astronomers and commentators on Aristotle. Books were extremely expensive in the early 16th century, but they were even more precious for what they contained: for their wisdom, their revelations, and that miracle of human contact that can survive even death itself. Just as the books in the Vatican Library were written in different scripts, at different times, in different places, so, too, there are people from every period of human civilization and several different cultures gathered beneath the

vaults of Raphael's magnificent building. This setting could be a Roman bath (where philosophers often conducted their schools in the ancient world), or a Temple of Philosophy – though the design would also have reminded contemporaries of the plans for St Peter's basilica, which Julius was in the middle of constructing, having torn down most of the old church.

The period from 1509 to 1511 marked the moment when Raphael began to reach full maturity as an artist, simplifying and schematizing forms while still managing to make them look totally natural. The painting is divided into a whole series of threes and twos: three large windows, three small, two main groups of people, two floor levels separated by a flight of stairs. The composition reflects a careful intellectual programme that was drawn up for, or perhaps with, Raphael – most probably by the flamboyant librarian of the Vatican, Tommaso Inghirami (whose sturdy, jolly figure appears in the painting's lower left, balancing Raphael's self-portrait on the right). The threes represent the Holy Trinity; Greek philosophers first posited the idea of one god with three different natures, and Raphael's painting suggests that without the Greeks there would be no Christian theology. The twos set up contrasts: between Plato and Aristotle, between music to the left and astronomy to the right. Two figures defy the careful construction: bald, bearded Diogenes, always a contrarian, reclines on the steps, oblivious of everyone, and in the centre, in suede boots, Raphael portrays a sulky Michelangelo as the dour philosopher Heraclitus, cleverly mimicking the strange colours and muscular style of his rival's Sistine Chapel ceiling. And like the Sistine Chapel, *The School of Athens* was an immediate success, an acknowledged masterpiece from the moment of its painting, and one of the most influential works in the history of European art.

Above

Raphael's self-portrait gazes out at the viewer, between the heads of other figures on the far right of the work. He was 25 when he began painting *The School of Athens*, a precocious artist whose work changed and matured with astonishing rapidity.

Right

Minerva and the astronomers (detail, right side). Minerva, born from the head of her father, was a Christ symbol in Renaissance Rome. She presides over astronomy. The bald-headed figure of the geometer Euclid is thought to be a portrait of Raphael's relative Donato Bramante, the architect of Saint Peter's basilica.

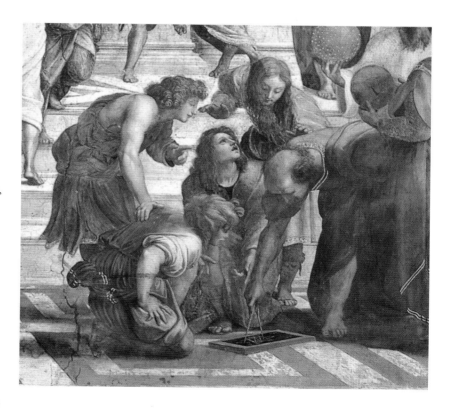

Terrible Beauty

The Isenheim Altarpiece, Matthias Grünewald

JOSEPH LEO KOERNER

> ' ... the violated skin remains eerily cohesive, undulating with the battered tissue underneath, stretching under the dead weight of muscle and bone ...

Opposite
The pervasive darkness shows two eclipses: that of the sun and that of Christ's divinity. Sheer ugliness conceals the perfect 'image of God' that Christ is.

1515
Oil on panel
269 cm × 307 cm / 8 ft 10 in. × 10 ft 1 in. (central panel)
Musée d'Unterlinden, Colmar, France

I t is the most beautiful painting of ugliness in the history of art, the ugliest beautiful painting. On two wooden panels, the join down the middle barely perceptible, Christ's corpse hangs on the cross, a surface all of wounds. Up close, flesh bristles with splinters, and paint catalogues the sepsis and necrosis caused by each. Seen from slightly further away, the violated skin remains eerily cohesive, undulating with the battered tissue underneath, stretching under the dead weight of muscle and bone, describing in chiaroscuro the suffocation that the crucifixion brings. The body draws its paradoxical liveliness from death, as Christ's nail-pierced hands seem to gain movement through postmortem rigor, and as the death rattle mimes a massive next breath.

Modern admirers rescued this painting from oblivion by celebrating its 'expressiveness'. They championed how feeling – the unspeakable pain of Christ's slow, violent death *and* the inner suffering his death should cause in Christians – breaks form. Yet the work's uncanny power lies in the composure of the painting, from the shadow-casting *trompe-l'œil* thorns sticking from Christ's flesh to the palpable volume of each ruined member and the calligraphic outline of the body's edge. And yet again, in restless paradox, what this painting (beyond its own awesome capabilities) shows is that which definitively lies wholly concealed and therefore wholly unpaintable: Christ's divinity, his being, even in ruin, the true, perfect and beautiful image of God. In tune with the background darkness, but antithetical to its own spectacular display, this painting visualizes Christ as the total eclipse of the visible. An ultimate masterpiece of art, it places its own ultimate categorically beyond art's reach.

Although everything begins and ends with the Crucifixion, this abject image belongs to a larger ensemble that explains how it began and where it is bound. Opening the Crucifixion scene down the middle, three new panels are revealed. On the left, Christ enters the world through the Virgin Mary, who sways away from the angel as if buffeted by the non-corporeal entrance here announced. In the right panel, his human existence come and gone, Christ rises from the tomb, a sublimated being all of light. And in between, an enigmatic orchestra of angels serenades the mystery of God's birth as man. And if we continue to open the panels, we find more images: Saint Sebastian, paradigm of martyrdom; the hermit–saint Paul in the wilderness; and thrice repeated, the founder of monasticism and Christ's exemplary imitator, Saint Anthony. Originally, all these panels enclosed a further Saint Anthony carved in wood. Enthroned and flanked by Saints Augustine and Jerome, he receives gifts of a pig and chicken from suppliant peasants.

Today all these images stand displayed in Colmar, in an old convent later (after the French Revolution) turned into the Musée d'Unterlinden.

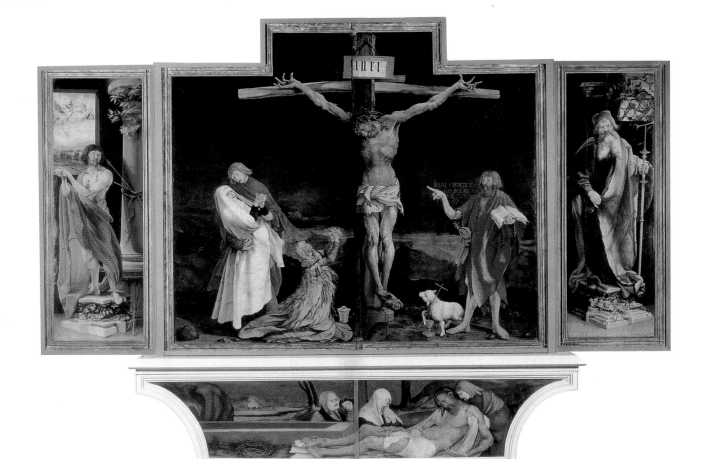

> *While we cannot penetrate the painter's faith, his Christ suggests that, before Protestant iconoclasts smashed church pictures as idols, Christian images had iconoclasm built into them.*

Originally, though, they stood in the church of a nearby monastic hospital complex at Isenheim. Secularization brought that monastery to ruin, but it also brought the altarpiece – and its maker – back to light. *The Isenheim Altarpiece* had its admirers during the 16th century. These referred to its creator as the painter 'Mathis' of Aschaffenburg, and one early commentator compared him to the two leading German masters, Albrecht Dürer and Lucas Cranach. The first historian of German art, Joachim Sandrart, writing in 1675, knew dimly of the altarpiece and cited the name 'Matthaeus' in his text. But he introduced the spurious surname, still used today, to which no surviving document attests: Grünewald. By the time the French dismantled *The Isenheim Altarpiece* in 1793–94, destroying its carved superstructure, it had been misattributed to Albrecht Dürer. Historical research soon linked it to Sandrart's 'Grünewald' and, much later, in 1938, to the painter (and hydraulic engineer) Mathis Gothardt Neithardt, active chiefly in Aschaffenburg. What else was lost besides the artist's name in the centuries between 1515, when 'Master Mathis' (as the documents call him) inscribed that date on Mary Magdalene's ointment jar, and today, when this masterpiece is appreciated as the supreme painting of the German Renaissance?

Most obviously, museum display severs the work's original link to sacred ritual. As an altarpiece, the various panels – all movable wings that opened and closed according to liturgical needs – served the Eucharistic rite. When a priest celebrated Mass before the image of Christ crucified, when he

announced that the bread and wine were Christ's flesh and blood, the gory painting of that body transported celebrants visually to the divinity they orally received. Divorced from the cult, the panels also lose their connection to motivating beliefs. In the eyes of users for whom Christ's death brings the promise of salvation, that saving corpse would have been both terrible and sweet.

With *The Isenheim Altarpiece*, though, another quite specific context has been lost. The work stood in a hospital, built to treat a single, specific illness: St Anthony's fire, named for the pains and visions experienced by sufferers, which linked them to the demon-tormented saint who now served as their protector. Modern medicine terms the disease 'ergotism', a long-term poisoning caused by eating grain infected by ergot fungus. Symptoms include dementia (the toxin resembles LSD) and painful and disfiguring gangrene.

Treatment for St Anthony's fire, which raged during bad harvests, especially among the poor, involved herbal remedies made from plants actually depicted in the altarpiece. However, since it was deemed to be a spiritual malady, caused by individual or collective sin, the disease called mainly for spiritual medicine aiming less to eliminate the symptoms than to impel repentance. Here the altarpiece helped. Forced to dress in peasants' garb (like the monstrous hooded figure in the Saint Anthony panel, lower right), new arrivals swore oaths before the painted Crucifixion. For the ill, the painting helped to convert pain into the experience of a saving sacrifice, like Christ's. For unscathed members of the Antonite Order who ran the hospital, the altarpiece's spectacle of ugliness merged with the living tableau of abjection enacted by the inmates. Such ugliness formed the necessary gateway to the divine comedy of images that followed. In crucifying Christ, humanity made their God into a 'man of sorrows' with 'no form nor comeliness' (Isaiah 53: 2–3).

When Master Mathis died in 1528, his possessions included tracts by Martin Luther. While we cannot penetrate the painter's faith, his Christ suggests that, before Protestant iconoclasts smashed church pictures as idols, Christian images had iconoclasm built into them. *The Isenheim Altarpiece* assaults us with the negation of what it displays. Like the scapegoat Christ, the artwork is both sickness and cure.

Opposite

The Crucifixion, with John the Evangelist, the Virgin, Mary Magdalene and John the Baptist beside the cross, is flanked by the plague saints Sebastian and Anthony, while the supporting, coffin-shaped predella features Christ's entombment. (*The Isenheim Altarpiece*, closed state)

Above left

This grand sweep of imagery carries Christ's story from the Annunciation (left) through the mysterious Nativity, with its orchestra of ambiguous angels (centre), to the Resurrection (right). (*The Isenheim Altarpiece*, first open state)

Above right

Sculpted effigies of Saints Augustine, Anthony and Jerome (with Christ and the apostles in the predella's shrine) are flanked by paintings of the Temptation of Saint Anthony and Saint Anthony and the Hermit Paul. (*The Isenheim Altarpiece*, second open state; sculpted shrine by Nicolas Hagenau, *c.* 1515; painted wings 1512–16. Polychromed wood and oil on panel)

High Drama

The Assumption of the Virgin, Titian
FRANCESCO DA MOSTO

> *To me, [the Virgin] didn't just symbolize salvation ... but also seemed to stand for the city of Venice itself ...*

My first encounter with Titian's genius was this painting of the Assumption that hangs above the high altar of the basilica of Santa Maria Gloriosa dei Frari, not far from where I grew up. A large work – in fact, the largest altarpiece ever painted in Venice, almost seven metres high – its unveiling in May 1518 cemented the young Titian's place as the pre-eminent master of Venetian painting. It wasn't just large, however, it was artistically groundbreaking. Whereas earlier altarpieces in Venice had been relatively static, with statue-like saints and regal Virgins, Titian's figures are ecstatic and full of life, giving the work incredible emotional charge and drama. And while a lesser artist might have turned and fled from the vast expanse of panel in front of them, Titian divided the composition into three sections – terrestrial at the bottom, heavenly at the top, and the Virgin, the intercessor, in the middle – and so made sense of the massive area.

Curiously, what touched me most deeply was one of the less obvious parts of the work, the image of God at the very top, heavily foreshortened and lost in shadow. The creator's face is painted in an almost impressionistic style; from behind a grey beard, he looks with a stern yet forlorn expression at the state of his children – almost as though he is thinking that the human experiment has proved a disappointment. The true focus of the canvas, of course, is the Virgin Mary who is represented as a heroic figure with upraised arms and a whirl of drapery, elevated on a solid-seeming cloud supported by armies of cherubs. This is the moment that, according to Roman Catholic dogma, she is assumed into heaven – in fact, this is probably the most famous depiction of the Assumption in Western art. To me she didn't just symbolize salvation, however, but also seemed to stand for the city of Venice itself, which at the time of the painting still enjoyed considerable power and glory. The cloud curves up at the edges to form a near circle with the rounded head of the panel; this heavenly part of the canvas is suffused with a miraculous golden light. In contrast the disciples, distraught at losing the mother of their saviour, implore the Virgin not to leave them, but her eyes are already directed heavenwards, and they are left in shadow under a grey sky. The Venetian sculptor Antonio Canova – whose heart is buried in this church – referred to this masterpiece as the most beautiful painting in the world.

Today, Titian is best known for his rich, sensual use of colour and his radical painting technique: energetic brushloads of pigment seem to float across the canvas. His clever use of colour can be seen in the *Assumption*: look at how the two apostles clad in red form a pyramid with the Virgin, drawing our eyes up to the similarly red-clad God. Soon after completing the *Assumption*, Titian painted another large-scale altarpiece in the Frari, known as *The Madonna of the Pesaro Family*. This shows even better his

Opposite
Titian's masterpiece was kept in the Accademia galleries of Venice for almost a century before being returned to its rightful place over the high altar of Santa Maria Gloriosa dei Frari in the early 20th century.

c. 1516–18
Oil on panel
690 cm × 360 cm / 22 ft 8 in. × 11 ft 10 in.
Basilica di Santa Maria Gloriosa dei Frari, Venice

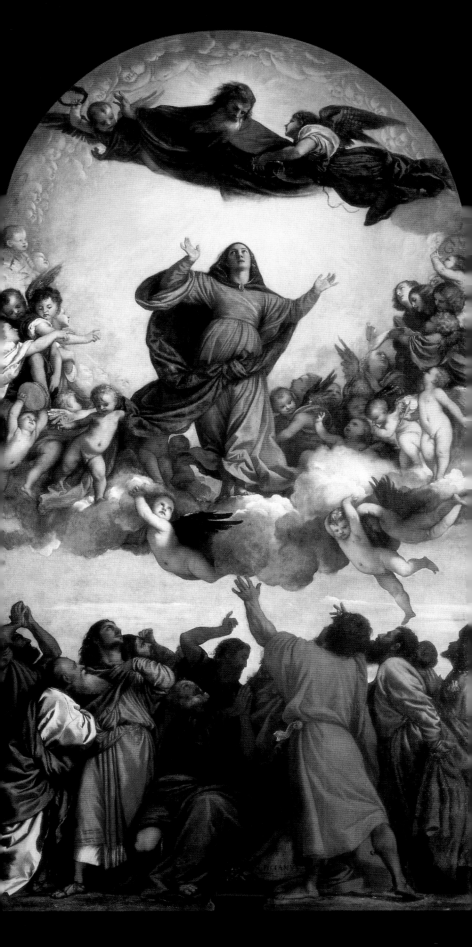

Above

The main altar, seen through the marble choir screen, is a Gothic masterpiece. The only surviving monks' choir in all Venice that is in its original location and in its original form, it was already there when Titian's work was commissioned.

skilful evocation of the luxurious velvets and silks that Venice was famed for. He achieved this particularly rich effect by gradually rubbing his fingers at the edges of the light colours, smudging one shade into another. More than any other Renaissance artist to date, Titian's use of light in particular seemed to bring his figures to life, giving them an unrivalled realism.

Titian was born Tiziano Vecellio around 1490 in the Dolomites, which at that point came under the control of the Venetian Republic. He was sent to Venice as a child and trained under first Gentile and then Giovanni Bellini. While working with Bellini, he came under the influence of the painter Giorgione. Official commissions soon followed, and just a couple of years before painting the *Assumption* Titian was awarded the sinecure previously held by Giovanni Bellini, ensuring that the rest of his long life would be relatively comfortable. Most of his work was executed in Venice, where he took Venetian painting to a new level of beauty and sensuality (and sometimes ungodly eroticism). His canvases brought him fame not just in Italy but across Europe.

Titian's long and colourful life coincided with Venice's 'golden age', a time when ungodly acts were rife and Venice itself had taken its relationship

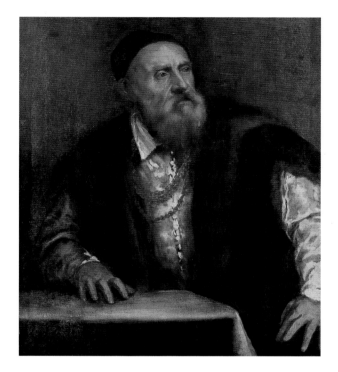

> *Titian is best known for his rich, sensual use of colour and his radical painting technique: energetic brushloads of pigment seem to float across the canvas.*

with the Catholic Church to the limit. As the city's population climbed to its all-time high, Titian and his friends may have gone too far. In June 1575 vengeance of a most biblical kind was delivered on the city in the form of a virulent plague. The population plummeted by nearly half from a peak of 190,000 and La Serenissima began its slow decline. Among the victims of the plague was Titian, who the following year died at his home in Cannaregio, where he had lived for forty-five years. He was buried in the same church where this masterpiece hangs.

Almost four centuries later Titian's early masterpiece is still remembered in unexpected ways. In 1984 the English band Frankie Goes to Hollywood, moved on from sex and war to touch the theme of love and redemption in their song 'The Power of Love' – the record cover featuring the *Assumption*.

Above right
A second Titian altarpiece in Santa Maria dei Frari, known as *The Madonna of the Pesaro Family* (1519–26), is also a striking composition: diagonal lines lead the eye up to the Madonna and Child, and on in a seemingly unlimited perspective.

Above left
Titian's self-portrait, *c.* 1562, painted when he was about 80 years old.

On the Brink of Tragedy

The Court of Gayumars from Shah Tahmasp's Shahnama ('Book of Kings'), Sultan Muhammad

DAVID J. ROXBURGH

'*Sultan Muhammad loses nothing in miniaturizing his forms because the execution is so refined … as to render everything legible.*

Above and opposite
Members of Gayumars's community gather round their king, who sits enthroned on a mountaintop.

c. 1522–25
Watercolour and gold on paper
47 cm × 31.8 cm / 1 ft 6½ in. × 1 ft 0½ in.
Collection of Prince Sadruddin Aga Khan, Geneva

Abu al-Qasim Firdawsi completed his *Shahnama* ('Book of Kings') in *c.* 1010, an epic poem of some 50,000 couplets about the lives and exploits of the kings of Iran up to the Arab conquests of the mid-7th century. Ideally suited as a vehicle for propounding royal ideology (both as history and as a mirror for princes), by the early 14th century Firdawsi's epic had become the subject matter of artists who fashioned programmes of paintings to accompany its poetry. Although the poem was relatively overlooked in the 15th century, the situation changed in the 1520s when the Safavid ruler Shah Isma'il (r. 1501–24) initiated a project to create an illustrated luxury manuscript of it for his son Tahmasp. Shah Tahmasp (r. 1524–76) supported the project after his father's death. Although the final *Shahnama* represented an extraordinary investment, in 1568 Shah Tahmasp gave his precious manuscript as a gift to the Ottoman Sultan Selim II (r. 1566–74). In the modern era, it passed to Baron Edmund de Rothschild and then Arthur A. Houghton Jr., who broke the manuscript up for sale.

At its completion, Shah Tahmasp's *Shahnama* included 258 paintings set in gold-sprinkled borders, with coloured rulings dividing paintings from borders and the Persian text copied in *nasta'liq* script. Intricate illuminations of geometric and biomorphic designs in gold and polychrome pigment marked transitions in the text and encased explanatory captions set above paintings. The entire manuscript, estimated to have taken twenty years to complete, required a workforce of artists, calligraphers, illuminators, ruling-makers, binders and experts in the production of materials. Human and material resources were gathered in the royal workshop in Tabriz.

Following the prefatory matter, the first painting illustrating the *Shahnama* depicts 'The Court of Gayumars'. This is the painting assigned to artist Sultan Muhammad by the contemporary writer–calligrapher–art historian Dust Muhammad. Gayumars, Iran's first king, enthroned by an outcrop of rock, presides over a fledgling human community gathered in a circle. Gayumars's son Siyamak sits to his left and his grandson Hushang stands to his right. It was during Gayumars's enlightened reign that humankind learned how to make food and fashion clothes from animal skins. Standing at the opening of the *Shahnama*, the image is already charged with a sense of tragedy that is carried through the epic poem as a constant play

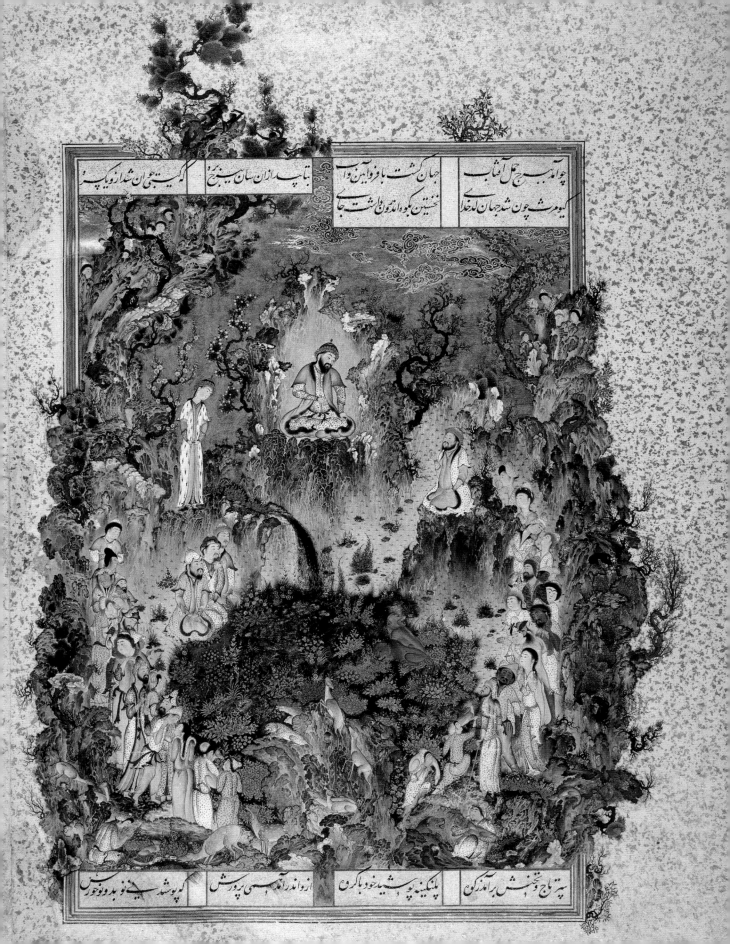

between the forces of good and evil. Although Gayumars fulfilled his role as just and wise king, causing society to prosper, the Black Div, son of the Devil Ahriman, would kill his designated heir Siyamak. The painting shows social equilibrium but at a moment after the angel Surush has warned Gayumars of Ahriman's intentions.

To heighten the pathos and imminent loss of this story, Sultan Muhammad locates his figures in an environment apparently prefabricated to contain them – nature anticipates this human order and finds a space for it. A broad circle of rock opens to embrace fur-clad men of various ages and races, arranged around a broad swathe of foliage at the painting's centre watered by a mountain stream of silver water (now blackened by oxidization). Craggy rocks of blue, pink, green and other colours rise upwards, while wizened trees, some in bloom, are scattered throughout the geological spectacle. Closer scrutiny turns up animals – deer, foxes, lions, monkeys. Moving closer still, we see rock striations, textures of clothing, and anthropomorphic faces camouflaged amid the rocks.

For its size the painting delivers a staggering complexity. It is no wonder that Dust Muhammad, writing a history of art in 1544–45, had this to say about Sultan Muhammad and *The Court of Gayumars*:

> First there is the rarity of the age...Sultan Muhammad, who has developed depiction to such a degree that, although it has a thousand eyes, the celestial sphere has not seen his like. Among his creations depicted in His Majesty's *Shahnama* is a scene of people wearing leopard skins: it is such that the lion-hearted of the jungle of depiction and the leopards and crocodiles of the workshop of ornamentation quail at the fangs of his pen and bend their necks before the awesomeness of his pictures. (Trans. Wheeler Thackston)

Such an assessment of painting is unusual, evidence of the profound impression it made. Dust Muhammad's metaphor of the celestial sphere and its 'thousand eyes' – the night sky's stars – places Sultan Muhammad in the span of creation, emphasizing his eternal status as artistic 'rarity'. More than this, however, by invoking the sensory faculty of vision, it implies that even a thousand eyes would be insufficient to take in Sultan Muhammad's oeuvre. The metaphor of sight is expanded in the next passage, where even the bravest among Sultan Muhammad's peers – who are likened to lions, leopards and crocodiles – are cowed, brought up short before his paintings.

It is easy to understand the response. Sultan Muhammad loses nothing in miniaturizing his forms because the execution is so refined (described by contemporaries as 'hair-splitting') as to render everything legible. The pigment does not break down into brushstrokes that would give evidence of the painting's manufacture. The composition enhances the impression of clarity. But legibility and clarity are a mirage – the density of painted forms and their scale work in the opposite direction. By overwhelming our capacity to see, these features deny us total knowledge of the painting and let it keep secrets that will be revealed in subsequent viewings. In this way, Sultan Muhammad exploited the constraints of book painting and lent the medium a phenomenological power equal to the text's capacity to convey political, social and cultural meanings.

[The artist] locates his figures in an environment apparently prefabricated to contain them – nature anticipates this human order and finds a space for it.

Above
Quarrelling monkeys embedded in the highly complex matrix of the painting.

Opposite
The painting is a masterful performance, from compositional design and colour harmonies to the execution of its most minute details, all of which create the impression of effortless artistry.

Between Heaven and Earth

Pavilions in the Mountains of the Immortals, Qiu Ying and Lu Shidao

CRAIG CLUNAS

' ... *the artist has created a realm of deathless beauty, one that the viewer may yearn for in the knowledge that this yearning will never be satisfied.*

Above
A glimpse through a crevasse indicates the idea of spaces beyond the spaces we can see, and the dwellings of beings yet more powerful and mysterious than those who inhabit the palaces in the painting's foreground.

1550
Watercolour on paper
110.5 cm × 42.1 cm / 3 ft 7½ in. × 1 ft 4½ in.
National Palace Museum, Taipei, Taiwan

The elongated mountains of this painting represent no real place on this earth. The meticulously drawn terraces and palaces that nestle beneath them are not such as we will ever actually inhabit. Instead, the artist has created a realm of deathless beauty, one that the viewer may yearn for in the knowledge that this yearning will never be satisfied. Some may even have been there long ago, in dreams or in visions – but on waking they could never find their way there again.

The subject matter is not original to this picture – indeed, these magic mountains are one of the longest established themes in Chinese painting, with at least a millennium of practice before this example. But here the tension between the intangible and the believable is balanced to an exquisite degree. At the same time, the presence of writing, and the seals of subsequent owners (an emperor among them) reminds us that a painting is not a window into a 'real' world. Marks on paper are all we have.

Part of what makes *Pavilions in the Mountains of the Immortals* an outstanding work of art is technical skill. It is painted in watercolour on paper, a surface on which it is extremely hard to control the layers of mineral pigment and prevent the bleeding of strokes. As in the calligraphy, there is no scope for mistakes, erasures or second thoughts. Only total control of the medium, achieved through a lifetime's practice, will enable writer and painter to achieve a surface of image and text that appears so effortless.

Pavilions in the Mountains of the Immortals was painted in 1550 by the greatest professional artist of Ming dynasty China, Qiu Ying (*c.* 1494–*c.* 1552) – a man around whom fables clustered even in his lifetime, though today we know very little about him. We do know he associated with the cultural elite of the great commercial city of Suzhou, where he lived and worked – for example, the agents behind the inscription, which is an integral part of the composition. The poem's author, Cai Yu (before 1470–1541), and its writer, Lu Shidao (1517–80), were everything that Qiu Ying was not – educated gentlemen with private means and potential access to careers in the official bureaucracy. The work's production would have involved the patron, too, since it was most probably created as a birthday gift, an elegant wish for longevity bestowed on its recipient, who might have been either a woman or a man of the upper classes. The network of connections that bound such people, named and unnamed, together was for the original viewers an integral part of the work's status. The idea of the autonomous 'masterpiece', unconnected to the art of the past or the social life of the present, would have had no meaning for them, though its beauty and exquisite execution would have been more than apparent. Like the Mountains of the Immortals themselves, it hovers just out of our line of sight, hard to see properly.

The Folly of the World

The Proverbs, Pieter Bruegel the Elder

STEPHAN KEMPERDICK

‘ *Bruegel also makes it absolutely plain who is to blame for this state of affairs: the Devil …*

Above
To light a candle to the Devil and to confess to the Devil (respectively to flatter, and to betray secrets to the enemy).

Opposite
The world turned upside down (everything is the opposite of what should be); to bite the pillar (to be hypocritically religious); and to carry fire and water (to be insincere).

1559
Oil on oak
117 cm × 163 cm / 3 ft 10 in. × 5 ft 2 in.
Gemäldegalerie, Staatliche Museen, Berlin

Hustle and bustle prevail in a village setting, populated by countless figures that fill every room, shack and square, as well as every dark corner. They are all totally focused on their tasks, most of which seem, on closer inspection, to be rather peculiar. In fact they are acting out more than 120 proverbs and sayings, the metaphors turned into literal depictions. One man is banging his head against a brick wall while another is throwing roses (in lieu of pearls) before swine; a woman is tying the Devil to a pillow (showing that she is stubborn and spiteful) while a man is carrying daylight in a basket out of the house (doing something useless). Even odder is the sight of a beggar stooping to crawl into the world (being devious to ensure success), which is rolling on the ground in the form of a glass sphere with a cross sticking out at the top.

The strange and sometimes absurd concept of taking proverbs literally was not of Bruegel's own devising. It was already known in the 15th century, and in 1558 Frans Hogenberg in Antwerp produced an engraving that portrayed forty-three proverbs in the form of figures in a landscape. This image may have been a direct stimulus for Bruegel's work, begun the following year. Unlike the engraver, however, Bruegel monumentalizes the subject, not only through the medium of panel painting, but by joining the individual scenes together to form a convincing whole. This stringing together of elements has created a genre painting whose particular appeal lies in the fact that it appears both real and unreal at the same time. Despite the apparent isolation of the figures from one another, they all fit together quite naturally to make up the scene, and the accurate observation of gestures, postures and expressions brings the composition to life. This liveliness is enhanced by the artist's vibrant brushwork, with paint applied in thin, transparent layers, and shapes and structures fashioned in an almost draughtsmanlike way. Endless variations on green and brown and nuanced, often murky, shades, mark the painting's refined treatment of colours. Blue and red stand out powerfully, giving emphasis to certain areas and motifs.

Bruegel's composition is based on a broad, slightly curved, diagonal that runs from the bottom left of the image to the top right, carrying the gaze from the close-up details in the foreground to the distant horizon. This drawing of the eye into the work gives the image dynamism and binds its individual elements together. At the same time, it underlines that the bustle of the village is actually the bustle of broader society, that the village represents the entire world. But its inhabitants are behaving foolishly, enthusiastically engaging in pointless, painful or ridiculous activities. Bruegel also makes it absolutely plain who is to blame for this state of affairs: the Devil, who sits in a small chapel with a delicate marble column and a blue and red roof at the centre of the picture. One man lights a candle to him while another goes to Satan

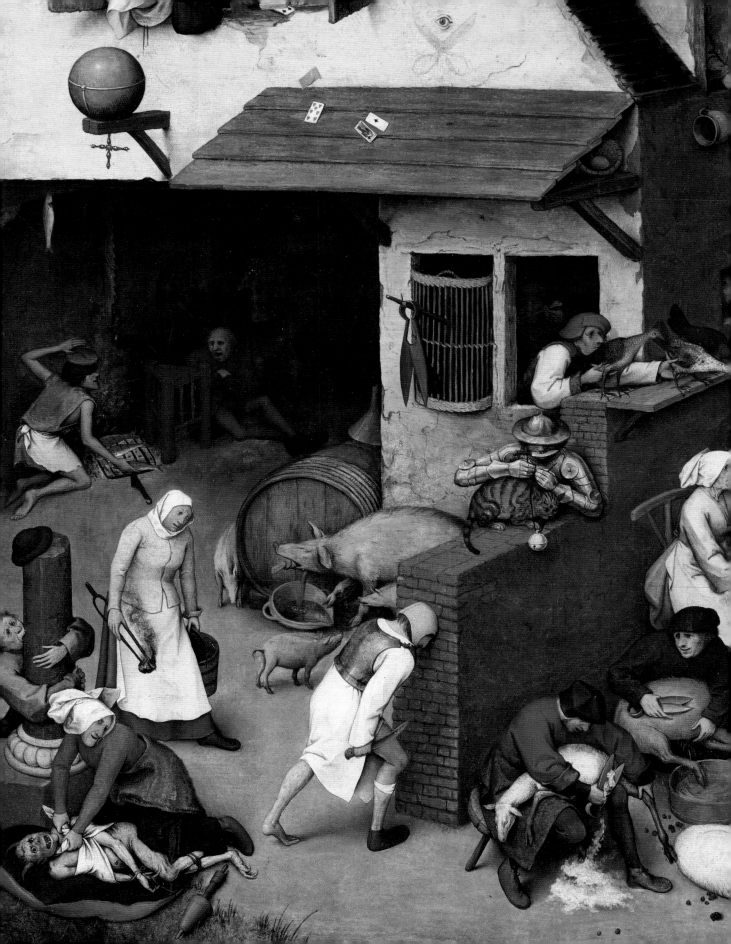

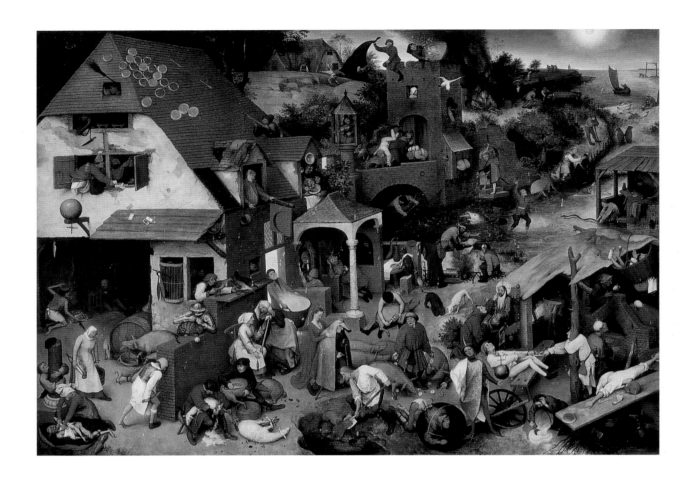

[The] figures ... are acting out more than 120 proverbs and sayings, the metaphors turned into literal depictions.

for confession – read as proverbs, these actions mean to flatter and to reveal secrets to an enemy, but at the same time they are the perverted parodies of Christian religious practice. Directly beneath, again in conspicuous red and blue, stand a couple who are a key image of human behaviour. The voluptuous young woman is putting a blue cloak on her ageing husband: in other words, she is being unfaithful to him. Hogenberg's aforementioned engraving of 1558 bears the title *The Blue Cloak*, and Constantijn Huygens the Younger used the same name to describe Bruegel's painting when he saw it in 1676 in Antwerp.

Collections of proverbs enjoyed great popularity in 16th-century humanistic circles. A notable early example was Erasmus of Rotterdam's *Adagia* (published in 1500), a collection of around 800 adages. Other anthologies in Latin and vernacular languages followed. In addition, the world of folly had already been portrayed in Sebastian Brandt's *Ship of Fools*, published in 1494 in Basel, and Erasmus's *The Praise of Folly* of 1508, both of which had become classics. Bruegel was therefore working within a great tradition that was artistic but also, primarily, literary. His painting is directed at an educated audience, the proverbs stemming less from folk wisdom than from literature – most of them existed in Latin as well as in Dutch. In accordance with Classical ideals, the painting was intended both to instruct and to entertain, offering both contemporary viewers and us today the enormous fun of untangling individual scenes. More so than almost any other painting, it encourages us to peer into the darkest corners or seek multiple meanings in the same motif.

> *The topsy-turvy world is predominantly populated with simple peasant folk, but its contemporary viewers would certainly not have been peasants.*

The moral message of the work goes hand in hand with a deliberately humorous distancing, an ironic attitude to the follies that are portrayed within it. The topsy-turvy world is predominantly populated with simple peasant folk, but its contemporary viewers would certainly not have been peasants. However, the upper classes are also included, with three figures being particularly notable. It is rarely commented upon that these three are shown wearing very old-fashioned clothing: the garments of the man throwing his money into the water (that is, wasting it) date from the early 16th century; the young nobleman in the right foreground, who has the world spinning on his thumb (at his command), is dressed in the style of the late Middle Ages; and the prosperous man throwing roses before swine is wearing a costume from around 1440. Perhaps Bruegel wanted to use these anachronisms to stress the timeless significance of the imagery. Perhaps also his clients, the wealthy people of 1559, were not keen to see their own kind, dressed in the fashions of the day, engaging in ridiculous antics, but felt better able to laugh if the scene was set in an indeterminate past.

It is not recorded for whom Bruegel painted the picture. It is first documented in 1668 in the estate of the Antwerp collector Peeter Stevens. Then it remained lost for centuries, until in 1913 it was discovered at an English country house and came into the possession of the Gemäldegalerie in Berlin the following year. This marked the rediscovery of the original of a composition that was already well known from a number of 17th-century copies. Around twenty-four such copies are still in existence, some of them created by Pieter Brueghel the Younger, who was working from his father's original cartoon, which is now lost. The number of surviving copies shows the high regard in which this peculiar invention of Bruegel was held.

Above
To make the world spin on one's thumb (to be in control); to crawl through the world (to succeed by deception); and to throw roses before swine (to waste precious things on the unappreciative).

Right
To have an eye on the sail (to keep a good watch); to shit on the gallows (to fear nothing).

Centre Stage

The Crucifixion, Tintoretto
QUENTIN BLAKE

> *The light radiating from Christ's head almost has physical substance, like wings, and though the head leans forward it is not drooping with exhaustion but rather looking …*

Above and opposite
Tintoretto's painting is a study in the depiction of the human body in strenuous action: the muscles on the back of the digger are clearly visible beneath his clothes. Only the attitude of Christ suggests stillness, but it is the stillness of majesty, not death: the light emanating from his head obscures the cross, and it is not until the eye reaches the nails that one is suddenly reminded of his suffering.

1565
Oil on canvas
518 cm × 1,224 cm / 17 ft × 40 ft 2 in.
Scuola di San Rocco, Venice

The *Crucifixion* **is the keystone,** though by no means the culmination, of the great series of paintings that Tintoretto produced for the Scuola di San Rocco in Venice. The Scuola is not actually a school (as the name might suggest) but a sort of guildhall or headquarters for a lay but pious confraternity – one in this case devoted to combating the plague (a repeated scourge of the city) by practical and religious means.

The painting is wide, almost panoramic, and hung high in the *albergo*, the meeting room of the Scuola. It is divided in half by the strong vertical of Christ on the cross; at the foot of the cross is a group of mourners, beautifully painted and brought together in a dignified and rhythmic movement. To either side, under a clouded sky that somehow manages to be at the same time calm and apocalyptic, is a huge cast of onlookers and participants. Unusually, the two thieves are not hanging on their crosses to left and to right. One is already attached to a cross, which half a dozen men are heaving and pulling to get upright; on the right, deeper into the picture, the other is still being put onto the cross. In a perceptive essay on the picture, Brian Robb added a personal observation that the man is securing the second thief's cross with the same techniques and same type of gimlet that he had seen used by a Venetian carpenter constructing a jetty. This is not simply a curiosity – it underlines the extent to which Tintoretto's work drew on the life around him, not least the balance and lean and thrust of gondoliers, whose gestures surely inspired many of the figures' tenuous relation to gravity.

In the foreground, on the right, is a man with his back to us, digging; perhaps he is preparing a hole for the stake of the cross, but more particularly he serves as a striking example of the energy being expressed across the painting. It is an energy that is also present in the handling of the paint – robust enough to make the forms convincingly and weightily present, yet free enough not to turn the image into still life, nor to limit the man's possibility of further movement. There is the same energy and reality in the painting of the stakes and crosses, and the ladder which starts at the base of the picture and which (in a typical Tintoretto move) sets us off into a grid of perspective taking us deeper into the picture.

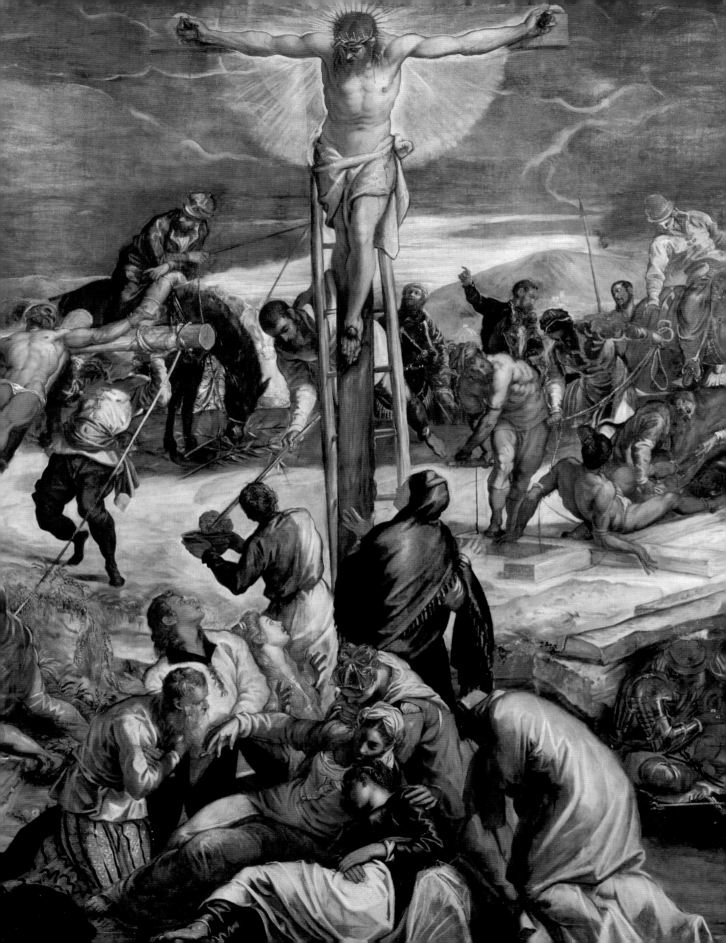

Assembled about the cross is an astonishingly varied throng with all kinds of reactions expressed in posture, all kinds of aura and authority. We are helped to move about among them, because the whole work is an astonishing weave and balance of directions, and of patterns of light and dark. As the design of the painting takes us into deep perspective, the figures become more hallucinatory; fantasy architecture glitters against the dark sky on the left of the picture, while to the right hurrying figures make their way across a wooden bridge that itself has an almost insect-like urgency.

To return to the Crucifixion: Christ is placed very high on the cross, almost at the top of the scene before us. The nails piercing his hands and feet are visible, but there is little here about agony or suffering. The light radiating from Christ's head almost has physical substance, like wings, and though the head leans forward it is not drooping with exhaustion but rather looking; looking at a scene that one can almost feel it owns. As Eric Newton observes in his study of Tintoretto, this isolated figure 'pales against the threatening sky, watches; and by doing so, enables us to watch'. The gesture of the arms is powerful. To call it one of acceptance sounds too passive; it seems almost as though it were a gesture of showing. And this is where the siting of the picture adds to the power of its theatre. The painting is wide, and the room not deep enough for it all to be seen at once, so that you find yourself, opposite the presiding Christ figure, looking to left and right to read this array of human life. Newton talks of it as a tragic drama of a scale and poignancy that is Shakespearian, and surely he is right to do so.

Newton also describes his experience, no doubt comparable to John Ruskin's, of *discovering* Tintoretto. Brought about first, no doubt, by viewing the paintings themselves, it also requires the sensibility of the viewer to become open to visual narrative of a drama and profundity unusual at any time in the history of painting.

Left
The dramatic use in this self-portrait of light and shadow (a hallmark of the artist's style), combined with the frontal pose, underscores Tintoretto's energy. (*Self-Portrait*, 1588, oil on canvas, 65 cm × 52 cm / 25½ in. × 20½ in. Musée du Louvre, Paris)

Above right
The imposing canvas of *The Crucifixion* covers an entire wall of the Sala dell'Albergo in the Scuola di San Rocco in Venice. It was just one work in a collection of scenes depicting the biblical narrative. Owing to the ongoing nature of the commission, the sequencing of the events was frequently disjointed. Viewers are forced to interpret and reorder the events for themselves.

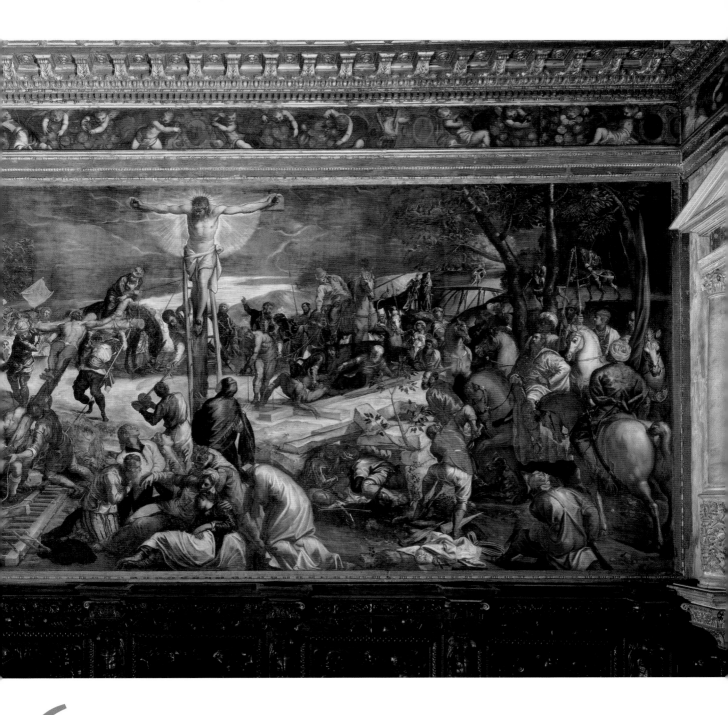

'The painting ... is divided in half by the strong vertical of Christ on the cross; at the foot of the cross is a group of mourners, beautifully painted and brought together in a dignified and rhythmic movement.

Heavenly Visitors

The Burial of the Count of Orgaz, El Greco

XAVIER BRAY

> *El Greco … divided the composition into two equal parts: the world of mortals in the lower half and the celestial vision above.*

According to local legend, the funeral of the Count of Orgaz in 1323 had some unexpected guests: Saints Stephen and Augustine, who appeared miraculously to help lower the count's body into his tomb. The count had been extremely generous to Toledo's religious institutions and the privilege of saintly attendance at his funeral was in recognition of this (it would also hopefully ensure that his soul be fast-tracked into heaven). The count stipulated in his will that a yearly donation be collected from the citizens of Orgaz, a small town outside Toledo in his seigniorial possession, and be given to the parish church of Santo Tomé in Toledo. The count had been a parishioner of that church and had his private chapel there. But in 1562 the townspeople decided to stop making the donation, hoping the bequest would be forgotten.

They could not have been more mistaken. The parish priest of Santo Tomé, Andréz Núñez de Madrid, immediately instigated legal proceedings against the town and in 1569 the royal chancellery in Valladolid ruled in the priest's favour. To mark this legal victory, as well as to immortalize the count's generosity, Núñez refurbished the count's chapel and commissioned El Greco to paint an exceptionally large canvas to be placed directly above his tomb. The contract that El Greco signed on 18 March 1586 included among its conditions a description of the subject: '[The artist] agrees to paint a picture that goes from the top of the arch to the bottom. The painting is to be done on canvas…he is to paint the scene in which the parish priest and other clerics were reciting the office for the burial of Don Gonzalo de Ruíz, Count of Orgaz, when Saint Augustine and Saint Stephen descended to bury the body of this gentleman, one holding the head, the other the feet, and placing him in the sepulchre. Around the scene should be many people who are looking at it and, above all this, there is to be an open sky showing heaven in glory.'

El Greco followed these specifications closely. He divided the composition into two equal parts: the world of mortals in the lower half and the celestial vision above. It would appear that he has set the funeral scene at night, as was increasingly fashionable for funerals of the nobility in 16th-century Spain. Mortuary torches have been lit and a solemn gathering of men has formed around the miracle. One can almost hear the whispering between a Franciscan friar and an Augustinian friar on the left. Saints Stephen and Augustine, young and old, clean-shaven and bearded, are dressed in richly embroidered liturgical vestments. They solemnly hold the count's body, clad in shining armour, the textures of their fabrics contrasting evocatively with the metallic polish of the steel. Seen close up, El Greco's brushwork is spirited and descriptive – Saint Stephen's reflection can be seen in the armour.

What is unusual about El Greco's representation, however, is that he sets the scene in Toledo of the 1580s: the black garments, white ruffs and goatee

1586–88
Oil on canvas
480 cm × 360 cm / 15 ft 9 in. × 11 ft 10 in.
Parish church of Santo Tomé, Toledo, Spain

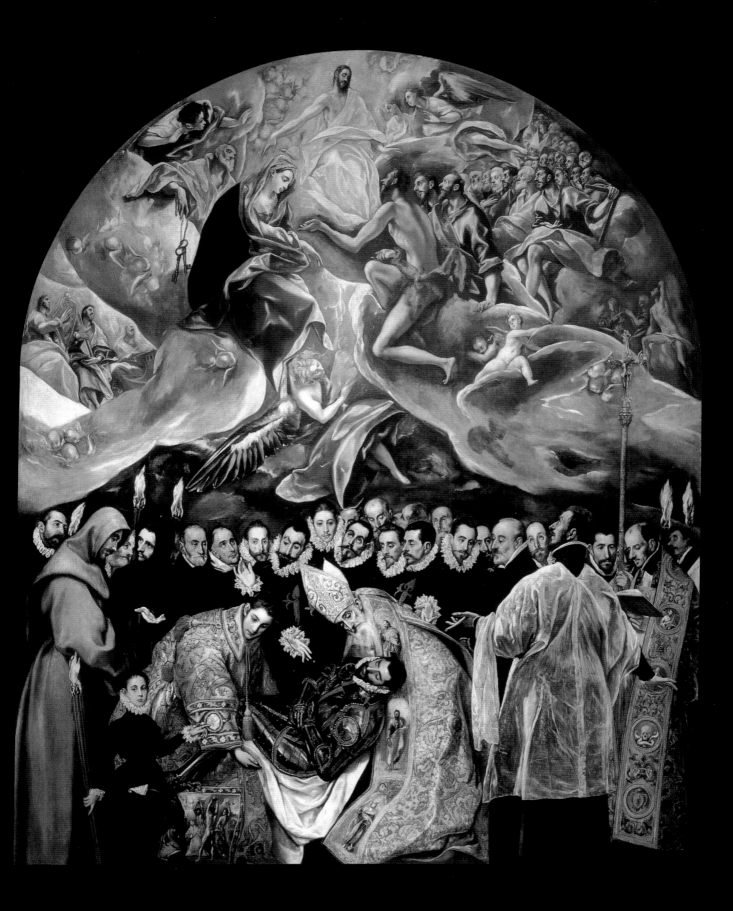

> *... the most moving detail is just visible ... a small translucent figure, which the Virgin and Saint John plead to have admitted into heaven.*

beards belong to the fashionable attire of late 16th-century Spain and not the 14th century in which Orgaz died. Each individual appears to be a real portrait, and some of the figures are members of the military Order of Santiago, identifiable by the red crosses on their chests. Although their identities are largely uncertain, the priest on the right holding a book and reciting the funeral rites must be Núñez de Madrid. The man with a white beard, behind Saint Augustine, is Antonio de Covarrubias, a scholar fluent in Greek and a close friend of El Greco, who would also paint his bust portrait years later. El Greco may be identified as the figure looking directly at us, positioned above Saint Stephen's head. And the young boy looking out at us and pointing to Orgaz's body is El Greco's son, Jorge Manuel. He is there not only to lead us into the picture but to emphasize El Greco's role as the creator of the composition. On the boy's handkerchief, El Greco has signed in Greek cursive letters: 'doménikos theotokópolis [*sic*] e'poíei 1578' ('Domenikos Theotokopoulos made this 1578'). The date refers not to the painting, but rather to the year of the birth of El Greco's son – a charming conceit.

'El Greco' means 'the Greek', since although the artist found fame in Spain he had been born on the island of Crete in 1541. He first trained as

Above

An angel propels the soul of the Count of Orgaz, in the form of a small translucent human figure, through a gap in the clouds. While the Virgin is preparing to receive the Count's soul, Saint John the Baptist speaks to Christ, asking him to consider the Count's entry into heaven.

Above right

The 8-year-old boy is Jorge Manuel, El Greco's son. He trained as a painter and practised as an architect. Although El Greco had hoped he would take over the studio on his death, Jorge was not such a skilful painter as his father, and El Greco's style very quickly went out fashion.

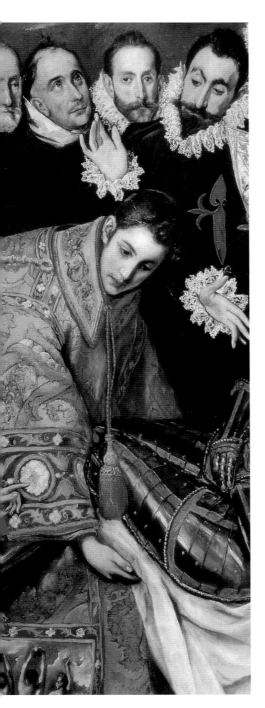

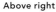

a painter of icons, an art form favoured by the Eastern Orthodox Church. Rather than representing natural phenomena as perceived by the senses, icons are designed to give a glimpse into the transcendental world of the divine. Figures are typically two-dimensional, elongated and uniform in size and proportion. One of El Greco's earliest signed icons is the *Dormition of the Virgin*, which shows the mother of Christ 'asleep' surrounded by the apostles. Christ has miraculously appeared and takes her soul in the form of a swaddled baby in his hands. Above, the heavens have opened, the Holy Spirit appears and the Virgin sits enthroned as she is assumed into heaven.

The visual connections between this icon and *The Burial of the Count of Orgaz* are intriguing. It is as if El Greco were consciously referring back to his earlier work but inserting a newly acquired skill: that of being able to paint the natural world realistically. On the one hand, we are drawn into the composition by the realism of the black-clad men gathered around the count; yet, on the other, we are witnessing both a miracle and a celestial vision. In order to depict the men, El Greco draws on the examples of Titian and Tintoretto, whose works he had studied while in Venice; but to capture the abstract visual world of paradise, El Greco has resorted to his training as an icon painter. The medley of elongated figures in heaven, dressed in brightly coloured drapery as if lit by neon lights, are not so removed from the figures that appear in his icon. As in scenes of a 'private judgment', El Greco also introduces an element of hierarchy, favoured by the Orthodox Church: Christ sits at the top, surrounded by the saints in heaven; Saint Peter with the keys and the rest of the saints sit behind in tiers, as though at the theatre. But the most moving detail is just visible through a gap in the clouds – it is a small translucent figure, which the Virgin and Saint John plead to have admitted into heaven. That figure signifies the Count of Orgaz's immaterial and immortal soul.

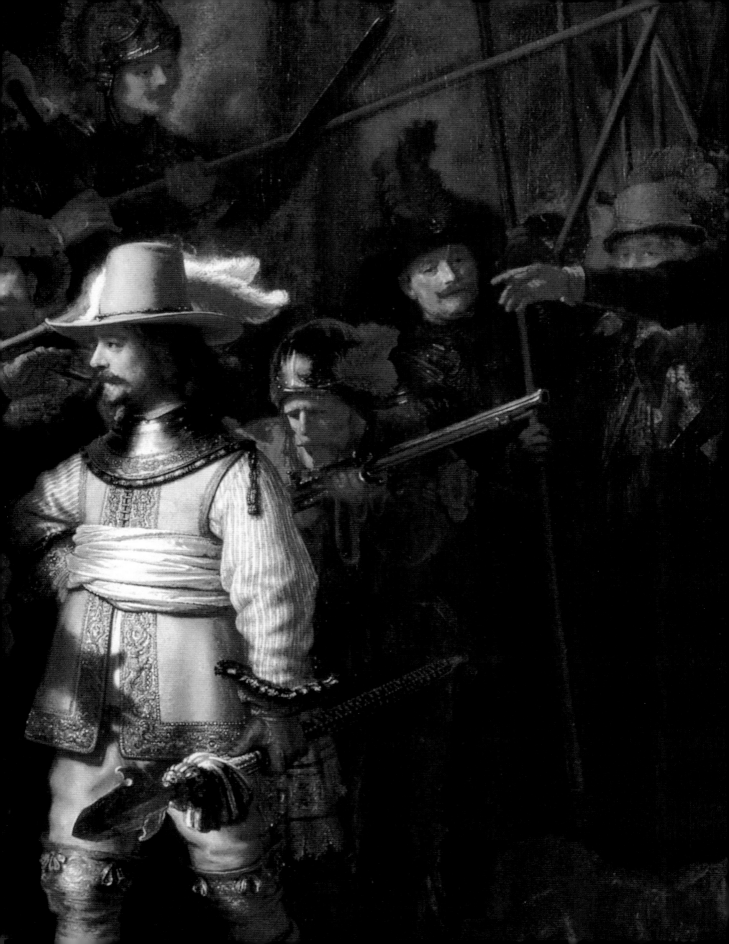

6

Past and Present

1600–1800

Revelations

The Supper at Emmaus, Caravaggio

HELEN LANGDON

Beardless and young, with a fleshy face, Jesus is not immediately recognizable, as he had not been to the disciples ...

Above

Titian's *Supper at Emmaus*, with Christ seated behind the table, the two disciples one on either side, and the innkeeper apart, his hands on his belt, is the forerunner of Caravaggio's painting. But where Titian tells the story with subtlety and restraint, Caravaggio, through lighting, perspective and theatrical gesture, creates a moment of intense drama, of the sudden and overwhelming recognition of the divine. (Titian, *Supper at Emmaus*, c. 1535, oil on canvas, 169 cm × 244 cm / 5 ft 6½ in. × 8 ft. Musée du Louvre, Paris)

1601
Oil and egg on canvas
141 cm × 196 cm / 4 ft 7½ in. × 6 ft 5 in.
National Gallery, London

The *Supper at Emmaus* **was painted in 1601,** at the height of Caravaggio's success in Rome, just as he was becoming known for his challenging pictures. He had already enchanted his contemporaries with the naturalism of his still lifes, rooted in the art of his native Lombardy; he painted fruit and flowers so fresh and bright that vine leaves seem to wilt before our eyes, and dewdrops to catch on the petals of flowers. But the naturalism of his religious art was more provocative; he shocked Roman artists, long trained in draughtsmanship and in study of the antique, by painting directly from the life model onto the canvas. He posed his models carefully, perhaps in a below street-level studio, and observed the fall of light from high windows or single lanterns.

In Caravaggio's works the stories of the Bible are given new and compelling urgency, for he sets them in the contemporary world. The disciples become travellers, with torn clothes and heavy, workmen's faces with wrinkled brows; martyrdoms take place in the dark Roman streets, where young swordsmen brawl and fight. Caravaggio's pictures have a strong feel of the studio; models, young boys and old men, and props – a majolica jug, a wooden chair – recur from painting to painting. The cellar lighting enhances the three-dimensionality of the figures, so that they seem, in a way entirely new, to be present before our eyes. It is this heightened realism, so evident in the painting shown here, that is unique to Caravaggio's art.

The *Supper at Emmaus* was a gallery painting. Unusually highly finished and brightly coloured, it has a virtuoso quality, as though Caravaggio intended it to be a showcase of these illusionistic skills. He shows the most dramatic moment in the story of Christ's appearance to the disciples after the Resurrection. Cleophas and an unnamed companion, fearful and despairing, are journeying to Emmaus, and as they travel Christ draws close and walks with them. They do not recognize him, but he comforts them, and they invite him to stay with them at the inn. As they ate, 'he took bread, and blessed it, and brake, and gave to them. And their eyes were opened, and they knew him: and he vanished out of their sight' (Luke 24: 30–31).

The subject was common in art, and Caravaggio's painting is close to paintings by Moretto and Titian, with Christ framed by two disciples, the innkeeper, and the elaborate still life, white tablecloth and rug. But he has utterly transformed this muted story into an intense drama of sudden recognition. His aim is to involve the spectator, almost physically, and he uses a variety of devices to break down the barriers between painted space and the world of the viewer. A chair is cut off by the frame, so that the disciple Cleophas is thrust towards us, and we seem to share his taut pose. A basket of fruit perches unsteadily on the edge of the table, as though inviting the viewer to move forward. The great gesture of the right-hand disciple, traditionally

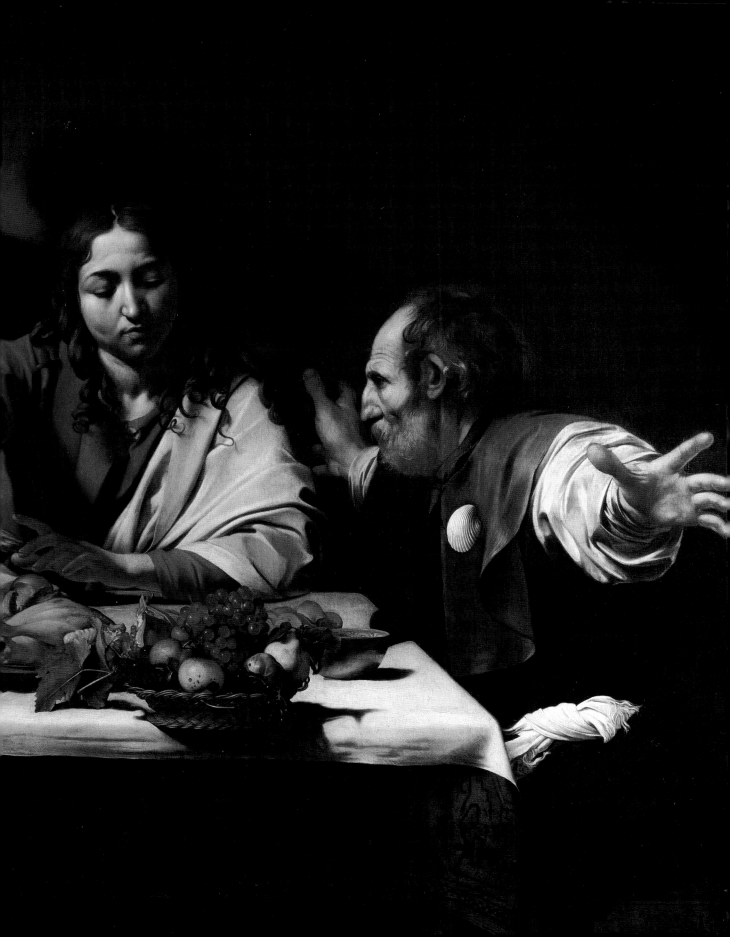

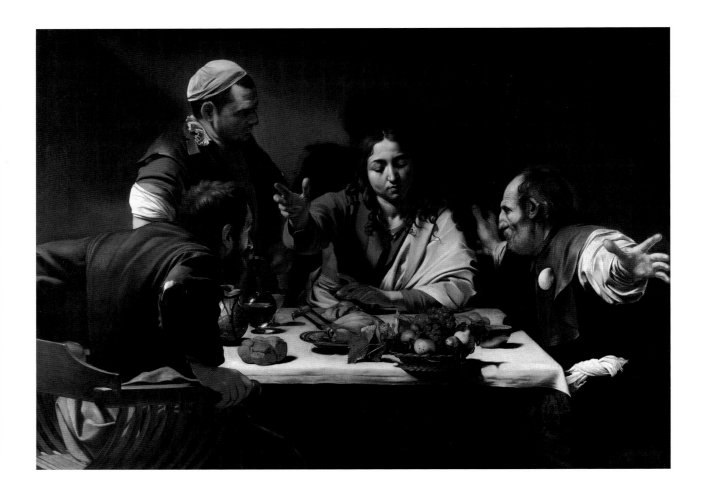

identified as Peter, seems to break through the picture plane, and echoes the swift perspective lines of the table – all of which lead to Christ. The still lifeexplores the beauty of surface and texture, of cast shadows dark on the white cloth, of chunky, solid bread, a chicken, plucked and roasted, and light passing through water to create a bright centre in the shadow of the carafe.

Yet this is not an ordinary meal, but a moment of divine revelation, and it is the fall of unnaturally bright light that endows Christ with the radiance of a vision; this symbolic use of light is perhaps Caravaggio's most important innovation. Beardless and young, with a fleshy face, Jesus is not immediately recognizable, as he had not been to the disciples, and this adds to our sense of wonder at the resurrected Christ, restored to youth, and freed from suffering. He seems posed between light and dark, framed by the shadow of the innkeeper, who, uncomprehending, stands still in darkness. Christ leans forward, but only for a moment – shortly, he will lean back into the shadows, and 'vanish out of their sight'. His sacramental gesture is a direct quotation from Michelangelo, from the Christ (also beardless) at the centre of his Sistine Chapel *Last Judgment*. In this way Caravaggio invests his scene, so immediate and fresh, with the weight of a traditional language of gesture and expression. The sense of the divine is underpinned by the symbolism of bread and wine, the elements of the Eucharist, while the fruits also suggest the Eucharist and Resurrection.

This painting was bought from Caravaggio by Ciriaco Mattei, in whose family palace Caravaggio lived from 1601 until 1602–03. The Mattei were an ancient Roman family, and two of the brothers, Asdrubale and Ciriaco, were avid collectors. They played an active role in the Roman art world, and, well versed in aesthetic debate, would have appreciated Caravaggio's provocative display of his naturalistic gifts. A year later Ciriaco bought the *Taking of Christ* (Dublin, National Gallery of Ireland). He paid high prices for these works; Baglione, an early biographer and rival of Caravaggio, remarked spitefully that 'Caravaggio pocketed many hundred scudi from this gentleman.' The two paintings formed a striking contrast, the *Supper at Emmaus* opening up a deep space, the *Taking of Christ* a night scene with a semi-circle of figures massed across the foreground. But by 1616 Ciriaco no longer owned the *Supper at Emmaus*; it had passed into the collection of Cardinal Scipione Borghese, where, in 1657, it was admired for its 'tremendous naturalism' by Francesco Scanelli. Scanelli, an amateur of painting, wrote in wonder of Caravaggio's 'astonishing deceptions, which attracted and ravished human sight'.

But Caravaggio's fame was by now in decline. To Giovanni Pietro Bellori, antiquarian and theorist, Caravaggio was a threat, whose rejection of drawing and of ideal beauty challenged the very bases of Italian art. He praised his colour, but in the *Supper at Emmaus* disliked the 'vulgar conception of the two Apostles and of the Lord, who is shown young and without a beard'. He objected to the autumnal fruits, so obviously out of season. In the 18th century, the age of Neoclassicism, Caravaggio's reputation remained low, and, astonishingly, the picture was unsold at a Christie's sale in 1831. It has been in the National Gallery in London since 1839, and, with the present immense popularity of Caravaggio, perhaps now the most feted of all old master painters, it has become one of the most famous paintings in the world.

Right
This painting was executed for the same patron as the *Supper at Emmaus*. The figure on the right, holding up the lantern, is a self-portrait; Caravaggio seems to summon young painters to follow him, and to celebrate his naturalism, rooted in the dramatic use of light and dark. (Caravaggio, *The Taking of Christ*, late 1602, 133.5 cm × 169.5 cm / 4 ft 4½ in. × 5 ft 6¾ in. National Gallery of Ireland, Dublin)

Sleeves Rolled Up

Judith Slaying Holofernes, Artemisia Gentileschi
GERMAINE GREER

Gentileschi's virtuosity is pitiless. The horror of the scene takes second place to a dazzling range of paint textures, built up by the gradual application of glaze upon glaze over rich pigments.

I n 1612 the painter Orazio Gentileschi brought an action in the Tribunale del Governatore in Rome against his friend and collaborator Agostino Tassi for raping his daughter Artemisia and stealing a large painting of Judith. For three years he had been training Artemisia, born in 1593, as a painter, having found her more gifted than any of his three sons. The situation was confused; Gentileschi may have tolerated Tassi's relationship with his daughter because he believed that Tassi intended to marry her, and Tassi may have come by the picture on the same understanding; but he was already married. Tassi was eventually found guilty but Artemisia was tortured and humiliated in the process, as Tassi's cronies did their best to prove that she was a whore. Tassi, meanwhile, never served his sentence, because the Grand Duke of Tuscany intervened on his behalf. The *Judith Slaying Holofernes* that is now in the Museum of Capodimonte in Naples may be the picture Gentileschi was referring to; it is generally thought to have been painted eight or nine years before the most famous version of the composition, which is the one in the Uffizi and dated nowadays to as late as 1620. By then Artemisia was married, and living and working in Florence under the protection of the Grand Duchess of Tuscany. When Anna Jameson saw this 'dreadful picture' in 1822, she declared that it was proof of both 'her genius and its atrocious misdirection'.

According to scripture, Judith was a widow living in mourning in Bethulia when the city was besieged by the Assyrians. With the assistance of her maidservant Abra, Judith secretly planned the assassination of their general, Holofernes. To that end she bathed and dressed herself in her finest clothes and 'put about her her bracelets, and her chains, and her rings, and her earrings and all her ornaments' (Judith 10: 4) and took fine food and drink with her to Holofernes' camp. 'And Holofernes took great delight in her, and drank more wine than he had drunk at any time in one day since he was born' (Judith 12: 20). As he lay on his canopied bed in a stupor, Judith took his sword and with two blows struck off his head. Abra then smuggled the head back to the city where Judith displayed it to the Hebrews.

One pictorial tradition treats Judith simply as a magnificently dressed beauty, for whom Holofernes' head is a kind of bizarre fashion accessory.

c. 1614–20
Oil on canvas
199 cm × 162 cm / 6 ft 6 in. × 5 ft 4 in.
Galleria degli Uffizi, Florence

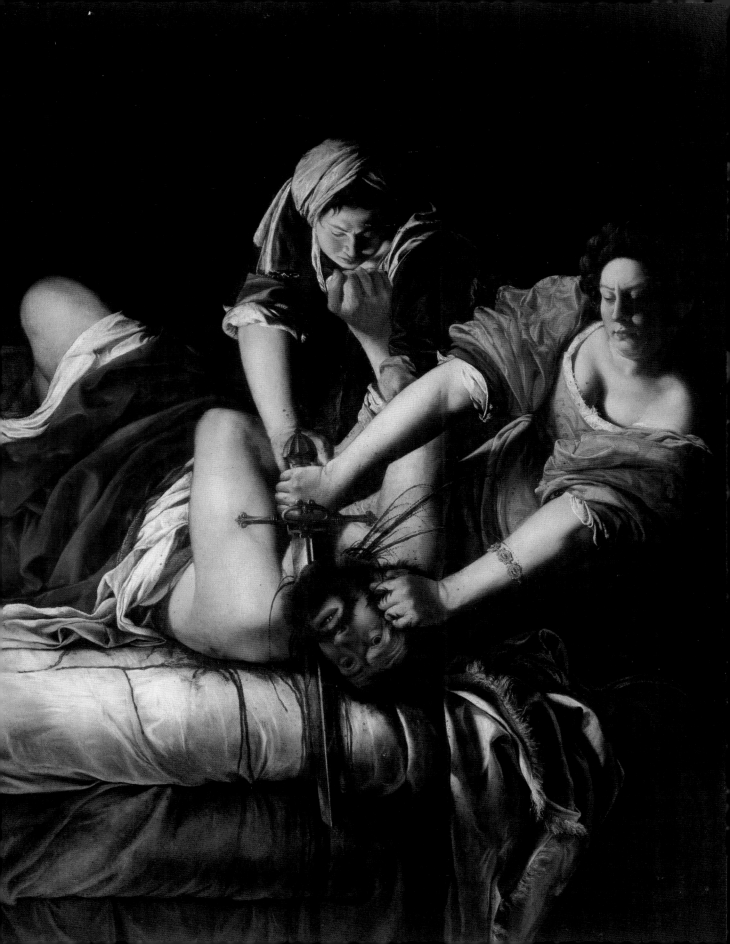

The versions of this subject by Titian, Alessandro Allori and Cranach are well known. A less well-known version by a woman is Fede Galizia's *Judith* of 1596. A year or two later Lavinia Fontana portrayed Judith stepping down from the canopied bed and handing the severed head of Holofernes to her maidservant, as Tintoretto did. Artemisia chose to show her Judith in the act of hacking off Holofernes' head.

The precedent for this had been set in about 1599 by her father's long-time friend and associate Caravaggio. In his *Judith Slaying Holofernes*, now in the Galeria Nazionale d'Arte Antica in Rome, Caravaggio shows us the very moment when Holofernes is roused from his stupor by the impact of cold steel on his jugular. Judith, bathed in celestial light, approaches her victim with revulsion and trepidation, her arms outstretched as much to ward him off as to behead him. Caravaggio makes quite clear that Judith is no murderer, but simply the instrument of divine power.

In Gentileschi's version there is no suggestion of a religious dimension; we see only two young women using their combined strength to attack a drunken man. The distance between Judith and her victim has been telescoped; the angle is swung round so that the play of the arms of the murderess, her maidservant and their victim intersects in a knotted, see-saw movement, mimicking Judith's physical struggle to work the heavy sword through the man's neck. Everybody is struggling, the victim, the perpetrator and her accomplice.

Gentileschi's virtuosity is pitiless. The horror of the scene takes second place to a dazzling range of paint textures, built up by the gradual application of glaze upon glaze over rich pigments. Everything is gorgeous, from the warm flesh tones of the murdering arms to the lush crimson velvet of the coverlet, to the figured gold brocade of Judith's spectacular dress, and the intricacy of the bracelet on the arm she uses to hold down her victim's head. The fulcrum of the composition is the burst of blood that sprays from Holofernes' throat, showing against the rose-white of Judith's bosom like so many flying rubies.

It is a mistake to treat this picture as Artemisia's revenge on Tassi, and an even bigger mistake to regard it as a precursor of the SCUM Manifesto.

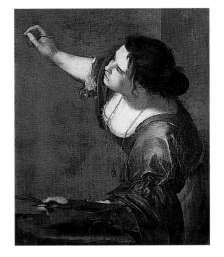

Above
This bravura self-portrait, now in Hampton Court Palace, shows Artemisia as La Pittura, the Art of Painting, wearing a gown of *color cangiante* and a mask pendant round her neck. (*La Pittura / Self-Portrait as the Allegory of Painting.* 1638–39, oil on canvas, 96.5 cm × 73.7 cm / 3 ft 2 in. × 2 ft 5 in. Royal Collection, London)

Right
In Caravaggio's early painting, Judith holds her victim's head at arm's length in a mixture of fear and repugnance. By her stance and expression, the artist suggests that she is not implicated in the deed but is the tool of God's vengeance. (Caravaggio, *Judith Slaying Holofernes*, 1599, oil on canvas, 145 cm × 195 cm / 4 ft 9 in. × 5 ft 7 in. Galeria Nazionale d'Arte Antica, Rome)

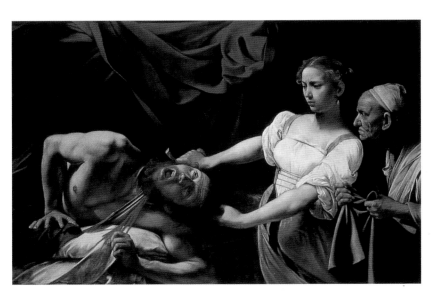

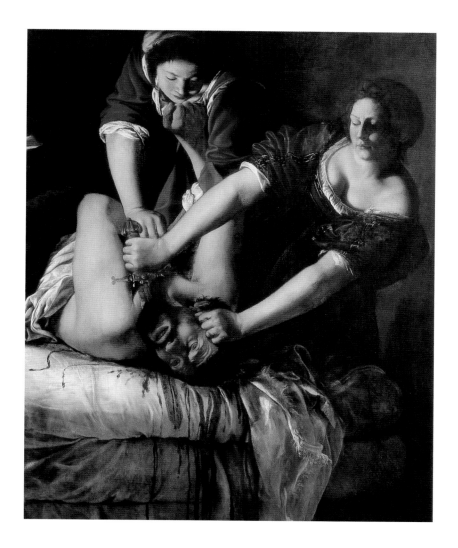

> *In Gentileschi's version there is no suggestion of a religious dimension; we see only two young women using their combined strength to attack a drunken man.*

As a professional artist living under grand-ducal patronage, Artemisia had to paint the subjects demanded by her patrons. The earlier version of the composition is journeyman work compared to the Uffizi painting that shows, as nothing else could have, how far Artemisia had come in the intervening years. She was to return to the Judith theme but never again to the murder of Holofernes. Instead she chose to show Judith and Abra collaborating in a dangerous enterprise. Women were her preferred subjects, perhaps because she was often limited to female models, including her daughters and members of her household, but she painted them on a scale that was verily heroic. Her treatment is never sentimental or sentimentalized. Her female figures are the first in Western iconography to have heft and weight and bones.

Greater Things in Mind

Portrait of Jahangir Preferring a Sufi Shaikh to Kings, Bichitr

DEBORAH SWALLOW

"For those interested in the ways in which India and Europe viewed each other in this period, the painting is particularly fascinating ...

Opposite

Jahangir offers a book to Shaikh Husain, ignoring the rulers of the world who are gathered on the left. Above, cupids turn away from the refulgent sun, overwhelmed by the powerful rays or distressed by the knowledge that the emperor is not immortal.

c. 1615–18
Opaque watercolour, gold and ink on paper
25.3 cm × 18 cm / 10 in. × 7 in. (46.9 cm × 30.7 cm / 1 ft 6½ in. × 1 ft with border)
From the St Petersburg Album,
Freer Gallery of Art, Smithsonian Institution, Washington, DC

The **Mughal emperor Akbar** (r. 1556–1605), seeking a male heir, made a pilgrimage to the shrine of Shaikh Salim Chishti, at Sikri near Agra. The concern to secure his lineage was well founded. His grandfather Babur, of Turko-Mongol ancestry and a descendant of both Timurlang and Chinggiz Khan, had died soon after establishing a foothold in north India. His father Humayun lost Delhi, spent four years wandering Rajasthan, sheltered for a short time as guest of the Persian ruler Shah Tahmasp, regained Kabul and later Delhi, and then died in an accidental fall some six months later. Akbar, a man of extraordinary ability, both expanded and consolidated Mughal rule in India. This painting of his son, born auspiciously in Sikri and named Salim after the saint, depicts Salim towards the end of his life, when he was better known as the emperor Jahangir – the 'world seizer' (r. 1605–27).

One of a string of masterpieces produced by the Mughal court atelier, *Portrait of Jahangir Preferring a Sufi Shaikh to Kings* is a magnificent and rich work, both visually and in terms of its meaning – a superb demonstration of the innovatory practices inspired by the liberal artistic patronage of the great sequence of Mughal emperors who so significantly transformed the visual horizons of India in the late 16th and early 17th centuries. This image too allows us to argue the case for greater attention to the artistic record for the better understanding of social custom and political ideology.

Mughal painting and the other Mughal arts are intimately associated with imperial patronage of an exceptional quality. Over his fifty-year rule, Akbar fundamentally changed the aims and aesthetics of artistic production in India. Vigorous in every activity he engaged in, from a very early age Akbar assembled a large atelier of native Indian artists under the supervision of two great Safavid masters – Mir Sayyid 'Ali and Abd us-Samad, whom his father Humayun had brought from exile in Persia. Under Akbar's close supervision, the studio rapidly evolved a distinctive style of epic, literary and historical manuscript illustration, which combined the technical refinement of Persian art with the colour intensity of indigenous Indian, mostly religious, painting. It also added a growing naturalism and feeling for nature, introduced through prints and pictures brought to court by merchants, envoys and missionaries.

Jahangir, the eldest and favourite son, the 'heir apparent' and ultimately the inheritor of a very substantial and relatively stable empire, was more connoisseur than soldier. Before acceding to the throne, while rebelliously setting up a rival court in Allahabad, he developed his own atelier, employing leading artists such as Aqa Riza, trained in the Persian style at the Safavid court and father of the equally renowned painter Abu'l Hasan. Jahangir's commissions moved away from the illustration of manuscripts to a greater focus on individual images. He was deeply curious about the natural world and the

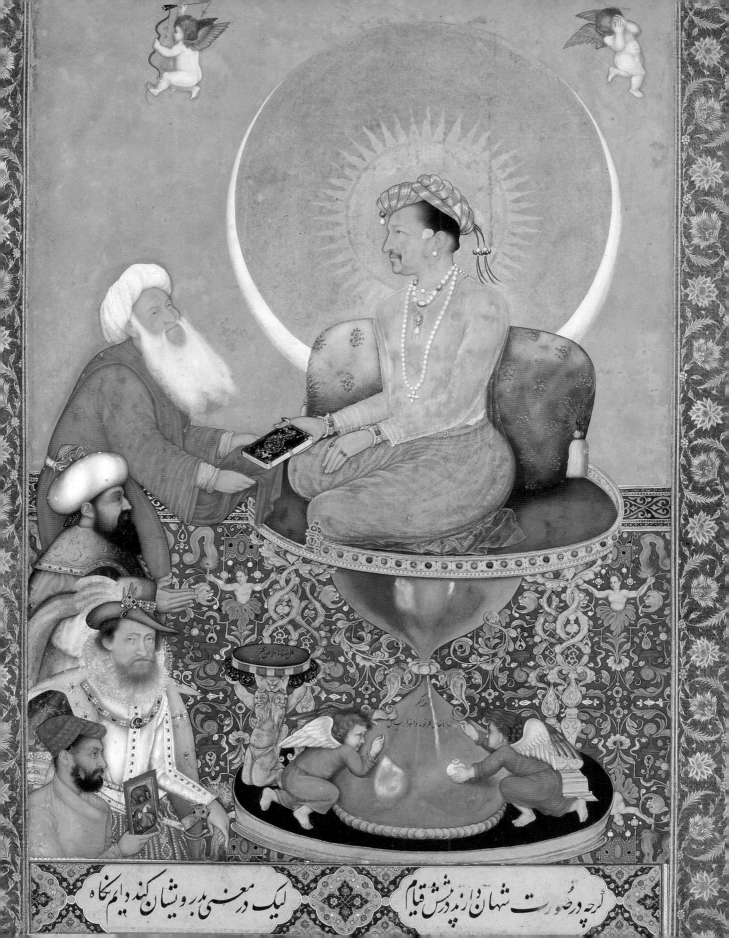

گرچہ در صورت شہان را زیں درش مش قیام لیک در معنی ہما زرویشان کند یا دیم نگاہ

Above

Squirrels in a Plane Tree (with detail),
probably by Abu'l Hasan, known as Nadir
al-Zaman ('Wonder of the Age'), perhaps
with the help of Ustad Mansur, known as
Nadir al-Asr ('Miracle of the Age'), *c.* 1610.
(36.5 cm × 22.5 cm / 14¼ in. × 8¾ in. From
Johnson album 1, no 15, India Office Library
and Records, British Library, London)

artistic techniques that could best render it in painting. Portraiture, studies of animals or flowers and genre scenes, now often mounted in decorative borders, were brought together in beautiful albums. Artists were encouraged to develop further their individual talents and distinctive styles.

We know more about the artists of the Mughal court through the histories, biographies and autobiographies of the emperors than about any earlier Indian artists, even though the fragmentary references still leave us with tantalizing questions. It is yet more difficult to determine the emperors' artistic intentions from written sources. However, the analysis of literary sources and architecture along with painting through Jahangir's reign does provide a fascinating picture of increasingly formalized court etiquette and imperial self-congratulation. The depiction of formal court durbars, which provide group portraits of key courtiers and document significant events, becomes more frequent, and in his later life Jahangir commissioned a series of imperial portraits that are rich with allegorical reference drawn primarily from the European tradition. Hashim was probably the first artist to establish the visual conventions for the most important subject of Mughal imperial portraiture – the emperors themselves. Subsequently, Abu'l Hasan, who collaborated with Hashim in early developments of this iconography and then became one of its greatest exponents, undoubtedly influenced Bichitr, the author of this painting.

Bichitr was a brilliant young follower of Abu'l Hasan, and later also became one of the principal court artists of emperor Shah Jahan (r. 1628–58). Like Abu'l Hasan, he was prolific, highly skilled and able to paint the full range of subjects required by his patron – from sensitive individual portraits and animals to complex historical subjects and inventive ornament.

This particular painting depicts the emperor, as always in profile, his head framed with a golden sun, itself framed in a crescent moon, enthroned on an hourglass that in turn sits on a richly decorated carpet. Angels have inscribed the hourglass with the wish that the emperor might live a thousand years, but it is clear that the sands of time are running out. Cupids turn their faces away from the refulgent sun – one with broken arrow, the other hiding his face in his hands – overwhelmed by the powerful rays or saddened by the implied age of the ruler. The main inscription – 'Though outwardly shahs stand before him, he fixes his gaze on darvishes' – focuses our attention on the figures below the emperor. The 'darvish' towards whom Jahangir gazes with sad expression, and who leans towards him to take a book, is Shaikh Husain of the Chishti shrine, a spiritual descendant of Shaikh Salim to whom Jahangir 'owed' his birth – the book perhaps the book of his life. Below the Shaikh, another figure in profile, a generalized image of the Ottoman ruler (along with Persia one of the Mughals' great imperial competitors), holds his hands deferentially towards Jahangir. Below him, looking out at the viewer, is the recognizable face of King James I of England. The bottom figure, holding a small painting, whose identity is debated, could be either a central Indian ruler or the artist himself. The overall message, however, is clear. Jahangir offers his life to the saint, to the faith, rather than to the rulers of the world – or, if this is the artist, to the arts which he has so enjoyed and encouraged throughout his reign.

For those interested in the ways in which India and Europe viewed each other in this period the painting is particularly fascinating, because its

> *This … painting depicts the emperor, … his head framed with a golden sun, … enthroned on an hourglass …*

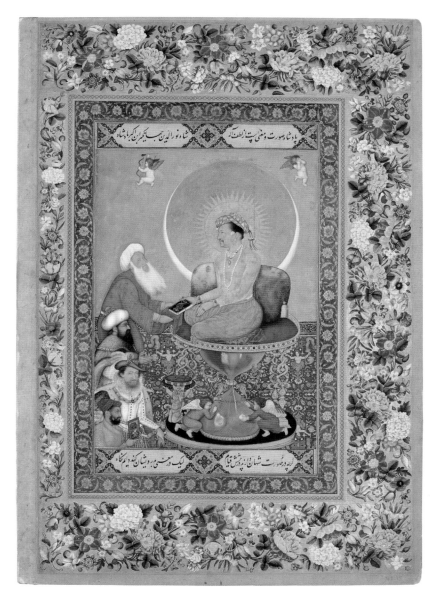

hieratic, allegorical structure and adoption of European devices reflect so tellingly how India saw Europe at the time. The Portuguese had been operating in India since the end of the 15th century and it was Jesuit priests from Goa who first gave the illustrated Antwerp Polyglot Bible to Akbar in the 1570s. By the early 17th century, the English had joined the Portuguese and the Dutch, the French and the Danish in the competition to establish direct trade relations with India. Sir Thomas Roe, the envoy of King James I of England, spent some two years (1616–18) at Jahangir's court and left a rich account, and we know that Jahangir was more fascinated by English miniatures than by any of the other crude gifts uncouth northerners had brought him. But of that visit, of King James himself, or of the remote island off the northern coast of the European mainland, there is no mention in Jahangir's own autobiography!

A Plea for Peace

Minerva Protects Pax from War ('Peace and War'), Peter Paul Rubens

DAVID JAFFÉ

" *The painting is a plea for the return of the mythical Golden Age of early man, when wild beasts were tame and children thrived.*

Above
The woman playing tambourine and castanets is suggestive of an ancient Bacchic party.

Right
The central scene was Rubens's original design for the painting, except for the docile leopard (a royal beast), which was added to enlarge the canvas and to reinforce the message of the Carolingian Golden Age. The flashy brushwork consciously imitates the great Titians in the king's collection.

1629–30
Oil on canvas
203.5 cm × 298 cm / 6 ft 6 in. × 9 ft 9 in.
National Gallery, London

Rubens's *Minerva Protects Pax from War* – commonly known as *Peace and War* – has long been recognized as one of the greatest displays of the Baroque artist's skill. On 1 October 1802 an agent for the art dealer William Buchanan excitedly wrote of the painting:

It contains almost everything in which Rubens excelled – women, children, a man in armour, a satyr, a tiger, fruit and furies; making altogether a composition wonderfully rich and pleasing. It is known in Genoa by the name of Rubens's family, and has always been a well known and celebrated picture, esteemed the best or second best by him in his city. It is in the collection of George Doria, a branch of the celebrated family of that name.

The following year the painting was bought by the (future) Duke of Sutherland and was later given to the newly formed National Gallery in 1827.

In the work the figure representing Peace is shown seated and expressing milk towards a baby, while a band of children led by a boy holding a torch approach in a grouping suggestive of nuptials. A kneeling satyr assisted by a cupid with his back towards us offers the assembled group a horn overflowing with fruits, and the little girl looking out has taken a grape. Behind this group a helmeted Minerva, the Roman Goddess of Wisdom, is pushing away Mars, the God of War. The canvas was enlarged by Rubens after he had painted this central group. The additions included more full-length figures and were literally sewn around the edges of the original canvas, expanding the image of a nurtured family benefiting from the suppression of war. On the right, beyond Mars, is a fury, his expelled companion; a further harpy flies above in the sky. On the left-hand side, two women enter carrying gold and playing a tambourine. The addition of a strip above the figures of Mars and Minerva inserts a flying putto holding a wreath of Peace; below these figures Rubens has added a leopard playfully reaching up to catch grapes.

We know that the children in the painting are those of Balthazar Gerbier: the infant is James, the child eating grapes is Susanne, the bride is Elizabeth and the torch-bearer acting as Hymen, the God of Marriage, is the eldest son, George. The figure representing Peace may even be Gerbier's wife, Deborah Kip. Gerbier was a courtier employed first by the Duke of Buckingham and later by Charles I, and Rubens (who served as a diplomat as well as an artist) and Gerbier worked together for many years to achieve a peace between England and Spain. Rubens probably included Gerbier's family in the painting because of this close connection; we know that Rubens stayed with Gerbier during his visit to England from May 1629 to March 1630

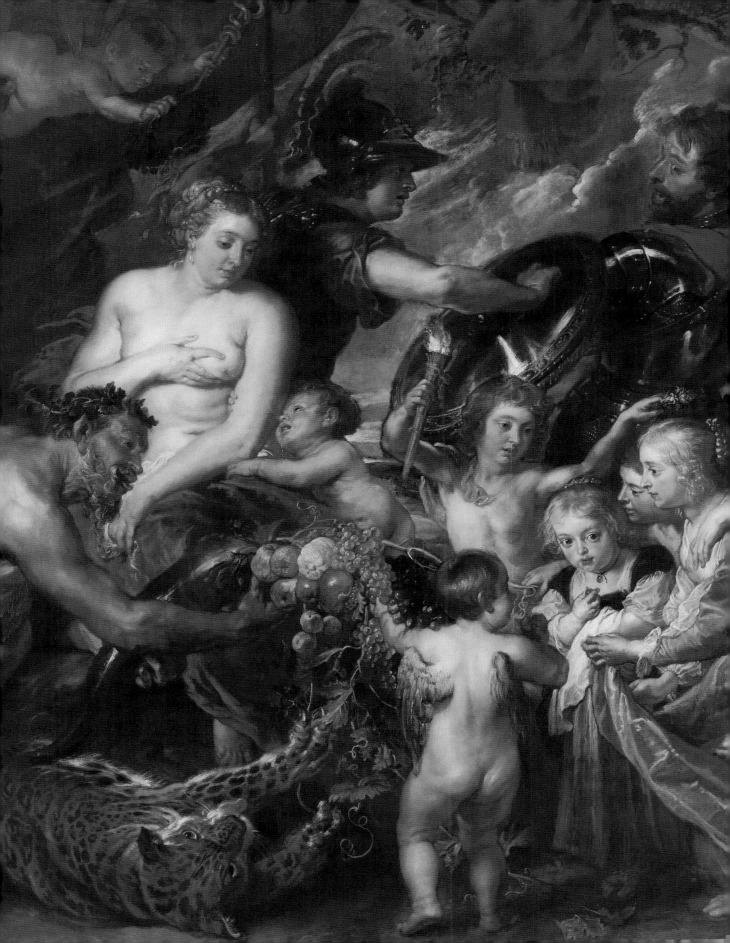

> *… the figure representing Peace is shown seated and expressing milk towards a baby …. Behind this group a helmeted Minerva, the Roman Goddess of Wisdom, is pushing away Mars, the God of War.*

Above
Minerva banishes War and his stormy companions, and starts a festive party, supplied by a mythical horn of plenty.

and so could have got the young Gerbier children to model for him. Rubens painted *Peace and War* during this London visit and presented it to Charles I.

Gerbier's involvement in the truce between England and Spain was a consequence of his serving the Duke of Buckingham, first as his curator and later as his Master of Horse; Gerbier later served as English representative to the Court of Brussels and Charles I's Master of Ceremonies. As Buckingham's art agent, Gerbier was a useful conduit for furthering English foreign policy without arousing suspicion. In 1625 Rubens and Gerbier met in Paris. Gerbier was ostensibly engaged in purchasing Rubens's antiquities collection and some paintings by Rubens for the duke, as well as commissioning a portrait and a ceiling showing the Apotheosis of Buckingham. While in Paris, Gerbier was also discreetly making peace overtures. When these diplomatic efforts failed and England attacked the Spanish port of Cádiz, Rubens was devastated as he had dedicated much time and effort to pursuing peace through diplomacy.

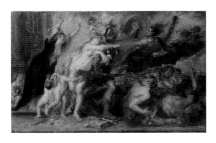

Top

The 'Apotheosis of James I' and a panel showing putti cavorting with tame leopards, rams and other creatures symbolize the wise and peaceful reign of James I. They are part of the ceiling Rubens had painted (by 1634) for James's son Charles, to decorate Inigo Jones's new Banqueting Hall in Whitehall Palace. *Peace and War* may have been the sampler which secured him this prize commission.

Above

Rubens's *Horrors of War*, painted in 1638 for the Grand Duke of Tuscany, is a pessimistic sequel to *Peace and War*, showing the dire consequences for motherhood and the arts if Mars is allowed to vent his fury. (*Horrors of War*, oil on canvas, Palazzo Pitti, Florence)

This painting, *Peace and War*, along with the *Glorious Reign of James I* (a ceiling decoration celebrating the achievements of James I, which Rubens later sent to the king for his Banqueting Hall in the Palace of Whitehall), were emphatic statements of the importance of peace for the kingdom. Rubens believed that only under a peaceful reign could the arts and family flourish. The painting is a plea for the return of the mythical Golden Age of early man, when wild beasts were tame and children thrived. While the mythological imagery is drawn from the Roman writer Virgil, the inclusion of the family of one of Charles I's courtiers made the message much more direct and personal. Charles I was apparently godfather to Charles Gerbier, who was christened in March 1630, just after the exchange of ambassadors between Spain and England, so the painting may be viewed as a reminder of the obligations for peace inherent in that diplomatic exchange. Rubens's scheme for the *Glorious Reign of James I* also stood as a reminder that Charles's father, James I, had already undertaken this noble path to Peace through the Union of the Crowns of Scotland and England.

Rubens knew from personal experience the horrors of war. 1648 marked the end of the Thirty Years War and also, for Rubens's native city of Antwerp, the end of eighty years of war between the United Provinces and the Spanish Netherlands (broken only by a twelve-year truce from 1609 to 1621). In 1638 he was to paint the *Horrors of War* (Pitti Palace, Florence) for the Grand Duke of Tuscany – clearly the ravages of war and the imperative of peace were recurring themes in Rubens's paintings.

Rubens couched the painting in the format and style of an artist that both he and the king admired: Titian. It is no coincidence that Peace the nurturer looks like a close relation of Rubens's copy of Titian's *Girl in a Fur Wrap* (Queensland Art Gallery, Brisbane), even down to the glistening earring. Charles owned this work by Titian as well as some twenty-two others. The core design of *Peace and War* in the central group around the figure of Peace also recalls the format of many half-length Titians. Furthermore, a black chalk study of the Gerbier children is drawn on the back of a quick sketch after the great Titian painting *Ecce Homo*, which Gerbier had bought for the Duke of Buckingham. One wonders whether Rubens conceived the idea for the painting after seeing that work in Buckingham's collection with Gerbier; perhaps it was, like the peace itself, a further collaboration between the two painter-diplomats.

By 1640 Rubens's *Peace and War* was hanging beside the artist's *Daniel in the Lions' Den* (National Gallery, Washington) in the Bear Gallery at the Palace of Westminster. Rubens may have wished his 'emblem of the consequences of Peace and War' to serve as a pictorial appeal in a Privy Council room but its function may have been far more mundane – as a reminder that leopards and lions were the monopoly of the crown and their royal keeper. The painting is a rare plea for peace by an artist who was committed to that cause and inventive enough cleverly to visualize this message. His royal recipient was less receptive.

Civic Pride

The Night Watch, Rembrandt van Rijn

CHRISTOPHER DELL

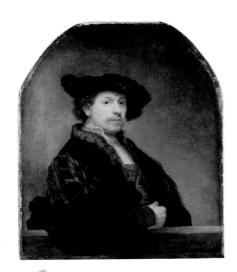

' *Along with Caravaggio, Rembrandt was the greatest proponent of chiaroscuro.*

Above
This self-portrait was begun at about the same time as *The Night Watch*, when Rembrandt was just 34.

Opposite
The central figures are the captain and his lieutenant. The captain's extended arm is a masterpiece of foreshortening, though the lieutenant's hooked partisan is less successful and was repainted several times before Rembrandt was satisfied.

1642
Oil on canvas
363 cm × 437 cm / 11 ft 11 in. × 14 ft 4 in.
Rijksmuseum, Amsterdam

The history of the Low Countries in the late 16th and early 17th centuries is in large part one of sporadic warfare, which history groups together (for convenience) as the Eighty Years' War. This stop–start conflict pitted the Spanish (Catholic) Habsburgs against the (largely Protestant) Dutch Republic, which had grown out of a union of rebel city-states; each of the cities in the union had its own civic militia, dedicated to both defending and keeping order in the city.

When we speak of militias we might imagine highly trained armies, but this was far from the case. The Dutch militias had first been formed in the early 16th century, but from their inception had more closely resembled confraternities than fighting forces. This is underlined by the tradition of militia portraits, which began in 1529 with a work by Dirck Jacobsz. Over the course of the 16th century such portraits became increasingly popular, and were often prominently hung in town halls and other civic spaces. Most of these works did not show full-length figures, however. That particular tradition originated in 1588 with Cornelis Ketel's *The Company of Captain Rosecrans*, in which the men stand in a more or less straight line, facing the viewer.

So, when Rembrandt was commissioned to address this subject in about 1640, not long before the end of the Eighty Years' War, he was presented with a well-defined tradition. However, the resulting work, which he completed in 1642 – *The Company of Frans Banning Cocq and Willem van Ruytenburch*, more commonly known as *The Night Watch* – was unlike any previous militia scene. Although *The Night Watch* was originally hung alongside works by four other painters, including Jacob Backer and Nicolaes Eliasz., in the Kloveniersdoelen (Arquebusiers' Hall) in Amsterdam, today the other works all languish in the vaults of the Rijksmuseum, while Rembrandt's takes pride of place in the collection. What, besides the simple fact of Rembrandt's superiority as an artist, can account for this outcome? What makes Rembrandt's militia portrait so great, so memorable, so universally celebrated and admired?

The answer is twofold. First, the distinctiveness of his conception arises from what Rembrandt does (and does not do) with his figures. The militiamen are not seated in a row, facing out at us. Nor are they on parade. Rather, the painting is characterized by a sense of informality as if the men are just assembling for duty. They are ranged casually in the space, preparing their weapons, talking. Each of them wears a different hat or helmet and there is little uniformity in their dress (which conveniently reveals their social status). At the back is an untidy criss-cross of pikes, far removed from the parallel lines seen in Velázquez's comparable work *The Surrender of Breda* (or *The Lances*, 1635), which tackles an episode from the Eighty Years' War seen from a Spanish perspective. Few of the subjects look directly at the viewer.

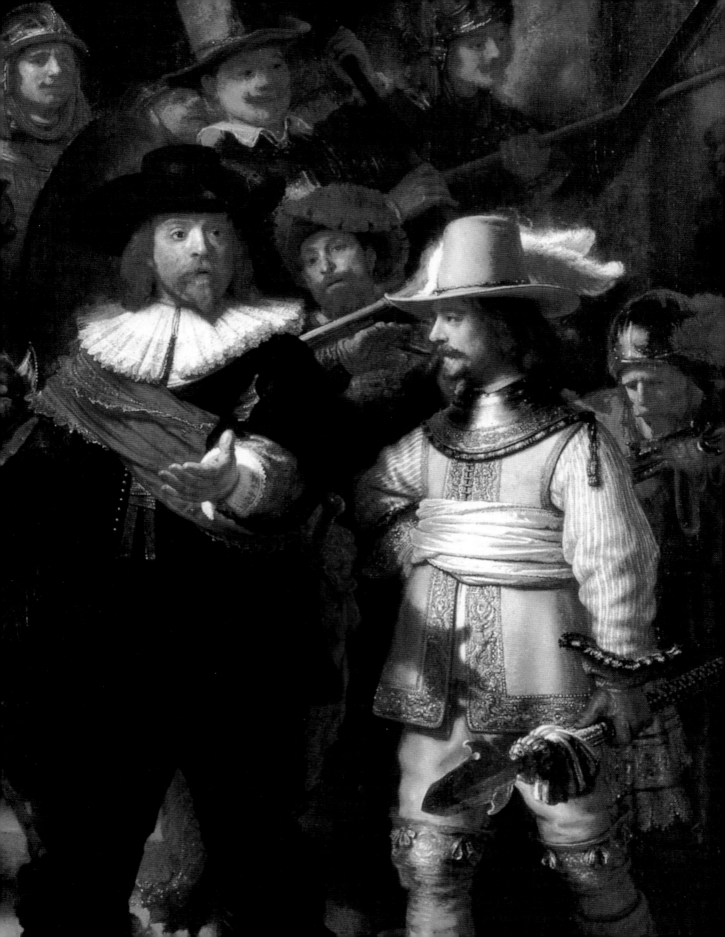

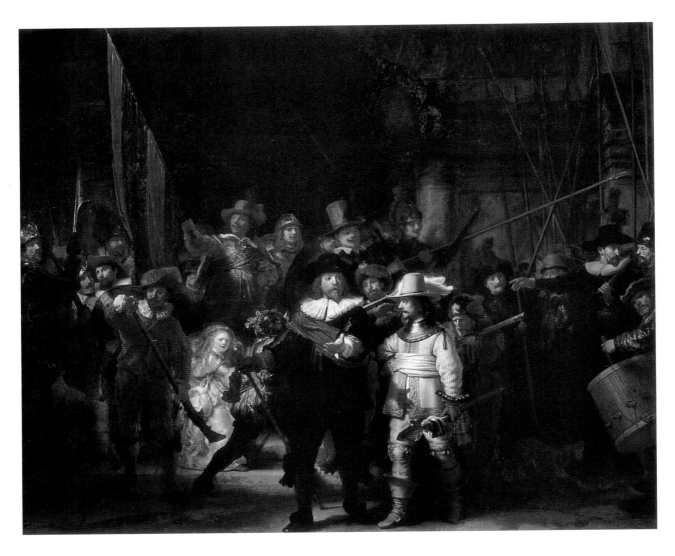

Above
Militia portraits were not cheap to commission, and each person depicted made a financial contribution. Those who appear in the work are recorded for posterity in the shield at the top, which was added in 1715. However, in the same year three unfortunate members were cut out when the canvas was trimmed on the left-hand side. The drummer was not a member of the militia, but was allowed to pose for free.

Right
A young girl adds a note of urgency in her luminescent gold dress. The helmet just to her right bears the oakleaf symbol of the arquebusiers.

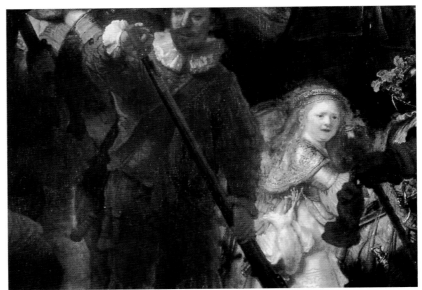

The relaxed disposition of the figures gives the scene a remarkable naturalism, even to the point of obscuring some of them (we know that a number of the sitters were disgruntled at being eclipsed). Yet the informality is not random and Rembrandt has carefully contrived to give due prominence to the most important people – not only by depicting them in the foreground but also by training a strong light on them. They are Frans Banning Cocq, the captain, and Willem van Ruytenburch, the lieutenant. Cocq looks as though he is explaining some new strategy to his (significantly shorter) deputy. This is a leader of men – even if the men, for the moment, aren't following. The result is something more akin to a history painting than portraiture, since we have a real sense that the band is on the verge of action.

The second way in which *The Night Watch* differs from previous militia portraits is in Rembrandt's handling of the paint and his masterly use of tone and colour. Along with Caravaggio, Rembrandt was the greatest proponent of chiaroscuro. Although the canvas appears to be black, most of it is made up of dark browns and greys. A true black is saved for the clothes of the captain, which as a result have the completely flat, saturated colour and rich texture of velvet. The presence of the bright light streaming from the left should also alert us to the fact that the scene does not take place at night. Indeed, the name *The Night Watch* was given not by Rembrandt but by Sir Joshua Reynolds (so the story goes), largely on account of the painting's darkness. Much of the light bounces off the figure of Cocq's lieutenant, who is dressed in pale colours. The shimmering gold fabric – which Rembrandt magics into life with his usual economy – shows up the shadow of Cocq's hand, depicted in a virtuoso display of foreshortening.

The other pool of light falls on the form of a young girl who dashes in from the left. While her inclusion may surprise us, she carries symbols relating to the militia. On her belt she wears the claws of a chicken, a play on 'Clauweniers', meaning 'arquebusiers', or the men who carry the arquebus gun. She also holds the goblet of the militia. (In front of her, a man wears a helmet decorated with an oakleaf, the traditional symbol of the arquebusiers.) The contrast of light and dark is further accentuated by Rembrandt's usual variation between minutely studied phrases and broad patches that are filled in with rough brushstrokes. Compare, for example, the detail of the drum on the right and the roughly sketched dog just to the left of it. Rembrandt is mimicking in paint the effects of poor light on sight.

The result of these two innovations – a new naturalism of composition and an astonishingly accomplished control of light and paint – is to imbue the scene with a profound gravity and dignity – indeed, the same gravity and dignity that Rembrandt gave to biblical and Classical scenes. The limited palette unifies everything – it makes everyday life more aesthetic. This is where Rembrandt excels. He takes some rather well-fed part-time soldiers and gives them a sense of purpose and nobility in a work that is both a narrative of its period and a timeless study in the art of portraiture.

The militiamen ... are ranged casually in the space, preparing their weapons, talking ... we have a real sense that [they] are on the verge of action.

Above
This masterpiece by Velázquez, *The Surrender of Breda* (or *The Lances*, 1635), commemorates one of the occasional truces in the Eighty Years' War, at Breda. The parallel, orderly lances of the Spanish on the right are contrasted with the disorder of the Dutch troops on the left. (Diego Velázquez, 1635, oil on canvas, 307 cm × 370 cm / 10 ft 1 in. × 12 ft 1¾ in. Museo Nacional del Prado, Madrid)

Spirit Made Visible

The Ecstasy of Saint Teresa, Gianlorenzo Bernini

MARINA WARNER

' ... one of the most passionate and innocent monuments ever created to convey a state of bliss.

Above
Even Teresa's toes seem to curl up with
excitement and anticipation. The
rough-hewn rocks behind her accentuate
the sculpted smoothness of her skin.

1647–52
Marble
H 150 cm / 4 ft 11 in.
Cornaro Chapel, Santa Maria della Vittoria,
Rome

Saint Teresa of Avila (1515–82), one of the few female Doctors of the Church, was a redoubtable reformer, highly active in public life in spite of her enclosed state as a Carmelite. She combined these organizational abilities with mystical experiences to an unusual degree even among saints. In her remarkable autobiography, she gives many memorable accounts of her visionary experiences – for example, how she would find herself levitating while at prayer and plead with God to spare her such embarrassing moments. But above all, no other saint's account of an encounter with an angel can surpass hers. The celebrated passage opens, 'Beside me…appeared an angel in bodily form, such as I am not in the habit of seeing except very rarely…'. She goes on to guess that he must have been one of 'the cherubim who seem to be all of fire' and then expands to evoke the full experience that Bernini depicts:

> In his hands I saw a great golden spear, and at the iron tip there appeared to be a point of fire. This he plunged into my heart several times so that it penetrated to my entrails. When he pulled it out, I felt that he took them with it, and left me utterly consumed by the great love of God. The pain was so severe that it made me utter several moans. The sweetness caused by this intense pain is so extreme that one cannot possibly wish it to cease… This is not a physical, but a spiritual pain, though the body has some share in it – even a considerable share. (Life, chapter 29)

Readers have always smiled to themselves reading this and nodded inwardly, sometimes even mockingly, as they recognize something here that St Teresa herself appears too guileless to understand. But if she was innocent – ignorant – of what she was saying, does that not make her more of a mystic and a saint? Perhaps that degree of difference from ordinary human circumstances defines the very nature of holiness?

If today, in the post-Freudian era, we have forfeited all innocence and have become too knowing to lose ourselves with Saint Teresa and her angel, this was not the case for Gianlorenzo Bernini, himself a profound believer. Consequently through his art it is possible to experience her rapture again, to intuit the feelings she felt and empathize – almost enviously – with the state she knew.

The angelic encounter is placed centre stage and above eye-level in the Cornaro Chapel of Santa Maria della Vittoria, a Carmelite church in Rome. Bernini had been commissioned to decorate the chapel by the Patriarch of Venice, Cardinal Federigo Cornaro, who had decided he would be buried there. The shallowness of the side chapel did not give the artist much room

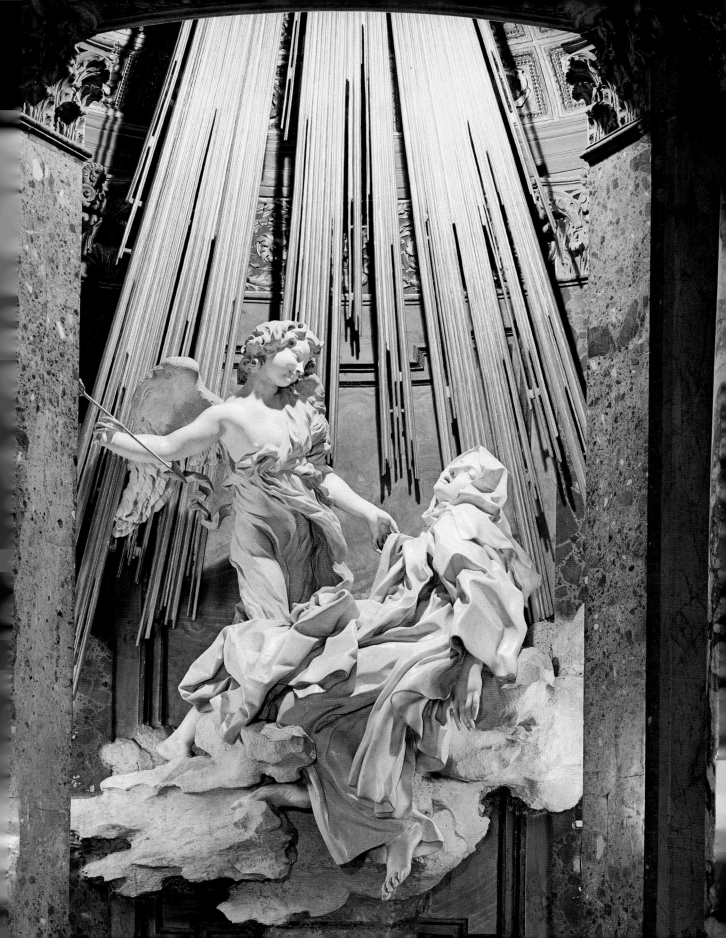

for manoeuvre, a difficulty he overcame through brilliant illusory use of the central alcove and raked perspective on the side walls. Bernini was not usually given to praising his own work, but in this case he thought he had indeed made something beautiful.

Bernini's religious art was informed by the Jesuits' Counter-Reformation programme for a vigorous political aesthetic. He treated the mystical heights of Saint Teresa's experience as a theatrical scene: raised up above the altar, lit from above in a shower of golden rays, the angel inflicts his blissful wound on the woman, whose head is flung back, her lips parted in pain/pleasure. A glorious shower of rays bursts above the two figures to add to the gleam and play of light from concealed windows; all around the sculpture, the marble pilasters, columns and revetments on the walls and plinth of the chapel display biomorphic whorls and striations, stirring connections to flesh. Visual rhymes on metaphors that communicate mystical rapture infuse every element: light, air and the rushing wind that accompany the arrival of spirits; the rhythm of the angel's strokes that find form in the tossing folds of Teresa's habit; the fluttering, crisper rills of the angel's tunic, his sash, his curls and his pinions – each of the feathers individually defined, quivering with vitality. The clouds scud beneath them; it is almost impossible not to imagine that they are both in motion.

Yet the spectacle is not of this world at all, but utterly fantastic, wrought out of heightened imagination. Bernini gives the visitor to the church the taste and feel of an exclusive, privileged vision: nobody else in the scene can see the angel and the saint. The prelates and potentates gathered on the sides of the altarpiece, like cardinals at a conclave, include the patron's father, Doge Giovanni Cornaro, but they are not privy to the vision as we are – they are talking among themselves and some are even turned away from the scene.

The great Bernini scholar Irving Lavin aptly entitled his collected essays on the artist *Visible Spirit*, and it is Bernini's significant achievement that through a virtuoso architectural *mise-en-scène*, his consummately sensitive carving and an impassioned involvement with the subject, he renders the vision entirely persuasive. The sweetly smiling angelic visitor, neither boy nor girl, adult nor child, embodies a synthesis of celestial axioms – the 'corpus sed non caro' (body but not flesh) as Augustine defined angelic beings. The oceanic sensation of rapture also takes material form in the tumble of Teresa's clothes, her responses conveyed by the flux and vortices of her habit, a convent equivalent of a crinoline, under which her legs are bare – her naked left foot dangles off the edge of her couch of clouds, suggesting that the experience she is having reaches to the tips of her toes.

The drapery's movements also stir associations with touch: the fold, as Gilles Deleuze has described in his book of that title, *Le Pli* (1988), implies

Above

Teresa's head is thrown back in ecstasy, while the hand of the angel delicately grasps the edge of her garment.

doubling, with one element moving against another in ripples. The 'pleats of matter', juxtaposed and touching, speak like lips. There are many such lips and openings, dips and hollows in Teresa's clothes, like a multiplication of the entry points or even wounds that the angel's iron-tipped spear is inflicting on her.

Seeing a work of art in its original setting gives a very special and different pleasure, but it is becoming less and less frequent, as threats of damage or theft bring beautiful things under firmer lock and key: the Madonna del Parto, for example, no longer lives in the inconspicuous little shrine at Montaperti where she was painted by Piero della Francesca. But Bernini's great sculpture still occupies the side chapel where he installed it, in an ordinary Roman church, one of countless others like it. Because Bernini was out of favour with the Pope at the time (Innocent X), Cardinal Cornaro was able to command the artist's services, and the commission inspired Bernini to make one of the most passionate and innocent monuments ever created to convey a state of bliss.

Above left
The Cornaro Chapel in Santa Maria della Vittoria. Bernini revelled in the challenge presented by the shallow space, creating a dramatic frame for his sculpture with an imposing broken pediment supported by dark marble columns.

Above right
One of Bernini's early sketches for the figure of Teresa, executed in soft red chalk. Already we can see where Bernini intended the areas of shadow to fall, to add drama to his carving.

Mortal Remains

The Phocion Paintings, Nicolas Poussin

PIERRE ROSENBERG

> *One by one, each detail is crafted and takes on its own meaning. Nothing is left to chance.*

Above
The procession that was held in Athens on 19 March – the day of Phocion's death by drinking hemlock (detail from *Landscape with the Funeral of Phocion*).

1648
Oil on canvas

Landscape with the Funeral of Phocion
116.8 cm × 178.1 cm / 3 ft 10 in. × 5 ft 10 in.
National Museum of Wales, Cardiff (on loan from the Earl of Plymouth, Oakley Park, Shropshire)

Landscape with the Ashes of Phocion
116 cm × 178.5 cm / 3 ft 9½ in. × 5 ft 10¼ in.
Walker Art Gallery, Liverpool

t is impossible to dissociate these two great landscapes by Poussin, one of which depicts the funeral of the Greek general Phocion and the other of which portrays his widow gathering the ashes after his cremation. Poussin was 54 years old when he painted these two images, by which time he was permanently based in Rome and his reputation was formidable. It appears that no previous painter had tackled these subjects, which were inspired by a text from Plutarch's *Parallel Lives* (late 1st century AD). Phocion, victorious Athenian general of the 4th century BC, was known for the austerity of his politics and became unpopular among his fellow citizens. Accused of serious crimes, he was condemned to death and forced to drink hemlock. His enemies ordered that his body should be banished and carried out of the Attic region: this is the subject of the Cardiff painting. Taken to Megara, the body of Phocion was burned and the ashes gathered by his widow and a female servant (as shown in the Walker Art Gallery painting). Phocion's wife took his ashes to Athens in the hope that the Athenians would admit their mistake and restore the general's reputation, which they soon did, recognizing 'that they had put to death him who had upheld justice and honesty in Athens'.

Is it essential to know the subjects in order to admire these paintings? Is it necessary to have read Plutarch? Ought we to question Poussin's interpretation of the Greek text? What were the artist's intentions? What was he trying to say, and how was he able to say it using only his brushes? It must be admitted that Poussin set the bar high for himself.

In the foreground of the first work, two men are carrying a stretcher. A white shroud covers the body of Phocion. The two stretcher-bearers are leaving Athens and have their backs to the city. In the middle ground, a shepherd is watching his sheep. Further away we see an ox cart. A horseman and some passers-by go about their daily business, indifferent to the events in the foreground. On the right, a tall tree grows up beside stone blocks with sharp edges. To the left are an embankment, more trees and two lakes, one of which reflects the tree trunks. In the distance are mountains, under a huge milky blue sky, a morning sky. Some austere buildings, a tomb, a temple and a tower inspired by the architecture of Palladio punctuate the scene. In the distance, in front of the portico of a basilica, a long procession can be seen: Phocion was put to death on 19 March, a day on which Athenians held a procession in honour of Zeus.

The second picture shows the town of Megara. As in the first picture, the road and the passers-by, set at varying distances – on the road of life itself – occupy the central section of the composition. In the background we see a woman playing the flute, a group of archers with their target, and some bathers, one of whom has taken off his shirt and is preparing to dive.

EFFIGIES NICOLAI POVSSINI ANDI
YENSIS PICTORIS. ANNO ÆTAT
ROMÆ ANNO IVBILE
1650.

> ' *... the eternal and idealized qualities of the natural world are seen in opposition to the lowly condition of man and the insignificance of his fleeting existence.*

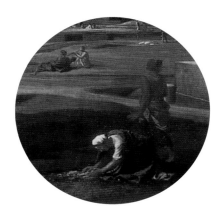

Nature – the trees dotted around the landscape, the large rocks in the centre under a cloudy sky of bright blue – fills most of the canvas. Alone in the foreground, standing out against the shadow of the tall trees, the two women are defying the proclamation and gathering the ashes of the hero, thus ensuring his passage to the afterlife. The servant has turned around for fear of being watched; Phocion's widow is bent humbly over the ashes that she is gathering with her hands.

The two pictures cleverly combine the countryside and the city. Was Poussin simply content to paint landscapes, as many other painters in Rome at the time – Claude Lorrain, Gaspard Dughet, Salvator Rosa, Pietro da Cortona – were? Or was he perhaps trying to depict something more specific, an idealized and sublime version of nature, luxuriant and constantly renewed, a calm and timeless nature, lush with vegetation, amid which the funeral rites of the hero unfold to general indifference? In these two works the eternal and idealized qualities of the natural world are seen in opposition to the lowly condition of man and the insignificance of his fleeting existence.

One by one, each detail is crafted and takes on its own meaning. Nothing is left to chance. There is human ingratitude, the drama of adversity and injustice; there is compassion, faithfulness and piety; there is a meditation on human destiny and a moral message; and there is the great and immutable spectacle of the natural world, which dwarfs all human actions. Above all, there is the ambition of the artist, who transforms what he sees into a meditation on the fragile existence of humanity and our place in nature. Man passes on, nature abides.

When Bernini (1598–1680) came to Paris in 1665 on the express request of Louis XIV, he wished to visit collectors who owned works by Poussin. The greatest architect and sculptor of his century was then at the peak of his powers, and had long been an admirer of the painter's oeuvre. Bernini visited the home of Sérizier, a Lyon silk-maker, who owned both *Phocion* paintings. He gazed at the pictures for a long time, and then, tapping his own forehead, exclaimed: 'Signor Poussin is a painter who works from *here.*' Poussin's work sprang from the thoughts in his head, of course, but even more so from emotion and the immense power of painting.

Opposite
Poussin did not consider himself a portraitist. In 1650, however, he acquiesced to the pleas of his chief patron (Paul Fréart de Chantelou) and executed this superb self-portrait for him (Musée du Louvre, Paris).

Above
The widow of Phocion, the unjustly accused Athenian general, surreptitiously gathers the ashes of her husband, while a servant keeps watch beside her (detail from *Landscape with the Ashes of Phocion*).

Growing Up in Public

Las Meninas, Diego Velázquez

AVIGDOR ARIKHA

> *Velázquez's brushstrokes are lively and swift, and baffle because of their impeccable precision.*

Above
One of her *meninas* offers a goblet of water to the Infanta Margarita.

Opposite
The Infanta Margarita Teresa (1651–73) was depicted here at the age of five years. She was the daughter of Philip IV, King of Spain, and Maria Anna of Austria. By her marriage to Leopold I, she became Holy Roman Empress, but she died at the age of twenty-two.

1656
Oil on canvas
318 cm × 276 cm / 10 ft 5 in. × 9 ft 1in.
Museo Nacional del Prado, Madrid

Velázquez painted *Las Meninas* ('the maids of honour') or *The Family of Philip IV* in 1656, towards the end of his life. Unprecedented in the artist's oeuvre, it is undoubtedly his most haunting masterpiece, hitting our senses like nothing else – and we do not quite grasp why. Though painted as a royal portrait, it is actually a huge genre scene: one wonders what Vermeer – the supreme master of genre painting – would have thought of it, had he seen it.

Arranged like a stage with its actors, the picture's principal role is played by the young *infanta* (princess). The setting is the *cuarto bajo del Príncipe*, the apartment once occupied by the beloved and much missed crown prince Don Baltasar Carlos (who had died in 1646). On the walls we see copies by Juan Bautista Martínez del Mazo (Velázquez's son-in-law) of various works by Rubens, including, on the rear wall, *Pallas and Arachne* and *The Judgment of Midas*. The sitters are (from left to right): Diego Velázquez behind his canvas, painting the scene; the *menina* (lady-in-waiting) Maria-Augustina Sarmiento, handing a goblet of water to the future empress; the five-year-old Infanta Margarita; the *menina* Isabel de Velasco, curtsying; and the dwarfs Maribárbola and Nicolasito Pertusato (and the sleepy dog). Behind them is the ladies' governess Marcela de Ulloa, and an usher; standing in the open doorway is Don José de Nieto Velázquez, 'Aposentador de la Reina' (usher to the queen); and finally, in the mirror, we see the reflections of the king and queen.

One is tricked by the ideas one has of perspective, which in this painting is multipoint. Our sensation of being pulled into the picture, beyond the figures of the *infanta* and her maids, is provoked not so much by the peculiarities of the perspective as by the tension between the two rectangles at the centre: the deflecting figure of José de Nieto in the open doorway, and the reflected half-figures of the king and queen in the mirror. The positive–negative bonds of light on dark (mirror) and dark on light (the open door), reflection (mirror) and deflection (door), interlock, and as if by a magnetic force draw our eyes. The picture was painted quite rapidly, with some subsequent modifications: Velázquez's right hand, Maria-Augustina's profile, and the position of Marcela de Ulloa (whose original placing, behind the usher, was an affront to etiquette).

Although Velázquez must have studied conventional perspective with Pacheco, and presumably read the essential treatises on the subject, such as those by Vitelo, Alberti and Daniele Barbaro (all of which were in his library), he did largely without it in his paintings, as is obvious in *The Surrender of Breda* (1635, Prado, Madrid). However, he is not the only painter of the 17th century to have replaced the perspective pyramid with a bifocal or multifocal perspective, which transforms depth into rhythm, bringing all perspective

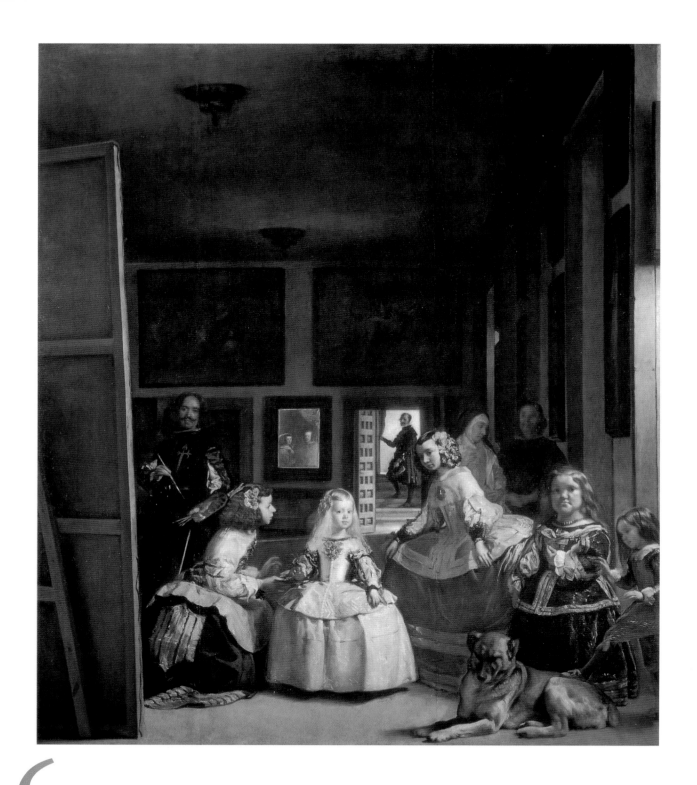

> *… painted as a royal portrait, it is actually a huge genre scene: one wonders what Vermeer … would have thought of it …*

Velázquez's use of colour is based on his perception of the differences between cool and warm colours, and the possibility of modifying hues by contrast.

Above
The *menina* in profile, wearing the butterfly hair decoration, is Doña Maria-Augustina Sarmiento, the daughter of Don Diego Sarmiento de Sotomayor (a member of the Spanish War Council).

lines back to the flat plane. The understanding of the flat plane, the *piano*, was not a discovery of Modernism.

Looking closely at his canvases, I think we can see that Velázquez painted directly, without drawing first, without 'calculating'; it seems clear that he started directly with the brush, sketching with a burnt umber, going from dark to light often *alla prima* ('wet-on-wet'), and when possible finishing in one session – as is the case with the *Portrait of Francesco II d'Este, Duke of Modena* (1638, Galleria Estense, Modena) or the *Portrait of a Man* (presumably of José de Nieto, *c.* 1649, Apsley House, London). In most cases, of course, he could not finish a painting in one session, but often, even in *Las Meninas*, completed most of the figures *alla prima*, and later retouched here and there (as in the shadow under the dress of the *infanta* and her right arm).

Velázquez's use of colour is based on his perception of the differences between cool and warm colours, and the possibility of modifying hues by contrast. He rarely used primary colours, and instead of using a brilliant red, he preferred to create an optical illusion of it. A good example is the red ribbon in the dress of the Infanta Margarita in *Las Meninas*. The pigment used by Velázquez is not vermilion, as one may think, but red ochre. The redness we perceive derives only from the contrast: the cool grey surrounding it and the point of yellow in it enhance the redness, and so transform red ochre into something redder than it is. On the other hand, vermilion was used, mixed with white, in the Infanta's face to produce the cool light pink of the cheeks. The masterly chromatic modulation seen in Velázquez's mature and late paintings is, as in musical modulation, based on juxtapositions and reversals.

His pictorial idiom, essentially concerned with expressing the visible by means of the brush, is in fact anti-illusionistic insofar as the painting is reduced to a limited pictorial language of brushstrokes. This language is not unusual; Guercino and Rembrandt used it in the 17th century, as had Titian in the 16th. In fact, spontaneity in painting is as old as painting itself. Velázquez's brushstrokes are lively and swift, and baffle because of their impeccable precision. They bring to mind the 'artless art' described in Eugen Herrigel's *Zen in the Art of Archery*. Velázquez let himself be carried along by his inner voice, which he may have perceived as his source of truth. The wonder is that a king could have perceived its greatness.

Few others had a chance to do so. Only a handful of artists and connoisseurs who had access to the Spanish royal court and to the king's quarters could see *Las Meninas*. Luca Giordano, who saw it there upon his arrival at the court in 1692, said to Charles II: 'This is the theology of painting.' He became more and more infatuated with Velázquez, even if other painters did not share his enthusiasm. The general public, however, had no access to the royal collections, and so Velázquez remained private until the opening of the Prado Museum in 1819. Since then, and particularly in the 19th century, Velázquez's work has grown in stature, and has had an enormous impact – most notably on Manet, for whom Velázquez was 'le peintre des peintres'.

The Domestic Goddess

The Art of Painting, Johannes Vermeer

ARTHUR K. WHEELOCK JR.

'*Vermeer's title indicates that he intended the picture to convey an abstract idea about the nature of painting.*

Opposite
The crisp brushstrokes describing the pleats
on the back of the painter's jacket stand in
stark contrast to the wall and map, which
appear softened by the sunlight.

c. 1666–67
Oil on canvas
120 cm × 100 cm / 3 ft 11 in. × 3 ft 3 in.
Kunsthistorisches Museum, Vienna

The Art of Painting **holds a special place** within Johannes Vermeer's oeuvre. While it displays all the captivating characteristics of his artistic genius – a carefully observed 17th-century Dutch interior illuminated by softly diffused light, exquisitely painted details, and a frozen moment imbued with psychological depth – it stands apart in its imposing scale and pronounced allegorical character. The painting must have had special meaning for the artist: he kept it in his possession from the late 1660s, when he painted it, until his death in 1675. And though he left his family in dire financial straits, Vermeer's widow still refused to sell it. Instead, identifying the work as 'The Art of Painting' (*De Schilderkunst*), she transferred ownership to her mother to keep it out of the hands of creditors.

Unlike the descriptive titles usually given to 17th-century paintings, Vermeer's title indicates that he intended the picture to convey an abstract idea about the nature of painting. His concerns belonged to a long tradition in which artists and theorists had sought to define the fundamental characteristics of painting, and the significance they held for human understanding. Vermeer's interpretation of these intellectual ideas was innovative. He presented his allegory in the guise of an everyday scene, an artist painting a model dressed as Clio, the muse of history. Clio's crown of laurel denotes honour, glory and eternal life; her trumpet stands for fame, and the thick folio she clasps, perhaps a volume of Thucydides, symbolizes history. Vermeer would have learned of these attributes from Cesare Ripa's 16th-century emblem book, *Iconologia*. The mask on the table in front of Clio was an established symbol of imitation and the attribute that Ripa gave to his personification of Painting.

By placing the muse of history at the centre of his allegory, Vermeer stressed the importance of history to the visual arts. 17th-century theorists argued that the noblest and most highly regarded form of artistic expression was history painting, a term that encompassed biblical, mythological and historical subjects, as well as allegories. By creating such paintings, artists demonstrated their knowledge and originality of thought, qualities that raised painting to the elevated status of a liberal art. Indeed, in Vermeer's painting the artist is not so much the recipient of the muse's inspiration as the agent through whom she takes on life and significance.

The large map of the Netherlands hanging on the back wall also connotes history. The map was made by Claes Jansz. Visscher, whose Latinized name, Nicolaum Piscatorem, Vermeer inscribed along the map's upper right edge. While faithfully recording the map's features, Vermeer also represented its patina, including the folds and creases that had formed over time. Interestingly, the map, which Visscher executed in 1638, and which depicts

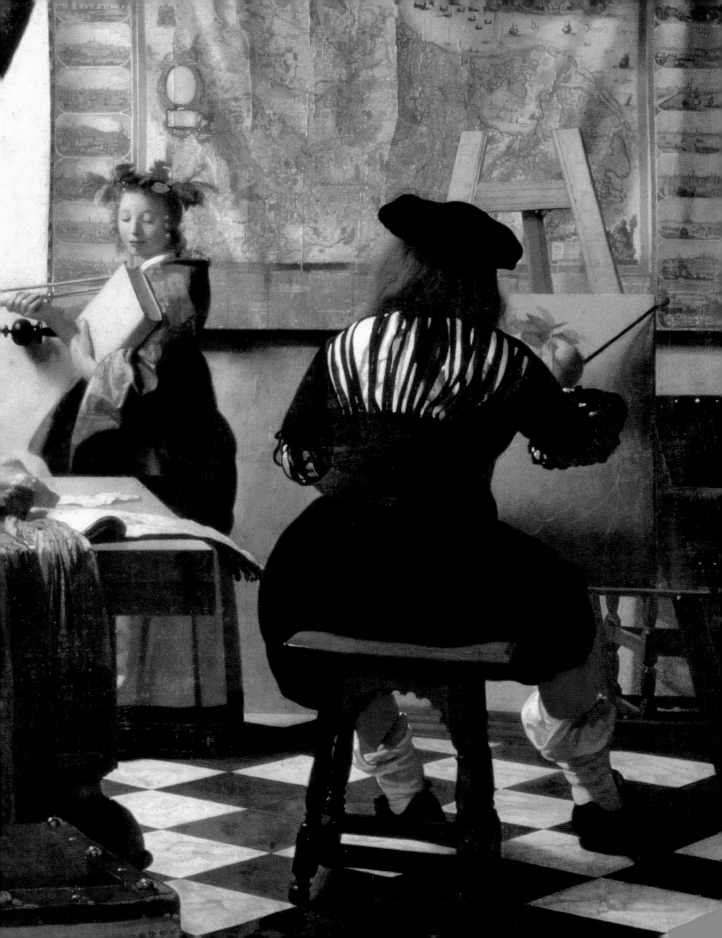

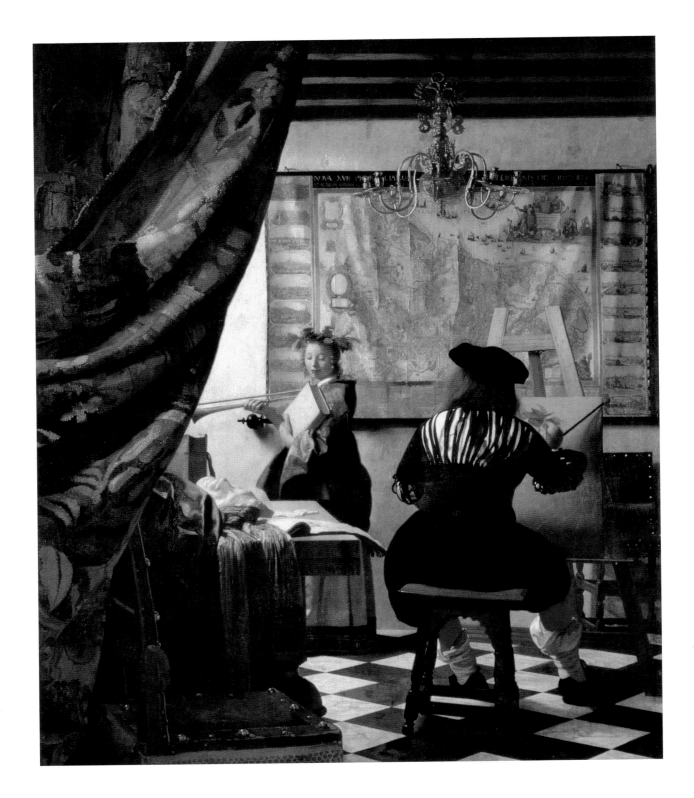

Above
The curtain pulled away to the left reminds us
that we are the observers of a scene that feels
as personal as it does allegorical or historical.

The notion that a painting should deceive the eye with its illusionism dates back to antiquity and the competition between the artists Parrhasius and Zeuxis ...

the seventeen provinces flanked by their major cities, was outdated by the time Vermeer executed this painting. Reclamation of lands from the sea had changed the physical character of the Netherlands, and political changes had occurred after 1648 following the signing of the Treaty of Münster. At that time the territory was divided into two distinct entities, the Dutch Republic in the north, and the southern provinces remaining under Spanish control. The intricate brass chandelier, decorated with an image of a double-headed eagle, the imperial symbol of the Habsburgs, also alludes to the Netherlands' recent past.

In his painting Vermeer carefully integrated the symbolic associations of fame, history and the Dutch Republic. He positioned Clio so that she holds her trumpet, symbol of fame, directly beneath a view of The Hague, seat of the Dutch government. The artist, wearing an elegant doublet decorated with slits across its back and arms, is seen from the back, his anonymity asserting the universality of the allegory. He is not dressed like an ordinary craftsman, but as an elegant gentleman, one with an awareness of the abstract ideals of art and history. Significantly, he has begun his painting by depicting Clio's laurel wreath, symbol of honour and glory.

Vermeer enhanced the realism of his scene through his sophisticated knowledge of linear perspective, which he used to create a logical and convincing sense of space. Equally important was his masterful observation of light, as in the sunlight reflecting off the brass chandelier's polished surface – an effect he achieved with sure brushstrokes ranging from thick impastos of lead-tin yellow in the highlights to darker and thinner strokes of ochre in the shadows. Perhaps with an optical awareness stimulated by the camera obscura, Vermeer occasionally altered his painting techniques to create different pictorial effects. He softly modelled his paint, for example, to create the diffused appearance of the cloth hanging over the edge of the table, while he used broad, crisp strokes to render the bold image of the artist at his easel.

The apparent realism of this allegory is a quality fundamental to Vermeer's concept of the art of painting. The notion that a painting should deceive the eye with its illusionism dates back to antiquity and the competition between the artists Parrhasius and Zeuxis that Pliny described in his *Natural History*. Parrhasius won when he painted a curtain so skilfully that Zeuxis tried to lift it to see the image beneath. We are reminded of this story by the large tapestry in Vermeer's painting, which seems to have been drawn aside to reveal the allegorical scene. Nevertheless, unlike Parrhasius' illusionism, the thematic culmination of Vermeer's work exists not on the painting's surface, but behind the curtain where the full meaning of the allegory unfolds.

Suspended Animation

The Jar of Olives, Jean-Baptiste-Siméon Chardin

PIERRE ROSENBERG

'*What Chardin was seeking ... through keen and constant observation of what lay before his eyes ... was contemplation and silence, absorption and emotion.*

Above
According to a common practice dear to the artist, Chardin leaves the handle of a knife overhanging the edge of the table.

Opposite
The open space between objects on the right evokes a sensation of airiness, and gives prominence to the jar of olives.

1760
Oil on canvas
71 cm x 98 cm / 2 ft 4 in. x 3 ft 2½ in.
Musée du Louvre, Paris

Placed on a stone table that forms a horizontal bar across the composition, a varied collection of fruits, glasses and other objects stands out against a wall (or is it?) of indeterminate colour – somewhere between grey, bistre and brown. Beginning at the left-hand side, we see a pâté on a wooden board and, beneath it, the blade of a knife with a wooden or metal handle. Next is a *bigarade*, a type of bitter orange used in 18th-century pâtisserie; two glasses apparently made of potash glass and partially filled with red wine; a porcelain plate holding three pears and an apple. In front of the plate is a crab apple, two macaroons, a biscuit, and the large glass jar of brine, half full of green olives, which gives its name to the painting. Finally, on the right-hand side, is a decorative lidded bowl in Meissen porcelain. The artist's signature and the date of the painting can be read on the edge of the tabletop, which has joins in two places and is broken only by the green stalk of the orange.

Why this disparate grouping? Is there some significance to be sought in it? Drinking, eating, sight, touch, even smell: are these an allusion to the five senses that so many 17th-century painters across Europe depicted? This would be a misreading of Chardin's ambitions: he shunned the anecdotal, the painterly, anything of a narrative nature, anything that could lend itself to interpretation or to storytelling. It is true that the picture has a festive look – some of the items are luxuries, and the fruits, the wine and the pâté look appetizing – but Chardin's intentions are of an entirely different nature.

In 1760 Chardin was over 60. He no longer had anything to prove. He began his career by painting still lifes of fruit and poultry, which he composed and executed with great skill. He used colour contrasts, alternating cool and warm tones, shunning straight lines and seeking simplicity. These filled the entire surface of the composition. Then, from around 1735, he turned to genre scenes, small-scale compositions that were calm and dreamlike, warm and modest. He depicted the world of children and adolescents with great delicacy. His return to still-life painting marked a step forward. From this point, his still lifes could breathe, they fade into space; air circulates between the objects, bringing together the harmony of colours, and connecting the reflections, repetitions and references. Of course, as in the past, the painstaking nature of Chardin's work remains hidden. Everything seems obvious and straightforward, but his virtuosity is no longer in question – proof of the

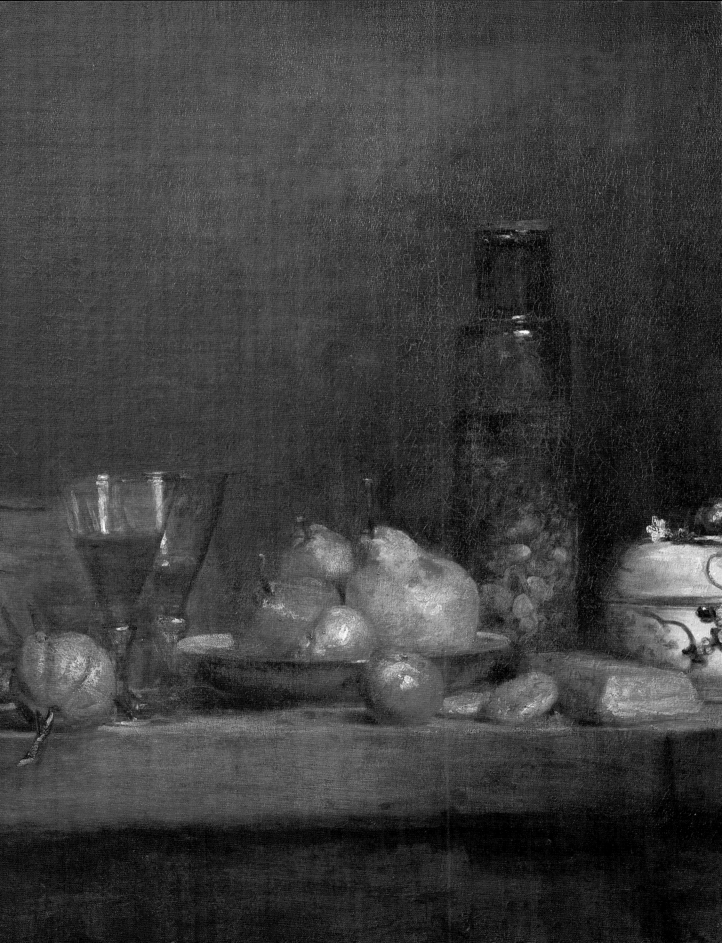

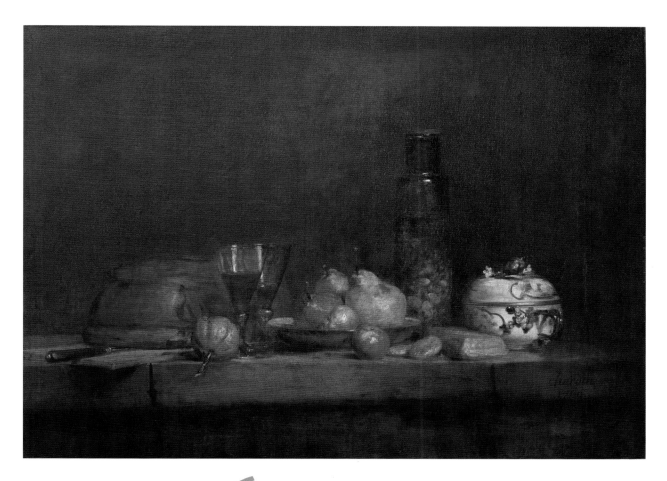

> *[Chardin's] still lifes ... breathe, they fade into space; air circulates between the objects, bringing together the harmony of colours ...*

artist's attention to the smallest details can be found in the pentimenti (which can be seen with the naked eye on the olive jar), the leaves of the orange and the plate of pears. What Chardin was seeking instead, through keen and constant observation of what lay before his eyes, and through the power and concentration of his gaze, was contemplation and silence, absorption and emotion. He allows us to escape from the everyday world and forget.

Denis Diderot (1713–84) made *The Jar of Olives*, exhibited at the Salon of 1763, the subject of one of the finest and most famous pages in the history of art criticism. Like his successors, though at a loss to describe this apparently incomprehensible 'magic' that defies words, Diderot did understand that Chardin not only painted what he could see, but also that which could not be seen.

Utamaro's Pillow Book

'Lovers' from *Erotic Book: The Poem of the Pillow (Ehon Utamakura)*, Utamaro

JULIE NELSON DAVIS

' *... her hand gently strokes his chin, his hand grasps her shoulder, their eyes are locked in a gaze.*

Opposite
Utamaro, like other *ukiyo-e* artists, made designs for books, including poetry albums, popular volumes and erotica. His total output numbers some thirty paintings and about 2,000 designs for printed formats. He made twelve designs for the album *Ehon Utamakura*.

1788
Woodblock print on paper
25.5 cm × 36.9 cm / 10 in. × 1 ft 2½ in.
Various collections

The lovers embrace on the second-floor verandah – her hand gently strokes his chin, his hand grasps her shoulder, their eyes are locked in a gaze. The artist, Kitagawa Utamaro, has rendered the intimacy of this moment so completely that it has become one of the signature examples of late 18th-century Japanese art.

Utamaro (1753?–1806) is well known today, as he was in his own day, for his pictures of beautiful women, including professional courtesans from the licensed pleasure districts, teahouse waitresses, shopgirls, servants, merchants' wives, mothers and daughters, among many others. These images participated in a contemporary dialogue on female occupations, accomplishments, activities and the appraisal of feminine beauty and behaviour. Like all artists in the genre known as *ukiyo-e* – meaning 'the pictures of the floating world' – Utamaro was trained as a painter. But for him, as for many others, his primary occupation was designing woodblock prints that depicted the leisures and pleasures of urban life, as it might be experienced in the city of Edo (modern-day Tokyo).

As such, Utamaro was employed on commission by publishers, who then hired the block carvers and printers to transform the artist's sketch into its printed form. A picture such as 'Lovers' demonstrates the extremely high skill of each of these craftsmen, in a process whereby each colour was printed with a separately carved block onto the sheet of paper. The block carvers' mastery is particularly well displayed in his transferral from sketch to woodblock of the wide range of marks the artist has used – from the delicate lines of the hair to the attenuated contour lines of the faces to the calligraphic lines describing the folds and play of the textiles. The same skill is also evident in the separation of the different colours into individual blocks that together would create the final image. The printers' skill is equally remarkable, particularly in their treatment of various visual effects – the play of saturated colours against the white of the paper, suggesting fabric against skin; the translucent gauze fabric draping over the leg, the deepening colour suggesting increasing opacity; and patterns replicated without fault. Clearly for this work the commissioning publisher spared no expense in hiring the finest artisans to replicate the artist's design.

This image is the first page in an album of erotic images, titled *Ehon Utamakura* or *Erotic Book: The Poem of the Pillow*, dated to 1788. Like many such works produced at this time, it is unsigned. Restrictions on 'floating world' publishing promulgated by the shogunal regime prohibited 'licentious' materials, and although these were not being actively enforced at the time this image was made, it must have seemed prudent not to include the artist's or publisher's information. Rather – and in a manner consistent with mores for sophistication at the time – the name of the artist and publisher are alluded to

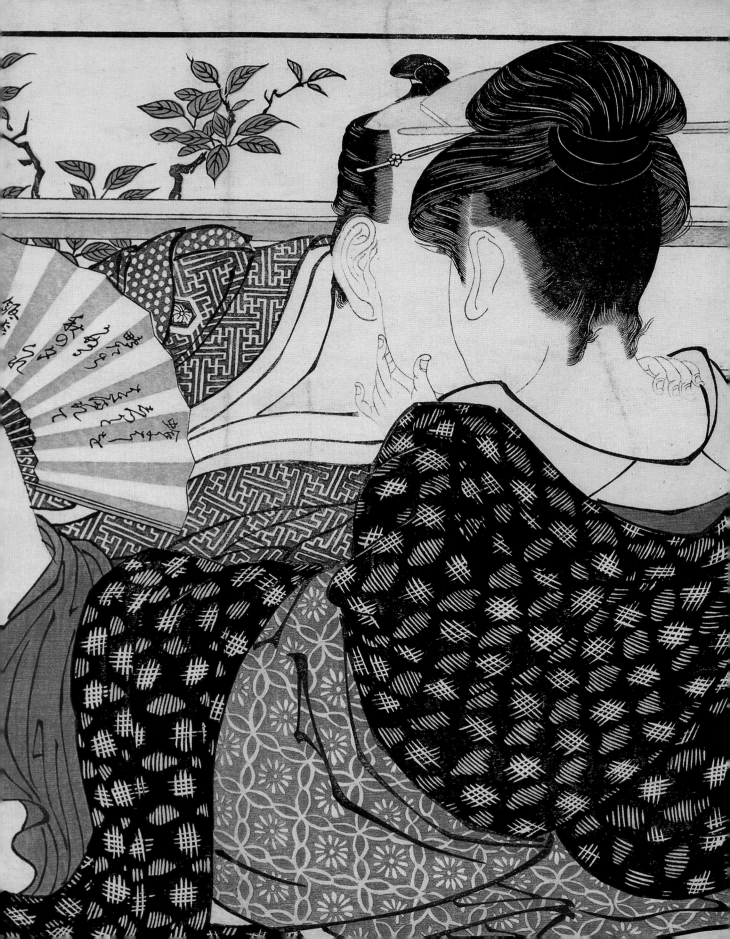

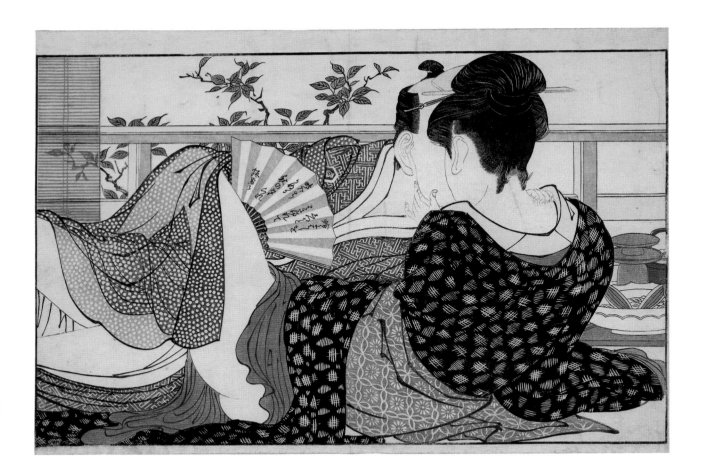

in the book itself. In this image, the crest on the man's robe resembles that of Tsutaya Jūzaburō, the publisher with whom Utamaro was most closely associated at this time; Tsutaya was well known for producing some of the finest printed works in *ukiyo-e*. Utamaro's identity is alluded to in the preface to the album, where the book's title is said to be like that of the artist: 'even coming close to the name of the painter, I call it Ehon Utamakura'. *Utamakura* (Poem of the Pillow) is just a short step away from Utamaro. In any case, stylistically, there is no doubt that this work was done by Utamaro.

Looking from right to left across the image (as is the custom in East Asian art), the viewer's attention is drawn first to consider the lovers' rapt engagement with one another, the man's eye just visible to the left of the woman's hair. Our attention proceeds across the bodies, pausing to note the inscribed fan, then considering the intimacy of the postures. The poem on the fan suggests the nature of this encounter:

> In the clamshell
> Its beak caught fast
> The snipe
> Cannot fly away
> Into the autumn dusk.

> *[The publisher's] strategy for distinguishing Utamaro in that competitive field relied upon presenting him as a kind of connoisseur of women: not just as a close observer, but also as a kind of expert in matters even more intimate.*

Unlike the album itself, this is signed by the poet Yadoya no Meshimori (1753–1830), a member of the publisher's literary circle. It not only alludes to the sexual engagement between the lovers, but also to well-known classical poems on the 'autumn dusk' dating to the late 12th and 13th centuries.

By this stage of his career, Utamaro was being actively supported through commissions by Tsutaya, their most significant productions being in the form of poetry albums and erotica. In the 1790s, Utamaro emerged as the leader in the genre of 'images of beauties' (*bijinga*), in large part through the continued sponsorship of the publisher. Their strategy for distinguishing Utamaro in that competitive field relied upon presenting him as a kind of connoisseur of women: not just as a close observer, but also as a kind of expert in matters even more intimate. Thus the preface to this album proclaims that, for Utamaro, using the brush was like 'using the hips', for one with 'skill in the art of love...moves the hearts of everyone'. Given that this representation of the artist appears in the preface to an album of erotica, this statement clearly served as a rhetorical device in service to the themes of the book. Whether or not Utamaro was indeed such a man cannot be verified by his biography, but it certainly worked wonders for his career.

Right
Two of Utamaro's portraits (39 cm × 26 cm / 15½ in. × 10¼ in.) from *A Collection of Reigning Beauties*, published by Wakasaya Yoichi *c.* 1794: (left) Takigawa of the Ōgiya and (right) Komurasaki of the Tamaya.

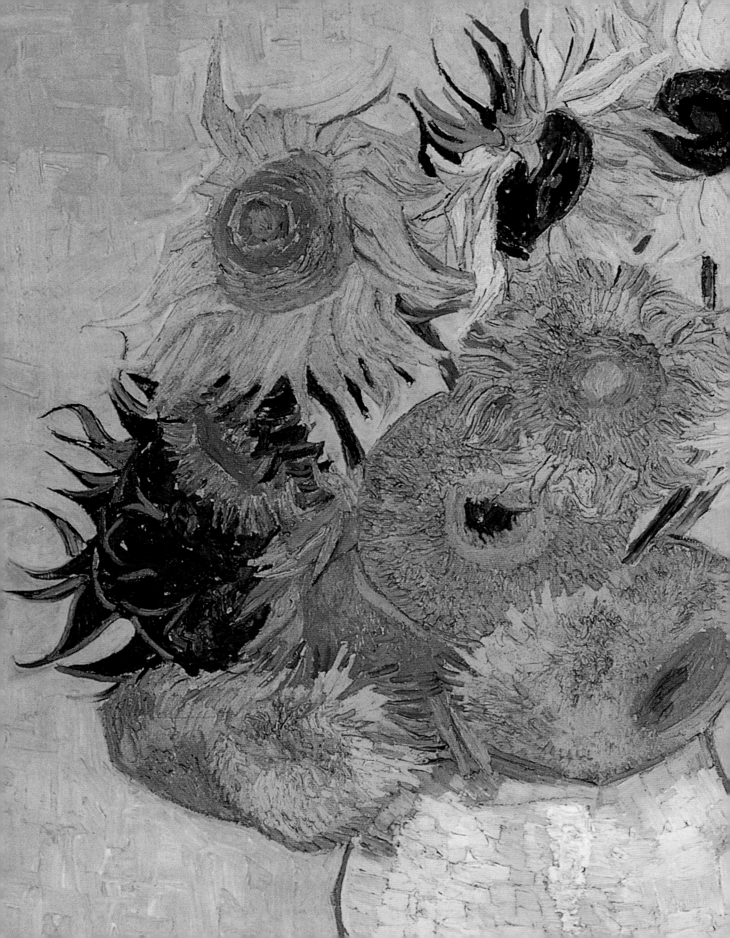

7

Towards the Modern World

AFTER 1800

A Revolution in Paint

The Third of May, 1808, Francisco de Goya
MANUELA MENA MARQUÉS

‘ ... *an image of such universal significance that it has become ... the defining symbol of the atrocities of war and the horror of its victims.*

Above and opposite
Goya's groundbreaking work exposes the true horrors of war by combining realism with a radically new approach to painting.

1814
Oil on canvas
266 cm × 345 cm / 8 ft 9 in. × 11 ft 4 in.
Museo Nacional del Prado, Madrid

n *The Third of May, 1808* Goya presented, for the first time in the history of art, the real, perverse nature of war, stripped of all heroism and honour. In so doing, he created an image of such universal significance that it has become – perhaps even more so than Picasso's *Guernica* – the defining symbol of the atrocities of war and the horror of its victims. *The Third of May, 1808* is actually the right-hand panel of a diptych, the other panel of which (*The Second of May, 1808*, also known as *The Charge of the Mamelukes*) shows the events of the previous day. The very modern war presented here by Goya is reinforced with a new technique, one that turns its back on the grandiose, epic, heroic and classical representations popular with Napoleon. If we look closely at *The Third of May, 1808*, with its beguiling yet realistic corpses in the foreground, we notice an unusual ferocity in the brushmarks, an expressive abstraction of forms, at once impetuous and streamlined, and a selective, symbolic use of colour: white, yellow, grey, ochre, black and red (always distinct from the blood) stand out in the foreground, at once attractive and repulsive in their affirmation of the violence.

These paintings were begun in 1814, after Goya was asked by the Supreme Council (who had coordinated resistance against the French since 1808) to immortalize the heroic deeds of the people of Madrid when they rebelled and attacked the French troops – who until 2 May 1808, had been the allies of Spain. The people's revolt, provoked by the sight of the last *infantes* of the House of Bourbon being taken from the palace, resulted in the death of many French soldiers, and Marshal Murat, the French leader, managed to contain the situation only through savage suppression and relentless executions that started in the early afternoon and continued through the night and well into the morning of 3 May.

By 1814 the events of 2 May 1808 had crystallized in the collective memory into four 'scenes' that were repeated in prints and in the theatre: the detention at the palace of the carriages carrying the *infantes*; the charge of the Mamelukes in the Puerta del Sol; the defence of the barracks of Monteleón; and the executions by firing squad in the Paseo del Prado. Goya's focus on just two of these episodes suggests that he was not especially interested in presenting an official, commemorative and nationalistic version of events. In *The Second of May, 1808* only the horses look at the spectator, their expressions of terror reflecting the madness of the men. *The Third of May, 1808*, meanwhile, does not simply pit the heroism or self-sacrifice of 'innocent' Spanish victims against the cruelty of the 'merciless' French oppressors but rather places both sides in the moral balance. 'If you kill with iron you will die by iron,' exclaimed Murat to a priest who begged for mercy; the gestures of fear, desperation, anguish and remorse tell us that it is those facing execution who are repentant of their deeds – and it is they whom Goya chose to depict

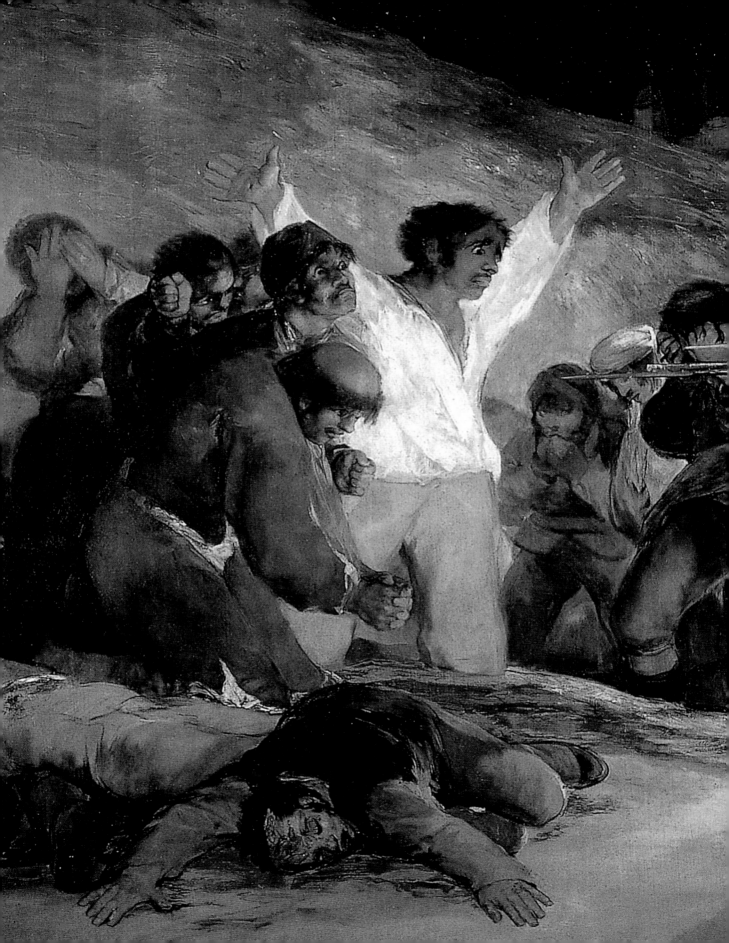

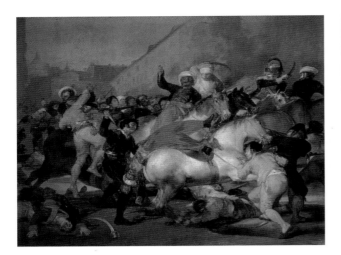 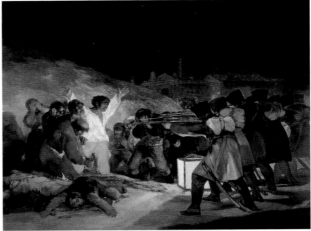

with his extraordinary psychological realism. The scene is clear, simple and inexorable. To the right stands the perfectly ordered firing squad, rifles aimed and shiny bayonets fixed. The soldiers, marines of the Imperial Guard, are dressed in field uniform, protected from the cold morning air by thick coats. They fire at the jumbled up, shirt-clad country people. The scene is illuminated by the soldiers' lamp, the light dispersing into the humid air of the night with scientific perfection. The figures that arrive to face the firing squad see the bodies of the dead; one of them has his head blown off after being shot at close range, while the others are covered in their own blood. Other figures emerge from the gates of their city, the city whose ancient walls have failed to protect its citizens.

The Second of May, 1808 and *The Third of May, 1808* were both painted in the months following the entrance of Ferdinand VII into Madrid in May 1814. Goya had just finished the *Disasters of War* etchings, which showed with neutral and righteous harshness the confrontations between the Spanish population and the French army. His modern, almost photographic, compositions share none of the optimism of the final victory. They were certainly not suitable for hanging in the palace, where Ferdinand was busy abolishing the liberal constitution of 1812. The two paintings share the etchings' madness, inhumanity, terror and desolation. Goya's expression of the reality of war, his pessimistic view of the human condition, is here expressed in terms of tragedy, devoid of the intellectual (and very 18th-century) irony of his earlier *The Sleep of Reason Produces Monsters*.

The initial impact of these masterworks, if they were ever shown to the public, is not known. There is no reference to them in contemporary writings, and only one sentence, in the liberal newspaper *El Conservador* (from 13 April 1820), indicates any knowledge of them. The Museo del Prado showed a similar lack of interest: in 1834 the two paintings were valued at 8,000 reales, compared with 80,000 reales for a painting of Charles IV's family. In 1840 the traveller Théophile Gautier saw them hanging in the museum and mentioned them in his *Voyage en Espagne* (1843) as 'Massacre of the 2nd May, invasion scene'; he expands on this in the 1858 edition of his book, describing the remarkable technique used by Goya: 'he executes, with a spoon instead of brushes, a scene of 2 May, where you see some French shooting some Spanish.

Above
The canvases of the diptych give two different, but equally horrifying, accounts of death in war. The frenzied action of battle in *The Second of May, 1808*, epitomized perfectly by the terrified eyes of the horses, leads inexorably to the execution scene, in which death is stripped of both reason and glory. (Left: *The Second of May, 1808*, known as *The Charge of the Mamelukes*, 1814, oil on canvas, 266 cm × 345 cm / 8 ft 9 in. × 11 ft 4 in. Museo del Prado, Madrid. Right: *The Third of May, 1808*)

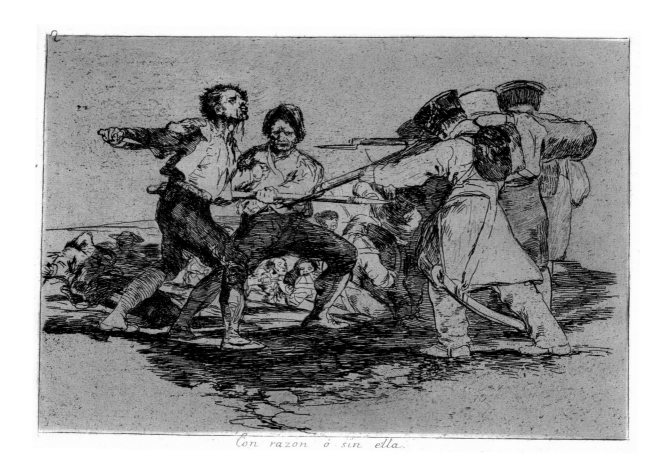

Con razon ó sin ella.

'*… madness, inhumanity, terror and desolation. Goya's conception of the reality of war, his pessimistic view of the human condition, is here expressed in terms of tragedy …*'

Above

In this engraving, related to *The Third of May, 1808*, the French soldiers are faceless, anonymous, as they aim their rifles. Goya's mastery of line, combined with his ability to tell a story in a few strokes, earned him the admiration of later artists such as Édouard Manet. ('Con razón o sin ella' / 'Rightly or wrongly', from the series *The Disasters of War*, 1810–12, engraving. Museo del Grabado de Goya, Fuendetodos, near Zaragoza)

It is a work of incredible verve and fury. This curious painting is relegated, without honour, to the antichambers of the museum.' The historian Charles Yriarte, in his 1867 monograph on Goya (which features the first reproduction of the painting, a poor quality woodcut), turns Gautier's spoon into a knife, in the process compounding one of the greatest obstacles to our understanding of the real Goya: 'the artist executes [*The Third of May, 1808*] with the help of only a palette knife'. Neither Gautier nor Yriarte was able to see the mutation that Goya had achieved with his modern use of the classical brush. The best description is that of Édouard Manet, who unconditionally appreciated the painting. In his visit to the Prado in 1865 he was dazzled by Goya's 'technical imagination', his composition and his political message; all of this Manet then translated into his 1867 *Execution of the Emperor Maximilian* (Kunsthalle, Mannheim).

Into the Void

The Wanderer above the Sea of Mist, Caspar David Friedrich

WERNER BUSCH

> " *... the image seems literally boundless, and so can be viewed as a representation of 'the sublime'. The painting remains a vision of a subject that cannot really be objectified.*

c. 1818
Oil on canvas
94.8 cm × 74.8 cm / 3 ft 1½ in. × 2 ft 5½ in.
Kunsthalle, Hamburg

It is often difficult to achieve consensus on whether or not a work of art is a masterpiece. What can be said with more certainty, however, is whether a work has achieved iconic status, since this is decided by the public. Caspar David Friedrich's *The Wanderer above the Sea of Mist* is a work that has grown into an icon, and remains recognizable even in the most unusual of contexts. The Wanderer can appear on the cover of the news magazine *Der Spiegel,* gazing out over the horrors of German history; or can feature on a box of teabags, embodying the longing for a nice cup of tea; or can even be shown wearing Levi's jeans. So what is it about the work itself that makes it so iconic? In the case of the *Mona Lisa,* it is its androgynous quality, which was underlined by Marcel Duchamp. In Friedrich's *Wanderer,* it is, perhaps, the intangible sense of pathos. The man, seen from behind and positioned on the vertical central axis of the painting, is very upright and seemingly proud and self-possessed as he stands on a rocky hilltop and looks out onto a sea of dissolving mist, through which other rocky peaks can be seen rising in the distance. Through the cloudy fog, the spatial relationships between these peaks is impossible to judge, so from the point of view of the Wanderer and for us, they appear to be stacked not only behind each other, but on top of one another too. In this way, the image seems literally boundless, and so can be viewed as a representation of 'the sublime'. The painting remains a vision of a subject that cannot really be objectified.

While the image of the landscape is far from concrete, the abstract aspects of the picture's construction can be clearly identified. Not only does the Wanderer stand on the central axis of the painting, but the horizontal and vertical axes intersect at the figure's navel. This recalls the 'Vitruvian Man' from Cesarino's 1521 edition of *De architectura,* whose navel marks the centre of the world in an abstract universe, and which turns man, made in God's image, into the measure of all things. In Friedrich's painting, the geometric ordering of orderless phenomena is also absolute, and the connection of the figure to the landscape must surely be intended to abolish any idea of alienation between mankind and nature. In countless pictures, Friedrich makes use of the Golden Section, the aesthetically pleasing division of space expounded in Luca Pacioli's *Divina proportione* of 1509. Here, the two vertical lines of the Golden Section frame the figure, passing through his foot on the left and the tip of his cane on the right. The upper horizontal of the Golden Section serves a double function: it cuts through the collar of the figure (the head rising above it), and on the right-hand edge of the picture it almost exactly marks the top of one of the two mountain ridges, which slope softly down on both sides to meet at the Wanderer's heart. This geometric precision is only revealed by taking exact measurements; so the fact that on one hand the painting is made up of disparate elements, and yet on the other

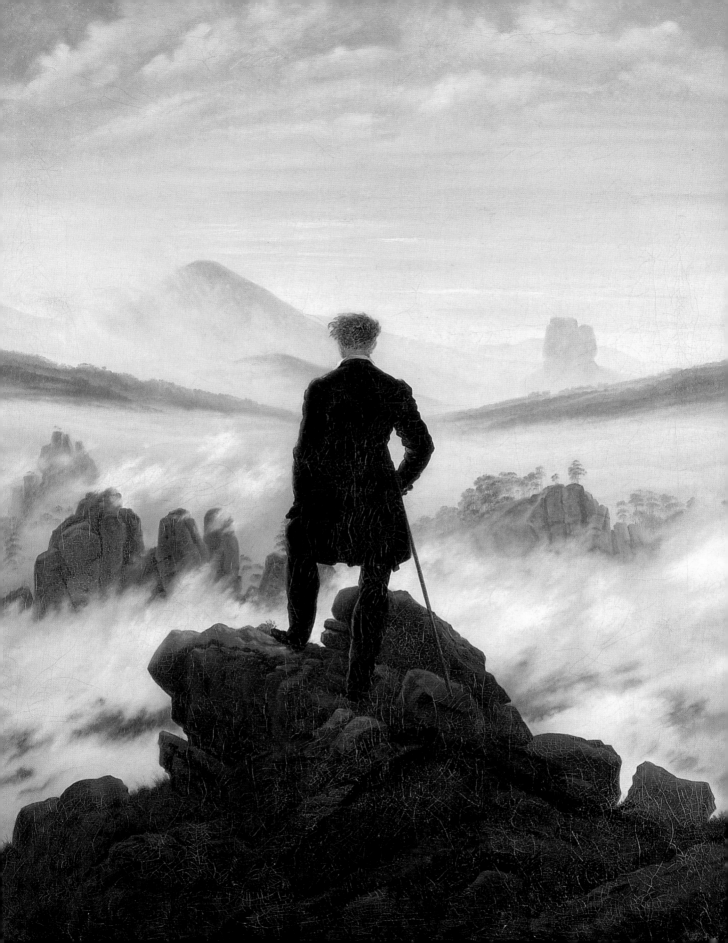

has evidently been carefully constructed is something that every viewer experiences when faced with a Friedrich painting, and even more so if it is based around a central axis.

What does this signify? How should the abstract pictorial composition, with its aesthetic power, be understood in relation to the apparently unconnected landscape elements? Friedrich's studies for the work can be given firm times and places, since he always noted the date and location on each sketch. In this case, every detail of the rocky hilltop on which the Wanderer is standing can be traced back to a drawing of 3 June 1813. On the left-hand edge of this drawing, Friedrich drew a long line, marked with short horizontal strokes at the top and bottom, and wrote next to it: 'The horizon is this far above the highest point of the rocks.' If this information from the sketch is applied to the proportions of the painting, the Wanderer's gaze is fixed precisely on the horizon. This rocky outcrop and the other mountain peaks are demonstrably taken from different parts of Saxon Switzerland: the Kaiserkrone, Gamrich near Rathen, the view of Wolfsberg from Krippen. The oddly flattened rock formation in the distance on the right is an image of the Zirkelstein, its height also exactly matching the top of the Wanderer's head.

As techniques of abstract construction and the montage-like assembly of the image from natural elements are recognized to be fundamental principles of Friedrich's paintings, so the way that they are used must be reconsidered for every single picture. One early source suggests that the figure could be Colonel Friedrich Gotthard von Brincken, who fought in the Saxon Infantry in the wars of liberation against Napoleon, and who was killed in around 1813 or 1814. Friedrich was a resolute supporter of the wars: he witnessed the

Opposite top

Caspar David Friedrich, *Self-Portrait in Profile*, *c*. 1802, indian ink, 13.1 cm × 9.2 cm / 5¼ in. × 3½ in. Kunsthalle, Hamburg.

Opposite below

The contours of the rocky outcrops captured in this drawing are minutely repeated in the mist-shrouded mountains of *The Wanderer*. (*Rocky Hilltop*, 3 June 1813, pencil, 11.1 cm × 18.5 cm / 4¼ in. × 7¼ in. Kupferstich-Kabinett der Staatlichen Kunstsammlungen, Dresden)

Above right

In one of two portraits by the German artist Georg Friedrich Kersting, Friedrich is shown wholly absorbed in the painting of a mountain landscape. The bare, empty studio, from which all distracting comforts have been banished, suggest his total dedication to his art. (Georg Friedrich Kersting, *Friedrich's Studio*, 1811, oil on canvas, 54 cm × 42 cm / 1 ft 9¼ in. × 1 ft 4½ in. Kunsthalle, Hamburg)

issuing of the Karlsbad Decrees and the dissent that followed, paid for equipment for his young artist colleague Kersting to join the Lützow Free Corps (which put him into debt), left Dresden during the French occupation, and spent a month living with a friend's family in Krippen in Saxon Switzerland, to escape the famine and disease that were rife in Dresden. Napoleon's long-held superior strength paralysed Friedrich's creative abilities, but as soon as his hope returned, he started to draw from nature, including the sketch of the rocks on which the Wanderer stands, which could almost be a memorial plinth. The *Wanderer* painting has been firmly dated to around 1818, so could well be a tribute to Colonel von Brincken. This would explain the otherwise atypical sublime sense of pathos. Normally Friedrich tackled subjects of Protestant humility, avoiding the awe-inspiring themes that here can be heard echoing from the hills. We must therefore imagine von Brincken facing this amazing mountain realm as if standing before the throne of God. His head, fixed on the vanishing point of the horizon and rising above the upper horizontal of the Golden Section, seems to be seeking the hope of redemption. Only for a dead man was Friedrich able to formulate such things.

Long Live Life!

Liberty Leading the People, Eugène Delacroix

BARTHÉLEMY JOBERT

... Delacroix's stroke of genius was to use the naturalistic posture [of the woman] to inject allegory into the realistic setting of a barricade ...

Above
The factory worker sports a sash and sabre, taken from a dead soldier; they are so precisely depicted that they can be identified with items from the 1816 ordinance (*règlement*).

Opposite
Near the Liberty, Gavroche, wearing the black beret traditionally associated with university students, waves two pistols taken from a cavalry soldier. His stance was inspired by Giovanni da Bologna's *Mercury*.

1830
Oil on canvas
260 cm × 325 cm / 8 ft 6 in. × 10 ft 8 in.
Musée du Louvre, Paris

In 1981 the newly elected French president, the Socialist François Mitterrand, decided to change the figure of Marianne that featured on postage stamps. And so the head of Hersilia from Jacques-Louis David's *Sabine Women* (which had been the personal choice of his right-wing predecessor, Valéry Giscard d'Estaing) was replaced by the heroic figure from Delacroix's *Liberty Leading the People*. Some pundits remarked that David's figure was oriented to the right and Delacroix's to the left; however, it is also true that the 100 franc banknote introduced in 1978 had already featured the *Liberty* alongside a superimposed Delacroix self-portrait with palette and brushes. Indeed, by the late 20th century, the identification of Delacroix's Liberty with Marianne – and with France itself – had been common for a century and a half (since the work's first exhibition, at the 1831 Salon), and the painting had gained the status of republican icon both in France and abroad.

Delacroix painted his *Liberty* between October and December 1830, in the aftermath of the 'Three Glorious Days' of 27–29 July in the same year. During these three days, a Parisian uprising defeated the regular army and overthrew the eldest line of the reigning Bourbons, replacing it with the younger branch of the family: the Duke of Orléans, the cousin of now exiled King Charles X, who ascended the throne as Louis-Philippe I. The new July Monarchy took as its emblem the revolutionary and republican Tricolour instead of the white flag of the Bourbons, thereby clearly signalling that the new regime would accept the changes introduced by the Revolution and the Empire, rather than seek a return to pre-1789 France (which had been Charles X's intention). The political background was as clear to those who first saw Delacroix's *Liberty* as it had been essential in the painter's decision to undertake such a significant canvas. This was made yet more explicit by the full title chosen by the artist: *28th July. Liberty Leading the People* – a direct reference to the second of the 'Three Glorious Days', when the insurrection had taken control of the Paris streets with the aim not only of forcing the king to withdraw his latest decrees suppressing press freedom and dissolving the Chamber of Deputies, but also of abolishing the Bourbon monarchy altogether. Hence the recurring presence of the Tricolour in the painting: on the left as a makeshift flag at the end of a pike, on the right flying from the towers of the cathedral of Notre-Dame and in the centre, at the summit of the composition, proudly waved by the figure of Liberty.

The painting is a realistic depiction of a Parisian riot scene. Despite the typical houses and the silhouette of Notre-Dame on the right, it is impossible to locate precisely. The clothing of the principal characters identifies them as specific types of rioter: the man brandishing a sabre is a factory worker, the figure holding a gun is a *bourgeois* (a student, perhaps, or an

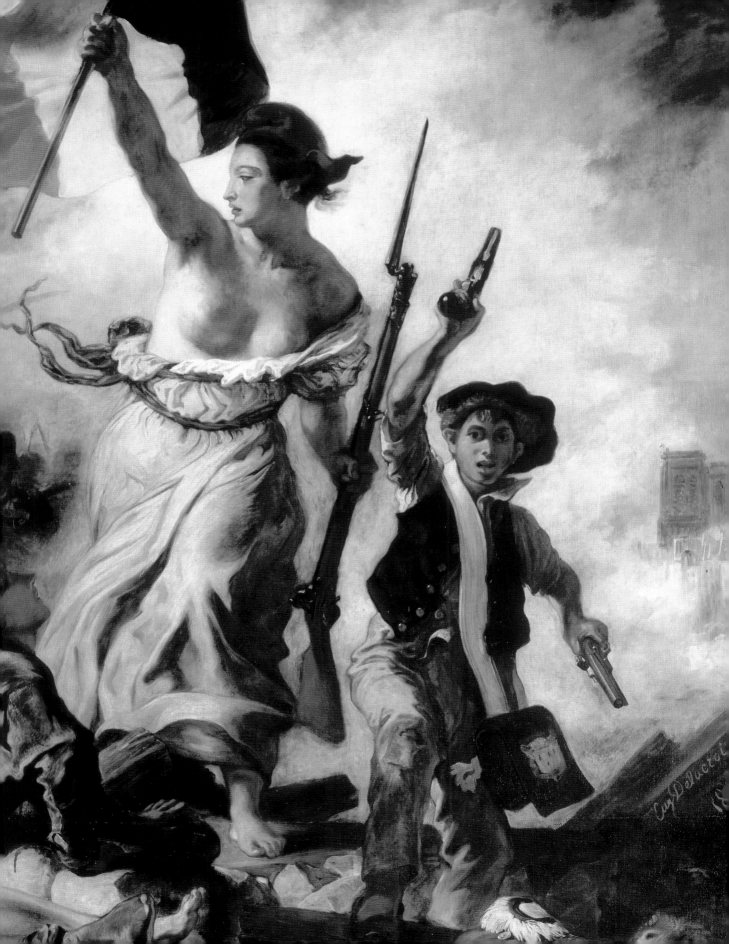

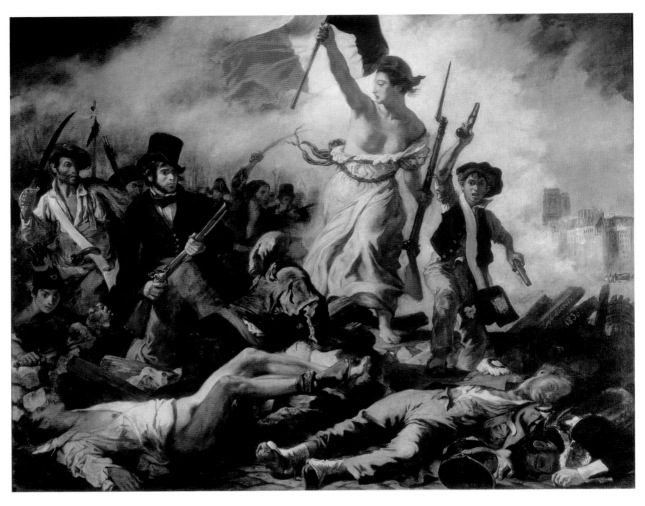

Above
'Important reasons argue against the
exhibition of a painting representing Liberty
in a red bonnet atop a barricade, with French
soldiers trampled under rioters' feet', wrote an
official in 1855, when Delacroix wanted the
painting shown at the Exposition Universelle.

Left
This sketch was submitted by Delacroix for
the competition for the decoration of the
Chambre des Députés in Paris; it was not
chosen, perhaps because its political message
was too liberal. (*Boissy d'Anglas at the
National Convention*, 1831, oil on canvas,
79 cm × 104 cm / 2 ft 7 in. × 3 ft 5 in. Musée
des Beaux-Arts, Bordeaux)

Opposite
Greece on the Ruins of Missolonghi is
Delacroix's first significant political painting.
As in *Liberty*, he mixes allegory, the use of the
nude and realism, heightened by the splashes
of blood on the rock. (1826, oil on canvas,
209 cm × 147 cm / 6 ft 10¼ in. × 4 ft 9¾ in.
Musée des Beaux-Arts, Bordeaux)

'

... by the late 20th century, the identification of Delacroix's Liberty with Marianne – and with France itself – had been common for a century and a half ...

artisan or foreman), and the man on his knees – who sports the three colours – is a worker from the countryside, probably a builder. In the background, a *Polytechnicien*, whose school distinguished itself in the rebellion, is wearing his typical cocked hat. And the two dead soldiers in the foreground are wearing the uniforms of the regiments of royal troops fighting the insurrection, a Swiss guard and a cavalryman. As for the small boy, he is frequently associated with Victor Hugo's Gavroche in *Les Misérables*, although the book was published more than twenty years after the painting was produced.

The most important figure – the one that gives the painting its full significance – is the semi-naked woman in the centre. Contemporaries undoubtedly saw her as modelled on one of the real rioters; critics at the time described her as a working-class woman, a fishwife or even a prostitute. But Delacroix's stroke of genius was to use the naturalistic posture to inject allegory into the realistic setting of a barricade; visually characteristic of the allegory, the nude – especially the female nude – gives the principal figure (remarkably, the only woman in the painting) a double significance.

Delacroix had already blended realism and allegory in a large canvas painted in 1826, *Greece on the Ruins of Missolonghi*, in which a Greek woman in national costume, palms outstretched and bare-breasted, personifies the fight of her country against its Turkish oppressors. It has been suggested that Delacroix drew his inspiration for the bust of his Liberty from the *Venus de Milo*, which at the time had only recently been discovered and was on display in the Louvre. This would certainly underline the Classical aspect of the composition's central figure, which is already reinforced by both the Tricolor in Liberty's hand and the red bonnet on her head, a reference to Greek antiquity (and the French Revolution) and to the emancipation of the slaves. (Technical analysis has shown that the cap was originally a brighter red, but was toned down by Delacroix, probably for political reasons.)

One of the most intelligent and penetrating contemporary critics of Delacroix's work, Théophile Thoré, well understood the dual nature of the central figure when he wrote in 1837 that *Liberty Leading the People*

is both history and allegory. Is this a young woman of the people? Is it the spirit of liberty? It is both; it is, if you wish, liberty incarnated in a young woman. True allegory should possess the quality of being at the same time a living type and a symbol, unlike the old pagan allegories which are no more than dead forms.... Here again, Mr Delacroix is the first to use a new allegorical language.

Delacroix was evolving from the peak of his Romantic period, symbolized by the universally rejected *Death of Sardanapalus* exhibited at the 1827 Salon, to a more Classical style that would be enriched by six months in Morocco the following year. Thus, while *Liberty Leading the People* is almost certainly Delacroix's most universal and best-known painting, it is also a turning point in his career and art.

Witness to History

The Burning of the Houses of Lords and Commons, October 16, 1834,
Joseph Mallord William Turner

ANDREW WILTON

' *... this occasion provided [Turner] with a subject that enabled him to express the two great themes of his art – the visual grandeur of the world and the multifarious lives of the people who inhabit that world ...*

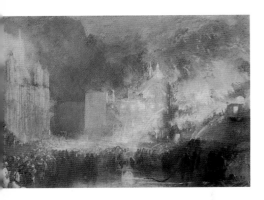

Above
The Burning of the Houses of Parliament,
1834 (watercolour, 23.3 cm x 32.5 cm /
9¼ in. × 12¾ in. Turner Bequest, Tate,
London).This sheet is hardly a fully finished
watercolour – rather an almost expressionist
exercise in the evocation of the nocturnal
scene in Old Palace Yard, with amazed
crowds and august buildings glimpsed fitfully
in the light of the fire.

Opposite
Turner shows a steam vessel towing the
floating fire engine up river, something
witnessed by the *Times* reporter, among
others. Because the tide was low when the
fire broke out at 7.00 p.m., the boat could not
reach the scene until 2.30 the next morning,
by which time it was no longer needed.

1835
Oil on canvas
92.5 cm × 123 cm / 3 ft 0½ in. × 4 ft 0½ in.
Cleveland Museum of Art, Ohio

The huge fire that destroyed the old Houses of Parliament on the night of 16 October 1834 was more than a great London spectacle. It was a national event with immense political and social resonance. The Reform Bill, passed two years earlier, had consigned to history the old, corrupt electoral system of bribery and rotten boroughs, and the blaze was seen by many as a moral bonfire, a symbolic purging of the body politic. The convergence of sublime spectacle and historical significance was a chance that Turner, in all his long life, rarely witnessed at first hand, and this occasion provided him with a subject that enabled him to express the two great themes of his art – the visual grandeur of the world and the multifarious lives of the people who inhabit that world – in a uniquely arresting manner.

A Londoner, living in Queen Anne Street, Marylebone, Turner was, of course, one of the thousands who watched the fire from the opposite bank of the Thames, and also took the opportunity to use one of the craft that swarmed out on to the river giving sightseers a closer view. It was his habit to draw on all possible occasions when travelling, but no pencil sketches of the fire have been identified with any certainty. A sketchbook full of magnificent watercolour studies of a big fire has been supposed to be an on-the-spot record, but it is highly unlikely that he could have produced such work in the dark and among dense crowds. Perhaps he made these rapid notes the following morning, or even as a record of another of the innumerable fires that happened so often in London: there is no conclusive evidence in the sketches, which include details of buildings that do not seem to relate to the Palace of Westminster. In any case, Turner made no obvious use of any of them in the pictures that he made of the subject.

At all events, he looked, and in the following days supplemented the visual information he had gleaned by reading circumstantial details in newspapers and journals, collecting as much practical information as he could. One of the popular prints that appeared shortly after the fire, an engraved *View of the Conflagration of the Houses of Lords and Commons*, shows the scene more or less as Turner presents it in one of his pictures, from the opposite bank of the Thames with Westminster Bridge in steep perspective at the extreme right.

Over the following winter he painted not one but two substantial oil paintings of the subject, which he showed in two separate exhibitions in London in 1835. One, now in the Philadelphia Museum of Art, he sent to the British Institution, and the other, now in the Cleveland Museum of Art, he submitted to the Royal Academy's summer exhibition. The sheer drama of the scene would have been enough to prompt the double response; but he may have had other motives. One of his dearest friends, and his most generous patron, Walter Ramsden Fawkes of Farnley Hall in Wharfedale, West Yorkshire, had died in 1825 after a lifetime of campaigning for electoral reform. On his account alone the passing of the Reform Bill must have had

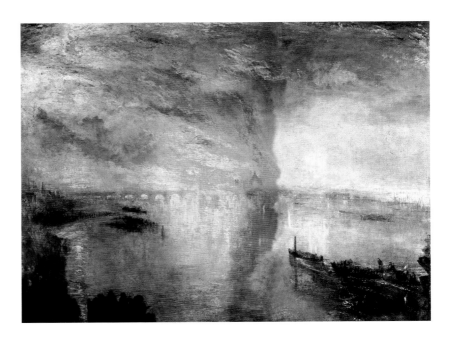

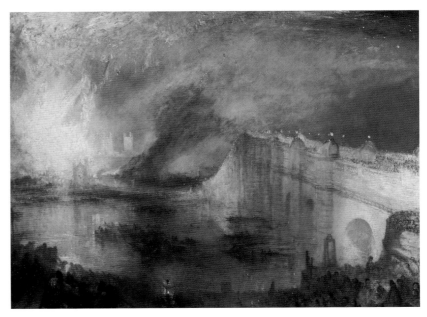

Above right

As *The Times* reported on 17 October 1834, 'We scarcely ever recollect to have seen the large thoroughfares of the town so thronged before. Within less than half an hour after the fire broke out it became impossible to approach nearer to the scene of the disaster than the foot of Westminster Bridge on the Surrey side.' That is Turner's viewpoint here.

Right

The Burning of the Houses of Lords and Commons, 16th October, 1834, 1835 (oil on canvas, 92.5 cm × 123 cm / 3 ft 0½ in. × 4 ft 0½ in. Philadelphia Museum of Art). This view of the conflagration is taken from the far end of Westminster Bridge; a great crowd has gathered on the riverbank like an audience at a theatrical spectacle.

great significance for Turner, and the fire will have seemed a perfect opportunity for him to pay tribute to Fawkes's memory. We might see the pictures as a pair, one as it were for Fawkes, the other for Turner himself, the citizen of London.

The sense that this was an occasion with deep meaning for the ordinary people of London is vividly presented in the picture, now in Philadelphia, that shows the fire from the other end of Westminster Bridge: the foreground is heaped with crowds of people like the stage of a theatre during the finale of a grand opera (Turner was an avid follower of the musical theatre). At the same time, the crowd seems to be warming itself at the blaze, which is palpably very hot. The cool creamy masonry of Westminster Bridge on the right, seen in steep perspective, plunges the eye into the depth of the picture space and seems to melt in the heat as it approaches the far bank.

The Cleveland version, where we observe the fire in the distance, from a height above the river, is more akin to cinema, the camera hovering high above the scene, and seeing everything in long shot: the flames leaping skywards in the distance, at the end of a great tunnel of darkness. The exalted viewpoint might even suggest the experience of the disembodied spirit of Fawkes, surveying the scene from 'the seventh sphere', as Troilus looks down on 'this little spot of earth' after his death at the end of Chaucer's *Troilus and Criseyde*.

In that broad scene, Westminster Bridge is a line of arches on the left horizon, while movement into the deep picture space is supplied by a steamboat towing a firefighting engine up the broad river towards the blaze. The composition anticipates another famous subject, of a decade later, *Rain, steam, and speed – the Great Western Railway* (1844). There, the movement of the railway train towards the viewer replaces the movement of the steamboat into the picture: the centripetal power of the fire that destroys the old world gives way to the centrifugal energy of a new age.

Right
Rain, steam, and speed – the Great Western Railway, 1844 (oil on canvas, 91 cm × 122 cm / 3 ft × 4 ft. Turner Bequest, National Gallery, London). This famous image celebrates Turner's fascination with the modern world that was emerging during the last decade of his career. But it suggests that old and new can perhaps coexist meaningfully: the bridge over which the train hurtles is a medieval stone structure, not the modern span of the bridge at Maidenhead that actually carried this stretch of the Great Western Railway across the Thames between Maidenhead and Taplow.

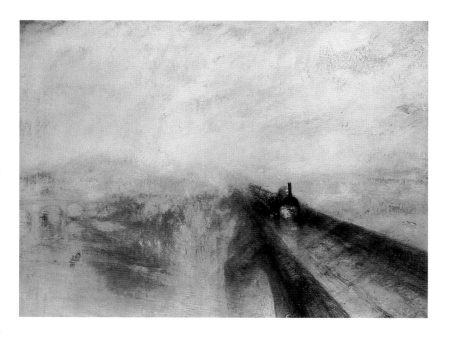

The Price of Progress

The Oxbow, Thomas Cole

MICHAEL J. LEWIS

> *The view of landscape that it presents – fraught by the contradictory lessons of religion and science, simultaneously enthralled by the beauty of nature and complicit in its destruction – is ultimately tragic ...*

Above
The figure in the foreground with paintbox and parasol stands for both Thomas Cole and for ourselves, as though the artist is asking us to step inside the painting and see *The Oxbow* through his eyes.

Right
Did *The Oxbow* celebrate the clearing of the land, or violently condemn it? Capable of being read either way, it seems to have pleased everyone.

1836
Oil on canvas
130.8 cm × 193 cm / 4 ft 3½ in. × 6 ft 4 in.
Metropolitan Museum of Art, New York

t is a strange artist indeed who can find the stuff of high drama in one of nature's slowest events. And few things are as leisurely as the forming of an oxbow. An elderly river passing over a flat landscape will in time begin to meander as its bottom silts up and its banks erode. Curves emerge, which gradually coil into loops, and which sometimes swing back on themselves to complete the circle. When this happens, the river can abruptly straighten itself out and return to its original course, leaving behind a ringlet of water known as an oxbow lake. This protracted process is at the heart of the painting that Thomas Cole titled *View from Mount Holyoke, Northampton, Massachusetts, after a Thunderstorm* and that everyone else calls *The Oxbow.*

'I have already commenced a view from Mt. Holyoke,' Cole wrote to his patron Luman Reed in March 1836; 'it is about the finest scene I have in my sketchbook & is well known – it will be novel and I think effective.' A month later he showed it at the annual exhibition of the National Academy of Design. It was indeed effective: it sold immediately and was repeatedly exhibited, remaining in private hands until 1908 when the Metropolitan Museum of Art acquired it. It remains one of the museum's most popular objects for it captures with peculiar clarity the paradox of American landscape art, which is that the American landscape was not seen as something sublime and lovely until the moment it was doomed. To 18th-century America, nature was still the site of hardship and peril, the 'howling wilderness'. But by the time Cole painted *The Oxbow,* railroads, canals and the other artifacts of industrial civilization were well along in the process of ruthlessly subduing the continent and banishing its wilderness. His works are not so much a celebration of that wilderness as its stately and melancholy recessional.

Like all of Cole's works, *The Oxbow* is a studio performance, an elaboration of a careful pencil sketch made on site. He invariably made minor adjustments in order to work in his repertoire of familiar props and devices, and each of them appears in *The Oxbow*: the sharp juxtaposition of wild and cultivated scenery, the solitary witness contemplating the scene, the blasted tree that bodes of mortality. Yet he deploys them in a composition of exceptional, almost schematic purity, neatly bisected into opposites. To the left all

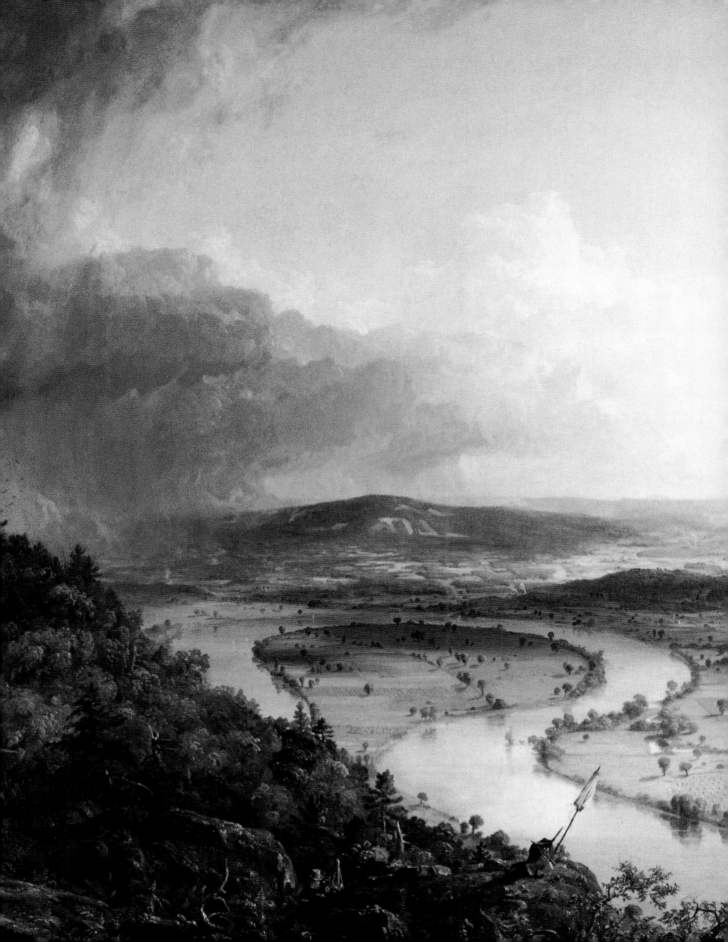

is darkness, storm and wilderness; to the right sunshine, calm and pasture. Even the lines and outlines of the landscape show a different calligraphy: jagged angularity on one side and easy curves on the other, like a painting that is one half Poussin and one half Ruysdael.

Cole's meaning is clear: two storms are sweeping relentlessly across the landscape. The advancing atmospheric storm will darken the skies, pummel the mountains with rain and lightning, and then pass; the human storm will fell the trees and clear the underbrush, leaving tidy geometric fields in its wake. It is this second, slower-moving storm that is the more destructive, for in due time it will traverse the country, bringing all that it touches under the sway of America's industrial civilization; we can already discern little wisps of smoke issuing from numerous settlers' cabins. One might grieve or one might rejoice at the prospect, Cole tells us, but such is the decree of fate. And as if to confirm that is nothing less than divine judgment, the Hebrew letters שדי are inscribed on the distant mountain, spelling out *shaddai* – 'the Almighty'. The letters are upside down, as they would be if written by God. (Oddly, although in plain sight, they were not noticed for a century.)

> ‘
>
> *[Cole's] works are not so much a celebration of ... wilderness as its stately and melancholy recessional.*

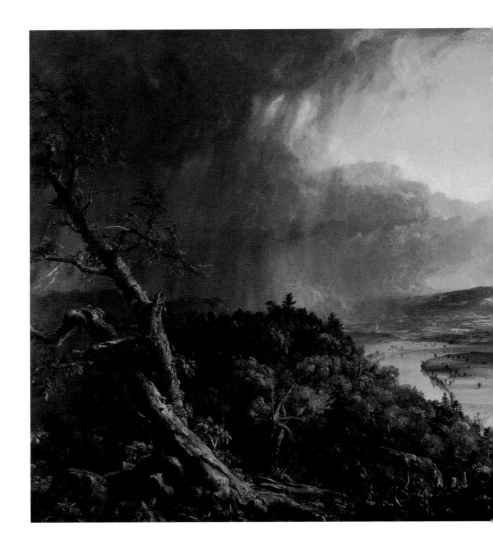

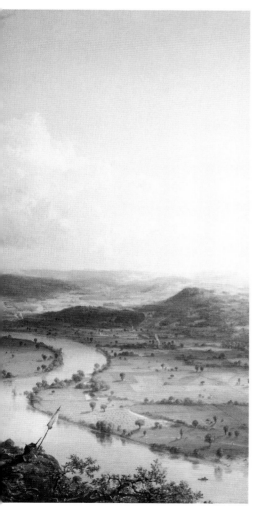

The critics of Shakespeare sometimes refer to *Hamlet* as having 'two clocks': there is the actual span of several months over which the action of the play takes place and then there is the apparent time, which seems to be a continuous stream of action and events. It is the great idiosyncrasy of *The Oxbow* to have three kinds of time and three advancing clocks, which in turn count out the minutes, the centuries and the millennia. The storm is a fleeting event, and we see it passing before our eyes. The clearing of the continent is the work of centuries, although we know that its course is inevitable. These two tempos are counted against a slower, massive tempo, the great grinding wheel of geological time.

Here Cole was responding to the intellectual sensation of his day, the publication of Charles Lyell's *Principles of Geology* (1830–33), which demonstrated that the earth was shaped by mighty but slow-acting forces, working incrementally over millions of years. The creation of the earth was not an accomplished fact, as had traditionally been believed, but land and sea continued to churn, caught up in violent but slow-motion upheaval. To Cole's generation, these were shocking revelations, and *The Oxbow* is the first major work to apply them to art. The view of landscape that it presents – fraught by the contradictory lessons of religion and science, simultaneously enthralled by the beauty of nature and complicit in its destruction – is ultimately tragic, but it has helped awaken generation after generation to the fragile dignity of nature. For all of its pious moralizing – and Cole was as full of platitude and formula as an opera – *The Oxbow* remains one of the least dated paintings of the 19th century.

Above left
Cole's *Self-Portrait*, *c.* 1836 (oil on canvas, 45 cm × 56 cm / 1 ft 5¾ in. × 1 ft 10 in. New-York Historical Society) suggests a quiet and thoughtful observer. His concern with the fragility of nature began in his boyhood in Lancashire, in the Industrial Revolution.

Above
The enigmatic Hebrew inscription of *The Oxbow* warns that even landscape is subject to divine judgment, but whether that judgment will be Eden or Noah's Flood, Cole leaves tantalizingly open.

Change on the Horizon

Wild Poppies, Claude Monet

JOHN HOUSE

> *The brushwork is variegated and informal, suggesting the diverse shapes and textures of figures, flowers, grasses, foliage and clouds without recourse to detail … we register the delicacy and finesse of the nuances of colour and touch that suggest the receding space of the meadow.*

A woman and a child walk through a meadow of thick grasses; red poppies cloak a bank that rises to the left; and another woman and child appear atop this bank. There is no hint of any link between the two pairs of figures, and no clue as to why the woman in the foreground has lowered her parasol. A ragged line of trees closes off the field in the background, with, at the centre, a single red-roofed house. The sun is not shining, and an even light is spread over the whole landscape.

This is a very ordinary scene. The site is not obviously picturesque; neither the lie of the land nor the line of trees offers any particular interest. Indeed, there are suggestions that we are near a town, rather than in the deep countryside; the figures are middle class rather than peasants, and the house in the background is a substantial villa, not a rural cottage. The scene presumably represents a meadow near Argenteuil, the town on the River Seine just north-west of Paris where Monet lived and painted in these years.

The treatment of the subject, too, gives no special focus to any of the elements in the scene. The brushwork is variegated and informal, suggesting the diverse shapes and textures of figures, flowers, grasses, foliage and clouds without recourse to detail. At first sight, the viewer's eye is attracted by the dark jacket of the woman on the right and the sharp tonal contrasts in her hat, and by the array of loose red dabs that suggest the poppies that give the picture its title, set against the grey-green of the grasses. As we look further, we see the boy, seemingly holding a bunch of poppies and waist deep in the grasses, and the other figures to the left, and we register the delicacy and finesse of the nuances of colour and touch that suggest the receding space of the meadow.

Wild Poppies was first exhibited in 1874. It appeared in the independently organized group exhibition in Paris that first prompted art critics to name the group the 'Impressionists', focusing on their sketch-like technique and everyday subject matter, which seemed to privilege the immediate impression of a scene over any further meanings and significance. In many ways, this approach

Opposite

A woman and a boy stroll through fields of poppies, while on the horizon a house hints at the encroaching city. This small work was painted in rapid brushstrokes, and yet close study of the composition and handling of colour reveals the eye of a true master.

1873
Oil on canvas
60 cm × 65 cm / 1 ft 11½ in. × 2 ft 1½ in.
Musée d'Orsay, Paris

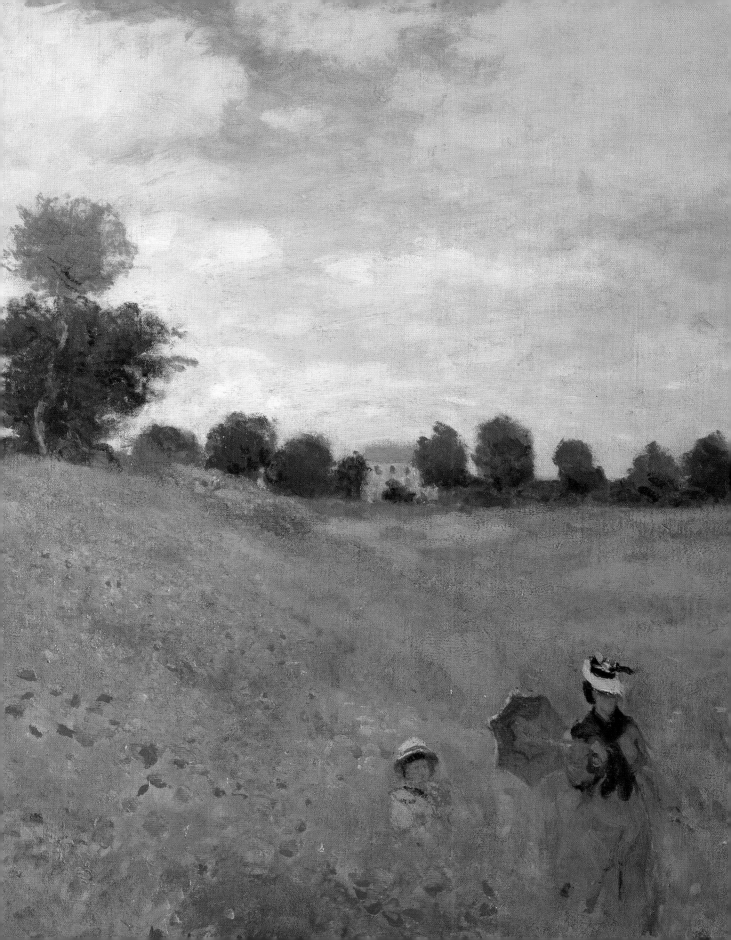

to painting challenged contemporary expectations about the purpose of the fine arts – that they should convey values and beliefs beyond the mere surface appearance of the work itself. The vision of the countryside that was current in the art exhibitions of the period, notably at the vast annual exhibitions of the Salon in Paris, focused either on the spectacular scenery of coasts and hills or on the fruitfulness of France's agricultural lands. In this hermetically sealed world, there was no place for middle-class figures or hints of the proximity of the city – no room for signs of material change or social distinctions. *Wild Poppies* posed a direct challenge to these expectations; its figures strolling in the meadow suggest nothing beyond the pleasures of a summer day, and their setting displays none of the markers of the true countryside.

Charles-François Daubigny's *Fields in the Month of June*, exhibited at the Salon in 1874 while *Poppies* was on view in the group exhibition, makes a revealing comparison with Monet's canvas. The foreground in both pictures is dominated by poppies, and the primary pictorial effect is created by the contrast of the red touches against the complementary green behind them; and in both the paint handling is broad and informal. But Daubigny's canvas is huge – its surface area is nine times as big as *Wild Poppies* – and it represents a vast panorama of agricultural land, with open fields and haystacks beyond the poppies, and small peasant figures embedded in the landscape. This is a totalizing vision of the essence of rural France. Monet's picture, by contrast, shows figures strolling in a trivial corner of the countryside, with no indication that there is any significance to the scene beyond the here and now.

The imagery of the French countryside had a special resonance in the early 1870s, when these canvases were exhibited. France had recently suffered the dual trauma of catastrophic defeat by the Prussians in the Franco-Prussian War of 1870–71 and the civil insurrection of the Paris Commune in the spring of 1871 and its brutal suppression. In the aftermath of these events, a special value was placed on the image of the French countryside as a fertile and serene realm, visibly untouched by recent events and implicitly the cradle of future national recovery. Daubigny's canvas celebrates this reparative vision, while Monet's does not.

What the Impressionists' art offered, as seen so vividly in *Wild Poppies*, was a modern view of the world, one that accepted and celebrated all its

Above
This painting by John Singer Sargent shows Monet painting in the open, a radical departure that allowed him to capture the effects of light more accurately than earlier artists. (*Claude Monet Painting by the Edge of a Wood*, *c*. 1885, oil on canvas, 540 cm × 648 cm / 17 ft 8½ in. × 21 ft 3 in. Tate, London)

Right
Charles-François Daubigny, *Fields in the Month of June*, 1874 (oil on canvas, 135 cm × 224 cm / 4 ft 5 in. × 7 ft 4 in. Herbert F. Johnson Museum of Art, Cornell University)

> *This is a very ordinary scene ... its figures strolling in the meadow suggest nothing beyond the pleasures of a summer day.*

contingencies. This view is expressed in both the technique and the subject matter of the picture. The informal brushwork gives a sense of the overall effect of the scene, as if caught by a rapid glance, and gives no special status to the figures or any other element in it, though there is remarkable subtlety and sophistication in this seemingly impromptu paint surface. Moreover, the title that Monet chose for the picture diverts attention from the figures, focusing instead on the purely visual effect of the red flowers scattered across the bank – there is no hint of flower symbolism here. At the same time, the view itself is quintessentially modern, depicting middle-class leisure in a setting where the natural world meets the suburban villa. By exhibiting *Wild Poppies* in the group exhibition in 1874, Monet was at one and the same time presenting a new vision of landscape and a new notion of the finished picture.

Life Begins

La Petite Danseuse de quatorze ans, Edgar Degas

QUENTIN BLAKE

Not beautiful in any conventional sense, but alert and full of story; and the strange half-closing of the eyes seems to assert a sort of privacy and independence of this young person in relation to her situation.

Above
A great number of Degas's sketches and paintings show (often very young) dancers at rehearsal. These images, compared to those of dancers on stage, are portraits imbued with a sense of individuality and informality, rather than occasion.

Opposite
The thirty or so recastings of the original dancer retain the tutu and hair-ribbon.

c. 1881 (cast 1922)
Bronze, with material
H 97 cm / 3 ft 2 in.
Various collections

Standing in front of some of Degas's more richly decorative scenes of the ballet, it can be easy to forget that they are also a depiction of working girls; there is no such problem, however, with *La Petite Danseuse de quatorze ans*. The little fourteen-year-old dancer as we are used to seeing her is a two-thirds life-size bronze cast, depicting one of those 'rats de l'opéra' employed in the 19th-century Parisian theatre. She is in a formal pose, one leg extended forward, the arms stretched and hands joined behind her back.

What strikes us on first view, I suppose, is the fact that the dancer is wearing a real tutu and a real hair-ribbon. If that surprises us, we nevertheless have to remember that what is before us is not what was seen by the visitors to the sixth Exhibition of Indépendants in Paris in 1881 when the work was first exhibited. J.-K. Huysmans in his review of the exhibition described both the sculpture as it then was and the public reaction to it. It was in wax, the corsage coloured, the flesh coloured, with real hair, a real skirt, real ribbons. Another, less sympathetic account by Paul Mantz in *Le Temps* of this 'disagreeable figurine' even suggests that Degas had added spots and maculations to indicate that his dancer was none too clean. To add to what the art critic Theodore Reff refers to as its 'ambiguous reality', the figure was shown in a glass case. (Strangely, this case had itself been put on show, empty, in the previous year's exhibition, as the sculpture it was to contain wasn't yet ready.) At the time, as Huysmans recorded, the average Parisian spectator fled offended: 'The terrible reality of this statuette produces [in them] an evident distress; all their ideas about sculpture, those lifeless cold blanched never-forgotten stereotypes repeated for centuries, are overturned.' Huysmans claimed *La Petite Danseuse* as the only truly modern experiment in sculpture that he knew of.

As we attempt to recreate a mental picture of the work as originally shown we are conscious of Degas making a sort of exploratory skirmish along the borders of the artificial and the real. With what we know of later developments we can see him anticipating that self-conscious, self-referential awareness of art that has become, post-Duchamp, common currency; and a provocation surely more interesting than that of the (all-too-often lame) followers of Duchamp who still go on, as they hope, challenging our sense of what is and isn't art.

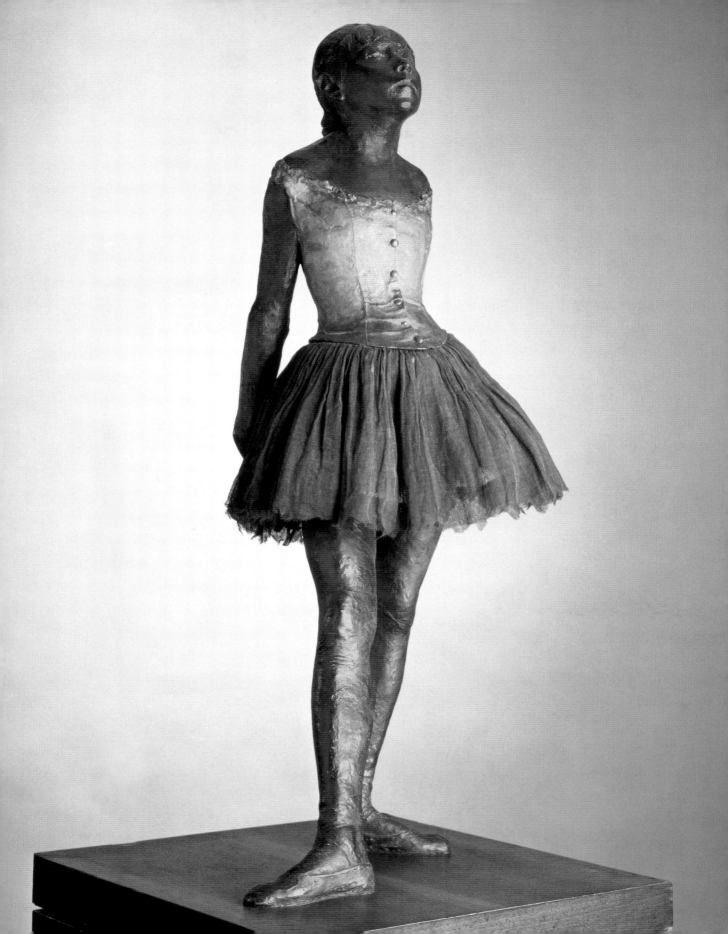

> *... we are conscious of Degas making a sort of exploratory skirmish along the borders of the artificial and the real.*

Not least because even when most of its multimedia characteristics fall away, the work retains its strength. It's a strength that prompted the negative reactions vividly expressed by Paul Mantz in his contemporary account: 'You walk around this little dancer, and you are not moved,' he says, before going on to ask: 'Why is she so ugly?' and to talk about the 'natural ugliness of a face where all the vices have imprinted their detestable promises'.

Mantz finds, perhaps disingenuously, that Degas is a moralist, who knows things that we don't know about the future of such dancers. Of course, this is not the morality of Degas, and it is not hard for us now to see that what was unbearable to Mantz was the artist's capacity to see not the accepted cliché but what was actually in front of him.

However, the power of the work comes from more than that accuracy of gaze; it comes also from an inner tension. The tension is between another artificiality – that of the pose that the dancer holds – and the potential energy implied in the real tension of the limbs.

Whatever Degas's reputation for misogyny, it never seems to have interfered with the concentration of his eye and hand at work, so that his portraits of women must be among the most realized, the most intelligent, of the 19th century. A similar degree of attention is given to the head of the little dancer, its planes and forms and weight; firmer and more authoritative than any of the preparatory drawings, it manages to be young but to show how it will develop later. Not beautiful in any conventional sense, but alert and full of story; and the strange half-closing of the eyes seems to assert a sort of privacy and independence of this young person in relation to her situation. This work gives me the sense of something genuinely authoritative, achieved; and as such works can do, it begins to take on some of the force of metaphor – not the ready-made metaphors of status labelled Virtue, Charity, Victory, Paris – but a real metaphor of human determination; perhaps even courage.

Puzzling Reflections

A Bar at the Folies-Bergère, Édouard Manet

PHILIP PULLMAN

'*... reflections on reality ... are right at the heart of Modernism ...*

Above
Frederick Yeames, *And When Did You Last See Your Father?* (detail), 1878, 103 cm × 251.5 cm / 3 ft 4½ in. × 8 ft 3 in. Walker Art Gallery, Liverpool.

Opposite
Manet's barmaid at the Folies-Bergère is one of the most enigmatic figures in all art, the subject of a visual and psychological puzzle.

1882
Oil on canvas
96 cm × 130 cm / 3 ft 1¾ in. × 4 ft 3¼ in.
Courtauld Institute of Art, London

This painting is full of mystery, ambiguity, doubt. At first sight it seems to do exactly what the title implies, and show a vivid life-like view of a bar at the popular music-hall. There is the marble counter with bottles and a dish of oranges; there is a barmaid behind it waiting to serve us; there is a mirror behind her...but here the mysteries begin.

Because what's in the mirror cannot be a reflection of what we see in front of it. Things are displaced; the barmaid's reflection is too far off to the right, when we can see that the mirror is parallel with the plane of the picture itself; there is a man in front of her reflection in the mirror, and there isn't one in the 'reality' in front of it; there is a whole balcony front missing – and so on.

Furthermore, there are perplexing passages in the paint itself – patches of light that might be the leg of the counter, or a drift of tobacco smoke, or simply an effect of light on the surface of the mirror. It's full of ambiguity.

Now at about the same time that Manet was painting *A Bar at the Folies-Bergère*, in the early 1880s, an English artist called Frederick Yeames was painting a picture called *And When Did You Last See Your Father?* It shows a scene from the English Civil War: a young boy from a Royalist family is being interrogated by a Roundhead officer, while his anxious mother and sisters wait behind him, hoping the honest little chap won't betray his father. Yeames was a competent draughtsman, and the scene is effectively composed; the handling of the paint is immaculate; the characterization of the individuals in the scene is vivid and convincing.

But here's a thought-experiment. Let's imagine a full description of that Civil War scene in words. It would be perfectly possible. There are no puzzles about mirrors and reflections and things in the wrong place: everything is easily and immediately readable.

Then let's imagine we give that description to another artist, of equivalent skill in draughtsmanship and composition and the handling of paint, one whose ability to convey character through facial expression was the equal of Yeames's, and let him or her paint a picture on a canvas of the same size and shape. It would be a different painting, but would it differ substantially in ways that are important to the way the painting works? I don't think so. Effectively, functionally, it would be the same picture. What the Yeames did, this would do. What excited admiration for the skill of the artist or arouses compassion or empathy for the people in one picture would do just the same in the other.

Now imagine the same process carried out with the Manet.

But would that be possible at all? Long before we get to the difficulty of painting an equivalent picture by reading a description of this one, we can't even say exactly what's being represented. Then there's the appearance of the

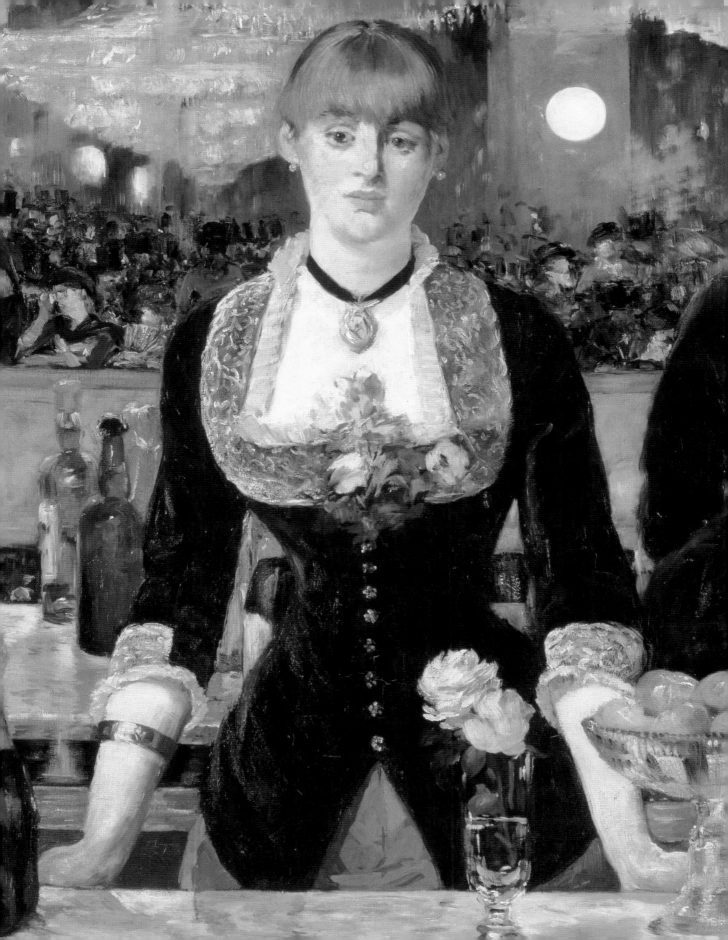

painted surface, which is so important a part of our experience of the picture: the way the paint is scumbled in the handling of the flowers in the barmaid's corsage, and in the great chandelier, and in the massing of the spectators on the balcony. It's Manet's particular touch, his hand, his brushstrokes, that matter in passages like these. The things that matter about the Yeames can be put into words quite easily: the things that matter about the Manet cannot.

But I still haven't mentioned the greatest mystery of all, an enigma so profound that even if we managed to describe the rest of the painting in words, we'd still have to throw up our hands in despair at the impossibility of resolving it, and it's this: what does the barmaid's expression mean? How on earth would we describe that? It is the most unreadable face I know in any painting. She is far more mysterious than that smirking Florentine we know as the Mona Lisa. At the heart of this scene of glittering light and the sensuous richness of a dozen different textures, at the very centre of this world of brilliant surfaces, there is this pretty young face expressing a profound, inexplicable…what is it, sadness? Regret? Unease? Alienation? Her face is flushed; it might be simply that she's warm under all those lights; it might be the flush that suffuses the cheeks of a young child kept too long from her bed. She's by no means a child, but for all the corseted fullness of her figure, she does look young; she looks innocent; at the same time, we wouldn't be surprised to learn that the conversation in the mirror between her reflection and the man in the top hat concerns her availability for quite other purposes than pouring glasses of wine and selling oranges.

But perhaps there's a clue in that. Which is the real girl, this one, or the one in the mirror? Is she two people, one whose character is as shallow as that of the man in the hat, as shallow as everything else in the mirror, only as deep as the glass itself, no more truly there than anything else in that glittering surface, because it's all surface – and the other who is as complex

Right
Manet's study for the painting shows that the barmaid's facial expression was part of his conception from the start. However, her reflection in the mirror is true to life, an effect that Manet deliberately distorted in the finished work. (Édouard Manet, study for *A Bar at the Folies-Bergère*, 1881. Stedlijk Museum, Amsterdam)

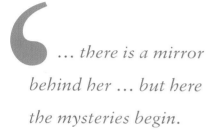

… there is a mirror behind her … but here the mysteries begin.

and profound as the expression on her face, a look that defies all description? The one in the mirror is not really there, and the one who is really there is not there either. She's somewhere else, thinking of her lover, or her debts, or her parents in the village she comes from, who haven't heard from her for months; or her little sister who has consumption…or thinking of nothing. And of course she can't think really, she's not real at all – she's a painted surface, just like the reflection that isn't a reflection.

But these reflections on reality (we can't get away from *reflections*) are right at the heart of Modernism, that astonishing movement in all the arts that was fertilized by Baudelaire, germinated with the Impressionists, and grew throughout the latter part of the 19th century to burst into a brilliant and fertile flowering with Picasso and Braque, with Stravinsky, with Joyce.

That's the real difference between *A Bar at the Folies-Bergère* and *And When Did You Last See Your Father?* Yeames and all the other Victorian narrative painters were only interested in half of what there was to be interested about. Manet was interested in all of it. That's why they belonged to the past, and Manet belonged to the future. *A Bar at the Folies-Bergère* is about a bar at the Folies-Bergère, it's about the mystery of that ordinary young woman's unfathomable expression, it's about champagne and oranges and tobacco smoke and chandeliers and fashionable dress; but it's also about seeing, and about recording the way the light glistens on those surfaces, and the way things in a mirror are different from things in front of our eyes; it's about the sensation of sight and the mysteries of representation; it's about painting itself.

Above

The barmaids themselves were part of the allure of the Folies-Bergère. The reflection of the young woman and the man in the top hat has an air of intensity that suggests something more than a client asking for a drink.

Fading Blooms

Sunflowers, Vincent Van Gogh

LOUIS VAN TILBORGH

' *Still-life painters always showed blooms in their full glory, but [Van Gogh] painted sunflowers past their prime The bloom with its wilted petals has the endless charm of what Van Gogh called 'that slight fadedness, that something over which life has passed'.*

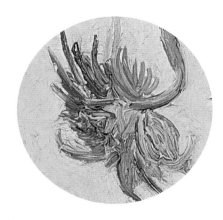

Opposite and Above
This still life is a display of technical virtuosity. Van Gogh demonstrated that he was able to use many variants of yellow without losing pictorial richness and form. The main colours are 'the three chrome yellows, yellow ochre and malachite green, and nothing else'.

1888
Oil on canvas
93 × 73 cm / 3 ft 0½ in. × 2 ft 4¾ in.
National Gallery, London

Van Gogh's *Sunflowers* is today regarded as an icon of his art. As it happens, he painted not one version but eleven – four in 1887, five in 1888, and two in 1889 – but when one reads the words 'the *Sunflowers*' one thinks of the painting now in the National Gallery, London. It was made in August 1888 with (to quote Van Gogh himself) 'the enthusiasm of a Marseillais eating bouillabaisse'. He painted two more versions, which are now in the Seiji Togo Memorial Sompo Japan Museum of Art in Tokyo and the Van Gogh Museum in Amsterdam.

The original version was kept by the family until 1924, when the widow of Vincent's brother Theo, Jo Van Gogh-Bonger, sold it to the trustees of the Courtauld Fund in London. Realizing that 'no picture would represent Vincent in your Gallery in a more worthy manner than the "Sunflowers"', she decided, reluctantly, to part with it: 'It is a sacrifice for the sake of Vincent's glory.' Even the critic and painter Roger Fry, who disparaged Van Gogh in favour of Cézanne, was impressed by the work: 'It has supreme exuberance, vitality, and vehemence of attack.... It belongs to a moment of fortunate self-confidence ... when the feverish intensity of his emotional reaction to nature put no undue strain upon his powers of realisation.'

The still life was painted by Van Gogh to impress Gauguin, who had promised to join him in Arles. Gauguin owned two of the 1887 paintings of sunflowers, so Van Gogh hit on the idea of decorating the studio in his so-called Yellow House with 'nothing but large sunflowers'. Sparkling from walls, they would symbolize the direction he felt their art should take. He thought of painting six, then twelve, but managed only four, of which only two were attempts at mature paintings – the work in London and the preceding one, with a bluish background, now in the Neue Pinakothek in Munich. But the two paintings did not end up in the studio. Van Gogh decided to decorate the *whole* apartment and placed the two still lifes in the guest-room. When Gauguin arrived at the end of October, he liked both of them, but preferred the yellow version, describing it later as 'a perfect example of a style that is completely Vincent's'.

Considering this judgment, it is no surprise that during their creative competition the still life was taken up as a challenge. They decided jointly to study 'the orchestration of a pure colour by all the derivatives of that colour', as Gauguin later put it. He painted a still life of a pumpkin with a yellow background and foreground, and Van Gogh made a free repetition of the sunflowers with the yellow background (the work now in Tokyo). This artistic dialogue was paralleled in the portraits they painted of each other. Van Gogh showed his companion at work in front of the pumpkin still life, and Gauguin depicted Van Gogh painting sunflowers. For him, Van Gogh's art was symbolized by this particular picture, and after his departure from Arles at the end of 1888, he impertinently asked his colleague to send it to him. Van Gogh categorically refused Gauguin's 'right to the canvas in question', but instead made a new version (the work now in Amsterdam). However, since Gauguin did not propose a specific work in exchange it was never sent to him.

This tug-of-war reflects the importance of the picture. Van Gogh was proud of it because he had 'taken the sunflower before others', as he wrote in 1889. Henri Fantin-Latour excelled in violets, Ernest Quost in hollyhocks, but he was the first to specialize in the *Helianthus annuus*. His interpretation of the sunflower was also truly original. Still-life painters always showed blooms in their full glory, but he painted sunflowers past their prime, displaying seeds and withered ray flowers. Van Gogh thus showed his debt to the Realists, who had celebrated the beauty of old, everyday objects. He had a preference for elderly ladies rather than young ones, down-at-heel and muddy shoes, and

... a perfect example of a style that is completely Vincent's.

(Paul Gauguin)

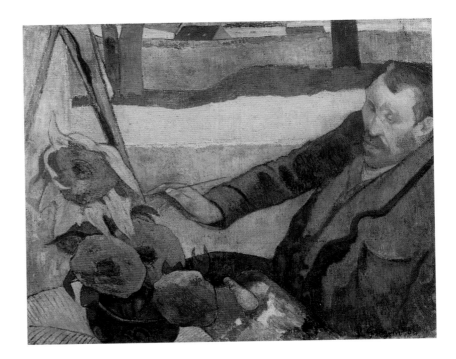

Right
Gauguin's painting of Van Gogh at work on *Sunflowers* is not true to life. Van Gogh is shown with a vase of sunflowers in front of him, but as they had long since finished flowering, it was an invention by Gauguin. He wanted to portray his friend as a realist: somebody who needed to work from life and not the imagination.

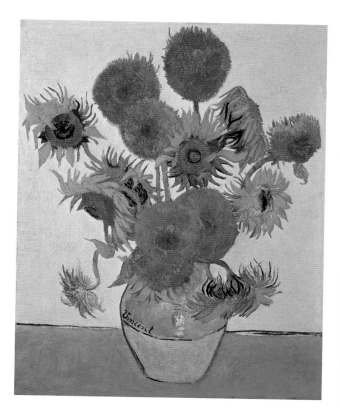
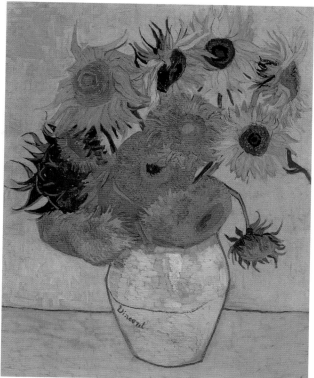

tumbledown cottages – the sunflowers belonged in the same category. The
bloom with its wilted petals has the endless charm of what Van Gogh called
'that slight fadedness, that something over which life has passed'.

This kind of humanist poetry was lost on Gauguin, but he must have
been intrigued by the modern way his friend had painted the plants. Rather
than following their morphological form (as he had done in his 1887 still
lifes) Van Gogh now preferred a naïve and more schematic presentation;
for instance, he depicted the faded sunflowers with green instead of brown
hearts. This primitive interpretation was in harmony with Gauguin's recent
determination, arrived at with Émile Bernard, to 'paint like children'; Van
Gogh wanted to show his friend – a true genius in his eyes – that he himself
was a trustworthy partner in the battle for modern art, his contribution to
which he believed lay in the use of bold and simple colours. However, the sun-
flowers were not meant simply to please the eye. He was seeking a higher goal.
In a painting he wanted 'to say something comforting, as music is comfort-
ing', and he was hoping to convey this 'by the actual radiance and vibrancy'
of the colouring. As applied to the *Sunflowers*, this suggests that Van Gogh
regarded its successful colouring as comforting 'music', and perhaps for
many of us it still is. Although the colours have darkened a little, the still life
is radiant, and charms us with its many shades of yellow. It was obviously
painted with a matching sense of pleasure. It dates from the happiest period
of Van Gogh's life, when he was eagerly awaiting Gauguin's arrival, and it
really looked as if he would finally satisfy his 'need for gaiety and happiness,
for hope and love'.

Potential Energy

Iris, Messenger of the Gods, Auguste Rodin

ANTHONY CARO

> *Rodin has left out whatever is irrelevant, whatever distracts. There is one arm only, no head, no clothes on the body. It is not an illustration.*

Above
Rodin's crowded studio in Meudon, which would later become a museum. The sculpture of Balzac is clearly visible on the right.

c. 1895
Bronze
H. 48.6 cm / 1 ft 7 in.
Various collections

Maillol's sculptures lie back, waiting to be discovered. Rodin's sculptures reach out and grab you. It is assertive. Rodin transmits his feelings direct. Nothing comes between the emotion and the sculpture. *Iris, Messenger of the Gods* is a flying figure, a small masterpiece. Without being literally in mid-air, the work captures the feeling of flight. Rodin has left out whatever is irrelevant, whatever distracts. There is one arm only, no head, no clothes on the body. It is not an illustration. In the Summer Exhibition of the Royal Academy one used to see, year after year in the old days, little statues of dancers. They were correct in every detail, but were tired, lifeless illustrations of dancers posing. Rodin's small sculptures of dance movements on the other hand are nothing like these. They are all about energy, the energy of the dance expressed in three dimensions. So also, *Iris, Messenger of the Gods* is the embodiment, the sculptural equivalent of flying. It says 'flying' and it says 'sculpture'. It is almost abstract.

What an understanding of sculpture Rodin had! His oeuvre was very wide ranging. His portrait heads and his full-length statues marry the character of the sitter with the intensity and strength that Rodin brings to all his work. The great statues of Victor Hugo and of Balzac in his dressing-gown, give us the whole man, blemishes as well as strengths, there is no prettifying, the hair uncombed, the stomach distended. In fact, the figure of Iris was originally intended to be part of his *Monument to Victor Hugo*, but *Iris, Messenger of the Gods* is complete in itself. Rodin makes us focus on the expression of energy.

This is a relatively small work, but neither did Rodin shy away from the monumental. The *Gates of Hell* and the *Burghers of Calais* are great visionary works though they are never bombastic. At the Rodin Museum in Paris one can see the loose way in which he worked. Photos of Rodin's studio show unfinished work marked up in pencil, limbs to be removed or altered. Just as *Iris* was developed from a figure for another project, so he would cut off parts of his plaster models and collage on pieces of the other sculptures. He was a modeller, not a carver. He loved the malleability of clay and the look of the white plaster casts.

Although Rodin had some pieces translated by craftsmen into white Carrara marble, the works that are cast from the clay are what we are most familiar with. The dark tone of the patina unifies the work, even if it obscures the working method. That unconstrained way of working pointed the way for Picasso's sculpture and for many succeeding generations. It placed the emphasis squarely on feeling, which has been inherited by sculptors right up until the present time and which marks sculpture once again as high art.

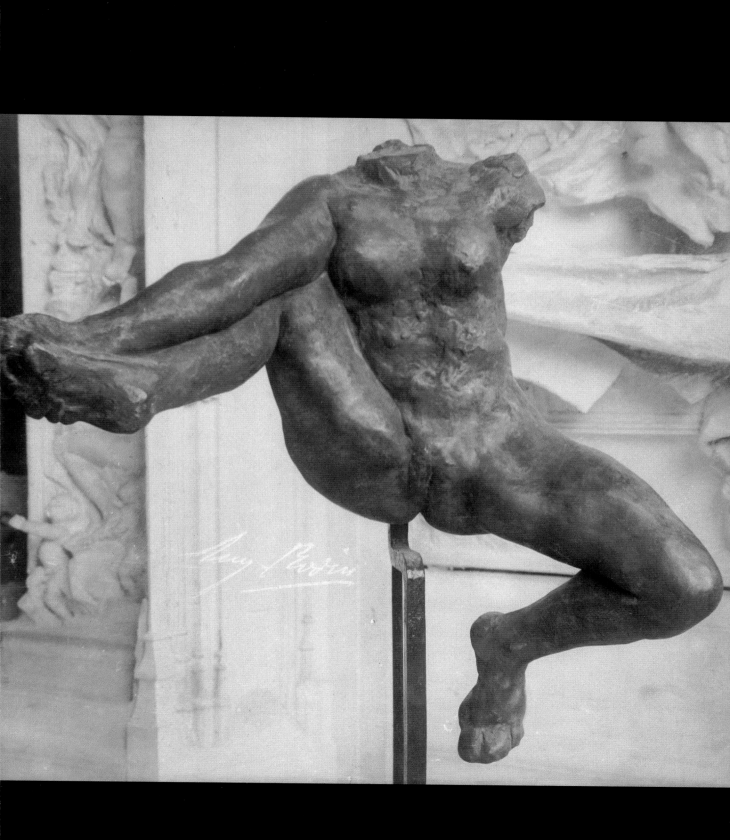

The Art of Arrangement

Apples and Oranges, Paul Cézanne

CHRISTOPHER DELL

> *Has Cézanne turned this still life into a landscape?*

Apples and Oranges has long been recognized as a pivotal work in Cézanne's output. Painted in his Paris studio, it was one of a series of works that showed the same rather mundane objects: apples, oranges, gaily painted earthenware, tablecloth, heavily patterned curtains, simple, dark furniture. Artists have always taken liberties with their subjects, adding here, subtracting there, nudging a tree to the left or introducing a ship on the horizon to suit the composition. That is the essence of art. But in a still life the artist can control the subject in the flesh as well as on the canvas. Cézanne seems to have acknowledged this when he said that he wanted to 're-do Poussin, but from nature'. Poussin famously modelled his compositions with miniature wax figures – for Cézanne it was apples and oranges.

He exploits the freedom offered by still life to the full, devising peculiar arrangements of fruit, fabric and furniture that defy immediate explanation. While we could, at a stretch, believe that Chardin had genuinely chanced upon a random group of pots and fruit in his pantry, Cézanne's composition is clearly the product of a very particular vision: we can imagine him poring over the disposition of the items, minutely adjusting the composition before seizing his brush to immortalize the contents of his kitchen. We can even imagine him bending down to retrieve the apples and oranges as the careful but precarious display succumbed to gravity.

Perspective is deliberately played with here. The assortment of cloths hung and crumpled, combined with the deliberately listing ceramic plate, merely mask the central issue: that under the white tablecloth there are (at least) two plausible positions for the table. At a first glance the horizontal line of loose fruit, and the nearly upright ceramic jug and compotier, suggest that the table stands parallel to the viewer. What confuses the eye is the twisted table-leg on the right hand side: bewilderingly, the light picks out the inside of the leg, something which would not be visible if the table were indeed horizontal. The twist suggests that the tabletop actually dives down vertiginously to the left, leaving the objects themselves defying gravity, and the viewer stranded between two perspectives.

The disorientation continues in the backdrop, which consists of two pieces of fabric of different patterns: on the left a jaunty diagonal pattern, and on the right a more conventional floral one. This contrast between geometric and natural forms embodies a tension that runs through the entire work. The material to the right, in particular, is folded into crevasses and peaks – for a fleeting moment we might even discern the outline of the artist's beloved Mont Sainte-Victoire in Provence. Has Cézanne turned this still life into a landscape? The fold to the left forms dark caves that make the oranges on their stand glow all the more brightly.

c. 1899
Oil on canvas
74 cm × 93 cm / 2 ft 5 in. × 3 ft 0½ in.
Musée d'Orsay, Paris

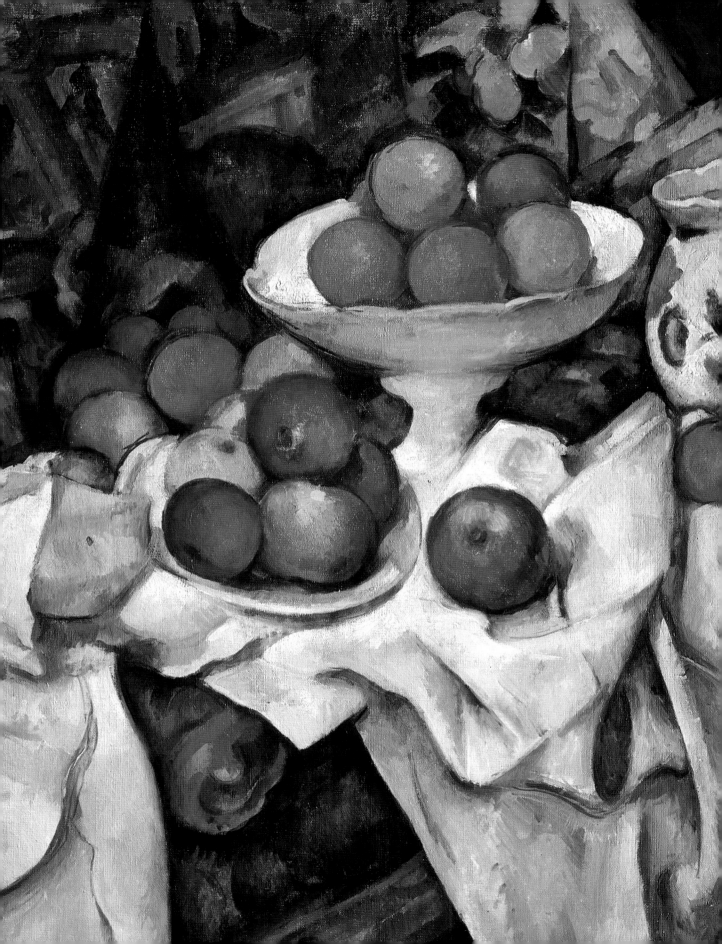

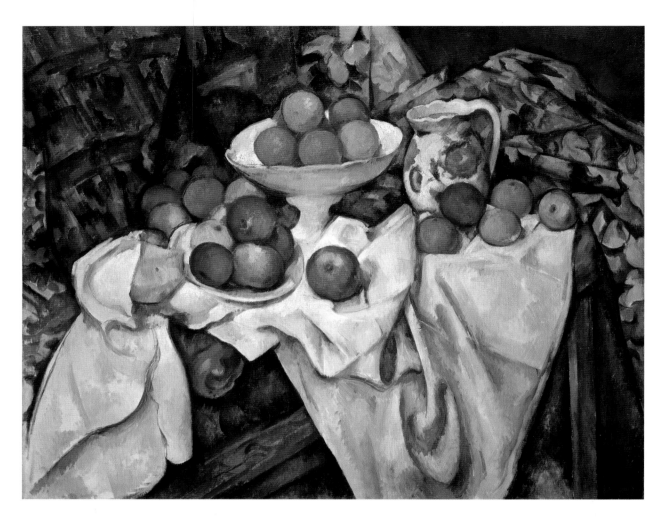

Above
Apples and Oranges is dominated by circles and clashing diagonals. The stark contrast between the white tablecloth and the dark material behind introduces a note of drama.

Right
In this earlier work, *Compotier, Pitcher and Fruit*, the fruit is loosely dispersed and appears in the lower part of the canvas. In the later work it is arranged into coherent groups towards the top, the bottom being filled with the lavish folds of the tablecloth. (*Compotier, Pitcher and Fruit*, 1892–94, oil on canvas, 72.5 cm × 91.8 cm / 2 ft 4¾ in. × 3 ft 0¼ in. The Barnes Foundation, Merion, Pennsylvania)

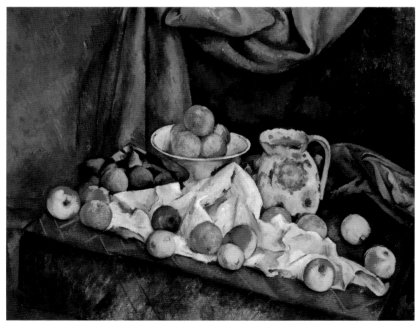

On top of this dark backdrop is draped the white tablecloth. So starched and artificial are the folds that it could almost be from a 15th-century Netherlandish painting. In fact, it is not remotely white, but a mixture of dirty yellows and blue-greys, an effect Cézanne may have imitated from the work of Monet. Now look more closely still: in a startling touch of realism Cézanne has represented earlier creases, where the tablecloth was neatly doubled and stowed away. It seems as though, while looking for props, he has raided the linen cupboard.

The tablecloth serves as the stage for the stars of the piece – the apples and oranges. Both come charged with meaning: apples evoke Eve, Original Sin, the Judgment of Paris. Oranges conjure up the south of France, Provence, sunshine. Yet Cézanne seems more interested in their form than their significance. The artist's fascination with geometrical shapes is well known, and grew more pronounced as he got older. Here he clearly revels in the spheres of the fruit set against the angles of the background. One of the apples – the lead apple – sits at the precise centre of the picture. The youthful Cézanne, never one for understatement, exclaimed: 'I am going to conquer Paris with an apple!' Many years later he did.

To appreciate fully how radical this work was, we may compare it with an earlier painting by Cézanne, the *Compotier, Pitcher and Fruit* (1892–94), today in the Barnes Collection in Philadelphia. The elements are almost identical, but the treatment is very different. The backdrop is sombre and sober, and the draped materials (all bland monotones) are gathered up in a single sweep that consumes the less animated top third of the painting. *Apples and Oranges* is, quite simply, more dramatic. Firstly the point of view is much closer to the objects; the frame forms fractured negative shapes around the periphery, imparting energy to the scene. The apples are also much closer together, and grouped so that they occupy only the centre of the canvas, whereas in *Compotier, Pitcher and Fruit* they spill haphazardly into the corners. One senses that Cézanne painted these apples with such zesty hues to compensate for the power they lost to the loose composition. And while in the earlier work we can still see the edge of the table, in the later it has been obliterated, cast into doubt by the shining white cloth. The effect in the later work is of a unified, integrated composition that effortlessly blends the decorative with the figural, filling every inch of the canvas.

Originally owned by the art critic Gustave Geffroy, who had written about Cézanne's work as early as 1895, *Apples and Oranges* entered the collection of the Louvre in 1911, just five years after the artist's death. Even then it was recognized as one of the most important still lifes of the late 19th century, not only great in its own right, but also important in the broader development of art. Its legacy, in the compression of background and foreground, sharp diagonals and limited tonal range, was Cubism. It was not for nothing that Picasso described Cézanne as 'the father of us all'.

Above
Although Cézanne is thought of principally as working in oils, he was also a master of watercolour painting, as can be seen from this self-portrait. (*c.* 1895, 28 cm × 26 cm / 11 in. × 10¼ in. Feilchenfeldt Collection, Zurich)

Down to Earth

Dust Motes Dancing in the Sunbeams (Sunbeams), Vilhelm Hammershøi

ANNE-BIRGITTE FONSMARK

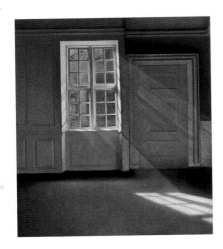

‘ *Sunbeams conjures up a disquieting atmosphere of strangeness. The ego is alone.*

Above
This silent, half-lit room seems devoid of significance. The viewer is compelled to examine the image entirely unaided, without the comforting interpretative structures of symbolism, history or religion.

1900
Oil on canvas
70 cm × 59 cm / 2 ft 3½ in. × 1 ft 11¼ in.
Ordrupgaard, Copenhagen

Dust Motes Dancing in the Sunbeams is one of the best-known works by Danish artist Vilhelm Hammershøi (1864–1916). The title is poetic, perhaps an attempt to incorporate a human dimension into a painting that is striking not for the presence of people, but for their absence. The room depicted in the image is empty, the only 'living' element being the encounter between the dust motes and the rays of light streaming in through a window, beaming past a door and then on down and across the floor. However, this poetic title was added later; Hammershøi himself used the rather less sentimental title *Sunbeams* (or *Sunshine*) when he exhibited the work.

Hammershøi would spend his entire life returning to a fairly small number of motifs, but is particularly known for his interiors. These are painted in low-key greys inspired by the Dutch painters of the 17th century. The rooms are often empty, but occasionally we see a woman dressed in black; this was Ida, Hammershøi's wife. Behind the external peace and harmony of his paintings there is often a sense of impending dissonance.

Sunbeams was painted in Hammershøi's apartment in an old building at Strandgade 30 in Christianshavn (now part of Copenhagen). He repeated this motif time and time again, with and without furniture, with and without people, but in *Sunbeams* it was at its most convincing, with an almost crystalline clarity. And yet the painting is something of an enigma. It does not depict the life lived in this home – despite the emptiness of the room, there is nothing to indicate that the bailiffs have just walked off with furniture belonging to a poor family (a popular theme among Danish artists of the 19th century).

The content is far subtler than that, and the light takes centre stage. Light was central to the works of Hammershøi, but in contrast to the Impressionists and the Danish painters of the early 19th century, this is not a light that reveals. Instead, it is used to disturb. In *Sunbeams* it takes on an almost physical tangibility, while by comparison the floor seems peculiarly ethereal and insubstantial. The light is depicted as a scientific phenomenon: this is the light of the sun, a light that, having travelled through the cosmos, finally reaches this Copenhagen home and ends its journey abruptly on the floor. It is a 'heavenly' light, but nothing like the divine light found in the Annunciation scenes of Botticelli or Piero della Francesca. The light in Hammershøi's painting creates a sense of doubt; doubt about our world, about Providence, about the existence of God.

Sunbeams conjures up a disquieting atmosphere of strangeness. The ego is alone. This painting depicts not only a physical room, but also a mental space; and more than anything else, it shows the existential loneliness of modern man. As such, it can be seen as one of the first depictions in the history of art of a state of mind, a full stop in the human psyche.

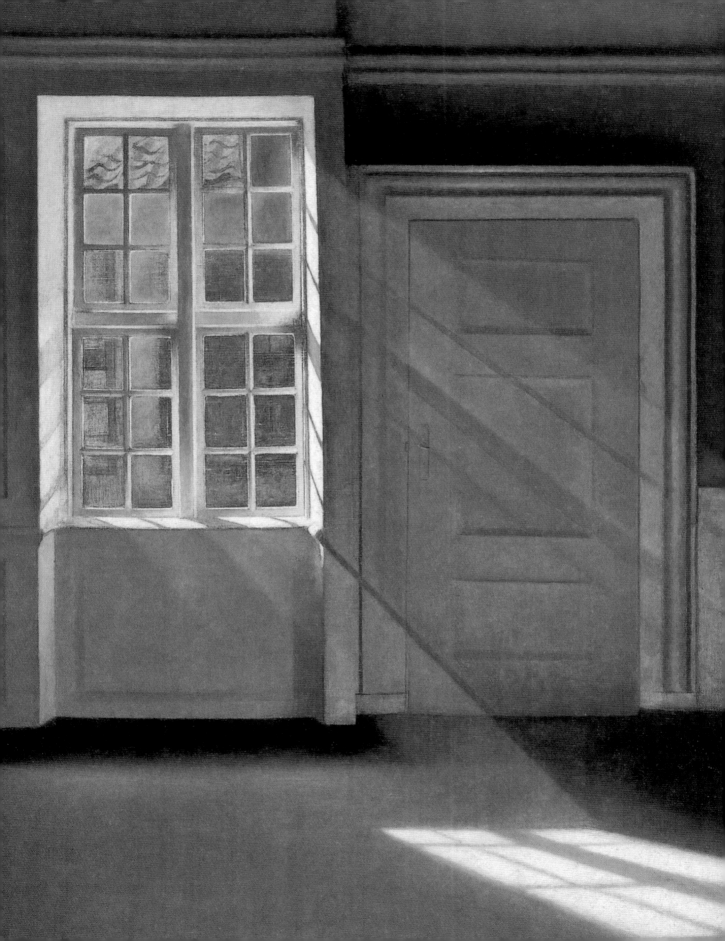

Further Reading

PART 1 THE BIRTH OF ART: UP TO 500 BC

The Chauvet Cave

J.-M. Chauvet, E. B. Deschamps and C. Hillaire, *Chauvet Cave: Discovery of the World's Oldest Paintings* (London, 1996)

J. Clottes, *Chauvet Cave: The Art of Earliest Times*, trans. P. G. Bahn (Salt Lake City, Utah, 2003)

J. Clottes, ed., *Return to Chauvet Cave*, trans. P. G. Bahn (London, 2003)

The Mycerinus Triad

D. Arnold, *Egyptian Art in the Age of the Pyramids* (New York and London, 1999) [exhibition catalogue]

B. von Bothmer, 'Notes on the Mycerinus Triad', *Bulletin of the Museum of Fine Arts*, 48 (1950)

M. Lehner, *The Complete Pyramids* (London and New York, 1997)

Olmec Colossal Head 8

J. Brügemann and M. A. Hers, 'Exploraciones arqueológicas en San Lorenzo Tenochtitlán', *Boletín del Instituto Nacional de Antropología e Historia*, 39 (1970), 18–23

M. D. Coe and R. A. Diehl, *In the Land of the Olmec*, 2 vols (Austin, Texas, 1980)

R. A. Diehl, *The Olmecs: America's First Civilization* (London and New York, 2004)

B. de la Fuente, *Escultura monumental olmeca* (Mexico City, 1973), 238–39

Ashurbanipal's Lion Hunt

R. D. Barnett, *Sculptures from the North Palace of Ashurbanipal at Nineveh* (London, 1976)

J. E. Reade, *Assyrian Sculpture* (London, 1983)

E. Weissert, 'Royal hunt and royal triumph in a prism fragment of Ashurbanipal', in S. Parpola and R. M. Whiting, eds, *Assyria 1995* (Helsinki, 1997), 339–58

The 'New York Kouros'

G. Richter, *Kouroi: Archaic Greek Youths. A Study of the Development of the Kouros Type in Greek Sculpture* (London, 1960), 41–42

A. Stewart, *Greek Sculpture: An Exploration* (New Haven, 1990), 111–13

PART 2 THE ART OF POWER: 500 BC–AD 1000

The 'Seven Against Thebes' Relief

R. Bianchi Bandinelli and A. Giuliano, *Etruschi e Italici prima del dominio di Roma* (Milan, 1973), 170–71, fig. 196

O. J. Brendel, *Etruscan Art* (Harmondsworth, 1978), 234–37, figs 163–64

G. Colonna, 'Il santuario di Pyrgi dalle origini mitistoriche agli altorilievi frontonali dei Sette e di Leucotea', *Scienze dell'Antichità*, 10 (2000), 309–25, figs 35–44

G. Colonna, ed., *L'altorilievo di Pyrgi: Dei ed eroi greci in Etruria* (Rome, 1996)

S. Haynes, *Etruscan Civilization: A Cultural History* (London, 2000), 179–81, fig. 154

E. Paribeni, 'La perplessità di Athena. Per una corretta lettura del frontone di Pyrgi', *Archeologia Classica*, 21/1 (1969), 53–57, plates XVII–XIX

The Ludovisi 'Throne'

L. Costamagna and C. Sabbione, *Una città in Magna Grecia Locri Epizefiri* (Reggio Calabria, 1990), 187–210, esp. 198

K. J. Hartswick, *The Gardens of Sallust: A Changing Landscape* (Austin, Texas, 2004), 119–30

J. M. Redfield, *The Locrian Maidens: Love and Death in Greek Italy* (Princeton, NJ, 2003)

The Riace Bronzes

J. Boardman, *Greek Sculpture: The Classical Period* (London, 1985)

A. Busignani, *The Bronzes of Riace* (Florence, 1981)

The Lady of Elche

Cien años de una dama (Madrid, 1997) [exhibition catalogue]

R. Olmos and T. Tortosa, eds, *La Dama de Elche: Lecturas desde la diversidad* (Madrid, 1997)

S. Rovira Llorens, ed., *La Dama de Elche* (Madrid, 2006)

The Villa of the Mysteries

M. Beard, *Pompeii: the life of a Roman town* (London, 2008)

B. Bergmann, 'Seeing women in the Villa of the Mysteries: a modern excavation of the Dionysiac murals', in V. C. Gardner Coates and J. L. Seydl, eds, *Antiquity Recovered: The legacy of Pompeii and Herculaneum* (Los Angeles, 2007), 231–69

R. Ling, *Roman Painting* (Cambridge, 1991)

A. Maiuri, *La Villa dei Misteri* (Rome, 1931)

The Equestrian Statue of Marcus Aurelius

J. Falus, 'Some iconographic questions of the equestrian statue of Marcus Aurelius', *Acta Historiae Artium Academiae Scientiarum Hungaricae*, 26 (1980)

P. P. Fehl, 'The placement of the equestrian statue of Marcus Aurelius in the Middle Ages', *Journal of the Warburg and Courtauld Institutes*, 36 (1974)

C. P. Presicce, *The Equestrian Statue of Marcus Aurelius in Campidoglio*, ed. A. M. Sommella (Milan, 1990)

The Buddha Preaching the First Sermon

Musée Guimet, *The Golden Age of Classical India: The Gupta Empire* (Paris, 2007)

J. Guy, *Indian Temple Sculpture* (London, V&A Publications, 2007)

J. C. Harle, *Gupta Sculpture* (London, 1974)

J. G. Williams, *The Art of Gupta India* (Princeton, 1982)

The Virgin and Child with Angels and Two Saints

H. Belting, *Likeness and Presence: A History of the Image Before the Era of Art* (Chicago, 1994), 129–32

R. Cormack, 'Reading Icons', *Valör: Konstvetenskapliga Studier*, 4 (1991) 1–28, esp. 8–16

R. Cormack, in M. Vassilaki, ed., *Mother of God: Representations of the Virgin in Byzantine Art* (Milan, 2000), 262–63

G. Sotiriou and M. Sotiriou, *Icônes du Mont Sinai*, 2 vols (Athens, 1956–58), vol. 1, 21–22

K. Weitzmann, 1, vol. 1: *From the Sixth to the Tenth Century* (Princeton, NJ, 1976), 18–21

Moche Portrait Vessel

C. B. Donnan, *Moche Art of Peru: PreColumbian Symbolic Communication* (Los Angeles, 1978)

C. B. Donnan, *Moche Portraits from Ancient Peru* (Austin, Texas, 2004)

J. W. Verano, 'Moche ceramic portraits', in J. Pillsbury, ed., *Moche Art and Archaeology in Ancient Peru* (Washington, DC, 2001)

'Coming of age in Moche portraits', *Minerva: The International Review of Ancient Art and Archaeology*, 16/2 (2005)

The Relief of Ahkal Mo' Nahb III

D. Stuart, *The Inscriptions from Temple XIX at Palenque: A Commentary* (San Francisco, 2005)

D. Stuart and G. Stuart, *Palenque: Eternal City of the Maya* (London and New York, 2008)

PART 3 THE BLENDING OF CULTURES: 1000–1300

Zhang Zeduan, *Spring Festival on the River*

J. Cahill, *The Painter's Practice: How Artists Lived and Worked in Traditional China* (New York, 1994)

M. K. Hearn, *How to Read Chinese Paintings* (New York, 2008)

A. Murck, *Poetry and Painting in Song China: The Subtle Art of Dissent*. Cambridge, Mass., 2000)

Yang Xin, Richard M. Barnhart and others, *Three Thousand Years of Chinese Painting* (New Haven, Conn., and London, 1997)

Vishnu Reclining on the Serpent Anantha

J. Boisselier, 'Notes sur l'art du bronze dans l'ancien Cambodge', *Artibus Asiae*, 29 (1968), 275–334

J. Guy, 'Angkorian metalwork in the temple setting: icons, architectural adornment and ritual paraphernalia', in L. Cort and P. Jett (eds), *Gods of Angkor: Bronzes from the National Museum of Cambodia*, (Washington, DC, 2010), 88–129

H. I. Jessup and T. Zephir, eds, *Sculpture of Angkor and Ancient Cambodia* (Washington, DC, and London, 1997)

The Vézelay Tympanum

C. Picard, 'Le mythe de Circé au tympan du grand portail de Vézelay', *Bulletin Monumental* (1945), 213–29

F. Salet, *La Madeleine de Vézelay: étude iconographique par Jean Adhémar* (Melun, 1948)

L. Saulnier-Pernuit and N. Stratford, *La Sculpture oubliée de Vézelay* (Paris, 1984)

E. Vergnolle, *L'Art roman en France* (Paris, 1994), 253–54

The Cefalù Mosaics

A. Cilento, *Byzantine Mosaics in Norman Sicily: Palermo, Monreale, Cefalù* (Udine, 2009)

O. Demus, *Byzantine Mosaic and Decoration: Aspects of Monumental Art in Byzantium* (London, 1947)

J. J. Norwich, *The Normans in Sicily* (Harmondsworth, 1992)

The Reclining Buddha of Polonnaruwa

J. Balasooriya, *The Glory of Ancient Polonnaruva* (Polonnaruwa, 2004)

S. Jos, 'Discovering Polonnaruwa', *The Hindu* (25 June 2006)

K. M. de Silva, *A History of Sri Lanka* (London, 1981)

UNESCO, *The Cultural Triangle of Sri Lanka* (Paris, 1993)

Unkei, *Muchaku* and *Seshin*

P. Mason, *History of Japanese Art* (New York, 1993)

S. Moran, 'The statue of Muchaku, Hokuendō Kōfukuji: a detailed study,' *Arts Asiatiques*, 5 (1958), 49–64

H. Mōri, *Japanese Portrait Sculpture* (Tokyo, New York and San Francisco, 1977)

H. Mōri, *Sculpture of the Kamakura Period* (New York and Tokyo, 1974)

The Stained Glass of Chartres Cathedral

P. Ball, *Universe of Stone: Chartres Cathedral and the Triumph of the Medieval Mind* (London, 2008)

C. Manhès-Deremble, *Les Vitraux narratifs de la Cathédrale de Chartres* (Paris, 1993)

M. Miller, *Chartres Cathedral: The Medieval Stained Glass and Sculpture* (London, 1980)

PART 4 A NEW BEGINNING: 1300–1500

Ife Copper Mask

L. Aronson, 'Ijebu Yoruba Aso Olona: a contextual and historical overview', *African Arts*, 25/3 (1992), 57

S. Blier, *Ancient Ife: Art, Dynasty, and the Birthplace of the Yoruba* (forthcoming)

S. Blier, 'Kings, crowns, and rights of succession: Obalufon arts at Ife and other Yoruba centers', *Art Bulletin*, 67/3 (1985), 73–91

H. J. Drewal and E. Schildkrout, *Kingdom of Ife: Sculptures from West Africa* (London, 2010) [exhibition catalogue]

E. Eyo, *Highlights of 2000 Years of Nigerian Art* (Lagos, 1976), pl. 15

E. G. Parrinder, *Religion in an African City* (London, 1953), 30F.

Willett, *The Art of Ife: A Descriptive Catalogue and Database* (Glasgow: Hunterian Museum and Art Gallery, 2004) [CD-ROM]

Giotto, The Scrovegni Chapel Frescoes

G. Basile, ed., *Giotto: The Frescoes of the Scrovegni Chapel in Padua* (Milan, 2002)

B. Cole, *Giotto: The Scrovegni Chapel, Padua, Great Fresco Cycles of the Renaissance* (New York, 1993)

A. Derbes and M. Sandona, eds, *The Cambridge Companion to Giotto* (Cambridge, 2004)

Water-Moon Avalokiteshvara

K. P. Kim, ed., *Goryeo Dynasty: Korea's Age of Enlightenment, 918–1392* (San Francisco: Asian Art Museum, 2003)

Y. Pak, 'Naksan legend and Water-Moon Avalokiteshvara (Suwol Kwanŭm) of the Koryŏ period', in N. N. Richard and D. E. Brix, eds, *The History of Painting in East Asia* (Taipei, 2008), 198–222

J. Smith, ed., *Arts of Korea* (New York: Metropolitan Museum of Art, 1998)

Claus Sluter, The 'Well of Moses'

S. Nash, 'Claus Sluter's "Well of Moses" for the Chartreuse de Champmol reconsidered', pts I–III, *Burlington Magazine*, 147 (2005), 798–809; 148 (2006), 456–69; 150 (2008), pp. 724–41.

S. Nash, 'Collaboration, colour and meaning: Claus Sluter, Jean Malouel and the polychromy of the Great Cross (the *Well of Moses*) at the Chartreuse de Champmol', in V. Brinkmann, M. Hollein and O. Primavesi (eds), *Circumlito: The Polychromy of Antique and Medieval Sculpture* (Frankfurt am Main, 2010)

S. Nash, *Northern Renaissance Art* (Oxford, 2008)

Hubert and Jan Van Eyck, *The Ghent Altarpiece*

E. Dhanens, *Van Eyck: The Ghent Altarpiece* (New York, 1973)

A. Dierick, *The Ghent Altarpiece: Van Eyck's Masterpiece Revisited*, trans. H. Brondeel (Ghent, 1996)

L. B. Philip, *The Ghent Altarpiece and the Art of Jan van Eyck* (Princeton, NJ, 1971)

W. H. J. Weale, *Hubert and John Van Eyck* (London, 1908)

Masaccio and Masolino, The Brancacci Chapel Frescoes

D. Amory, 'Masaccio's *Expulsion from Paradise*: a recollection of antiquity', *Marsyas*, 20 (1979–80), 7–10

U. Baldini and O. Casazza, *La capella Brancacci* (Milan, 1990)

O. Casazza, 'Il ciclo delle storie di San Pietro e la Historia salutatis', *Critica d'Arte*, 9 (1985), 77–82

K. Christiansen, 'Some observations on the Brancacci Chapel frescoes after their cleaning', *Burlington Magazine*, 133 (1991), 5–20

A. Molho, 'The Brancacci Chapel: studies in its iconography and history', *Journal of the Warburg and Courtauld Institute*, 40 (1977), 40–58

Fra Angelico (and Lorenzo Monaco), *The Deposition*

G. Bonsanti, *Beato Angelico: Catalogo completo* (Florence, 1998)

M. Eisenberg, *Lorenzo Monaco* (Princeton, NJ, 1989)

R. Jones, 'Palla Strozzi e la sagrestia di Santa Trinita', *Rivista d'Arte*, 37 (1984), 9–106

L. B. Kanter, 'A decade of transition, 1422–1432', in L. B. Kanter and P. Palladino, *Fra Angelico* (New York: Metropolitan Museum of Art, 2005), 79–87

A. Padoa Rizzo, 'Dal Gotico estremo al Rinascimento: la "Deposizione di croce" per Palla Strozzi di Lorenzo Monaco e del Beato Angelico', in G. Marchini and E. Micheletti, eds, *La Chiesa di Santa Trinita a Firenze* (Florence, 1987), 125–32

J. T. Spike, *Fra Angelico* (New York, 1996)

C. B. Strehlke, *Angelico* (Milan, 1998)

G. Vasari, *Lives of the Artists*, trans. J. C. Bondanella and P. Bondanella (Oxford, 1991)

Rogier van der Weyden, *The Descent from the Cross*

L. Campbell, *Van der Weyden* (New York, 1980), 7–9

L. Campbell and J. van der Stock, *Rogier van der Weyden, 1400–1464: Master of Passions* (Leuven, 2009), 18–21, 32–47

D. De Vos, *Rogier van der Weyden: The Complete Works* (New York, 1999), 10–41

V. Nieto Alcalde, *El 'Descendimiento' de Van der Weyden* (Madrid, 2003)

Donatello, *David*

F. Caglioti, *Donatello e i Medici: storia del David e della Giuditta*, 2 vols (Florence, 2000)

V. Herzner, 'David Florentinus', *Jahrbuch der Berliner Museen*, new series, 24 (1982), 63–142

H. Kauffmann, *Donatello: eine Einführung in sein Bilden und Denken* (Berlin, 1935)

S. B. McHam, 'Donatello's bronze David and Judith as metaphors of Medici rule in Florence', *Art Bulletin*, 83 (2001), 32–47

U. Pfisterer, *Donatello und die Entdeckung der Stile* (Munich, 2002)

A. W. B. Randolph, *Engaging Symbols: Gender, Politics, and Public Art in Fifteenth-century Florence* (New Haven, Conn., and London, 2002)

Aztec Eagle Knight

C. F. Klein, 'The ideology of autosacrifice at the Templo Mayor', in E. H. Boone, ed., *The Aztec Templo Mayor* (Washington, DC, 1987), 293–370

L. López Luján, *La Casa de las Águilas* (Mexico City, 2006)

Fray B. de Sahagún, *The Conquest of Mexico, Florentine Codex*, book 12, 1569, trans. A. J. O. Anderson and C. E. Dibble (Santa Fe, 1975)

Piero della Francesca, *The Montefeltro Altarpiece*

J. V. Field. *Piero della Francesca: A Mathematician's Art* (New Haven, Conn., 2005)

M. A. Lavin, *Piero della Francesca* (new edn, London, 2002)

M. Meiss with T. G. Jones, 'Once again Piero della Francesca's Montefeltro Altarpiece', *Art Bulletin*, 48 (1966), 203–06

Alessandro Botticelli, *The Birth of Venus*

A. Cecchi, *Botticelli* (Milan, 2005)

C. Dempsey, *The Portrayal of Love: Botticelli's*

Primavera and Humanist Culture at the Time of Lorenzo the Magnificent (Princeton, NJ, 1992)

H. P. Horne, *Alessandro Filipepi, commonly called Sandro Botticelli, Painter of Florence* (London, 1908; repr. 1980)

R. Lightbown, *Sandro Botticelli*, vol. 1: *Life and Work* (2nd edn, London and New York, 1989)

PART 5 PERFECTING THE ART: 1500–1600

Albrecht Dürer, *Self-Portrait*

G. Goldberg, B. Heimberg and M. Schawe, *Albrecht Dürer: die Gemälde in der Alten Pinakothek* (Heidelberg, 1998), 314–53

L. J. Koerner, *The Moment of Self-Portraiture in German Renaissance Art* (Chicago, 1993)

G. Kopp-Schmidt: 'Mit den Farben des Apelles: antikes Künstlerlob in Dürers Selbstbildnis von 1500', *Wolfenbütteler Renaissance-Mitteilungen*, 28 (2004), 1–24

E. Panofsky, *The Life and Art of Albrecht Dürer*, 2 vols (Princeton, NJ, 1943)

D. Wuttke, 'Dürer und Celtis: von der Bedeutung des Jahres 1500 für den deutschen Humanismus', *Journal of Medieval and Renaissance Studies*, 10 (1980), 73–129

P. Zitzlsperger, *Dürers Pelz und das Recht im Bild: Kleiderkunde als Methode der Kunstgeschichte* (Berlin, 2008)

Leonardo da Vinci, *Portrait of Lisa del Giocondo* (*Mona Lisa*)

S. Bramly, *Mona Lisa* (London, 1996)

M. Kempo, *Leonardo da Vinci: The Marvellous Works of Nature and Man* (rev. edn, Oxford and New York, 2006)

R. McMullen, *Mona Lisa: The Picture and the Myth* (Boston, 1975)

Giovanni Bellini, The San Zaccaria Altarpiece

O. Bätschmann, *Giovanni Bellini* (London, 2008)

P. Humfrey, *The Altarpiece in Renaissance Venice* (New Haven and London, 1993)

G. Robertson, *Giovanni Bellini* (Oxford, 1968)

Hieronymus Bosch, *The Garden of Earthly Delights*

H. Belting, *Hieronymous Bosch, Garden of Earthly Delights*, trans. I. Flett (New York, 2005)

C. D. Cuttler, *Northern Painting from Pucelle to Bruegel* (New York and London, 1968; rev. repr. 1991)

C. L. Virdis and M. Pietrogiovanna, *Gothic and Renaissance Altarpieces* (London, 2002)

Michelangelo, The Sistine Chapel Ceiling

R. King, *Michelangelo and the Pope's Ceiling* (New York, 2003)

P. de Vecchi, ed., *The Sistine Chapel: A Glorious Restoration* (New York, 1994)

W. E. Wallace, *Michelangelo: The Complete Sculpture, Painting, Architecture* (New York, 1998)

Raphael, *The School of Athens*

M. B. Hall, ed., *Raphael's School of Athens*, Masterpieces of Western Art (Cambridge and New York, 1997)

C. L. Joost-Gaugier, *Raphael's Stanza della Segnatura: Meaning and Invention* (Cambridge and New York, 2002)

B. Kempers, 'Words, images, and all the Pope's men: Raphael's Stanza della Segnatura and the synthesis of divine wisdom', in I. Hampsher-Monk, Karin Tilmans and Frank van Vree, eds, *History of Concepts: A Comparative Perspective* (Amsterdam, 1998), 131–65

Matthias Grünewald, *The Isenheim Altarpiece*

Grünewald und seine Zeit (Berlin, 2007) [exhibition catalogue]

A. Hayum, *The Isenheim Altarpiece: God's Medicine and the Painter's Vision* (Princeton, 1989)

R. Mellinkoff, *The Devil at Isenheim: Reflections of Popular Belief in Grünewald's Altarpiece* (Berkeley and Los Angeles, 1988)

W. K. Zülch, *Der historische Grünewald* (Munich, 1938)

Titian, *The Assumption of the Virgin*

F. da Mosto, *Francesco's Venice* (London, 2004)

C. Hope and others, *Titian*, ed. D. Jaffé (London, 2004) [exhibition catalogue]

P. Humfrey, *Titian: The Complete Paintings* (Ghent, 2007)

Sultan Muhammad, *The Court of Gayumars*

Abu al-Qasim Firdawsi, *Shahnameh: The Persian Book of Kings*, trans. D. Davis (New York, 2006)

S. R. Canby, *Persian Painting* (London and New York, 1993)

M. B. Dickson and S. C. Welch, *The Houghton Shahnameh*, 2 vols (Cambridge, Mass., 1981)

Dust Muhammad, 'Preface to the Bahram Mirza Album', in *Album Prefaces and Other Documents on the History of Calligraphers and Painters*, trans. W. M. Thackston (Leiden, 2001)

R. Hillenbrand, 'The iconography of the Shah-nama-yi Shahi', *Pembroke Papers*, 4 (1996), 53–78

D. J. Roxburgh: 'Micrographia: toward a visual logic of Persianate painting', *RES: Anthropology and Aesthetics*, 43 (spring 2003), 13–30

Qiu Ying and Lu Shidao, *Pavilions in the Mountains of the Immortals*

C. Clunas, *Empire of Great Brightness: Visual and Material Cultures of Ming China, 1368–1644* (London, 2007)

Wen C. Fong and J. C. Y. Watt, *Possessing the Past: Treasures from the National Palace Museum, Taipei* (New York and Taipei, 1996) [exhibition catalogue]

E. J. Laing, 'Qiu Ying's late landscapes', *Oriental Art*, 43/1 (1997), 28–36

Pieter Bruegel the Elder, *The Proverbs*

A. Dundes and C. Stibbe, *The Art of Mixing Metaphors: A Folkloristic Interpretation of the 'Netherlandish Proverbs' by Pieter Bruegel the Elder* (Helsinki, 1981)

W. Fraenger, *Der Bauern-Bruegel und das deutsche Sprichwort* (Zurich, 1923)

R. Grosshans, *Pieter Bruegel d. Ä: die niederländischen Sprichwörter* (Berlin, 2003)

R. H. Marijnissen and others, *Bruegel: tout l'œuvre peint et dessiné* (Antwerp and Paris, 1988), 133–45

M. A. Meadow, *Pieter Bruegel the Elder's 'Netherlandish Proverbs' and the Practice of Rhetoric* (Zwolle, 2002)

M. A. Sullivan, 'Bruegel's Proverbs: art and audience in the northern Renaissance', *Art Bulletin*, 73 (1991), 431–66

Tintoretto, *The Crucifixion*

E. Newton, *Tintoretto* (London and New York, 1952)

B. Robb, *Brian Robb on Tintoretto's San Rocco 'Crucifixion'*, Painters on Painting, (London, 1969)

El Greco, *The Funeral of the Count of Orgaz*

X. Bray, *El Greco: The Greek of Toledo* (London, 2004)

D. Davies, *El Greco* (Oxford, 1976)

D. Davies, ed., *El Greco* (London, 2003; New York, 2004) [exhibition catalogue]

PART 6 PAST AND PRESENT: 1600–1800

Caravaggio, *The Supper at Emmaus*

H. Langdon, *Caravaggio: A Life* (London, 1999)

C. Puglisi, *Caravaggio* (London, 1998)

J. T. Spike, *Caravaggio* (New York and London, 2001) [with CD-ROM catalogue]

Artemisia Gentileschi, *Judith Slaying Holofernes*

K. Christiansen and J. Mann, *Orazio and Artemisia Gentileschi: Father and Daughter, Painters in Baroque Italy* (New York, New Haven, Conn., and London, 2001) [exhibition catalogue]

M. D. Garrard, *Artemisia Gentileschi* (New York, 1993)

G. Greer, *The Obstacle Race: The Fortunes of Women Painters and their Work* (London, 1979)

Bichitr, *Portrait of Jahangir Preferring a Sufi Shaikh to Kings*

J. Guy and D. Swallow, *Arts of India, 1550–1900* (London, 1990)

F. S. Kleiner and C. J. Mamiya, *Gardner's Art Through the Ages: Non-Western Perspectives* (13th edn, Boston, 2009)

S. C. Welch, *Imperial Mughal Painting* (New York, 1978)

Peter Paul Rubens, *Minerva Protects Pax from War*

M. Lamster, *Master of Shadows* (New York, 2009)

G. Martin, *Rubens: The Ceiling Decoration of the Banqueting Hall* (London, 2005)

Rembrandt van Rijn, *The Night Watch*

H. Berger Jr., *Manhood, Marriage and Mischief: Rembrandt's 'Night Watch' and Other Dutch Group Portraits* (New York, 2006)

G. Schwartz, *Rembrandt's Universe: His Art, his Life, his World* (London, 2006)

Gianlorenzo Bernini, *The Ecstasy of Saint Teresa*

G. Careri, *Bernini: Flights of Love, the Art of Devotion*, trans. L. Lappin (Chicago, 1995)

G. Deleuze, *The Fold: Leibniz and the Baroque*, trans. T. Conley (Minneapolis, 1993)

H. Hibbard, *Bernini* (Harmondsworth, 1965)

I. Lavin, *Bernini and the Unity of the Visual Arts* (New York, 1980)

I. Lavin, ed., *Gianlorenzo Bernini: New Aspects of his Art and Thought: A Commemorative Volume* (Pennsylvania, 1986)

J. Pope-Hennessy, *An Introduction to Italian Sculpture*, vol. 3: *Italian High Renaissance and Baroque Sculpture* (4th edn, London, 1996)
The Life of Saint Teresa of Avila, trans. J. M. Cohen (London, 1957)
R. Wittkower, *Bernini: The Sculptor of the Roman Baroque* (4th edn, London, 1955)

Nicolas Poussin, The Phocion Paintings
A. Blunt, *The Paintings of Nicolas Poussin* (London, 1966)
R. Verdi and P. Rosenberg, *Nicolas Poussin, 1594–1665* (London, 1995) [exhibition catalogue]

Diego Velázquez, *Las Meninas*
A. de Beruete, *Velázquez* (Paris, 1898)
E. Harris, *Complete Studies on Velázquez* (Madrid, 2006)
J. Lopez-Rey, *Velázquez*, 2 vols (Cologne, 1996)

Johannes Vermeer, *The Art of Painting*
I. Gaskell and M. Jonker, eds, *Vermeer Studies* (Washington, DC, and New Haven, Conn., 1998)
W. A. Liedtke, *Vermeer: The Complete Paintings* (Antwerp and New York, 2008) [exhibition catalogue]
W. A. Liedtke, with M. C. Plomp and A. Rüger, *Vermeer and the Delft School* (New Haven, Conn., 2001) [exhibition catalogue]
J. M. Montias, *Vermeer and his Milieu: A Web of Social History* (Princeton, NJ, 1989)
A. K. Wheelock, Jr., *Johannes Vermeer: The Art of Painting* (Washington, DC, 1999) [exhibition catalogue]
A. K. Wheelock, Jr., *Vermeer and the Art of Painting* (New Haven, CT, 1995)

Jean-Baptiste-Siméon Chardin, *The Jar of Olives*
P. Rosenberg, *Chardin, 1699–1779*, trans. E. P. Kadish and U. Korneitchouk (Cleveland, Ohio, 1979) [exhibition catalogue]
P. Rosenberg and others, *Chardin*, trans. C. Beamish (New Haven, Conn., 2000) [exhibition catalogue]

Utamaro, 'Lovers' from the *Poem of the Pillow*
S. Asano and T. Clark, eds., *The Passionate Art of Kitagawa Utamaro* (Tokyo and London, 1995), 279
J. N. Davis, *Utamaro and the Spectacle of Beauty* (London and Honolulu, 2007)

PART 7 TOWARDS THE MODERN WORLD: AFTER 1800

Francisco de Goya, *The Third of May, 1808*
J. M. Alía Plana, *Dos días de mayo de 1808 en Madrid, pintados por Goya* (Madrid, 2004)
R. Andioc, 'Algo más (o menos?) sobre el Tres de mayo de Goya', *Goya*, 265–66 (1998), 194–203
R. Andioc, 'En torno a los cuadros del Dos de Mayo', *Boletín del Museo e Instituto Camón Aznar*, 51 (1993), 133–66
J. Bâticle, 'Le 2 et le 3 Mai 1808 à Madrid: Recherche sur les épisodes choisis par Goya', *Gazette des Beaux-Arts*, 116 (1990), 185–200
M. Mena Marqués and others, *Goya en tiempos de guerra* (Madrid, 2008) [exhibition catalogue]
H. Thomas, *Goya: The Third of May 1808*

(London, 1972)
C. Yriarte, *Goya: sa biographie, les fresques, les toiles, les tapisseries, les eaux-fortes et le catalogue de l'œuvre avec cinquante planches inédites* (Paris, 1867)

Caspar David Friedrich, *The Wanderer above the Sea of Mist*
H. Börsch-Supan and K. W. Jähnig, *Caspar David Friedrich: Gemälde, Druckgraphik und bildmässige Zeichnungen* (Munich, 1973)
W. Busch, *Caspar David Friedrich: Ästhetik und Religion* (Munich, 2003)
W. Hofmann, ed., *Caspar David Friedrich, 1774–1840* (Munich, 1974) [exhibition catalogue]
J. L. Koerner, *Caspar David Friedrich and the Subject of Landscape* (London, 1990)
H. Gassner, *Caspar David Friedrich: die Erfindung der Romantik* (Munich, 2006) [exhibition catalogue]

Eugène Delacroix, *Liberty Leading the People*
B. Jobert, *Delacroix* (Princeton, 1998)
A. Sérullaz and V. Pomarède, *Eugène Delacroix, 'La Liberté guidant le peuple'* (Paris, 2004)
H. Toussaint, *'La Liberté guidant le peuple' de Delacroix* (Paris, 1982)

J. M. W. Turner, *The Burning of the Houses of Lords and Commons, October 16, 1834*
M. Butlin and E. Joll, *The Paintings of J. M. W. Turner* (rev. edn, New Haven, Conn., and London, 1984), nos 359, 364
R. Dorment, *British Painting in the Philadelphia Museum of Art from the Seventeenth through the Nineteenth Century* (Philadelphia, 1986), 396–405
K. Solender, *Dreadful Fire! Burning of the Houses of Parliament* (Cleveland, Ohio, 1984) [exhibition catalogue]

Thomas Cole, *The Oxbow*
M. Baigell and A. Kaufman, 'Thomas Cole's "Oxbow": a critique of American civilization', *Arts Magazine*, 55/5 (1981), 136–39
D. Bjelajac, 'Thomas Cole's Oxbow and the American Zion divided', *American Art*, 20 (2006), 60–83
T. Cole, 'Essay on American Scenery', *American Monthly Magazine*, 1 (January 1836), 1–12
B. Novak, *American Painting of the Nineteenth Century: Realism, Idealism, and the American Experience* (3rd edn, Oxford, 2006)
E. C. Parry, 'Overlooking the Oxbow: Thomas Cole's "View from Mount Holyoke" revisited', *American Art Journal*, 34 (2003), 6–61
O. R. Roque, '"The Oxbow" by Thomas Cole: iconography of an American landscape painting', *Metropolitan Museum Journal*, 17 (1982), 63–74
A. Wallach, 'Making a picture of the view from Mt. Holyoke', in D. C. Miller, ed., *American Iconology: New Approaches to Nineteenth-Century Art and Literature* (New Haven, Conn., 1995), 80–91, 310–12

Claude Monet, *Wild Poppies*
J. House, *Impressionism: Paint and Politics* (New Haven, CT, 2004)
P. Smith, *Impressionism: Beneath the Surface* (London, 1995)
B. Thomson, *Impressionism: Origins, Practice,*

Reception (London, 2000)

Edgar Degas, *La Petite Danseuse de quatorze ans*
P. Cabanne, *Edgar Degas* (Paris, 1957); Eng. trans. M. L. Landa (Paris and New York, n.d. [1958])
J.-K. Huysmans, *Écrits sur l'art: 1867–1905* (Paris, 2006)
T. Reff, *Degas: The Artist's Mind* (London and New York, 1976)

Édouard Manet, *The Bar at the Folies-Bergère*
F. Cachin, *Manet: Painter of Modern Life* (London, 1995)
T. J. Clark, *The Painting of Modern Life: Paris in the Art of Manet and his Followers* (Princeton, NJ, 1985)
J. Cuno and J. Kaak, eds, *Manet: Face to Face* (Munich, 2004) [exhibition catalogue]
R. King, *The Judgment of Paris: The Revolutionary Decade that Gave the World Impressionism* (New York, 2006)

Vincent Van Gogh, *Sunflowers*
R. Dorn, *Décoration: Vincent van Goghs Werkreihe für das Gelbe Haus in Arles* (Hildesheim, Zürich and New York, 1990)
R. Dorn, 'Van Gogh's Sunflowers series', *Van Gogh Museum Journal* (1999), 42–61
L. van Tilborgh, *Van Gogh and the Sunflowers* (Amsterdam, 2008)
L. van Tilborgh and E. Hendriks, 'The Tokyo Sunflowers: a genuine repetition by Van Gogh or a Schuffenecker forgery?', *Van Gogh Museum Journal* (2001), 16–43

Auguste Rodin, *Iris, Messenger of the Gods*
M. Busco and D. Finn, *Rodin and his Contemporaries: The Iris & B. Gerald Cantor Collection* (New York, 1991)
Metropolitan Museum of Art, *Auguste Rodin: Iris, Messenger of the Gods, also known as Another Voice, Called Iris*, Heilbrunn Timeline of Art History (New York, 2006)
W. Tucker, *The Language of Sculpture* (2nd edn, London, 1974)

Paul Cézanne, *Apples and Oranges*
J. Rewald, *Cézanne: A Biography* (New York, 1996)
D. Sylvester, *About Modern Art: Critical Essays 1948–96* (London, 1996)

Vilhelm Hammershøi, *Dust Motes Dancing in the Sunbeams* (*Sunbeams*)
Hammershøi (London, 2008) [exhibition catalogue]
Hammershøi, Dreyer: The Magic of Images (Copenhagen, 2006) [exhibition catalogue]
P. Vad, *Vilhelm Hammershøi and Danish Art at the Turn of the Century* (New Haven and London, 1992)
Vilhelm Hammershøi, 1864–1916: Danish Painter of Solitude and Light (Copenhagen, 1998) [exhibition catalogue]

Contributors

AVIGDOR ARIKHA is an Israeli and French citizen, who survived the Holocaust and studied art at the Bezalel Academy in Jerusalem. During his career as an artist he has painted commissioned portraits of, among others, Queen Elizabeth, the Queen Mother. Recent retrospectives of his work have taken place at the Museo Thyssen Bornemisza (2008) and the British Museum (2006). He has lectured on art at the Louvre, the Prado and the Frick Collection.

GIUSEPPE BASILE was a student of the pioneer of art conservation and restoration Cesare Brandi. He was director of the Istituto Centrale del Restauro in Rome (1976–2008), and is now Professor of the Theory and History of Restoration at the Sapienza University. His restoration projects include the Scrovegni Chapel, the basilica of San Francesco at Assisi, the Palazzo del Te in Mantua and Leonardo da Vinci's *Last Supper* at Santa Maria delle Grazie in Milan. He has published widely on conservation and restoration.

MARY BEARD is Professor of Classics at the University of Cambridge, where she has taught for the last twenty-five years. She has written numerous books on the ancient world, including *The Roman Triumph: Classical Art from Greece to Rome* (2007) and the Wolfson Prize-winning *Pompeii: The Life of a Roman Town* (2008). She is Classics editor of the *Time Literary Supplement* and writes an engaging, often provocative, blog, 'A Don's Life'. In 2008 she was visiting Sather Professor at the University of California, Berkeley, where she lectured on Roman laughter, one of her current research interests.

QUENTIN BLAKE is one of the world's most beloved illustrators. Perhaps best known for his children's books and collaborations with Roald Dahl, he has recently worked extensively for the wards of hospitals in England and France. Since 2000 he has also curated exhibitions at, among other places, the National Gallery, London, the British Library and the Musée du Petit Palais in Paris.

SUZANNE PRESTON BLIER is Allen Whitehill Clowers Professor of Fine Art and African and African American Studies at Harvard University. She has done extensive research in the West African countries of Benin and Togo and has been active in bringing African art into the mainstream of art historical study. She has published numerous articles and books, curated exhibitions, and is editor-in-chief of 'Baobab: Visual Sources in African Visual Culture', an interactive database of images on African art and material culture.

XAVIER BRAY is Assistant Curator of 17th- and 18th-century European Painting at the National Gallery, London, where he has co-curated and curated a number of exhibitions, including 'Orazio Gentileschi at the Court of Charles I' (1998–99), 'The Image of Christ: Seeing Salvation' (2000), 'Goya's *Family of the Infante Don Luis*' (2001–02),

'El Greco' (2004), 'Caravaggio' (2005), 'Velázquez' (2006) and 'The Sacred Made Real: Spanish Painting and Sculpture, 1600–1700' (2009). He is now working on an exhibition of Goya's portraits.

WERNER BUSCH holds the Chair in Art History at the Freie Universität, Berlin. He studied in Tübingen, Freiburg, Vienna and London, and then taught at the universities of Bonn and Bochum. He is a Member of the Berlin-Brandenburg Academy of Sciences and Humanities. His many publications on European art include studies of Netherlandish art of the 16th and 17th centuries, and English art of the 18th and 19th centuries.

The sculptor ANTHONY CARO worked as a part-time assistant to Henry Moore during the 1950s. He began in the 1960s to create abstract metal sculptures and his work has been the subject of numerous exhibitions and retrospectives at (among other galleries) the Whitechapel Art Gallery, the Rijksmuseum, the Hayward Gallery, Tate Britain and the Museum of Modern Art in New York. With the architect Norman Foster and the engineer Chris Wise, he designed the Millennium Bridge, which spans the Thames from St Paul's Cathedral to Tate Modern.

ORNELLA CASAZZA works in the Superintendency of Artistic and Historical Heritage of Florence, where she heads the Department for the Study and Application of Advanced Technologies. She directed the restoration of the frescoes by Masaccio, Masolino and Filippo Lippi in the Brancacci Chapel of the Carmine church in Florence. She has produced various important studies on conservation and especially iconography, and currently teaches at the International University of Art Restoration in Florence and theory and techniques of restoration at the University of Pisa. She is the co-author of *The Brancacci Chapel* (1992).

JEAN CLOTTES is an internationally acclaimed expert on cave painting and world rock art. He researched the Chauvet Cave and has served as a scientific adviser to the French Ministry of Culture. He is the former chairman of ICOMOS's International Committee of Rock Art and the honorary president of the Société Préhistorique Française.

CRAIG CLUNAS is Professor of the History of Art at the University of Oxford. He has worked at the University of Sussex, at the School of Oriental and African Studies, University of London, and as a curator at the Victoria and Albert Museum. His most recent book is *Empire of Great Brightness: Visual and Material Cultures of Ming China, 1368–1644* (2007).

MICHAEL D. COE is Professor of Anthropology, Emeritus, at Yale University. He has specialized in the archaeology of the Maya civilization and the Olmec culture of southern Mexico. He is a Member of the National Academy of Sciences,

and has received the Order of the Quetzal from the government of Guatemala.

GIOVANNI COLONNA is Professor Emeritus of Etruscology and Italic Archaeology at the University of Rome La Sapienza, where he has taught since 1980. He has excavated in Pyrgi, Veii and other Etruscan sites around Viterbo. His publications include a selection of his essays, entitled *Italia ante Romanum Imperium* (2005). A Fellow of the Accademia dei Lincei, the Swedish Royal Academy, the Institut de France and the Archaeological Institute of America, he is also Vice-President of the Istituto Nazionale di Studi Etruschi e Italici.

PAINTON COWEN is an expert on the history and iconography of stained glass, and his interest in Chartres dates from 1973, since when he has been visiting and photographing the cathedral and its windows. His publications include *The Rose Window* (2005) and *English Stained Glass* (2008), both for Thames & Hudson, *A Guide to Stained Glass in Britain* (1984) and *Six Days: The Story of the Making of the Chester Cathedral Creation Window* (2003).

JULIE NELSON DAVIS is Associate Professor of Modern East Asian Art at the University of Pennsylvania. She received her PhD from the University of Washington, studied at Gakushūin University, and was a Fellow of the Sainsbury Institute for the Study of Japanese Arts and Cultures. She is the author of *Utamaro and the Spectacle of Beauty* (2007) and numerous articles on *ukiyo-e*.

CHRISTOPHER DELL is a writer and art historian based in Barcelona. He studied at Winchester School of Art and the Courtauld Institute of Art, and has worked at the National Gallery, London, and the Architectural Association, for the Corpus Vitrearum Medii Aevi (a medieval stained glass research project), and in art publishing.

CHRISTOPHER B. DONNAN is Emeritus Professor of Anthropology at the University of California, Los Angeles. Considered one of the word's foremost authorities on the Moche, he has studied Moche civilization for more than four decades, combining the systematic analysis of Moche art with numerous archaeological excavations in Peru.

JAS̀ ELSNER is the Humfry Payne Senior Research Fellow in Classical Art at Corpus Christi College, Oxford, and Visiting Professor of Art History at the University of Chicago. His books include *Art and the Roman Viewer* (1995), *Imperial Rome and Christian Triumph* (1998) and *Roman Eyes: Visuality and Subjectivity in Art and Text* (2007).

SUSAN TOBY EVANS is an archaeologist at the Pennsylvania State University, specializing in the Aztecs of Mexico. Her recent publications include *Art of Ancient Mexico* (2010) and *Ancient Mexico*

and Central America: Archaeology and Culture History (2004; 2nd edn 2008), winner of the Society for American Archaeology's book award.

GABRIELE FINALDI gained his doctorate from the Courtauld Institute of Art while working at the National Gallery, London, as Curator of Later Italian and Spanish Painting. He is now Deputy Director for Collections and Research at the Museo del Prado, Madrid. He is the co-author of the exhibition catalogues *Discovering the Italian Baroque* (1997) and *The Image of Christ* (2000), and has curated exhibitions on Genoese Baroque painting, Orazio Gentileschi and Jusepe de Ribera.

ANNE-BIRGITTE FONSMARK is Director of the Ordrupgaard, Copenhagen, the Danish museum of French Impressionism and Danish nineteenth-century art. As an art historian she has specialized in French art of the 19th century, Impressionism and the early works of Paul Gauguin in particular, as well as in Danish art of the 19th century.

JEAN-RENÉ GABORIT is a distinguished scholar of Italian and French sculpture, and has published widely on the Romanesque and Gothic periods in France. He worked for many years for the Department of Sculpture at the Louvre, latterly as its head, where he was also responsible for the conservation of the collection. He organized a number of exhibitions for the museum, including the landmark 'La France Roman' in 2005. He is now Conservateur Général Honoraire du Patrimoine.

Over the last twenty-five years, ANTONY GORMLEY has revitalized the human image in sculpture through a radical investigation of the body as a place of memory and transformation, evident in large-scale installations like *Another Place*, *Domain Field* and *Inside Australia*, and more recent works, such as *Clearing*, *Blind Light* and *Another Singularity*.

GERMAINE GREER is the author of *The Obstacle Race: The Fortunes of Women Painters and their Work* (1979, reissued 2001) and *The Boy* (2003), a study of the iconography of the adolescent male in Western art. She writes a fortnightly column on art and related issues for *The Guardian*. Her latest full-length book is *Shakespeare's Wife* (2007).

JOHN GUY is Curator of South and Southeast Asian Art at the Metropolitan Museum of Art, New York, and an elected Fellow of the Society of Antiquaries, London. He has worked on a number of archaeological excavations and served as an adviser to UNESCO on historical sites in Southeast Asia. He has curated a number of exhibitions – for the Victoria and Albert Museum and the Royal Academy in London, La Caixa Foundation in Barcelona and the Metropolitan Museum, among others – and his many publications include *Arts of India: 1550–1900* (1990), *Indian Art and Connoisseurship* (1995), *Indian Temple Sculpture* (2007) and *Indian Textiles in the East* (2009).

JOHN HOUSE studied at the Courtauld Institute of Art, where he retired as Walter H. Annenberg Professor in 2010. He taught at the University of East Anglia (1969–76) and was Slade Professor at the University of Oxford in 1987. He has been involved in the organization of many exhibitions, most recently 'Impressionism by the Sea' (Royal Academy of Arts, Phillips Collection, and Wadsworth Atheneum, Hartford, 2007–8). His many publications on French art of the mid-to late 19th century include *Monet: Nature into Art* (1986).

PETER HUMFREY is Professor of Art History at the University of St Andrews and a Fellow of the Royal Society of Edinburgh. His many publications on Venetian art of the 15th and 16th centuries include *Cima da Conegliano* (1983), *The Altarpiece in Renaissance Venice* (1993) and *Titian* (2007).

DAVID JAFFÉ was educated in Australia, went on to lecture at the University of Queensland, and later became a curator at the Australian National Galley, Canberra. He worked at the Getty in Los Angeles, before being appointed Senior Curator at the National Gallery, London, where he has curated exhibitions on Rubens and Titian. He is a contributor to the *Burlington Magazine*, and his other publications include a book on Rubens's *Massacre of the Innocents* (2003).

PAUL JOANNIDES is Professor of Art History in the Department of History of Art at the University of Cambridge. He has published widely on topics from the Italian Renaissance, including books and catalogues on Michelangelo, Raphael and Titian and articles on a wide variety of related subjects, among them an essay on Botticelli's late work.

BARTHÉLEMY JOBERT is Professor of Modern and Contemporary Art at the University of Paris Sorbonne. He formerly worked in the Print and Photography Department of the Bibliothèque Nationale de France. A specialist in the work of Eugène Delacroix, he is currently preparing a new, electronic, edition of the artist's correspondence – a collaboration between the Sorbonne and the Musée du Louvre / Musée Delacroix – and writing a general history of 19th-century French painting.

MARTIN KEMP FBA is Emeritus Professor in the History of Art at Trinity College, Oxford. He has written, broadcast and curated exhibitions on imagery in art and science from the Renaissance to the present day. He has published extensively on Leonardo da Vinci, including the prize-winning *Leonardo da Vinci: The Marvellous Works of Nature and Man* (1981; rev. edn 2006).

STEPHAN KEMPERDICK is Curator of Early Netherlandish and Early German Paintings at the Gemäldegalerie in Berlin. He has published important works on the Master of Flémalle and Rogier van der Weyden (1997), Martin Schongauer (2004) and early portraiture (2006).

JOSEPH LEO KOERNER is the Thomas Professor of the History of Art at Harvard University. His books include *Caspar David Friedrich and the Subject of Landscape* (1990), *The Moment of Self-Portraiture* (1993) and *The Reformation of the Image* (2004). He is currently completing a book on Hieronymus Bosch and Pieter Bruegel.

HELEN LANGDON is an art historian and biographer with a special interest in the art of the Italian Baroque. She was formerly Assistant Director of the British School in Rome. She has written on Claude Lorrain and Salvator Rosa, and her *Caravaggio: A Life* was published in 1998. She was the curator of the Dulwich Picture Gallery's exhibition 'Salvator Rosa: Bandits, Wilderness and Magic' (2010).

MARILYN ARONBERG LAVIN specializes in Italian painting of the 13th–16th centuries, with an emphasis on the work of Piero della Francesca. She has been a pioneer in two areas: 'Collectionism' (*Seventeenth-Century Barberini Documents and Inventories of Art*, 1975), and computers used for research, teaching and publication (*The Place of Narrative: Mural Painting in Italian Churches, 431–1600*, 1990). Her 3-D computer model (2008) of Piero's fresco cycle *The Legend of the True Cross* in the basilica of San Francesco in Arezzo is available on line (http://projects.ias.edu/pierotruecross).

MICHAEL J. LEWIS is Faison-Pierson-Stoddard Professor of Art at Williams College in Williamstown, Massachusetts. He writes on art and culture for a variety of publications, and his books include *Frank Furness: Architecture and the Violent Mind* (2001), *The Gothic Revival* (2002) and *American Art and Architecture* (2006).

DONALD F. McCALLUM is a Professor of Japanese Art History at the University of California, Los Angeles, where he has taught since 1969. He specializes in Buddhist art, and his publications include *Zenkoji and its Icon: A Study of Medieval Japanese Religious Art* (1994), *The Four Great Temples: Buddhist Archaeology, Architecture, and Icons of Seventh-Century Japan* (2009) and numerous articles and reviews. He has spent many years in Japan studying all aspects of the Japanese Buddhist tradition, and he is currently working on a major study of Hakuho sculpture.

MANUELA MENA MARQUÉS has been working at the Prado Gallery in Madrid since 1980. She is currently Head Curator of 18th-century paintings there. She has organized a number of major exhibitions on Goya's work, including 'Goya en Tiempos de Guerra' on his wartime paintings (2008), and has written a number of guides to his work. She holds a doctorate from the Universidad Complutense in Madrid.

FRANCESCO DA MOSTO is a Venetian architect, writer and broadcaster. While running his professional practice, he has published books on the history of Venice, the culture of Italy, and the Mediterranean, each of which accompanied a BBC television series, and a cookbook of the authentic flavours of the region.

SUSIE NASH is a Senior Lecturer at the Courtauld Institute of Art, where she has taught since 1993. She has published on a wide range of northern European art from the period c. 1350–1520, including illuminated manuscripts, panel paintings, textiles, sculpture and sculptural polychromy. Her recent publications include a series of articles in the *Burlington Magazine* on the

'Well of Moses', *Northern Renaissance Art* (2008) and (as co-editor) *Trade in Artists Materials to 1700* (2010), to which she has contributed an extensive discussion of the purchase, cost and use of painters' materials at the Burgundian court, *c.* 1370–1420.

JOHN JULIUS NORWICH has written histories of Norman Sicily, the Venetian Republic, the Byzantine Empire and the Mediterranean; *A History of the Papacy* is shortly to be published. He has also written books on architecture, music and travel, and has made some 30 historical documentaries for BBC television.

ROBIN OSBORNE is Professor of Ancient History, Fellow and Senior Tutor at King's College, Cambridge. He has been president of the Society for the Promotion of Hellenic Studies, and in 2006 was elected a Fellow of the British Academy. He is the author of several influential monographs, including *Greece in the Making, 1200–479* BC (1996; 2nd edn 2009) and *Archaic and Classical Greek Art* (1998).

YOUNGSOOK PAK studied for her doctorate in the history of art at the University of Heidelberg, and then taught at School of Oriental and African Studies, University of London. In 2007–08 she was Korea Foundation Distinguished Visiting Professor at Yale University. She is the author of several books and articles on Korean art history and Buddhist art.

The artist GRAYSON PERRY is best known for his elaborate ceramic vases, but also works in cast metal, etching, tapestry and embroidery. He was the winner of the 2003 Turner Prize. He appears in the media as a commentator on cultural issues and for a time wrote an arts column for *The Times*.

ULRICH PFISTERER holds a doctorate in art history from the University of Göttingen (1997) and is now Professor of Art History at the Ludwig-Maximilians-Universität, Munich. His research focuses on the art and art theory of the Renaissance and Baroque, and on questions of methodology and the disciplinary history of art history.

TOM PHILLIPS has lived and worked in London all his life. Although best known as an artist, whose work is represented in museum collections all over the world, he also has a reputation as a writer and composer. His pioneering artist's book *A Humument* (1970) is now in its fourth edition.

PHILIP PULLMAN is the author of the trilogy *His Dark Materials*, and recipient of the Carnegie Medal, the Guardian Children's Fiction Award and the Whitbread Book of the Year Award (among other honours). He has recently delivered a series of talks on his favourite paintings at the Courtauld Gallery, London.

NANCY H. RAMAGE is Charles A. Dana Professor Emerita at Ithaca College, New York. She is a Fellow of the Society of Antiquaries, London, and a life member of Clare Hall, Cambridge University. Her publications include *Roman Art* (1991; 3rd edn 2000) and *The British Museum Concise Introduction to Ancient Rome* (2008), both co-authored with Andrew Ramage.

JULIAN READE, formerly Assistant Keeper in the Ancient Near East Department at the British Museum and now Honorary Professor in the University of Copenhagen, has directed excavations in Iraq and Oman, and written extensively on the history, art and archaeology of Assyria and Babylonia. His books include *Assyrian Sculpture* (1983; 2nd edn 1998) and *Mesopotamia* (1991; 2nd edn 2000).

PIERRE ROSENBERG, Member of the Académie Française since 1995, worked in the Department of Paintings at the Louvre, and was President and Director of the museum from 1994 to 2001. A specialist in French and Italian painting of the 17th and 18th centuries, he has organized exhibitions of work by Poussin, and authored books and articles on Chardin and La Tour.

INGRID D. ROWLAND holds a doctorate in ancient Greek and Classical archaeology, and has specialized in Classical influences on the Italian Renaissance. She lives in Rome, where she is professor at the University of Notre Dame School of Architecture, and is a contributor to the *New York Review of Books* and the *New Republic*. She is the author of many books, including *The Culture of the High Renaissance* (1998), *The Scarith of Scornello: A Tale of Renaissance Forgery* (2004) and *Giordano Bruno: Philosopher / Heretic* (2008).

DAVID J. ROXBURGH is Prince Alwaleed Bin Talal Professor of Islamic Art History at Harvard University, where he has taught since 1996. He is the author of books and articles on the art of the book, albums and the practice of collecting, calligraphy, aesthetics and art historical writing.

RUBÍ SANZ GAMO is the Director of the National Archaeological Museum in Madrid. Holding a doctorate in history, she was formerly director of the Museum of Albacete. She is also a member of the Cuerpo Facultativo de Conservadores de Museos. She has published a number of books on the Iberian people and Spain under Roman rule.

MAGNOLIA SCUDIERI is an art historian, born and resident in Florence, where she directs the Museo di San Marco and the Office of Conservation and Restoration. Her studies are focused on the history of the miniature, the restoration process and the art of the 15th century (particularly the work of Fra Angelico). She is the author of several essays and papers published in specialist magazines, books and the catalogues of exhibitions held in Italy and abroad.

DEBORAH SWALLOW is Märit Rausing Director at the Courtauld Institute of Art, London. She has also held curatorial positions at the Victoria and Albert Museum and at the University Museum of Archaeology and Anthropology in Cambridge. Her academic career has focused on Hindu art, Indian and Southeast Asian textiles, South Asian contemporary art, and the history of museums and collections. She holds a number of executive positions, and is a Fellow of the Royal Society for the Arts.

LOUIS VAN TILBORGH, studied art history at the Rijksuniversiteit, Utrecht, where he afterwards worked as a researcher; he was appointed a curator at the Van Gogh Museum in Amsterdam in 1986. He has curated a number of exhibitions, including 'In Search of the Dutch Golden Age: Dutch Paintings 1800–1850' (1986, with Guido Jensen: Haarlem, Vienna, Munich), 'Van Gogh and Millet' (1988, Van Gogh Museum; 1998, Musée d'Orsay, Paris) and the major Van Gogh retrospective in 1990. He has written extensively on Van Gogh, and his recent publications include *Van Gogh and the Sunflowers* (2008). He is co-editor of *Simiolus*, the Dutch art history journal, and writes regularly for the *Burlington Magazine*.

WILLIAM E. WALLACE is an internationally recognized authority on Michelangelo Buonarroti. His books include the award-winning *Michelangelo: The Complete Sculpture, Painting and Architecture* (1998), *Michelangelo at San Lorenzo: The Genius as Entrepreneur* (1994) and the biography *Michelangelo: The Artist, the Man and his Times* (2010).

MARINA WARNER's writings embrace criticism, cultural history and fiction. Her books include *Alone of All Her Sex: The Myth and the Cult of the Virgin Mary* (1976), *Monuments and Maidens* (1985) and *Phantasmagoria: Spirit Visions, Metaphors, and Media* (2006), a study of phantasms and modern technologies. She has curated exhibitions, including 'The Inner Eye' (1996), 'Metamorphing' (2002–03) and 'Only Make-Believe: Ways of Playing' (2005). She is a Trustee of the National Portrait Gallery, and Professor of Literature, Film and Theatre Studies at the University of Essex.

ARTHUR K. WHEELOCK JR. is curator of Northern Baroque painting at the National Gallery of Art in Washington DC and Professor of Art History at the University of Maryland. He has organized many exhibitions, including *Johannes Vermeer* (1995) and *Jan Lievens* (2009), and has written a number of books, including *Vermeer and the Art of Painting* (1995). Wheelock has been named Knight Officer in the Order of Orange Nassau by the Dutch government, and is the recipient of the Johannes Vermeer Prize for Outstanding Achievement in Dutch Art.

RODERICK WHITFIELD is Percival David Professor Emeritus in the School of Oriental and African Studies, University of London. Formerly Assistant Keeper in the Department of Oriental Antiquities at the British Museum, he is the author of numerous books on Chinese painting, Chinese Buddhist art and, with Youngsook Pak, Korean art.

ANDREW WILTON is a leading Turner scholar. He was the first curator of the Turner Collection in the Clore Gallery at what is now Tate Britain, and has been responsible for many books and exhibitions about the artist. He was Keeper of the British Collection at the Tate, 1989–98, and is currently Visiting Research Fellow there, working on the drawings in the Turner Bequest.

Sources of Illustrations

a=above, b=below, r=right, l=left

2 Museo Arqueológico Nacional de Espana, Madrid; 4 Giovanni Caselli; 5 Aga Khan Trust for Culture, Geneva; 6 akg-images/Erich Lessing; 7 Neue Pinakothek, Munich; 8 The Gallery Collection/Corbis; 9 I Musei Capitolini, Rome; 10a Museo del Prado, Madrid; 10b Christopher Donan; 11 akg-images/Erich Lessing; 12 Photo Angelo Rubino, Ministero per i Beni e le Attività Culturala Istituto Centrale per il Restauro; 13 Barnes Foundation, Merion, PA; 14 British Museum, London; 16–17, 18a French Ministry of Culture and Communication, Regional Direction for Cultural Affairs, Rhones-Alpes Region, Regional Department of Archaeology; 18b Jean Clottes; 19 French Ministry of Culture and Communication, Regional Direction for Cultural Affairs, Rhones-Alpes Region, Regional Department of Archaeology; 20 Heidi Grassley, © Thames & Hudson Ltd., London; 21–23 Egyptian Museum, Cairo; 25 Museo de Antropologia de Xalapa, Universidad Veracruz; 26–28 British Museum, London; 30–31 Metropolitan Museum of Art/Art Resource/Scala, Florence; 32, 34 Giovanni Caselli; 35–36 Photo Scala, Florence; 37 Giovanni Caselli; 39 Gianni Dagli Orti/Corbis; 40 Museo Nazionale Romano-Palazzo Altemps, Rome; 41a akg-images/Nimatallah; 41b Burstein Collection/Corbis; 43–44 Photo Scala, Florence, Courtesy of the Ministero per i Beni e le Attività Culturala Istituto Centrale per il Restauro; 46–47 Museo Arqueológico Nacional de Espana, Madrid; 49–51 Giovanni Caselli; 53 I Musei Capitolini, Rome; 54a Gabinetto Fotografico Nazionale, Rome; 54b Private Collection; 57 Alamy; 58 Sarnath Museum, Bihar; 59l Government Museum, Mathura; 59r Birmingham Art Gallery & Museum; 60–61 akg-images/Erich Lessing; 62–63 Christopher Donan; 64–65 Jorge Perez de Lara; 66 akg-images/Yvan Travert; 69 akg-images/Erich Lessing; 68 Neil Stewart; 70a Archives photographiques du musée national des Arts Asiatiques-Guimet, Paris; 70b akg images/Erich Lessing; 71 John Guy; 72–75 Palace Museum, Beijing; 76–77 akg-images/Hervé Champollion; 78–79 akg-images/Yvan Travert; 81 akg-images; 83l akg-images/Andrea Jemolo; 82 akg-images/Erich Lessing; 83r Photo Scala, Florence; 85 akg-images/Yvan Travert; 86 Hugh Sitton/Corbis; 87 akg-images/Bildarchiv Steffens; 88l Sakamoto Photo Research Laboratory/Corbis; 88r Hokuendo, Kofukuji, Nara; 91–95 Painton Cowen; 96–97 akg images/Erich Lessing; 98–99 © Frank Willett. Licensor www.scran.ac.uk; 100–105 Photo Angelo Rubino, Ministerio per i Beni e le Attività Culturala Istituto Centrale per il Restauro; 108–09 Kagami Shrine, Saga Prefecture; 110–13 Susie Nash; 115–21 Photo Scala, Florence; 122 Sandro Vannini/Corbis; 123 Photo Scala, Florence; 125–26 Nicolò Orsi-Battaglini; 128–30 Museo del Prado, Madrid; 133 Photo Scala, Florence; 134 Biblioteca Medicea-Laurenziana, Florence; 135 South American Pictures; 136–38 Alinari Archives/Corbis; 139 Pinacoteca di Brera, Milan; 141 akg-images/Rabatti-Dominghie; 142 Galleria degli Uffizi, Florence; 143 akg-images/Erich Lessing; 144 Galleria degli Uffizi, Florence; 145 Gemäldegalerie, Staatliche Museen zu Berlin; 146 Aga Khan Trust for Culture, Geneva; 149 Alte Pinakothek, Munich; 151 The Gallery Collection/Corbis; 152 Musée du Louvre, Paris; 155 Osvaldo Böhm; 156 Mimmo Jodice/Corbis; 157 National Gallery, London; 159–62 Museo del Prado, Madrid; 163 British Museum, London; 164–65 akg-images/Erich Lessing; 166–67 I Musei Vaticani, Vatican City; 168 Takashi Okamura © NTV, Tokyo; 169 akg-images/Erich Lessing; 170 I Musei Vaticani, Vatican City; 171–72 akg-images/Erich Lessing; 173 I Musei Vaticani, Vatican City; 175–77 Unterlinden Museum, Colmar; 179 Bridgeman Art Library, London; 180 akg-images/Erich Lessing; 181l Gemäldegalerie, Staatliche Museen zu Berlin; 181r Archivio RCS Libri, Milan; 182–85 Aga Khan Trust for Culture, Geneva; 186–87 National Palace Museum, Taipei; 189 bpk/Gemäldegalerie, Staatliche Museen zu Berlin/Photo Jörg P. Anders; 190–91 Gemäldegalerie, Staatliche Museen zu Berlin; 192 Photo Scala, Florence; 193 akg-images/Cameraphoto; 194 Musée du Louvre, Paris; 195 Photo Scala, Florence; 197–98 National Gallery, London; 199 Holy Cathedral of the Dormition of the Virgin, Ermoupolis; 200 akg-images/Erich Lessing; 202 National Museums, Liverpool; 203–04 National Gallery, London/Scala, Florence; 205 National Gallery of Ireland, Dublin; 207 Summerfield Press/Corbis; 208a H.M. Queen Elizabeth II, The Royal Collection; 208b Galleria Nazionale d'Arte Antica, Rome; 209 Museo di Capodimonte, Naples; 210 Freer Gallery of Art, Smithsonian Institution, Washington, D.C.; 212 British Library, London; 213 Freer Gallery of Art, Smithsonian Institution, Washington, D.C.; 215–16 National Gallery, London/Scala, Florence; 217a Photo Spectrum/Heritage Images/Scala, Florence; 217b National Gallery, London/Scala, Florence; 218 National Gallery, London; 219–20 akg-images/Erich Lessing; 221 Museo del Prado, Madrid; 222–24 Photo Scala, Florence; 225l akg-images/Erich Lessing; 225r akg-images; 227a National Museum of Wales, Cardiff; 227b National Museums, Liverpool; 228 Musée du Louvre, Paris; 230–31 Museo del Prado, Madrid; 235–36 Kunsthistorisches Museum, Vienna; 239 akg-images/Erich Lessing; 240 Musée du Louvre, Paris; 241–44 akg-images/Erich Lessing; 245 National Museum, Tokyo; 246 Neue Pinakothek, Munich; 249 akg-images/Erich Lessing; 250l Museo del Prado, Madrid; 250r akg-images/Erich Lessing; 251 British Museum, London; 253, 254a Kunsthalle, Hamburg; 254b Kupferstichkabinett, Staatliche Kunstsammlungen, Dresden; 255 Kunsthalle, Hamburg; 257–58 Photo Scala, Florence; 259 akg-images; 260 Tate, London; 261, 262a Cleveland Museum of Art, Ohio; 262b Philadelphia Museum of Art: The John Howard McFadden Collection, 1928; 263 Tate, London; 265 Francis G. Meyer/Corbis; 266a National Gallery of Art, Washington, D.C., Andrew W. Mellon Fund; 266b, 267 Francis G. Meyer/Corbis; 269, 270a akg-images/Erich Lessing; 270b The Herbert F. Johnson Museum, Cornell University, Ithaca, NY; 271 Tate, London; 272 Philadelphia Museum of Art; 273 Getty Images; 274 Musée d'Orsay, Paris; 275a akg-images; 275b Nasjonalgalleriet, Oslo; 276 National Museums, Liverpool; 277 Courtauld Institute of Art, London; 278 Stedelijk Museum, Amsterdam; 279 Courtauld Institute of Art, London; 280–81 National Gallery, London; 282 Van Gogh Museum, Amsterdam; 283l National Gallery, London; 283r Neue Pinakothek, Munich; 284–87, 288a Photo Scala, Florence; 288b The Barnes Foundation, Merion, PA; 289 Sammlung Feilchenfeldt, Zurich; 290–91 Ordrupgaard, Copenhagen

TEXT CREDITS

The following serves as an extension of the information on p. 4:

pp. 192–95, 272–75 copyright © 2010 Quentin Blake; pp. 276–79 copyright © 2010 Philip Pullman; pp. 222–25 copyright © 2010 Marina Warner

The essays listed here have been translated by the following:

Barbara Belelli Marchesini:
The 'Seven Against Thebes' Relief, Unknown Etruscan artist

Rosa Dell-Niella:
The Scrovegni Chapel Frescoes, Giotto; *The Lady of Elche*, Artist unknown; *The Brancacci Chapel Frescoes*, Masaccio and Masolino; *The Deposition*, Fra Angelico (and Lorenzo Monaco); *The Third of May, 1808*, Francisco de Goya

Michael Hoyle: *Sunflowers*, Vincent Van Gogh

Sian Marlow: *Dust Motes Dancing in the Sunlight (Sunbeams)*, Wilhelm Hammershøi

ACKNOWLEDGMENTS

Christopher Dell would like to thank everybody who has helped to prepare this book, in particular Rosa Dell-Niella.

Index

Illustrations are indexed by page number, indicated by *italics*. Captions are also indicated by *italics*.